ART MADE MODERN

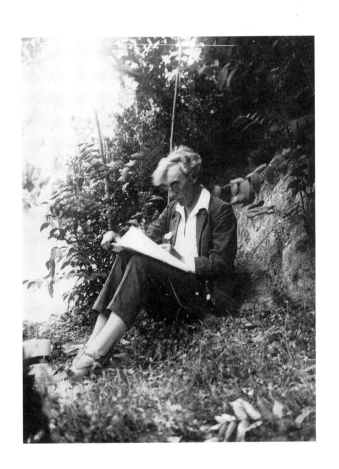

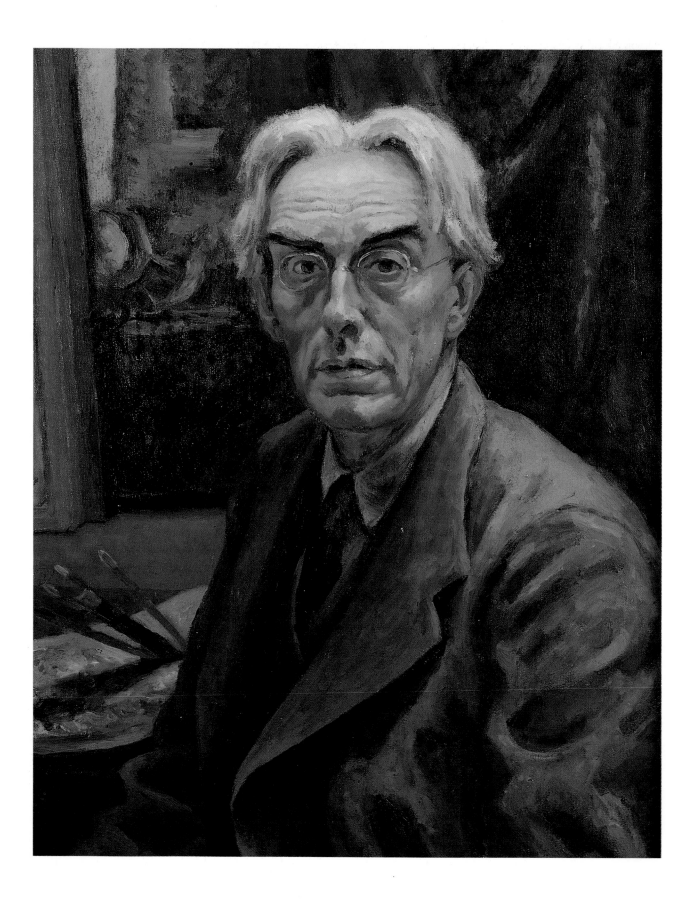

ART MADE MODERN

ROGER FRY'S VISION OF ART

EDITED BY CHRISTOPHER GREEN

MERRELL HOLBERTON

PUBLISHERS LONDON

in association with

The Courtauld Gallery

Courtauld Institute of Art

Published on the occasion of the exhibition
Art Made Modern: Roger Fry's Vision of Art
at The Courtauld Gallery, Courtauld Institute of Art,
Somerset House, Strand, London WC2R 0RN
15 October 1999 – 23 January 2000

The exhibition and publication have been generously supported by the
Gabrielle Jungels-Winkler Foundation on the occasion of the establishment
of a Chair in Contemporary European Studies at Scripps College, Claremont,
California, USA

The exhibition has also received support from the Henry Moore Foundation

First published in 1999 by Merrell Holberton Publishers Ltd, 42 Southwark
Street, London SE1 1UN

Distributed in the USA and Canada by Rizzoli International Publications, Inc.
through St Martin's Press, 175 Fifth Avenue, New York, New York 10010

British Library Cataloguing in Publication Data
 Art made modern: Roger Fry's vision of art
 1. Fry, Roger, 1866–1934 — Influence
 2. Painters — England
 3. Art, Modern — 20th century
 I. Green, Christopher, 1943 June 11–
 700.9'2

ISBN 1 85894 082 6 (Hardback)
 1 85894 081 8 (Paperback)

Produced by Merrell Holberton Publishers Ltd

Exhibition Design: Calum Storrie and Graham Simpson
Exhibition Co-ordination: Catherine Pütz
Catalogue Design: Roger Davies
Printed and bound in Italy

Jacket/cover: Georges Seurat *La Luzerne, Saint-Denis*, 1885, cat. 228 (detail)
Half title: Roger Fry sketching, cat. 256
Frontispiece: Roger Fry *Self-Portrait*, 1934, cat. 86

PICTURE CREDITS

CONTENTS

FOREWORD

Following the exhibition in 1994, *Impressionism for England: Samuel Courtauld as Patron and Collector*, this is the second in a series of major exhibitions intended to distinguish the individual character of the several private collections that make up the integrated public displays at the Courtauld Gallery. Roger Fry used a letter to *The Burlington Magazine* to welcome the idea of the Courtauld Institute before its foundation in 1932. He was the earliest of those who responded to the establishment by Samuel Courtauld of Home House as a permanent memorial to his late wife. Fry died suddenly in 1934, bequeathing paintings and objects – either his own work, or collected by him as the familiar objects of an aestheticized existence – for display in the house. He envisaged them as extending the period range of Courtauld's modernism from the seminal works of French Impressionism, to the work of those British contemporaries who had been influenced by the artists he called the Post-Impressionists. As with Courtauld, Fry's primary interest was always in the creative and critical enhancement of people's lives in the present, and his bequest has helped to impart that character to the collections of historic art, which, with the death of Lord Lee of Fareham in 1947 and the opening of the purpose-built galleries in 1958, followed on from the early benefactions. However, with the increase in those collections, and in the light of their great art historical importance, the Fry Collection has inevitably been obscured. To post-war generations, Fry himself has seemed more important for his involvement in the lives and loves of his younger Bloomsbury friends than as an artist and critic in his own right. Yet his role as the virtual inventor of British modernism in the years around 1910, and his immense influence on the way in which people saw and understood art in the first half of the twentieth century, make him one of the leading spirits of that century. By the 1990s the time seemed ripe for his re-assessment and for a substantial exhibition covering, as far as possible, all facets of his intellectual and creative life.

I was extremely grateful, therefore, that my colleague Chris Green accepted the suggestion that he should be the guest curator for the exhibition and the lead author and editor of this volume of essays. Within days, he had transformed the project into a thoroughly exciting undertaking, seeing instantly how to deal with the key issue of Fry's 'vision' both as a historical phenomenon and as something that we might still share, and putting together his team of authors to cover Fry's achievement at an appropriate scholarly level.

Especially important to Professor Green for their contributions to the development of the project have been Dr Anna Greutzner Robins, whose great

knowledge of twentieth-century British art was freely shared; Dr Elizabeth Prettejohn, also involved from the start, whose help in assembling a comprehensive record of Fry's critical writing was fundamental; William Bradford, whose acute curatorial sense helped with many difficult decisions in the selection of exhibits; Dr Patricia Rubin, who made it easier to see the importance of Berenson and his connoisseurship to Fry; Ariane Bankes, who gave generously of her time in following up possible loans when the pressures were greatest; Jackie Cox, of the Archive at King's College, Cambridge, whose support has been crucial throughout, and whose encouragement made research in the Archive such a pleasure; Catherine Pütz, whose intelligence and panoramic competence has made the realisation of the project so much smoother for everyone concerned; and Richard Shone, who, besides co-operating at every stage by avoiding conflicts with his Bloomsbury exhibition at the Tate Gallery, has been a constant source of information and ideas. Professor Green also wishes to thank Pauline Adams, Somerville College, Oxford; Dr Judith Collins, Tate Gallery; Caroline Elam, Editor, *The Burlington Magazine*; Michael Harrison, Director, Kettle's Yard, University of Cambridge; K.A. Hook, Domus Bursar, King's College, Cambridge; Richard Morphet; Daniel Porter; Dr Frances Spalding; Professor John Swift, University of Central England, Birmingham; and Professor Lisa Tickner, Middlesex University.

Otherwise, our thanks are owed, as always, to the lenders to the exhibition, who have parted with paintings and other works of art, often of the greatest importance and fragility, about which Fry wrote. Very special thanks are owed to Roger Fry's family in England for their kindness and patience in the face of repeated invasions of their privacy. The generosity of Mrs Annabel Cole, Mrs Betty Taber and Dr Roger Diamand has made much possible. Moreover, our thanks are owed to Mrs Cole for permission to cite from Fry's unpublished papers.

Finally, it is a pleasure to record publicly our debt to the Gabrielle Jungels-Winkler Foundation for supporting both the exhibition and this publication, and for creating through the project a link between the Courtauld Institute and Scripps College in California. Roger Fry, who spent several crucial years of his professional life in the United States, exemplifies perfectly that open, questing transatlantic and European culture that the Foundation seeks to promote through its benefactions.

JOHN MURDOCH
Director, Courtauld Gallery

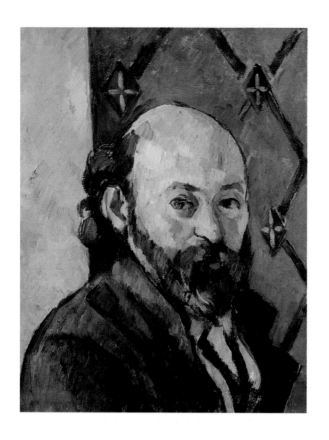

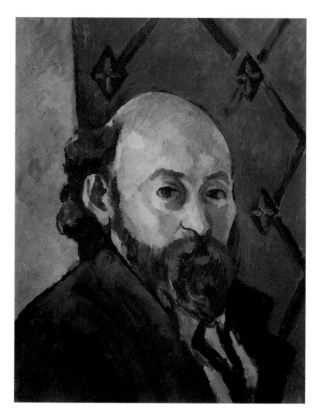

TOP LEFT Fig. 1 (Cat. 26) Paul Cézanne, *Self-Portrait*, 1879. Oil on canvas, 48.5 x 41.5 cm. National Gallery, London.

ABOVE Fig. 2 (Cat. 84) Roger Fry, *Copy of a Self-Portrait by Cézanne*, 1925. Oil on cardboard, 35.8 x 28.6 cm. Courtauld Gallery (Fry Collection).

LEFT Fig. 3 (Cat. 85) Roger Fry, *Self-Portrait*, 1928. Oil on canvas, 45.7 x 37.1 cm. Courtauld Gallery (Fry Collection).

PREFACE

CHRISTOPHER GREEN

The exhibition for which this book has been put together is conceived as an exploration of a way of looking at art: Roger Fry's. It aims to raise questions about our current ways of exhibiting and looking at art as well as about Fry's.

Now, at the turn of the millennium, Fry is remembered most of all for his role as modernism's impresario: as the man who created controversy in England around the names Gauguin, Van Gogh and Cézanne, and then Matisse and Picasso, with the first and second Post-Impressionist exhibitions at the Grafton Galleries in 1910 and 1912. He made an impact, however, in many guises, and as a cross-Channel and transatlantic figure. His impact was certainly least as an artist, but his practical engagement in making art gave a special acuteness to his judgements in the role of connoisseur and critic, and, as a writer, his range was enormous, taking in Chinese or Persian pottery, Mayan or African sculpture, Giotto or Piero della Francesca or Fra Bartolommeo, as well as Daumier or Cézanne or Matisse. Moreover, he was not just English Post-Impressionism's most energetic impresario and most subtle theorist; he also contributed to the development and sometimes the foundation of many enduring art-world organizations, from *The Burlington Magazine* to the National Art Collections Fund and the Courtauld Institute. This institutional role has sometimes led to an over-emphasis on his role in legitimating a new cultural establishment in England, but in fact much about what he wrote and did can connect with the most challenging developments, not only just before the 1914–18 war, but also now at the turn of the twentieth and twenty-first centuries, often in surprising ways.

The "vision of art" that he developed between the late 1880s and his death in 1934 crosses cultures and periods with a global thrust that ignores the cultural hierarchies of 'high' and 'low'. It was a vision that erased boundaries in ways that can seem to anticipate the most recent approaches to 'world art'. And yet Fry's Humanist world view could not be further from those current stances that stress difference and are attracted to the peripheries rather than the centre. For him, it was the unifying function of affinities perceived from his modern European vantage-point that mattered. Once Fry had convinced himself of modern art's importance (from 1906), he devoted his enormous energy and intelligence to applying his new modern values as widely as possible. At a moment routinely called postmodern, the exhibition and much of this book draws out the significance of an extraordinary attempt to make 'modern' the art of all times and all cultures.

Since the overriding focus here is, thus, on Fry's activities as artist, critic and

art historian, the best ending to this preface must be a glimpse of him as a person. No one has captured the impression he could leave with people better than Virginia Woolf. This is how she writes of him as he was just before the exhibition *Manet and the Post-Impressionists* in April 1910:

"To a stranger meeting him then for the first time he looked much older than his age. He was only forty-four, but he gave the impression of a man with a great weight of experience behind him. He looked worn and seasoned, ascetic yet tough … He did not live up to his reputation, if one expected a man who lectured on Old Masters at Leighton House to be pale, academic, ascetic-looking. On the contrary, he was brown and animated. Nor was he altogether a man of the world, or a painter – there was nothing Bohemian about him … He talked that spring day in a room looking over the trees of a London square, in a deep voice like a harmonious growl … and he laughed spontaneously, thoroughly, with the whole of him. It was easy to make him laugh. Yet he was grave – 'alarming', to use his own word for his father. He could be formidable. Behind his glasses, beneath bushy black eyebrows, he had very luminous eyes with a curious power of observation in them as if, while he talked, he looked, and considered what he saw. Half-consciously he would stretch out a hand and begin to alter the flowers in a vase, or pick up a bit of china, turn it round and put it down again. That look, that momentary detachment, was so instinctive that it made no break in what he was saying, yet it gave a sense of something held in reserve – things played over the surface and were referred again to some hidden centre. There was something stable underneath his mobility. Mobile he was. He was just off – was it to Paris or to Poland? He had to catch a train" (Virginia Woolf, *Roger Fry: A Biography*, London 1940).

ABBREVIATIONS

The following abbreviations are used throughout:

Fry Papers
The Fry Papers held in the Archive, King's College Library, Cambridge

Last Lectures
Roger Fry, *Last Lectures*, with an introduction by Kenneth Clark, Cambridge 1939

Letters, I, *Letters*, II
Denys Sutton (ed.), *Letters of Roger Fry*, 2 vols., London 1972

Transformations
Roger Fry, *Transformations: Critical and Speculative Essays on Art*, London 1926

PART I
ESSAYS ON ROGER FRY:
ART, CRITICISM AND DESIGN

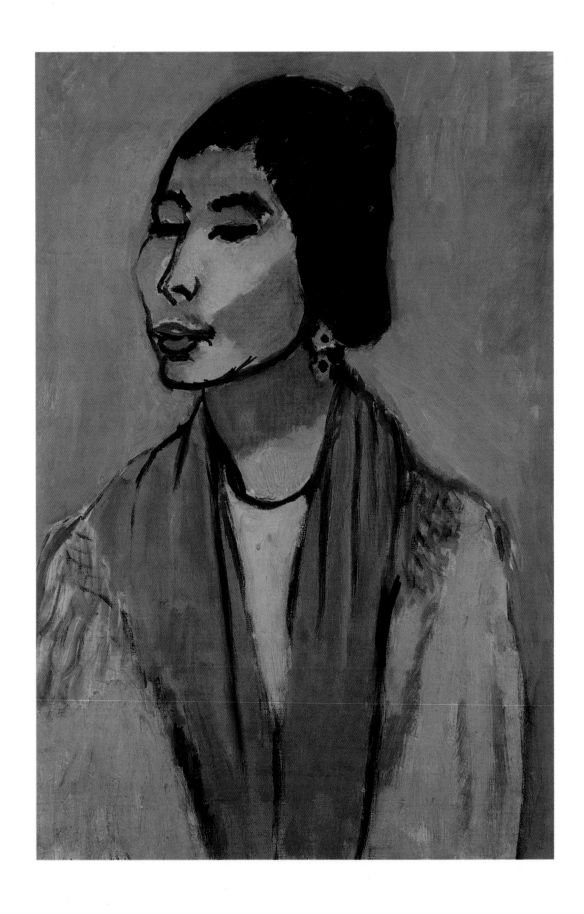

INTO THE TWENTIETH CENTURY

Roger Fry's Project Seen from 2000

CHRISTOPHER GREEN

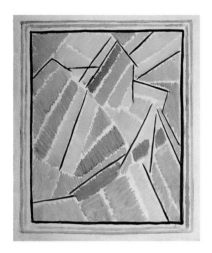

Fig. 4 (Cat. 14) Vanessa Bell, *Composition in Buff, Green and Blue-grey*, undated. Pencil on paper, 56.5 x 48.1 cm. Courtauld Gallery (PD 86).

FACING PAGE Fig. 5 (Cat. 185) Henri Matisse, *Joaquina*, 1911. Oil on canvas, 55 x 38.5 cm. National Gallery, Prague.

"We ought to protect ourselves", Roger Fry wrote to Virginia Woolf from a train on the way to Paris in 1928; "it's really a curse that we have become so notorious and that means so *recherché* by all the people whose intellectual life consists in pure snobbism. But I think England's hopeless: we've never got over the Norman Conquest; that makes every one believe that there exists a race of superior beings and they spend their lives searching for them, now in the aristocracy and now in Bloomsbury, but the abjection is always constant."[1]

For nearly two decades now, Roger Fry has been repeatedly attacked as an élitist at the centre of a tiny coterie of snobs to be pigeon-holed under the label 'Bloomsbury'.[2] A major cause of this is the self-protective exclusivity of the social group centred on Gordon Square and Charleston House which had Fry, Duncan Grant, Vanessa Bell and her sister Virginia Woolf at its heart. Another is the degree to which Fry's assertively 'modern' cultural values along with his revised version of the canon overtook the prejudices of the art-world establishment to become orthodoxy between the 1930s and the 1980s. Neither can it be denied that, with their links to Cambridge and their origins in county, professional and business families, the so called 'Bloomsburies' did form what Raymond Williams has called a "class fraction" of the English upper-middle classes, a circle of friends whose values could in the end be absorbed into their society without undermining its structural divisions.[3]

I start with the point that Roger Fry the modernist actually set himself and his cultural values *against* what he consistently thought of as the snobbery of the English middle classes, and by the end of the 1914–18 war actually considered the small group to which he belonged not a success but a marginalized failure, despite its notoriety – the victim of majority indifference. Just a few months before his letter of 1928 to Virginia Woolf abhorring Bloomsbury's snob image, Fry had pronounced in print the failure of the onslaught on public taste he had led as impresario of the Post-Impressionist exhibitions in 1910 and 1912, and confessed that the artists involved (including himself) had been forced by the obduracy of the British middle classes to set aside their ambitions for a new public "monumental art" and accept the limitations of easel painting for a few supporters.[4] In 1928 as in 1910, Fry painted and wrote from what for him were the margins, and, though he set himself apart from the masses of capitalist consumerism, his priority was to reach as many individuals as possible with his words, from the

NOTES

1. Letter to Virginia Woolf from the train between Port Vendres and Paris, 3 November 1928, *Letters* II, p. 630. I respond often in this essay to Christopher Reed's important re-direction of writing on Fry, but I would also like to acknowledge the fundamental contributions made by Denys Sutton with his two-volume edition of Fry's correspondence, and Frances Spalding with her fundamental biography. Sutton and Spalding were the first to work through the Fry Papers. More directly, my work has been helped by Anna Gruetzner Robins and Elizabeth Prettejohn, whom I thank for their generosity and patience.

2. The attacks were initiated in Charles Harrison's *English Art and Modernism, 1900–1939*, London 1981.

3. Raymond Williams, 'The Significance of "Bloomsbury" as a Social and Cultural Group', in Derek Crabtree and A.P. Thirlwall (eds.), *Keynes and the Bloomsbury Group*, London 1980, pp. 40–67.

4. Roger Fry, 'The London Group', *The Nation and Athenaeum*, 12 May 1928, pp. 174–75.

5. Christopher Reed, 'Forming Formalism: The Post-Impressionist Exhibitions', in Christopher Reed, *A Roger Fry Reader*, Chicago 1996.

6. Christopher Reed, 'Revision and Design: The Later Essays', in Reed 1996, p. 309.

7. Roger Fry, '*The Toilet*, by Rembrandt', *The Listener*, 19 September 1934, p. 468.

8. Roger Fry, 'Art Now – An Introduction to the Theory of Modern Painting and Sculpture', *The Burlington Magazine*, LXIV, May 1934, p. 242. Without naming them, Fry had already mounted an attack on the sculpture of Henry Moore and Barbara Hepworth, both supported by Read: he was unable to reconcile his views with their work as well (see Roger Fry, 'Sculpture and the Public', *The New Statesman and Nation*, 10 December 1932, pp. 717–78. Fry maintained his liberal pluralist stance, however, even in relation to these new developments. Thus, he was able to write to Kenneth Clark in 1933 supporting the "consensus" that Read was "the best man" for the vacant editorship of *The Burlington Magazine*, "in spite of my distaste for his writings and his general *weltenschauung*" (letter to Kenneth Clark, 3 August 1933, in *Letters*, II, p. 683). Read got the job.

very first lectures he gave in 1894 to the talks he regularly delivered for the brand new BBC in the last half-decade of his life. The image of Fry the élitist has been effectively challenged in the last few years by Christopher Reed above all. As Reed has shown, Fry and Bloomsbury are much more convincingly to be approached as a sub-culture openly committed to counter-cultural values than as a well connected controlling élite: a sub-culture operating from within whose considered aim was "to wrest art from the imperatives of capitalist consumerism", not to sustain establishment interests.[5]

The image of Fry the élitist is the complement to another image of him which has been unquestioned for too long: that of Fry the rigid formalist, whose separation of art from life not only conserved art as the privilege of the few, but opened the way to the Anglo-American formalism of Clement Greenberg from the 1940s onwards. Reed again has made an effective case for the actual openness of Fry's formalism, coining the apt phrase a "methodology of doubt".[6] My intention in this essay is to take this argument further by exploring the practices and guiding principles of Fry's formalism in a context that includes both the rarified intellectual environment from which his writing emerged in the 1890s and theory and criticism as it developed in Europe, especially France, between the 1900s and the 1930s. Fry's formalism, I believe, is more to be differentiated from than compared to Greenberg's; it can help us think about our critical attitudes to visual culture at the turn of the millennium much more because of its differences than for its similarities to later American formalism; and openness is indeed one of its key features. Fry concludes the very last article he published, in September 1934, by leaving unresolved what had become the central theoretical issue for him, the question of whether "psychological" and "plastic" (formal) responses can combine in the experience of paintings (it is an issue to which I shall return, pp. 27–28). His final words are: "That is a question I have never been able to answer."[7] The impetus behind Fry's unflagging engagement with theory was never certainty.

It was also in the final year of his life that Fry wrote an assessment of the position of the critic who would succeed him as the most influential protagonist of modernism in Britain, Herbert Read. One of his last contributions to *The Burlington Magazine* was a furious attack on Read's primer of modern art for the 1930s, *Art Now*. Nothing could more plainly expose the distinctiveness of Fry's stance as an English intellectual and its core values. What is essential is not his visceral hostility to Read's germanophilia, and his utter dismissal of Expressionism and Surrealism along with such figures as Paul Klee and Max Ernst, it is his insistence on maintaining continuity with "the European tradition of the past", and his demand for "plastic unity" if "art now" is to succeed.[8] Unity and continuity were the values that underpinned both his theory and his practical criticism from beginning to end. As he makes clear in his 1905 edition of Sir Joshua Reynolds's *Discourses*, he identified with Reynolds not only because he was the model for all English painter-critics like himself, but because his work and his writing promoted above all "unity" in

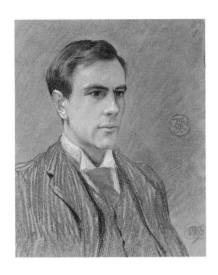

Fig. 6 (Cat. 89) Roger Fry, *Portrait of Goldsworthy Lowes Dickinson*, 1893. Chalk, 49.5 x 40.3 cm. By courtesy of the National Portrait Gallery, London.

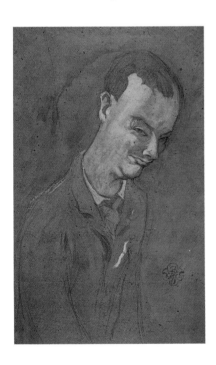

Fig. 7 (Cat. 97) Roger Fry, *Caricature of J.E. McTaggart*, undated. Pencil, pen and pastel on brown paper, 38.1 x 22.86 cm. The Master and Fellows, Trinity College, Cambridge.

the "general effect" of pictures, and the idea that the principles behind such a unity are "more or less discoverable in the great traditions of past masters".[9]

This dual demand for unity and continuity had as its analogue in Fry's thinking a profound, a compelling faith in reason and in the idea of civilization. It comprehensively separates him from the anti-rational, de-civilizing alternatives within the European avantgardes, above all Dada and Surrealism, and is at the root of his refusal to adapt his aesthetics to psychoanalysis. The unities available to reason were, he knew, threatened by the primacy given to the Freudian Unconscious. Fry's passionate rationalism identifies him with a very particular mentality produced inside a very particular, distinctly enclosed intellectual milieu in England at the end of the 1880s: the Cambridge Conversazione Society, better known as the Society of Apostles.

Fry arrived among the select undergraduate community of King's College, Cambridge (just sixty strong), in October 1885, and in his second year was invited to join the far more select Society by a young fellow of King's, Goldsworthy (Goldie) Lowes Dickinson (fig. 6). It dominated his intellectual life in 1887–88, as it did that of Dickinson and an undergraduate from Trinity who would remain the friend of both of them for decades, J.E. (Jack) McTaggart (fig. 7), later to become a major Hegelian philosopher.

All reminiscences of this intense formative phase agree on one point, that McTaggart was 'the leader'.[10] Fry and McTaggart had been inseparable friends at Clifton School, but between Fry and Dickinson there developed an intimacy which Dickinson called love. Theirs remained a special friendship even after Fry's involvement with Helen Coombe from 1896 had brought into the open their sexual incompatibility.[11] McTaggart's intellectual leadership of this tiny circle was marked by his own transition from the radical materialism of John Stuart Mill to Hegel at his most idealist. At the end of the 1880s and into the 1890s, Dickinson joined McTaggart in what he described as their "tussle" with Hegel, but where McTaggart was interested exclusively in the "Reality" behind "Appearance" – Hegel's "Absolute" – Dickinson became increasingly involved in the application of dialectics to the concrete, especially to politics and history. From the start, Fry kept out of McTaggart's metaphysical enterprise, preferring to think about concrete "Appearance" rather than in the abstract about absolutes. In one of his papers written for the Apostles, there is exasperation in the way he exclaims: "For the fact that the absolute is expressed through the phenomenal must have a meaning and therefore if the absolute itself be worthy of our respect are we not right in seeing it through phenomenal manifestations?"[12] He was prepared to contemplate "the Absolute", but only as revealed in phenomena. His Natural Sciences course at Cambridge consolidated a determination to deal only with phenomena, and when, in 1891, he unsuccessfully submitted a fellowship dissertation to King's, it was an attempt to apply "the science of Phenomenology" (by which he meant "the science of appearances") to ancient Greek painting.[13] Invited to

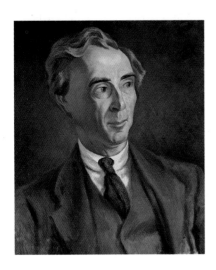

Fig. 8 (Cat. 83) Roger Fry, *Portrait of Bertrand Russell, Earl Russell, c.* 1923. Oil on canvas, 54 x 45.1 cm. By courtesy of the National Portrait Gallery, London.

9. 'Introduction', in Roger Fry (ed.), *Discourses Delivered to the Students of the Royal Academy by Sir Joshua Reynolds, Kt.,* London (Seeley & Co.) 1905, pp. vii–xxi. Fry's interest in Reynolds developed very early. The *Discourses* are cited in one of his unpublished papers for the Apostles (probably written 1887–89), 'Are we compelled by the true and Apostolic Faith to regard the standard of beauty as relative', Fry Papers, 1/10. See also 'Reynolds (Sir Joshua)', p. 202 (below).

10. The key texts are the following: E.M. Forster, *Goldsworthy Lowes Dickinson and Related Writings,* London 1934 and 1973; G. Lowes Dickinson, *The Autobiography of G. Lowes Dickinson,* ed. Dennis Proctor, London 1973; and G.Lowes Dickinson (with chapters by Basil Williams and S.V. Keeling), *J.E. McTaggart,* Cambridge 1931.

11. The course of events can be followed both in Dickinson's movingly confessional autobiography (see note 10) and in his correspondence with Fry, now in the Fry Papers. Briefly, in 1888, he wrote to Fry as "Beloved".

12. Roger Fry, 'Shall We Temporize', paper delivered to the Society of Apostles (probably between 1887 and 1889), Fry Papers, 1/10.

speak to a philosophical society in Oxford nearly forty years later, after McTaggart's death in 1925, he would still find it necessary to place himself on the side of appearances against metaphysics, mentioning "the late Dr. McTaggart" and remarking that he (Fry) had "never understood anything he [McTaggart] expounded to me".[14]

The only sign of Fry accepting the possibility of a new "metaphysic" is in a letter to Marie Mauron of 1920, where he enthusiastically reports "reading Bertrand Russell's books" and being struck by the possibility that here was "a real metaphysic based on fundamental ideas about mathematics – a humble, unpretentious metaphysic with the same solidity as other sciences". He had acknowledged Russell very early on in one of his Apostles papers. In 1923, he painted Russell's portrait, and showed the picture in his solo exhibition at the Independent gallery that year (fig. 8). The sympathy between artist and sitter was obvious enough to the *Daily Mirror* critic. "One could have guessed," he wrote, "that Mr. Fry would like to paint Mr. Russell and that Mr. Russell would like to be painted by Mr. Fry."[15]

At a structural level, however, the way Fry approached the development of his formalist theory between 1908 and 1914, nearly two decades after his intellectual apprenticeship with the Apostles, bore the mark of McTaggart's passionate rigour. As Dickinson observed, "The origin of McTaggart's philosophy was not in his intellect but in his emotions". Another admirer related those emotions to "a conviction of a harmony between ourselves and the universe at large". They amounted to a feeling of unity orientated towards the "universal" (what Freud would call the "oceanic" feeling).[16] And yet if feeling "set our problems, never," in McTaggart's view "may it be permitted to solve them." His philosophy, as summed up by Dickinson, aimed "at demonstration and [in its demonstration] he refused to make appeal to anything but reason".[17] Fry, too, would always start with the problems set by emotion, what Clive Bell taught him to call "aesthetic emotion" – a feeling of unity in formal relations, which he never tried to describe verbally, and which he always claimed oriented the individual towards the universal.[18] And Fry, too, would try to exclude everything but reason in the demonstration of the general principles that followed from the emotion. His starting-point was always things seen – appearances – and his mode of exposition was always strictly logical. To this extent he remained the phenomenologist of the 1891 dissertation. But his focus on the emotional intensity of response led him increasingly away from the scientific model. In an essay of 1919 on 'Art and Science' he wrote of a "unity-emotion" underlying both, concluding: "This unity-emotion in science supervenes upon a process of pure mechanical reasoning; in art it supervenes upon a process of which emotion has all along been an essential component".[19] And yet the order of reason remained as fundamental to him as it was to Dickinson and McTaggart, and as it had been to Hegel, for not only could the very workings of reason provoke, he believed, the "unity-emotion", but reason had to guide any inquiry into the way the

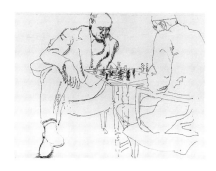

Fig. 9 (Cat. 92) Roger Fry, *Goldsworthy Lowes Dickinson Playing Chess with André Gide*, August 1918. Pen and ink. 34.8 x 50.4 cm. (Archive cat. 4/8/9) By kind permission of the Provost and Fellows of King's College, Cambridge.

13. Roger Fry, *Some Problems in Phenomenology and its application to Greek Painting: A Dissertation by R.E. Fry*, 1891, Fry Papers, 1/13.

14. Roger Fry, 'Representation in Art', unpublished lecture delivered to an unidentified "society of philosophers" at Oxford, January or February 1929, p. 1, Fry Papers, 1/126.

15. Anon., 'Art with an A', *The Daily Mirror* 28 March 1923. See also letter to Marie Mauron, 3 July 1920, in *Letters* II, p. 483; 'Do We Exist?', Fry Papers, 1/10. Russell, earlier an Apostle like Fry, had been close to Bernard Berenson in the period when Fry was; his first wife was Mary Berenson's sister. For McTaggart's wartime antagonism to Russell, see note 20.

16. Freud discusses the "oceanic feeling", a "sensation of 'eternity', a feeling as of something limitless, unbounded", in *Civilization and its Discontents*, 1930; see Sigmund Freud, *Civilization, Society and Religion* (The Pelican Freud Library), Harmondsworth 1985, XII, pp. 251ff.

feelings released by art could provoke the "unity-emotion", too.

McTaggart's metaphysics focused on a possible spiritual rather than material perfection. It allowed him to see injustice and conflict in the world as merely part of a dialectical process moving towards the Absolute (a comfortable position for a Cambridge don). From the late 1880s, his metaphysics accompanied a resolute cultural, social and political conservatism, which, especially during the 1914–18 war, led to sharp disagreement with Dickinson and Fry, though the old spark between them was never extinguished.[20] Fry's and later Dickinson's refusal of metaphysics in favour of a rational approach to things *in* the world accompanied a radical reforming impulse aimed at producing change, which in Dickinson's case opposed Western imperialism and the confrontational diplomacy that led to the war. In both cases, unity was the ideal which was to be made concrete in perfected relations (Dickinson responded to the declaration of war in 1914 by sketching a project for a League of Nations, which he then helped to realise). In both cases, too, the prerequisite for that ideal, whether cultural or political, was civilization, by which was understood a social order capable of continuity in which reason had a determining role (a conviction which I explore in my other essay in this book). It meant, of course, that both constructed themselves as reformers, not revolutionaries – resistant to the idea of any dramatic social or cultural break with the past.

Dickinson's steely resolve in the face of war was his response to the realisation that "the world is ruled by force", when he had spent his "whole life ... trying to establish reason".[21] In 1919, as Fry came to terms with what he saw as the failure of the Post-Impressionist experiment after the war, he wrote to André Gide, who he had sketched playing chess with Dickinson in King's the summer before (fig. 9), that "English Civilization is carried on by a small minority of men (mostly from Cambridge, I think ...) who are generally in violent reaction against the attitudes of the mass of their fellow countrymen".[22] So closely could he identify now with the Cambridge rationalism which had shaped his view of the world that he believed it constituted, in itself, "English Civilization". By that date, it embraced, of course, the circle around Bloomsbury and Charleston. It is a rationalism that has tended to be identified with the profoundly influential role of G.E. Moore in Cambridge at the turn of the century. Its beginnings, however, lay in the earlier generation who broke away from J.E. McTaggart's idealist metaphysics, taking the passion of his rationalism with them: the older generation of Fry and Dickinson, rather than the younger generation of Clive Bell and Lytton Strachey. Its mentality – the Apostles' mentality of the late 1880s – was certainly the product of a kind of élitism, however much it revelled in the outsider condition; it could never have assimilated the anti-rational aggression of André Breton and Louis Aragon's reaction to the war, let alone the milder anarchist version developed in England by Herbert Read in the 1930s.

Between leaving Cambridge in 1888 and writing his first formalist theory

17. The quotations from Dickinson are from Dickinson 1931, pp. 82, 84 and 91; the quotations from an admirer of McTaggart are from S.V. Keeling's chapter, 'McTaggart's Metaphysics', in the same publication, p. 129.

18. For Bell's highly influential discussion of "aesthetic emotion", see Clive Bell, *Art*, London 1914.

19. Roger Fry, 'Art and Science', *The Athenaeum*, 6 June 1919; in Roger Fry, *Vision and Design* [1920] London 1961, pp. 72–3.

20. McTaggart was very much involved in stripping Bertrand Russell of his fellowship at Trinity College, Cambridge, in 1916 for publishing his pacifist arguments. This led to serious divisions with Fry and Dickinson, who were both deeply antagonistic to the war.

21. Letter from Lowes Dickinson to C.R. Ashbee's wife, 4 November 1914, cited in Forster 1934 and 1973, p. 132.

22. Roger Fry to André Gide, 9 February 1919, Durbins, Guildford; *Letters* II, p. 445.

23. A serviceable and concise introduction to Fry's formalism in the context of late nineteenth and early twentieth century art criticism in England is also to be found in Jacqueline V. Falkenheim, *Roger Fry and the Beginnings of Formalist Art Criticism*, Ann Arbor 1980.

24. Reed, p. 7.

25. See Caroline Elam's essay below, pp. 89–92.

26. For Berenson's relationship with Fry and his activities as wheeler and dealer in the art trade, see Ernest Samuels, *Bernard Berenson. The Making of a Connoisseur*, Cambridge MA and London 1979; M. Secrest, *Being Bernard Berenson*, New York 1979.

27. Both Berenson and Fry began as out-and-out Morellians in their connoisseurship. In Fry's case this is already clear in the notes he took during his first visit to Italy in 1891 (Fry Papers). He made a point of meeting Morelli's editor Frizzoni when he visited Bologna in 1894, and wrote to his mother, "I think he was delighted that I had studied Morelli so carefully" (Letter to Lady Fry, Bologna, November 1894, in *Letters*, I, p. 159). See also Caroline Elam's essay below, p. 88.

with a Modernist inflection in 1908–09, there were many contexts within which Fry's rationalism developed its application to art, some of which are explored in other essays in this book – notably the Arts and Crafts movement, the New English Art Club in the 1890s and 1900s, and the 'new art criticism' (the latter two separately considered here by Anna Gruetzner Robins and Elizabeth Prettejohn).[23] On the level of theory, however, there was a context that was of particular importance, connoisseurship. It, too, is explored elsewhere in this book, by Caroline Elam and Flaminia Gennari Santori, but its formative importance for Fry's theory and criticism is such that I need to look at it here as well, especially since even Christopher Reed sidelines Fry's connoisseurship as merely conventional and therefore insignificant.[24]

The connoisseur context for Fry's developing criticism was not exclusively English. It was European and transatlantic, too, though once again a small, select group was involved. The key relationship in Fry's case was with the Florence-based Bernard Berenson, who was only a couple of years his senior but who considered him his pupil during the half decade when they were close. They had met by 1898, and fell out after a characteristic display of Berensonian paranoia late in 1903, though they would keep respectful contact for years afterwards.[25] By that date Fry had established himself as a leading light in an international community of connoisseurs centred, in England, on *The Burlington Magazine*, which had been launched in 1901 as a monthly "for connoisseurs". Berenson more than anyone commercialized the relationships within this community (something that would be increasingly at odds with Fry's rejection of capitalist values), but it included scholar-curators from the major museums as well as agents and traders: Wilhelm von Bode in Berlin and Saloman Reinach at the Louvre, for instance.[26]

What Berensonian connoisseurship gave Fry the critic and theorist was a way of applying his empirical scientific bent and his belief in rational analysis without compromising the primacy of his emotional engagement in works of art: Berenson showed him how to go beyond the unrelenting empiricism of Giovanni Morelli to a practice that was responsive and critical as well as quasi-scientific.[27] What he brought to it, as Caroline Elam shows, was an extraordinarily knowledgeable and sensitive awareness of technique – a painter's understanding – which made him much more than a conventional acolyte. That the lessons of connoisseurship were not forgotten is demonstrated by the way his *Burlington* articles on the remarkable exhibition of Italian art at Burlington House in 1930 were still given their impetus by the cool yet intense excitement of the chase for attributions.[28] Even in December 1910, as the fury of reaction to the first Post-Impressionist exhibition gathered force, Fry took space in *The Burlington* to suggest Lorenzo Lotto as the author of a portrait attributed to Raphael.[29]

Fry's priorities as a connoisseur are summed up in the concluding paragraph of the series of Cambridge Extension lectures, 'Florentines II', which he wrote in 1900–01. He thanks his audience for their "patience", confessing

28. Roger Fry, 'Notes on the Italian Exhibition at Burlington House–I', *The Burlington Magazine*, LVI, February 1930, pp. 72–89.

29. Roger Fry, 'A Portrait attributed to Raphael', *The Burlington Magazine*, XVIII, December 1910, pp. 137–38.

30. Roger Fry, 'Florentines II. V. Piero della Francesca. Alesso Baldovinetti', unpublished Cambridge Extension lecture, written 1900–01, Fry Papers, 1/65.

31. Bernhard (*sic*) Berenson, *The Study and Criticism of Italian Art*, London 1901, pp. vii–viii.

32. For Berenson's and Pater's stance in this respect, see Bernard Berenson, *Sketch for a Self-Portrait*, London 1949, p. 124, and Walter Pater, *Marius the Epicurean*, 1885, and *Plato and Platonism*, London and New York 1893, especially pp. 162–63.

33. Fry argued for an Epicurean position based on Pater in a paper written for the Apostles, 'Do We Exist?' (Fry Papers, 1/10), but had moved away from it by the date of his first Cambridge Extension lectures (1894), by which time he was a fully fledged Morellian (see note 27, above).

34. The fullest account is in Frances Spalding, *Roger Fry: Art and Life*, London, Toronto, Sydney and New York 1980, pp. 116f. The Cézannes were shown at the International Society Exhibition in London, which Fry reviewed; see *The Athenaeum*, 13 January 1906, pp. 56–57.

that the lectures "must sometimes have seemed coldly analytical and far removed from those glowing and enthusiastic emotions and that fervent partisanship which more eloquent exponents of Art can arouse". "My ambition", he tells them, "has been to examine pictures purely with a view to extracting the utmost aesthetic pleasure from them and to arrive at the most intimate perception of the peculiar and unique qualities of each artist in turn." His ultimate focus is on the individuality of the artist, but only as revealed by the analysis of the most "apparently trivial" features of pictures. For him, "the imaginative atmosphere of the artist" is in "these minute characteristics".[30] Connoisseurship identified feeling in art with the individuality of the artist, what Berenson called "artistic personality". Responding to a picture placed the viewer in a personal relationship with the artist. This far Berenson and Fry followed Walter Pater: the artist was only to be found *in* the work of art, emotionally engaged spectatorship came first. But their writing set aside Pater's evocative use of language to re-create aesthetic experiences in prose, and replaced it with spare verbal austerity geared to the most exacting rational analysis. As Berenson put it in 1901, "The world's art can be studied ... as is the world's fauna or the world's flora ..." to arrive, "if qualitative analysis also be applied", at "the perfect determination of purely artistic personalities".[31]

In line with the art trade's consuming interest in attribution, connoisseurship rarely went beyond the characterization of individual "artistic personalities". Berenson was a professed Epicurean, intent on training himself to extract the "utmost enjoyment" from paintings. Pater also had concentrated on the intensity of individual experiences; he was not interested in "universal" principles.[32] Fry the Cambridge Apostle, though he, too, wanted "the utmost aesthetic pleasure" from paintings, could not have been content with this.[33] Like McTaggart and Dickinson, his ultimate interest was in the formulation of general principles. He needed to move beyond practical criticism to aesthetic theory in a way that no other connoisseur did. Connoisseurship had no general theory to offer, but it did a great deal to reinforce Fry's conviction that general principles had to be based on an empirical study of works of art as phenomena, phenomena that aroused feeling.

Emotional response certainly came first when Fry finally made his move towards the formulation of a formalist theory that could apply both to the art of "the great European traditions" and to recent avantgarde art. It is highly significant that he, and all who have written about his theory since, fix its origin at the moment he saw and responded to a landscape and a still life by Cézanne at a London exhibition in January 1906.[34] True to the passionate rationalism fundamental to the mentality he shared with McTaggart and Dickinson, the starting-point which might lead through logical analysis to new general principles had to be in the intensity of what we have seen him elsewhere call a "unity-emotion".

In his 1920 *Vision and Design* essay, 'Retrospect', Fry makes a story of the way his epiphany in front of Cézanne's paintings pushed him progressively

35. His 'Essay on Aesthetics' first appeared in *New Quarterly*, II, April 1909, pp. 171–90. It was reprinted in *Vision and Design*. Reed has published a lecture by Fry, written in 1908, which, he points out, is the first statement of the argument that is refined in the 1909 article; see Reed 1966, pp. 61ff.

36. Roger Fry, 'Retrospect', 1920; in *Vision and Design* [1920], Harmondsworth (Penguin) 1961, pp. 222ff. Here Fry does not specify the exhibition at which he saw the two Cézannes or which paintings they were, but he confirms the revelatory role of his belated discovery of the painter (p. 226).

37. Roger Fry, 'The French Post-Impressionists – Preface to the Catalogue of the 2nd Post-Impressionist Exhibition, Grafton Galleries, 1912', in *Vision and Design*, p. 188.

38. See Elizabeth Prettejohn's essay, pp. 34f.

39. Desmond McCarthy, 'Kant and Post Impressionism', *The Eye-Witness*, 10 October 1912, pp. 533–34. McCarthy was the exhibition secretary in 1910 and had written the preface to that catalogue, using Fry's notes.

40. Roger Fry, 'Mr. Westcott or Mr. Whistler?', unpublished paper delivered to the Society of Apostles, undated (probably between 1887 and 1889), Fry Papers, 1/10.

41. Roger Fry, 'Giotto. The Church of S. Francesco at Assisi', in *Vision and Design*, p. 109. The essay is adapted with some revisions from 'Giotto: I. The Church of S. Francesco at Assisi', *Monthly Review*, I, December 1900 and 'Giotto: II', *Monthly Review*, II, February 1901.

towards the elucidation of his theory in its extreme form in 1912. He identifies as his first step the 1909 'Essay on Aesthetics', where he distinguished clearly between emotions conveyed by art and emotions conveyed by life, but still linked the two, suggesting that the former were rooted in the latter.[35] His final step was the *complete* separation of aesthetic emotions from emotions felt in life. It was made possible, he claims, by seeing the work, as he puts it, "of some artists peculiarly sensitive to the formal relations of art", by which he means, of course, his new young intimates Vanessa Bell and Duncan Grant.[36] Once again, responses to works of art are represented as the springboard for a crucial development in his theory. That development was complete by the time he wrote the preface for the French section of the Second Post-Impressionist exhibition in 1912, where, tellingly, he marks it by writing about what the artists *do* before writing about what their work is supposed (by the theory) to do *to* the viewer. "They do not seek to imitate form, but to create form; not to imitate life, but to find an equivalent for life. By that I mean that they wish to make images which by the clearness of their logical structure, and by the close-knit unity of texture, shall appeal to our disinterested and contemplative imagination with something of the same vividness as the things of actual life appeal to our practical sensibilities."[37] Logic and unity are, of course, key features of the appeal offered to our "contemplative imagination".

As Elizabeth Prettejohn shows in her essay, Fry's critical writing before 1906 already made the distinction between formal relationships and "associated ideas", as indeed had Sidney Colvin years before, in the 1860s and 1870s.[38] Responding to both Fry's and Clive Bell's prefaces in the catalogue of the Second Post-Impressionist exhibition, Desmond MacCarthy pointed out that it was a distinction that went back to Kant's late eighteenth-century theory of beauty.[39] Indeed, Fry had made the distinction even as an undergraduate, in one of his papers for the Apostles, where he asserts that "there are two kinds of art", which he calls "pure and suggestive", the "pure" being the substance of art, the "suggestive" being added like "jam ... to make the powder go down".[40] He had not before, however, indicated that the two were so distinct that they could not mix: that to consume the powder and the jam together, without separating them out, was to rob the powder of all its goodness. By 1912 his theory said as much even for art which had both "pure" and "suggestive" qualities. The point is made most plainly of all in the famous footnote he wrote to mark out the distance between his aesthetic ideas in 1901 and in 1920, when he re-published his two-part essay of 1900–01 on Giotto in *Vision and Design*. In the work of Giotto, who he would always believe a great pictorial dramatist, he can no longer accept that "the value of the form for us is bound up with recognition of the dramatic idea". His conviction now is that "our reaction to pure form" can and must be disentangled from "our reaction to ... associated ideas" in all works of art.[41]

So complete a separation of "pure form" from "associated ideas" had many logical consequences, which Fry's writing drew out with ruthless rigour.

Looking at art was removed into a quasi-sacred region of contemplation, separated from "practical life". It required complete detachment from the arena of life emotions – horror, pity. It required what Fry called a "disinterested", even "inhuman", state of mind.[42] Further, the distinction implied the possibility of an art of nothing but "pure form", a "visual music", as he put it in 1912.[43] It demanded a clear separation of the history of art from political and social histories, even though art was patently produced in and for societies (the most notorious consequence of the theory). Because of the claim made for the universality of the unity-emotion and the contingent character of "associated ideas", it elevated the first in relation to the second as the only basis for a general theory of art. Because most people demanded "associated ideas" in art, it erected a social and cultural hierarchy, with those responsive to form at the top; a hierarchy, though, which countered the class hierarchy of capitalist society, since the dominant class in the formation of modern culture was, Fry constantly repeated, the well-off middle class. Cultural snobbery, for Fry, went inevitably with the demand for associated ideas in art, and above all with the associated idea of cultural status imposed upon art by most who bought it.[44]

There is one logical consequence in particular of the distinction between "pure form" and "associated ideas" that I want briefly to dwell on here. It is Fry's response to the fact that he could actually experience the pleasures of "pure form" in works of art which were produced solely to convey, by subject-matter or symbol, associated ideas. It brings out especially well the relationship of his formalist theory to Berensonian connoisseurship, and the wider significance of both.

Fry's study of individual artists convinced him that often there was a disjunction between their known intentions and what he found in their work to admire. This applied paradigmatically to Uccello, about whom he published in 1914: an artist obviously driven by a quasi-scientific obsession with exactness of representation, but led by the abstractions and simplifications that his pictorial 'science' of perspective required to produce, Fry asserted, patently inexact representations which ultimately invited the purest of aesthetic responses.[45] History and the present day were, for Fry, packed with such inadvertent artists: figures who produced works to be valued for their formal qualities apparently with no such intention, figures as different as Claude Lorrain, the Douanier Rousseau and even Walter Sickert.

Fry's constant recourse to the inadvertency manoeuvre was certainly a logical consequence of his complete separation of "pure form" from "associated ideas", but it clearly followed, too, from the priorities of Berensonian connoisseurship. Berenson, as we have seen, placed all the emphasis on the act of viewing by which the spectator's relationship with "artistic personalities" was to be developed, making the intention of the artist increasingly irrelevant. It was not the artist as a conscious individual with intentions that mattered; it was the "artistic personality" discovered by the

42. Fry's paradigms here were Seurat and Piero della Francesca. Much later, in 1930, he brought the two together when analysing Piero's *Flagellation* (Galleria Nazionale delle Marche, Urbino), writing with admiration that Piero "seems to be one of the most detached spirits that ever managed to communicate with his kind through the medium of art"; Roger Fry, 'The Italian Exhibition – III', *The Nation and Athenaeum*, 18 January 1930, pp. 539–40. See also 'Seurat (Georges)', p. 208, below.

43. That possibility is acknowledged in Fry's preface for the French section of the Second Post Impressionist exhibition, with special reference to Picasso's latest Cubist work; see *Vision and Design*, p. 190.

44. For an especially sharp statement of this argument, see Roger Fry, 'The Religion of Culture', *The Nation and Athenaeum*, 6 June 1925, pp. 293–95; reprinted as 'Culture and Snobbism' in *Transformations*, pp. 56–66.

45. For the Uccello analysis, see Roger Fry, 'Three Pictures in the Jacquemart-André Collection', *The Burlington Magazine*, xxv, May 1914, pp. 79–85; in *Vision and Design*, pp. 151–54.

spectator *in* the work. A painter's "artistic personality" could, indeed, be something quite distinct from the personality described by his or her biographer. When Fry reviewed Ambroise Vollard's biography of Cézanne in 1917, he welcomed it as a biography, but distinguished it absolutely from the "complete study of Cézanne's work" which still, he said, had to be written.[46] And when he himself attempted a sketch for such a study ten years later, he accepted the picture of Cézanne as a "grumbling misanthrope" in his life, to dramatize the "hero" he found in the paintings.[47] Even living people were not to be confused with their own "artistic personalities", hence the existence of individuals out of touch with the art in their own painting – inadvertent artists. Fry's theory continued a process begun in the nineteenth century: the gradual shift from a focus on the relationship between the artist and the work to one on the relationship between the work and the spectator, a shift that has culminated at the end of the twentieth century with the artist becoming in critical theory merely one of many signifieds *in* the work. This shift towards spectatorship was a major thrust within modernism altogether, whether or not an interactive relationship between art and society was promoted. There are those who identify it as a defining feature of postmodernism. Berenson's notion of "artistic personality" and Fry's inadvertency manoeuvre bring out, however, the degree to which it was essential to early twentieth-century formalism, too.

The overall shape of Fry's theory, as it was established between 1908 and 1912, did not change: the fundamental distinction between responses to "pure form" and to "associated ideas" gave him the ammunition for his attack on psychoanalysis in 1924 and on Herbert Read in 1933, just as it had for his defence of Post-Impressionism.[48] To this extent Fry was indeed a rigid formalist. But at the heart of his theoretical and critical practice was an acceptance of the provisional status of his conclusions which ensured a kind of openness not found in his major formalist contemporaries (for instance Pierre Reverdy and Maurice Raynal in France), which can seem to strike a postmodern chord. Where McTaggart's metaphysics aimed at absolute conclusions based on abstract *a priori* concepts, Fry's empiricism from the beginning, before he left Cambridge, aimed only at the provisional on the basis of concrete *a posteriori* observations. The places where he saw art became his laboratories, his responses supplying what could never be definitive experimental results for analysis. He set himself the impossible task of observing objectively his own subjective experiences. Both his major anthologies, *Vision and Design* and *Transformations*, give prominence to this methodology of doubt (to recall Christopher Reed's phrase). In *Vision and Design*, he opens the 'Retrospect' essay by explicitly setting aside the possibility of a "complete [aesthetic] system such as the metaphysicians deduce from *a priori* principles", and asserts that his theory is "held merely until such time as fresh experiences might confirm or modify it".[49]

The most categorical statement of a formalist theory in England between

46. Roger Fry, '*Paul Cézanne* by Ambroise Vollard', *The Burlington Magazine*, XXXI, August 1917, pp. 52–61.

47. Roger Fry, *Cézanne: A Study of his Development*, London 1927.

48. Roger Fry, *The Artist and Psychoanalysis*, London 1924; see also note 8, above.

49. *Vision and Design*, p. 223.

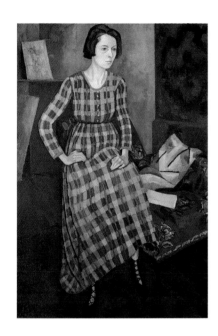

Fig. 10 (Cat. 80) Roger Fry, *Portrait of Nina Hamnett*, 1917. Oil on canvas, 137.2 x 91.4 cm. The University of Leeds Art Collection.

50. See Bell 1914.

51. Roger Fry, 'A New Theory of Art', *Nation*, 7 March 1914, pp. 937–39.

52. A.C.-B., 'Mr. Roger Fry', *The Athenaeum*, 18 June 1920, p. 805. The writer is almost certainly Arthur Clutton-Brock, who had known Fry as director of Omega well. Clutton-Brock's *Simpson's Choice* was published by Omega with illustrations by Roald Kristian (Nina Hamnett's husband, Edgar de Bergen).

1910 and 1914 was, of course, Clive Bell's book-length polemic *Art*, with its imperious claims for the hegemony of "significant form".[50] Fry's reaction to it in print gives the strongest possible indication of where his own theory would prove unstable. Bell's contention that formal relations provoked emotions of a special kind, "aesthetic emotions", was one that Fry accepted gratefully, but Bell's determination to keep "significant form" away from *all* contact with life aroused his scepticism for two key reasons. In the first place, he holds out the possibility that not merely forms but also "images" might be so put together in literature and in painting as to "arouse aesthetic emotions", just as forms do. There may be, he therefore suggests, "a true art of illustration", also based on relationships. In the second place, he is not convinced that significant form is self-sufficient, and suggests that its significance actually derives from some extra ingredient related to lived experience. "Why", he asks, "must the painter begin by abandoning himself to the love of God or man or Nature unless it is that in all art there is a fusion of something in order that form may become significant?"[51] He puts his finger on the two areas of instability that would preoccupy him until, inevitably, he left the problems unresolved at his death in 1934: the relationship in visual art between illustration and formal design, and between significant form and things seen.

I shall take the problem of the relationship between significant form and things seen first. The moment of greatest purity in Fry's own trajectory as a writer of theory came, as Reed argues, with the publication of *Vision and Design* in 1920. That year Fry showed his recent paintings at the Independent gallery, among them the Leeds *Portrait of Nina Hamnett* (fig. 10) and landscapes that included Provençal work comparable with *Provençal Landscape* (fig. 11). *The Athenaeum* commented: "In theory, the visible world is to him a Circe which, if he yielded to it, would make him a bad artist; but, in practice, he is a good one when he yields to it." "Significant form" is found to make "its last stand" in the cushion in the Nina Hamnett portrait, the picture's one trace of the abstract Post-Impressionist designing made notorious by Fry's decorative arts company, Omega.[52] As *Vision and Design* appeared, with its uncompromising formalist footnote on Giotto, Fry the artist confirmed a growing inclination openly to ground his painting in the direct experience of nature. It went with the end of his attempt to make a public art of Post-Impressionism (Omega was finally wound up in 1919), and with the realisation that easel painting was all that was left to him: it went with what he perceived, as I noted at the beginning of this essay, to be the failure of the experimental avantgarde in England. But already in 1919 he was fully aware of the challenge mounted against the purity of his and his friends' understanding of significant form by his new engagement with the things he painted. That autumn he wrote to Vanessa Bell from Aix-en-Provence (where he had gone to paint Cézanne's landscape): "I know you think it don't matter much where one is, and theoretically you're right, but I think the excitement of seeing Nature which isn't refractory, which seems to invite one and accept one's

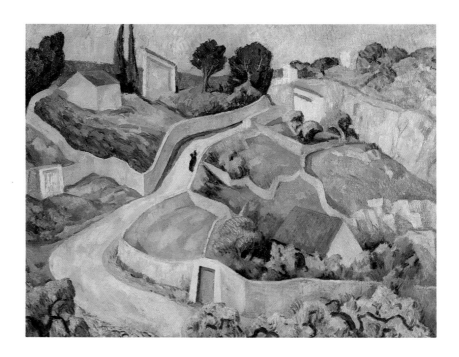

Fig. 11 (Cat. 82) Roger Fry, *Provençal Landscape*, 1919. Oil on canvas, 91 x 117 cm. Private collection.

prejudices about shapes and colours, is stimulating." And he added, "I think more and more that Cézanne was a pure naturalist or almost; as far as his conscious and deliberate self went though, of course, he had a terrific inner bias towards certain associations of form".[53]

The case of Cézanne the "naturalist" would be one that consistently supported his growing conviction through the 1920s that form often became most significant in art as a result of the most intense encounters with things seen. Another such case that he found especially telling was Matisse, Matisse placed in contradistinction to the Cubist Picasso. The essentials of the Matisse/Picasso opposition he developed through the 1920s were established as early as 1912, when he made them the crux of his 'Apologia' for the Second Post-Impressionist exhibition in *The Nation*. Already there Picasso is represented as an impulsive painter whose latest work has to a high degree abandoned "direct reference to natural appearance" and so attains an "abstract and musical quality" (fig. 12). Matisse is represented as an intellectual painter whose "design almost always comes out of some definite thing seen".[54] But while Fry was willing at this point to find "the beauty of intensely organised wholes" in Picasso's Cubism, by 1921, writing about it in *The New Statesman*, he stresses instead the feebleness of "the effect on the mind of flat forms ... in comparison with the effect of forms that either present or represent relief in three dimensions", and deplores the way "the circumambience of space seems to be almost cut off ...".[55] By contrast, during the 1920s Matisse became for Fry *the* modern exponent not only of a new naturalism, but of what he called, in the little monograph on him that he published in 1930, the "dual nature of painting". He explained it thus in the

53. Letter to Vanessa Bell, Aix-en-Provence, 19 November 1919, *Letters*, II, p. 471. The actual significance of place in Fry's painting is brought out in Richard Morphet, 'Roger Fry: the Nature of his Painting', *The Burlington Magazine*, CXII, July 1980, pp. 478–88.

54. Roger Fry, 'The Grafton Galleries: an Apologia', *The Nation*, 9 November 1912, pp. 249–51.

55. Roger Fry, 'Picasso', *The New Statesman*, 29 January 1921, pp. 503–04.

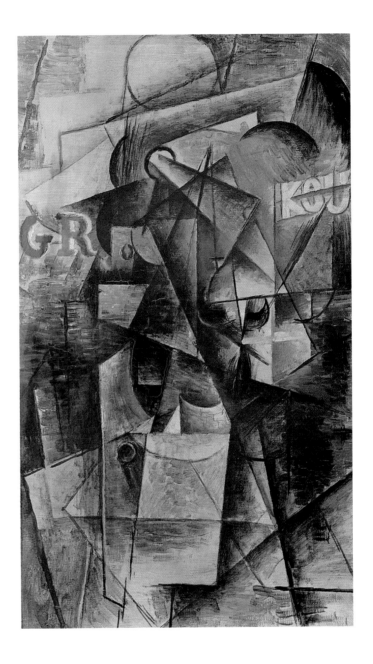

Fig. 12 (Cat. 59) Pablo Picasso, *Head of a Man with a Moustache*, Spring 1912. Oil on canvas, 61 x 38 cm. Musée d'art moderne de la Ville de Paris (Dr Girardin bequest). © Photothèque des Musées de la Ville de Paris.

fifth and last of his series of lectures on 'The Principles of Design' written for the Slade in the early 1920s: "Matisse has the secret of handling flat positive chunks of colour so that in spite of their apparent flatness & their violent assertion of the picture surface they yet suggest to the mind the exact degree of recession required – *they remain in their plane in the ideated picture space*".[56] As he put it in 1930: from Matisse's "systematic understanding of plastic form, as ascertained by unaided vision in nature", came a special capacity to suggest both mass and space on flat surfaces which are not "utterly violated".[57]

This juxtaposition of the "flat" Cubist Picasso and the "plastic" naturalist Matisse, skewed so strongly in favour of Matisse, brings out a feature of Fry's formalism that clearly distances him from Clement Greenberg: his conviction, especially after 1918, that form at its most significant is "plastic", by which he means directly evocative of mass and space in three dimensions. Flatness alone, for Fry, could only be insignificant: it could not be his key to modernist painting as it would be for Greenberg.[58] Once again in this he looks back to the connoisseurship of Berenson, whose writing is unmistakably invoked by that phrase "ideated picture space" and whose "tactile values" were never far away. For Berenson, aesthetic experience was an intensification, a heightening of sensual experience, bringing sensibility and reason together.[59] This was increasingly so of Fry, too, especially after 1919.

Fry's growing conviction that form's significance, however "pure", was rooted in the experience of things seen did not lead him to question the fundamentals of his theory. He was still able to separate aesthetic emotions absolutely from life emotions without any qualms, by making it clear that, when artists went to nature, they had to see aesthetically if they were to produce significant form (even if this might be inadvertent). The fundamentals of the theory were put at risk, however, by Fry's commitment, between the early 1920s and his death, to the idea that story-telling – "illustration" – was an art that could and sometimes did combine with the art of pure form – "design". For it clearly followed from this possibility that responses to form and associated ideas might fuse after all.

Such a conclusion was first explored in print in the essay that introduced his 1926 anthology, *Transformations*, where the test cases chosen for experimental viewing included Rembrandt's *Ecce Homo* in the National Gallery, London (fig. 133). Fry's analysis of the picture brings out its success both as pictorial "design" and as pictorial drama (illustration). There is no question in his mind that here is an instance of the art of illustration: a story of passions which in the telling can itself provoke a strong "unity-emotion". In considering this, he takes up a new formulation applied to literature by a new French friend, Charles Mauron, which introduces the idea of "psychological volumes" which in combination can be apprehended on the level of "pure form".[60] Still, however, he maintains the fundamental separation of design and illustration, insisting that he cannot respond to both "plastic forms" and "psychological volumes" simultaneously, that there is no fusion.[61] The problems become more troubling in two lectures, one of which was cannibalized in the writing of the other, 'Representation in Art', delivered in 1929, and 'The Literary Element in Painting', delivered in 1931.[62]

In both lectures he opens, as he had in the *Transformations* essay, by stating that for any aesthetic theory to be valid it has to apply not only to visual art but to all the arts, including literature; the scale of his theoretical ambition had increased since 1912. In the 1929 lecture, he claims that his modernist theory – which he calls the "architectural theory" – has only recently emerged

56. Roger Fry, 'Some Principles of Design, V', early 1920s, Fry Papers, 1/90.

57. Roger Fry, *Henri Matisse*, London 1930, pp. 14–15.

58. Reed discusses Fry's notion of "the plastic" at length, and himself makes the contrast with Greenberg; see Reed 1996, pp. 121–23.

59. For a discussion of this in relation to Berenson's reading of William James (who was also read by Fry), see Sylvia Sprigge, *Berenson: A Biography*, London 1960, pp. 140–41.

60. Charles Mauron, *The Nature and Beauty of Art and Literature*, London 1926.

61. Roger Fry, 'Some Questions of Aesthetics', in *Transformations*, pp. 1–41.

62. Roger Fry, 'Representation in Art', unpublished lecture delivered to an unidentified "society of philosophers" at Oxford, January or February 1929, Fry Papers, 1/126. Roger Fry, 'The Literary Element in Painting', delivered as the Henry Sidgwick Memorial Lecture at Newnham College, Cambridge, 21 November 1931, Fry Papers, 1/158.

to oppose the previously dominant "literary theory" of art, of which the focus remains associated ideas. He refers to Maurice Denis's 1907 article on Cézanne, which he had published in English in 1910, as an early exposition of the "architectural theory", acknowedges both his debt to it and his own role in developing the theory, and stresses the theory's "insistence on ... [painting's] *unlikeness* to literature". But now, he says, he has begun "tampering" with the architectural theory. "I regret it extremely", he goes on. "It will make it less tidy and neat, less satisfactory to our drive for simple unity." He has realised, he says, that not only are there works in which "both architectural and literary elements occur", but in which there is actual "co-operation of [these] two distinct arts", and he suggests that this is possible because "the same tools and materials" are being used in "both arts". He calls such works "operatic pictures", and in both lectures once again his key case is Rembrandt, for him the "operatic" painter *par excellence*. This is not, he insists, a matter of "form" and "content" fusing, but of form operating in two distinct ways in combination. "In such pictures", he sums up, "there is the pattern of space-volume arrangement akin to architecture and the pattern of the psychological moments, akin to literature." Genuine operatic painters, capable of real combinations, he thinks very rare, and he sets them against painters who find the "architectural" not in psychological drama but in their intense experience of nature. These latter he calls "symphonic", and Cézanne is singled out as the model. As ever he claims only provisional status for his conclusions, and makes the point that his method is experimental in such a way as to bring his audiences in. Before he turns to his test cases, he tells them, "We will look together at a number of pictures. I will explain my own reactions to each as clearly as I can and will ask you to watch how far they correspond with your own." [63] It would be the problem of how the "architectural" and the "psychological" combined in the "operatic pictures" of Rembrandt that he left open in his last published essay of September 1934, as we saw.[64] In 1912, he could neither have countenanced the notion of the "operatic" in visual art nor posed the problem.

In the early 1920s, Fry showed in Paris, and throughout the decade he published in France. His formalism relates very much to a French as well as an English modernist context, though he thought of himself as an outsider in France however much he felt at home there.[65] As such the particular combination in his formalism of aesthetic extremism and naturalist compromise gives it a very distinct identity. To find the essential significance of art in formal relations alone was to approach the idealism of Cubism's most uncompromising supporters, Reverdy and Raynal, and even the extreme represented by Mondrian's Neo-Plasticism and Van Doesburg's Elementarism. But Fry's refusal of metaphysics kept him well away from the latter (both committed Hegelians like McTaggart), and his acceptance of nature as a primary stimulus for art kept him away from the former. He managed to bridge the binary opposition between "idealist" and "realist" categories into

63. All quotations here are from 'Representation in Art'.

64. Roger Fry, '*The Toilet*, by Rembrandt', *The Listener*, 19 September 1934.

65. He calls himself "*un admirateur étranger*" in a lecture given to a French audience in 1931; see 'Quelques réflexions sus [*sic*] l'art français', Fry Papers, 1/97.

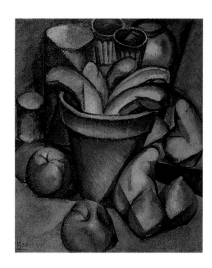

Fig. 13 (Cat. 181) Jean Marchand, *Still Life with Bananas*, 1912. Oil on canvas, 59.2 x 51 cm. The Charleston Trust.

66. For this distinction between the "idealist" and "realist" categories, see Maurice Raynal, *Anthologie de la peinture en France de 1906 à nos jours*, Paris 1927.

67. Fry makes the "pure science" comparison in Fry 1924. Raynal makes the comparison between Cubism and pure mathematics in Maurice Raynal, *Quelques intentions du cubisme*, Paris 1919. For Fry's view of Marchand, see 'Marchand (Jean)', p. 188, below. I have discussed Vauxcelles's and Lhote's stances as critics in Christopher Green, *Cubism and its Enemies. Modern Movements and Reaction in French Art, 1916–1928*, New Haven and London 1987, chapter 11.

68. Fry 1924; in Reed 1996 p. 365; and in 'The Literary Element in Painting', 21 November 1931, p. 51, Fry Papers, 1/158.

69. Roger Fry, 'Representation in Art', January or February 1929, p. 2, Fry Papers, 1/126.

which Raynal divided French art in the mid-1920s.[66] Just as Raynal compared Cubist art to pure mathematics, Fry compared "pure art" to "pure science", thereby justifying its uselessness and its minority appeal; yet, by encouraging artists to return to representation, Fry also took a position close to that of the critics who attacked "pure Cubism" in France, notably Louis Vauxcelles and André Lhote. His strong support of Jean Marchand in 1919 for throwing away "the scaffolding of cubism" (fig. 13) aligned him unequivocally with the campaign Vauxcelles had mounted in summer 1918 to pronounce Cubism finally dead. [67]

The notion of "psychological volumes", borrowed from Mauron, perhaps for us now the strangest by-product of his formalism, functioned of course to aestheticize even literature and so to preserve it, as well as the visual arts, from the disruptive incursions of psychoanalysis and Surrealism. The furthest he was able to go towards psychoanalysis in his theory was to suggest in his 1924 pamphlet, 'The Artist and Psycho-analysis', that deep irrational feelings were there beneath aesthetic emotion; that, as he put it in his 'Literary Element' lecture, aesthetic emotion might ultimately itself emerge from "the unplumbed depths of our sub-conscious nature".[68] In fact, however open and empirical Fry's thinking, its shaping framework remained still the late 1880s Apostles mentality which could do no other than place the order of reason above the anarchy of the Unconscious. It was simply beyond him to imagine the possibility of opposition when he said to the audience at his 1929 lecture on 'Representation in Art': "Unity in some sense or other is perhaps the one and only quality which everyone agrees to [be the] predicate of a work of art".[69]

In the end, Fry's openness as a writer on art is there most compellingly not in his theory but in his critical practice. Fry operated as an art critic in three major phases: the first between 1900 and 1906, the pre-modernist phase, which is examined by Elizabeth Prettejohn in this book, the second most importantly between 1910 and 1914, the experimental phase focused on here by Richard Cork, and the third the period after 1919, a phase characterized both by expansion and by consolidation. The 1910–14 phase was so dominated by controversy that practical criticism as such almost vanished: Fry's critical writings were predominantly polemics aimed at defending his new theoretical position and his new artistic heroes. It was after 1919 that he wrote his most striking practical criticism in a modernist vein. It is found in regular articles for the art press (some of which I have already cited) on such figures as Picasso and Seurat, or, much closer to him, Grant, Bell and Jean Marchand. But its high points are two monographs, one his short but intensely wrought monograph on Cézanne, published in 1927, the other his even shorter 1930 monograph on Matisse.

The spirit of Fry's post-1919 practical criticism is summed up by his invitation to his lecture audience in 1929 to look for themselves, to test their own responses against his account of his responses. It is a kind of writing

aimed at inviting an active engagement in the experience of looking, and its openness follows directly from that aim. We return once again to that shift towards an emphasis on spectatorship led by Pater and by Berensonian connoisseurship, but, as before, I emphasize the fact that in Fry's critical writing there is not the least echo of Pater's emotive prose. Distinguishing him from John Addington Symonds as well as Pater, Virginia Woolf put it thus: "He was not led away to write prose poems He wrote of pictures as if they were pictures, and nothing else."[70] She saw this as the result of a natural inadequacy as a writer which led him to develop virtues as inadvertent as those of Uccello and Rousseau in painting; in fact, it was firmly grounded, as we have seen, in his commitment to rational exposition, however much feelings were at issue. Fry's tone is always measured and sweetly reasonable. And yet, despite the forensic precision of his writing, there is a strong note of exhortation: the reader is repeatedly invited to look for her or himself. When Fry writes on his experience of, say, Cézanne's *Houses in Provence* (fig. 88), or Matisse's *Decorative figure on an ornamental background* (Centre Georges Pompidou, Paris) he repeatedly uses the complicit "we" to involve the reader with him, less often the distancing passive tense.[71] Fry writes for a reader who is constructed as the kind of sensitive yet rational, inquiring yet reflective individual he finds in the "artistic personalities" most admires – Cézanne above all – an individual capable of becoming a participant spectator, and so of testing his or her own responses against Fry's. He writes to fill the world with participant spectators as committed to passionate rationalism in their relationship with art as he had been since his earliest papers delivered to the Society of Apostles.

In Fry's writing, theory was in fact never far away from practical criticism, since every encounter with a work was another test case. In 1929 he broadcast a series of talks on 'The Meaning of Pictures'. Each one involved the intensive viewing of two pictures, which were illustrated in *The Listener* immediately beforehand. His agenda as a practical critic using theory is summed up at the end of the final broadcast: "Whatever value such principles or theories as I have suggested may have, lies not so much in their truth, for we are still at the beginning of aesthetics, as in their power to stimulate latent sensibilities, in the assistance they may be to you in the art of being a spectator; for in that transmission from one spirit to another, which is the essence of art, the spectator is as essential as the artist."[72]

The fundamentally empirical character of Fry's critical writing, the phenomenological starting-point it always has in his own experience, its orientation outwards towards a possible participant spectator, coupled with the plainsong simplicity of its prose, all connect it more with English art writing in the later twentieth century than with the American formalism of Greenberg or the post-structuralism of Greenberg's heirs publishing in *October*. The line of Fry's writing has been continued in the mid and later twentieth century by, for instance, David Sylvester and John Golding, in Sylvester's case

70. Virginia Woolf, *Roger Fry. A Biography* [1940], ed. Diane F. Gillespie, Oxford 1995, p. 106.

71. These instances are given special prominence as test cases; see Roger Fry 1927 and 1930.

72. Roger Fry, 'The Meaning of Pictures, VI: Truth and Nature in Art', *The Listener*, II, no. 43, 6 November 1929, pp. 618.

its phenomenological underpinning strengthened by Merleau-Ponty (another to have taken Cézanne as a starting-point). Prose honed to re-create the experience of close looking yet devoid of the emotive is its mark; and an avoidance of the professionals' keep-out sign of jargon.

Yet, the passionate rationalism – the late 1880s Apostles mentality – that drives Fry's writing in the end separates it at a deep structural level from most later formalist writing. In the first place, the pursuit of general principles applicable to 'art' as a transcendent category is profoundly alien. Greenberg's formalism was explicitly contemporary and materialist. It set aside altogether such pan-cultural, 'universal' notions as 'unity' and 'continuity', and applied itself entirely to the condition of art after Manet as the product of a materialist society. Thus, when in 1946 he enunciated what was for him the fundamental "principle" of modern art – "the superiority of the medium over whatever it figures" – he added, "this expresses our society's growing impotence to organize experience in any other terms than those of the concrete sensation, immediate return, tangible datum".[73] Second, Roger Fry's profound hostility to the heterogeneous and the irrational is not to be found in a Sylvester or a Golding, both of whom have been powerfully drawn to Surrealist and post-Surrealist artists, let alone Greenberg. It is an aspect of the progressive idealism that produced the League of Nations as well as modernism in its more rationalist early twentieth-century forms.[74]

Yet the very distance away from us of Fry's formalism can make it an 'other' against which we can see our own ways of thinking about and responding to visual culture. The homogenizing thrust of Fry's thinking, its humanism, allowed him to blur boundaries: between the fine and decorative arts, between high and low, between the European and the non-European, as well as between literature and visual art – and so, paradoxically, can connect with the heterogenizing thrust of the postmodern at the turn of the millennium, with its devotion to difference. At the same time, his empirical openness can connect with our hostility to the closure of definitive conclusions, despite his desire to emulate positivist science even in a field dominated by feeling. And the way Fry's arguments managed at once to represent the mentality of a marginal group and to become the impetus behind what emerged as the dominant culture can pose the question of élitism for those who continue to operate in small groups with powerful institutional connections that perceive themselves to be counter-cultural. It is a mentality that can seem far more than just a few decades away, and yet it produced judgements in the light of which our own can often be seen much more sharply, because those judgements concern things and ideas that can still excite and provoke.

73. Clement Greenberg, 'Henri Rousseau and Modern Art', *The Nation*, 27 July 1946; in John O'Brian (ed.), *Clement Greenberg: The Collected Essays and Criticism*, Chicago and London 1986, II; *Arrogant Purpose 1945–1949*, p. 94.

74. Dickinson was a key figure, with others, in formulating the plans, drafting the projects and participating in the debates that made possible the setting up of the League of Nations. He produced a sketch of such a League late in August of 1914. Fry himself took part in the League's programme of 'Intellectual Cooperation' during the 1920s. The openness of Fry's writing to a postmodern reading, despite his rationalism, is shown by the persuasive job Reed has made of postmodernizing his writing.

OUT OF THE NINETEENTH CENTURY

Roger Fry's Early Art Criticism, 1900–1906

ELIZABETH PRETTEJOHN

BEFORE THE FOOTLIGHTS OF ÆSTHETICISM

QUIZ

Fig. 14 (Cat. 23) "Quizz" (Powys Evans), *Caricature of Roger Fry: "Before the footlights of aestheticism"*, published in *The Saturday Review*, 30 December 1922. Pen and ink, 39.4 x 24.5 cm. By kind permission of the Provost and Fellows of King's College, Cambridge.

In 1899, an anonymous writer in the *Academy* noted a categorical division between contemporary styles of art criticism:

The papers may be said to have ranged themselves under two standards. In one camp are those who take things lightly, contented with what is offered to them and preferring to praise good-naturedly the pictures that are relatively good when compared with those that are worse. In the other camp are those who judge a picture by fixed rules of excellence, who ignore the accidents of the moment, and see it with the eyes of the foreigner and of posterity.[1]

Critics of the second camp were prepared to endorse only a tiny fraction of the works displayed in the annual exhibitions – less than 1% of those at the Royal Academy, according to this writer. Moreover, their criteria for judgement differed altogether from those of their less censorious colleagues, who ordinarily gave priority to the description of a picture's subject-matter. Critics of the second camp practised a 'formalist' criticism, attending first of all to the visual and stylistic characteristics of the works they noticed.

It was this second camp that Roger Fry joined the next year, when he began his career as a professional art critic: he elevated the few above the many, form above content, and the traditions of the old masters above the fashions of the moment. In retrospect, these critical criteria seem to foreshadow the familiar, or notorious, Fry of 1910 and beyond – champion of a small elite among artists, rigorous formalist, and arbiter of the art-historical canon. But in 1900, when Fry began to write exhibition reviews for the *Pilot*, the criteria would be recognized as routine marks of a practice of specialist art criticism that had been increasingly conspicuous in the English periodical press through the past four decades.[2] In 1901 Fry took up the more important post of regular art critic for *The Athenaeum*, a weekly periodical that had provided thorough coverage of the art world since its founding in 1828. Since 1860, *The Athenaeum*'s art critic had been F.G. Stephens, one of the original members of the Pre-Raphaelite Brotherhood and one of the first English writers to practise art criticism as a profession.[3] By the turn of the century Stephens's critical preferences seemed distinctly old-fashioned; readers would have detected a shift when Fry replaced him, even though *The Athenaeum* articles were published anonymously. Along with colleagues such as D.S. MacColl and R.A.M. Stevenson, Fry represented a second generation in the professional practice of art criticism. This second generation favoured younger artists and

NOTES

Although the illustrations that appear in this essay relate to the broad topic of the book and the related exhibition, in this case they do not relate specifically to the content of the essay itself.

I should like to give special thanks to Caroline Campbell and Catherine Heathcock, who helped to compile the dossier of Fry's articles used for this essay. I am grateful to Anna Gruetzner Robins and Charles Martindale for their comments on drafts.

1. 'Memoirs of the Moment', *Academy*, LVI, 6 May 1899, p. 512.

2. See Elizabeth Prettejohn, 'Aesthetic Value and the Professionalization of Victorian Art Criticism 1837–78', *Journal of Victorian Culture*, 2:1, Spring 1997, pp. 71–94.

3. See Dianne Sachko Macleod, 'F.G. Stephens, Pre-Raphaelite critic and art historian', *The Burlington Magazine*, CXXVIII, June 1986, pp. 398–406.

4. For these statistics I am indebted to Donald A. Laing, *Roger Fry: An Annotated Bibliography of the Published Writings*, New York and London (Garland) 1979. My numbers slightly exceed Laing's because I have counted each instalment of exhibition reviews published in multiple parts; this gives a better idea of the volume of Fry's writing, since review instalments were usually at least as long as other articles.

5. See, for example, Kenneth Clark's introduction to *Last Lectures*, p. ix: "In so far as taste can be changed by one man, it was changed by Roger Fry".

newer trends in the art world. Nonetheless, they followed first-generation professionals such as Stephens in distinguishing their critical writing from more generalist approaches by claiming specialist expertise in the discernment of artistic quality, particularly on formal grounds.

The professional art critics of both generations wrote exclusively on subjects involving art, but in order to construct full-time careers they were obliged to be prolific, and to range widely over art history as well as contemporary art. Fry's writing was no exception. Between 1900 and 1906 Fry contributed 491 articles to periodicals, 424 of which appeared in *The Athenaeum*.[4] The articles varied considerably in length, but it was not unusual for a review in the closely printed pages of *The Athenaeum* to extend to 2000 words or more. About 45% of the articles were exhibition reviews, covering not only the major institutions for showing contemporary art, such as the Royal Academy, the New Gallery and the New English Art Club, but a bewildering variety of exhibitions in dealers' galleries, exhibitions of old masters, antiquities and the applied arts, and important exhibitions abroad. A further 30% of Fry's articles were book reviews, providing thorough coverage of what constituted a virtual explosion in art publishing at the beginning of the twentieth century. In 1904 alone, Fry reviewed books on Donatello, Whistler, Watts, Michelangelo, Turner, Benozzo Gozzoli, Rodin, Titian, Veronese, Leonardo, Blake, Romney and Holbein; books on the collections of the Pitti, the Prado, the National Gallery and Christ Church, Oxford; books on French medieval sculpture, French sixteenth-century painting, Impressionism and Florentine Renaissance drawings; and others ranging from George Clausen's volume of Royal Academy lectures to Max Beerbohm's book of caricatures, *The Poets' Corner*. A third category in Fry's writing consisted of articles that might broadly be characterized as art historical, such as a series on the art of Giotto, his predecessors and followers; these were relatively few in number but longer and more reflective than the more topical articles.

Neither the volume nor the range of Fry's writing was exceptional for the period. Moreover, on a first reading there is little in these writings to distinguish Fry from his colleagues. The voice is that of the responsible professional critic, commenting judiciously on the full range of art-world events. Yet I shall argue that the routine critical practices of the beginning of the twentieth century are not irrelevant to the revolution in taste with which Fry was later credited.[5]

On these terms Fry's notorious élitism might be re-described as an extension of the practice by which professional art critics shored up their claims to a discernment superior to that of the casual observer. This is not to excuse Fry for the social snobbery that permeates his writings in this early period.[6] He praises the portraiture of G.F. Watts for presenting "a type of distinction and breeding" that may provide posterity with "the explanation of why the English aristocracy retained its power so long". In the same breath he denounces

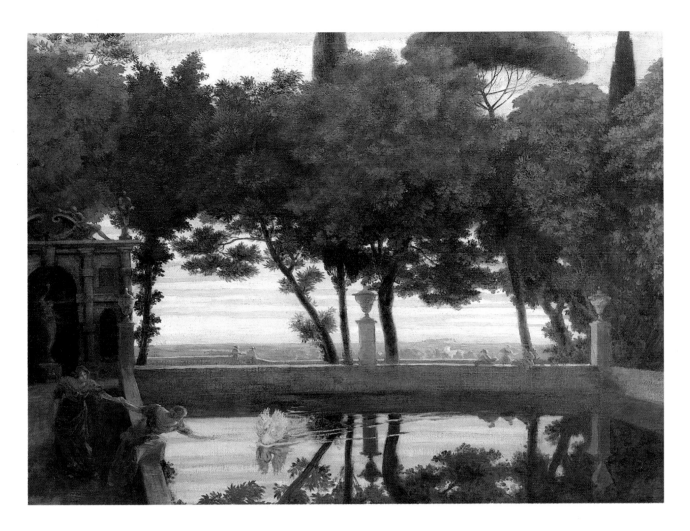

Fig. 15 (Cat. 71) Roger Fry, *The Pool*,
1899. Oil on canvas, 42 x 68.5 cm. Private
collection.

Sargent's portraits of "aspirants to aristocracy, on their guard, socially on the
defensive – supercilious and self-conscious"; Sargent's extrovert manner of
posing is appropriate for the Jewish *nouveau-riche* sitter Miss Wertheimer, but
"it does not do for the Countess of Lathom".[7] Without a hint of self-
consciousness, Fry pays extravagant deference to the first solo exhibition of a
young artist, the Hon. Neville Lytton: "His art is in fact, in the best sense of the
word, aristocratic."[8]

Fry's social élitism is exceptional for the art criticism of the period. However,
the conviction that the world of art is divisible between a tiny number of great
works and a vast mass of mediocrity was deeply embedded in the English
critical tradition that Fry joined in 1900, and inextricable from the professional
critic's claim to authoritative judgement. As early as 1875 Stephens denounced
the "acres of rubbish" on the walls of the Royal Academy, in contrast to the
few works of distinction.[9] Fry, like Stephens, constantly stresses the
overwhelming preponderance of mediocrity: "The Academy becomes every
year a more and more colossal joke played with inimitable gravity on a public
which is too much the creature of habit to show that it is no longer taken

6. For an attack on Fry's élitism see Simon Watney, 'The Connoisseur as Gourmet: The Aesthetics of Roger Fry and Clive Bell', in Tony Bennet *et al.* (eds.), *Formations of Pleasure*, London, Boston, Melbourne and Henley (Routledge & Kegan Paul) 1983, pp. 66–83. Fry's early criticism shows a more marked deference to the hereditary aristocracy than the later writings on which Watney concentrates, but this is a social bias; it is not clear even in the early writings that Fry considered aesthetic sensibility to be either innate or linked to class, as Watney claims. Fry did claim that women were either innately gifted with aesthetic sensibility or not, as opposed to men who were capable of learning to judge art, but even here there is no evident connection between women's natural gifts and their class or social position; see Fry's review of C.J. Holmes's *Pictures and Picture Collecting*, *The Athenaeum* no. 3959, 12 September 1903, p. 356. Later Fry's views on social class drew closer to the "class fraction" position discussed by Raymond Williams, 'The Significance of "Bloomsbury" as a Social and Cultural Group', in Derek Crabtree and A.P. Thirlwall (eds.), *Keynes and the Bloomsbury Group*, London and Basingstoke (Macmillan) 1980. For a different emphasis see Christopher Green's essay in this volume, pp. 13–30.

7. Roger Fry, 'The Royal Academy', *The Athenaeum*, no. 3993, 7 May 1904, pp. 597–98.

8. Roger Fry, 'Carfax's Gallery', *The Athenaeum*, no. 4000, 25 June 1904, p. 823.

9. F.G. Stephens, 'The Royal Academy', *The Athenaeum*, no. 2483, 29 May 1875, p. 724; see Prettejohn 1997, pp. 86–88.

10. Roger Fry, 'Royal Academy', *Pilot*, 12 May 1900, p. 321.

11. Roger Fry, 'The New Gallery', *The Athenaeum*, no. 4081, 13 January 1906, p. 56.

12. Sidney Colvin, 'Art and Criticism', *Fortnightly Review*, N.S. XXVI, August 1879, p. 212; see Prettejohn 1997, pp. 83–88.

13. Virginia Woolf mentions Fry's attendance at "meetings of the Fine Arts Society in Sidney Colvin's rooms", in Woolf 1995, p. 52. For Colvin's career see E.V. Lucas, *The Colvins and Their Friends*, London (Methuen) 1928.

in."[10] In the later nineteenth century the presupposition that the few vastly outranked the many could be used to support a wide variety of artistic projects. During his *Athenaeum* stint, Fry had not yet found his cause; Cézanne does not appear until 1906, in one of the last articles Fry contributed as the periodical's regular critic.[11] But the structure by which an élite art practice could be elevated above the diverse activities of a flourishing art world was in place before Fry even began to write. To match the structure with a specific content – the art that Fry dubbed "Post-Impressionist" in 1910 – was a last step in the process. However, the revolution in taste that continues to inform art criticism and art history nearly a century later derived much of its power from the structure of discrimination formulated in precisely the art world it so decisively rejected, that of later Victorian England.

Despite the diversity of works and artists that regular employment at *The Athenaeum* obliged Fry to notice, a consistent critical approach is evident from the very beginning. The familiar word 'formalist' is certainly relevant, but too crude to capture the complexity of Fry's evaluative criteria or of his descriptive language. Nor can the word distinguish Fry's writing from that of many of his colleagues; as noted above, specialist art criticism rooted its claim to authority in the expert discernment of visual qualities that critics insisted were invisible to the untrained eye. As the critic Sidney Colvin put it in 1879:

Picture-blindness in a greater or less degree – the condition of those who have not the faculty or the habit of seeing and feeling for themselves what there is to see and feel in the combination of lines and colours before them – is certainly the condition of the majority. The only cure for picture-blindness lies in habitual and rightly directed looking, and it is the business of criticism to teach people how to look.[12]

Colvin's views are particularly relevant, for it was he who had established the study of art at Cambridge, as Slade Professor (1873–85), Director of the Fitzwilliam Museum (1876–84) and leading member of the Fine Arts Society.[13] Although Colvin left Cambridge for the British Museum just as Fry arrived at King's College, Fry continued to hold the older critic in high esteem, paying elaborate deference to Colvin's aesthetic discernment every time he reviewed one of his later publications. As early as 1867, Colvin had advanced a 'formalist' art theory that was novel for its date:

The only perfection of which we can have direct cognizance through the sense of sight is the perfection of forms and colours; therefore perfection of forms and colours – beauty, in a word – should be the prime object of pictorial art. Having this, it has the chief requisite; and spiritual, intellectual beauty are contingent on this, are something thrown into the bargain.[14]

14. Sidney Colvin, 'English Painters and Painting in 1867', *Fortnightly Review*, N.S. II, October 1867, p. 465.

15. See E.V. Lucas, *The Colvins and Their Friends*, London (Methuen) 1928, pp. 24–29.

16. I borrow the terms 'centrifugal' and 'centripetal' from Stephen Bann, with apologies for changing his suggestive usages somewhat; see his 'Art History in Perspective', *History of the Human Sciences*, II, no. 1, February 1989, p. 1. For Colvin's view of the art critic's responsibility to attend closely to the object, see his 'Art and Criticism', *Fortnightly Review*, August 1879, pp. 210–23.

17. See, for example, Watney 1983, pp. 72–74.

18. Roger Fry, 'The Whitechapel Art Gallery', *The Athenaeum*, no. 3988, 2 April 1904, p. 440.

19. Roger Fry, review of Colvin's *Selected Drawings from Old Masters in the University Galleries and in the Library at Christ Church, Oxford*, *The Athenaeum*, no. 4007, 13 August 1904, p. 216.

20. Roger Fry, 'The Royal Society of Painters in Water Colours', *The Athenaeum*, no. 3826, 23 February 1901, p. 248.

21. For a critique of this habit of polarization see Martin Heidegger, 'The Origin of the Work of Art' in D.F. Krell, *Martin Heidegger: Basic Writings*, London (Routledge) 1993, pp. 153–56.

22. Sidney Colvin, 'English Painters and Painting in 1867', *Fortnightly Review*, II, October 1867, p. 476; Colvin prefers the artists who would later be associated with terms such as 'art for art's sake' and 'Aestheticism': Leighton, Albert Moore, Whistler, Rossetti, Burne-Jones, Simeon Solomon, Watts, Arthur Hughes and G.H. Mason.

23. James McNeill Whistler, 'The Red Rag', 1878, repr. in Nigel Thorp (ed.), *Whistler on Art: Selected Letters and Writings*, Manchester (Carcanet) 1994, p. 51.

24. Roger Fry, 'The Royal Society of Painters in Water Colours', *The Athenaeum*, no. 4074, 25 November 1905, p. 731.

25. Roger Fry, 'Mr. C.H. Shannon's Work at the Dutch Gallery', *The Athenaeum*, no. 3830, 23 March 1901, p. 376.

26. W.M. Rossetti and A.C. Swinburne, *Notes on the Royal Academy Exhibition, 1868*, London (John Camden Hotten) 1868, p. 32.

Colvin's teaching, as Slade Professor at Cambridge, was deliberately opposed to that of Ruskin, his opposite number at Oxford.[15] Where Ruskin's approach was centrifugal, constantly expanding from the work of art out to its wider relationships either to the natural world or to its social context, Colvin's was centripetal, constantly converging on the immediate qualities of the work itself.[16] Fry is often taken to task for neglecting the historical and social contexts of art;[17] in a sense, he is blamed for following the Cambridge tradition of Colvin rather than the Oxford tradition of Ruskin.

Fry's neglect of context was not, then, inadvertent, or the result of ignorance; it was deliberate and principled. At times he makes this explicit, cautioning that facts about the artist, "his age and his country" are only "the by-products of beauty"; they are the "associated ideas of an art rather than ... its fundamental principles".[18] He takes Colvin himself to task for explicating the symbolic subject-matter of Leonardo's drawings, a matter of "chiefly ... psychological and historical interest", when "the drawings would have contained in themselves their own sufficient explanation".[19] Ruskin, on the other hand, is more roundly censured for his "illogical condemnation of the artifices of picture-making", for judging a work in relation to the natural world it purported to imitate rather than for its imaginative transformation of that world.[20]

This criticism of Ruskin is symptomatic of a more general tendency evident throughout Fry's writing: a constant habit of setting up antitheses between the internal consistency of the work of art and its dependence on extraneous matter from the world beyond its frame. In broad terms these antitheses are multiple reflections of the compulsion to polarize form and content that has haunted Western aesthetics at least since Kant.[21] More immediately, they derive from late Victorian debates about the autonomy of art that revolved around the terms 'art for art's sake' and 'Aestheticism'. For critics of Colvin's generation the imperative was to distinguish the autonomy of the work from its reliance on an external narrative or literary source; already in Colvin's article of 1867 the work of W.P. Frith appears as the quintessential example of the "merely illustrative and anecdotic", to be contrasted with "the true end of art".[22] A more notorious advocate for the work's independence from literary associations was the artist James McNeill Whistler: "the picture should have its own merit, and not depend upon dramatic, or legendary, or local interest".[23] Fry continued to draw on this kind of antithesis on the rare occasions when he chose to notice a work with anecdotal content, such as Albert Goodwin's watercolour, *When the Day's Work is Done*: "[the artist] seems to have been too much absorbed in the sentimental associations to work out the essentially pictorial aspects of his subject".[24] On the other hand, Charles Shannon is praised for avoiding this pitfall: "Mr. Shannon refuses the aid of definite literary or poetical ideas; he seeks and finds satisfaction in the contemplation of pure formal beauty".[25] The passage recalls aestheticist criticism such as that of Swinburne, writing in 1868 of Albert Moore's "faultless and secure expression

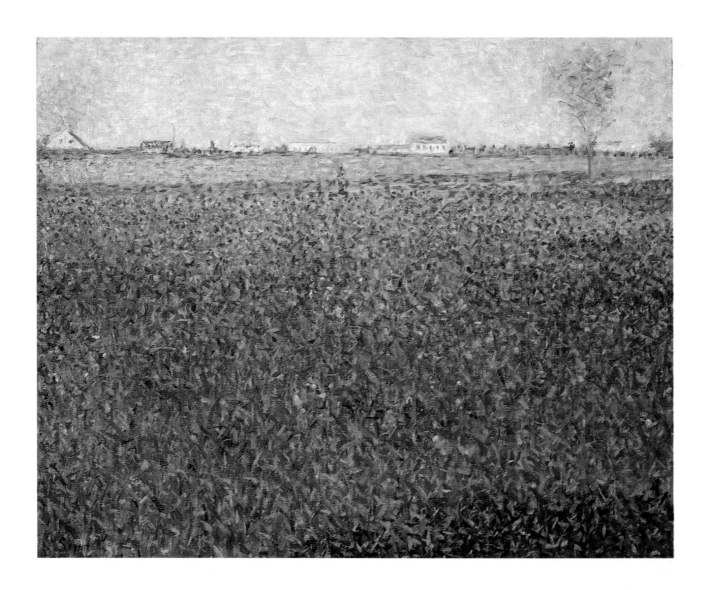

of an exclusive worship of things formally beautiful [He leaves] to others the labours and the joys of thought or passion."[26]

But for Fry at the beginning of the twentieth century the greatest threat to art's autonomy is no longer subservience to a narrative or literary source; instead it is the slavish imitation of "observed fact". Thus the most prevalent form of antithesis, in Fry's writing, is that between artistic beauty and "verisimilitude". This, too, echoes a preoccupation of Whistler's: "To say to the painter, that nature is to be taken, as she is, is to say to the player, that he may sit on the piano!"[27] Oscar Wilde's dialogue of 1891, 'The Decay of Lying', elaborated the idea into ingenious paradox – not only should art disavow the imitation of nature, but nature can be seen instead to imitate art:

At present, people see fogs, not because there are fogs, but because poets and

painters have taught them the mysterious loveliness of such effects. There may have been fogs for centuries in London. I dare say there were. But no one saw them, and so we do not know anything about them. They did not exist until Art had invented them.[28]

Fry's criticism brings Whistler's and Wilde's flights of fancy down to earth and transforms them into a basic evaluative criterion to be applied to the widest possible range of works of art. To do so he sought a more orthodox sanction in Sir Joshua Reynolds's exhortations to transcend the "particularities" of nature in pursuit of the "great style" in art. In the critical edition of the *Discourses* that he brought out in 1905, Fry places special emphasis on the Third Discourse, where Reynolds deals with the problems of imitating nature. To conclude his introduction, Fry sums up his interpretation of the *Discourses*: "[Reynolds's] creed may be defined in Goethe's words: 'The genuine law-giving artist strives for artistic truth; the artist who knows no law, but follows a blind inner instinct, strives for natural verisimilitude'".[29]

The antithesis between art and nature is ubiquitous in Fry's criticism, beginning with his first exhibition review for the *Pilot* in 1900:

It is not to be wondered at that, with no living tradition of creative art to clear the way, so many artists keep to the safe path of skilfully recording on canvas some of the patterns that the kaleidoscope of life turns up instead of seeking to construct them for themselves.[30]

Parallel antitheses appear in a bewildering variety of contexts. Vermeer's work is praised in opposition to "the besetting Dutch craving for verisimilitude at any price".[31] Fry distinguishes the hands of Hubert and Jan van Eyck by assuming that such a dichotomy must have operated: beside Hubert, the "great poetic creator", the "literal realism" of Jan's work "appears of a lower order".[32] "Turner had more important matter in hand than to carry on a private meteorological record office", so he is preferred to Constable.[33] Among the French Impressionists, Fry favours Manet and Degas over Monet, Sisley and Pissarro: "Unlike Monet, [Manet] is always the artist first and a naturalist by the way."[34]

Fry's hostility to Impressionism is quite consistent, then, with his views on other kinds of art, but it placed him in a strange position among the art critics of his generation, one that is difficult to categorize as either progressive or conservative. Most of the so-called 'New Art Critics', the second-generation professional critics who began their careers after 1880, made championship of the Impressionists a distinguishing mark of their critical approach.[35] They made their case not only in their routine periodical criticism but also in such books as D.S. MacColl's *Nineteenth-Century Art* of 1902 and R.A.M. Stevenson's *The Art of Velasquez* of 1895, which finds a historical sanction for Impressionism in Velázquez's work. Fry specifically reproved his colleagues for

27. Roger Fry, 'Mr Whistler's "Ten O'Clock"' (1885), repr. in Thorp 1994, p. 84.

28. Oscar Wilde, 'The Decay of Lying', first published 1891 in *Intentions*, London (Methuen) 1909, p. 39.

29. 'Introduction', in Roger Fry (ed.), *Discourses Delivered to the Students of the Royal Academy by Sir Joshua Reynolds, Kt.*, London (Seeley & Co.) 1905, p. xxi.

30. Roger Fry, 'The New Gallery', *Pilot*, 5 May 1900, p. 291.

31. Roger Fry, 'Dutch Masters at the Burlington Fine Arts Club', *Pilot*, 30 June 1900, p. 546.

32. Roger Fry, 'Review of Frances C. Weale's *Hubert and John van Eyck*', *The Athenaeum*, no. 3956, 22 August 1903, pp. 258–59.

33. Roger Fry, 'Review of C.J. Holmes's *Constable and His Influence on Landscape Painting*', *The Athenaeum*, no. 3937, 11 April 1903, p. 471.

34. Roger Fry, 'The New Gallery', *The Athenaeum*, no. 4081, 13 January 1906, pp. 56–57.

35. For the 'new critics' see Kate Flint, 'The English Critical Reaction to Contemporary Painting 1878–1910', D.Phil. thesis, Oxford 1983; John Stokes, '"It's the Treatment Not the Subject": First Principles of the New Art Criticism', in *In the Nineties*, New York (Harvester Wheatsheaf) 1989, pp. 34–52; Maureen Borland, *D.S. MacColl: Painter, Poet, Art Critic*, Harpenden (Lennard) 1995, especially pp. 63–85.

appropriating Velázquez in this way: in Velázquez's work "[t]he tones symbolize a reality which we accept because of its self-consistency, not because of the accuracy of its record of actual appearances".[36] Readers might easily have interpreted the disparagement of Impressionism as a mark of the critic's conservatism, particularly because Fry did not consistently favour any newer movement in art before 1906. Indeed, he could prefer an older artist such as James Clark Hook, "whose observation is not cramped by the scientific theories of values of quite recent times", to younger artists he thought tainted by Impressionism.[37] In positioning himself against Impressionism and the New Art Critics, Fry was, in one sense, reverting to the aestheticist prejudices of older critics such as Colvin. A close parallel to Fry's views on Impressionism occurs in Wilde's dialogue of 1891, 'The Critic as Artist', where one of the interlocutors, Gilbert, expresses limited approbation for the Impressionists, but prefers other artists, "who, refusing to leave the artist entirely at the mercy of the weather, do not find the ideal of art in mere atmospheric effect, but seek rather for the imaginative beauty of design and the loveliness of fair colour".[38] The aestheticist notion that the work of art should declare autonomy not only from literary sources but from sources in the natural world remained basic to Fry's critical procedures.

Fry's version of 'formalism', then, differed significantly from that of his colleagues among the New Art Critics: he did not delight in the play of colours and values on the picture surface as a record of the painter's vision. Instead he emphasized the beauty of the medium itself – the visual qualities of oil paints, of water colours, tempera or pastels. Since the 1860s, the critical vocabulary for describing artists' techniques had expanded steadily, and most of the New Art Critics were adept at describing the technical aspects of pictures. Many were, like Fry, practising artists. But none of them developed their fascination for the sensuous traces of the work's making with anything approximating the subtlety of Fry's writing (as Caroline Elam also shows in her essay in this volume).

For the particularity of the medium as a mark of art's autonomy there is a crucial precedent in a basic text associated with Aestheticism, Walter Pater's essay of 1877 on 'The School of Giorgione':

It is the mistake of much popular criticism to regard poetry, music, and painting – all the various products of art – as but translations into different languages of one and the same quantity of imaginative thought, supplemented by certain technical qualities of colour, in painting; of sound, in music; of rhythmical words, in poetry. In this way, the sensuous element in art, and with it almost everything in art that is essentially artistic, is made a matter of indifference; and a clear apprehension of the opposite principle – that the sensuous material of each art brings with it a special phase or quality of beauty, untranslatable into the forms of any other, an order of impressions distinct in kind – is the beginning of all true aesthetic criticism.[39]

36. Roger Fry, 'Spanish Art at the Guildhall', *The Athenaeum*, no. 3836, 4 May 1901, p. 572.

37. Roger Fry, 'The Royal Academy', *The Athenaeum*, no. 3838, 18 May 1901, p. 636.

38. Wilde 1909, p. 199.

39. Walter Pater, *The Renaissance: Studies in Art and Poetry*, ed. Donald L. Hill, Berkeley, Los Angeles, and London (University of California Press) 1980, p. 102.

40. See, for example, Fry's use of the phrase "beauty of quality" to designate sensitive use of materials, in Roger Fry, 'Carfax's Gallery', *The Athenaeum*, no. 4000, 25 June 1904, p. 824.

41. *Ibid.*, pp. 823–24.

42. Roger Fry, 'The Royal Academy – Sculpture', *The Athenaeum*, no. 3841, 8 June 1901, p. 732; see also 'The Exhibition of Statuettes at the Fine-Art Society', *The Athenaeum*, no. 3881, 15 March 1902, p. 344.

43. Roger Fry, 'The Old Masters at Burlington House', *The Athenaeum*, no. 4082, 20 January 1906, p. 84. Later Clement Greenberg would stress a similarly catastrophic nineteenth-century decline; see 'Towards a Newer Laocoon' (1940), in John O'Brian (ed.), *Clement Greenberg: The Collected Essays and Criticism*, Chicago and London (University of Chicago Press) 1986, I, p. 27.

44. Roger Fry, 'The Holland Fine Art Gallery', *The Athenaeum*, no. 3928, 7 February 1903, p. 183.

45. Roger Fry, 'The Royal Academy', *The Athenaeum*, no. 3995, 21 May 1904, p. 662.

In Fry's writing, it is not merely the pattern of forms and colours, but also the sensuous particularity of the materials from which the work is made that constitutes what he calls its "quality".[40] His descriptions of works dwell on the special characteristics of their materials. They are therefore consistent in detail with his general emphasis on evaluating the work as an autonomous object. Indeed this refines his criteria for judgment: he praises works that he sees as realising the beauty of their media, but roundly condemns those that seek effects he considers unsuited to the particular medium they use.

The predominant effect might be characterized as reactionary: Fry's general view is that the artists of his day lack the old masters' basic knowledge of the materials with which they work. Modern art is therefore in a state of appalling degradation relative to the great art of the past: "the old masters used their materials and the moderns abuse them".[41] Fry characterizes recent developments in sculpture, the so-called 'New Sculpture', as a decadent abuse of materials: "Many of our sculptors ... are giving up the bare and essential beauty of carved stone, and seeking to enliven it by an admixture of gilding, jewels, and enamel. The effect of these additions is, we think, distinctly to lower the appeal that sculpture makes to the imagination."[42] Here again Fry allies himself with Reynolds, echoing the insistence on the special purity of sculpture's medium in the Tenth Discourse, but distances himself from the contemporary critics who welcomed the varied use of materials in the work of 'New Sculptors' such as Alfred Gilbert. However, it is the decline in painting that concerns Fry most. He posits a turning-point early in the nineteenth century, followed by a more precipitous decline in the Victorian period: "The curious failure of the sense of fine colour and rich tone which befell artists in the first half of the nineteenth century is manifest in the dull accomplishment of Herring, Webster, Stark, and Vincent; while the abysmal depths to which artistic intelligence sank are seen in Sir E. Landseer's *Cat's-paw*."[43] This sets up a narrative of decline and fall uncannily reminiscent of Ruskin's moralized tale of the transition from medieval to Renaissance.

In his nuanced descriptions of particular materials, Fry sets up what might be described as a hierarchy of media, parallel to the traditional hierarchy of pictorial genres in Reynolds, but now divorced from subject-matter. Oil paint occupies the summit, at once the richest of media and the one most misunderstood in modern painting: "for many years modern artists have ceased to paint in oils with any sense of the proper quality of the medium."[44] For Fry the medium of oil paint is characterized by "fusion and flow",[45] by continuous and homogeneous modulation through colour, tone and modelling. The Impressionist procedure of breaking up the continuity of the painted surface into a 'mosaic' or patchwork of separate brushstrokes thus represents a transgression of the basic properties of the medium, properties that were thoroughly understood by the old masters. Among modern French painters, only Louis Anquetin "has attempted to recover that really scientific use of the medium of oil paint which was the common

inheritance of earlier painters. He, at least, has learnt by the study of Rubens how flexible, how insinuating, the touch of a full liquid brushstroke may be".[46] By contrast, English 'Impressionists', such as Clausen, La Thangue or Stott, misuse oil in a method more suited to pastel; they "have laboriously painted with separate touches of a pigment so stiff that, even though it is applied with a brush, the result has all the appearance of having been done with sticks of colour".[47]

Watercolour in Fry's characterization is a less complete medium than oil: "it is the charm of water colour that in it one may say as little as one wants; there is no compulsion to round off a period or lead up to a point".[48] Here, too, modern artists are apt to misunderstand, to use the medium as a form of painting rather than drawing: "Water colour, whenever it forgets to be a form of drawing, becomes a clumsy and roundabout imitation of something quite distinct, which it can never rival, while it forfeits its own particular prerogatives."[49] Fry prefers earlier English watercolourists such as Crome and Cotman.[50] His admiration for Girtin's skill extends even to his use of paper: "No one knew better how to distil from the complex of appearances a concentrated essence than Girtin. The fact that he employed an absorbent paper in which wiping out was an impossibility – that he had to rely entirely on the purest wash – compelled him to search thus vigorously for the ultimate terms of expression."[51] So, too, with other media; each is less "complete" or "rich" than painting in oils, yet each has its own characteristic "quality". In pastel, "elusiveness becomes almost a virtue".[52] Etching particularly suited Whistler's temperament, for it "gave free scope to the spontaneity, the wit and elegance of his gestures",[53] while in mezzotint the great master is Turner, who understood its special adaptation to night scenes.[54] William Nicholson distinguishes himself in lithographs, Charles Conder in wash drawings on silk.[55] Each medium may offer an appropriate mode of expression to an artist who seizes its "quality".

For all the delight in the physicality of the medium, Fry's descriptions are not purely 'formalist' in the sense of disregarding representation or meaning. The artist's use of the medium is always evaluated in terms of its adequacy to express the represented content or, better still, some deeper underlying 'idea'. Even the "typical modern vision of nature" has its appropriate media. Although Fry consistently disparages the Impressionist habit of breaking up oil paint into coloured patches, he finds that "the soft crumbling of pastel is peculiarly fitted to render the broken quality and the vibrating colour of strongly lit surfaces" characteristic of the "modern vision".[56] Fry welcomes the revival of interest in tempera for similar reasons; the minute, hatched strokes required by the quick-drying medium make open-air effects possible:

Such effects, for instance, as the powdered greyness of noon sunlight or the tenderer greys of evenly-spread clouds, the crumbled greys of ancient masonry, or the lichenous greys of old tree-trunks and weathered beams; all

46. Roger Fry, 'The Salons', *The Athenaeum*, no. 3943, 23 May 1903, p. 664.

47. Roger Fry, 'The Holland Fine Art Gallery', *The Athenaeum*, no. 3928, 7 February 1903, p. 183.

48. Roger Fry, 'Mr. Tonks's Water-Colours at Carfax's', *The Athenaeum*, no. 4047, 20 May 1905, p. 633.

49. Roger Fry, 'Water-Colour Drawings at Messrs. Agnew's', *The Athenaeum*, no. 3930, 21 February 1903, p. 248.

50. Roger Fry, 'The Reeve Collection at the British Museum', *The Athenaeum*, no. 4009, 27 August 1904, pp. 276–77.

51. Roger Fry, 'Water-Colour Drawings at Messrs. Agnew's', *The Athenaeum*, no. 3930, 21 February 1903, p. 248.

52. Roger Fry, 'Mr. C.H. Shannon's Work at the Dutch Gallery', *The Athenaeum*, no. 3830, 23 March 1901, p. 376.

53. Roger Fry, 'Whistler's Etchings', *The Athenaeum*, no. 3966, 31 October 1903, p. 588.

54. Roger Fry, 'The Royal Society of Painter-Etchers', *The Athenaeum*, no. 3882, 22 March 1902, p. 378.

55. Roger Fry, 'Mr. Nicholson's Pictures at the Stafford Gallery', *The Athenaeum*, no. 3947, 20 June 1903, p. 794; 'The Leicester Gallery', *The Athenaeum*, no. 4077, 16 December 1905, p. 842.

56. Roger Fry, 'The Pastel Society', *The Athenaeum*, no. 3846, 13 July 1901, p. 68.

these, which make up so large a part of what appeals to us in nature, lend themselves particularly to a rendering in tempera.[57]

But Fry reserved his most impassioned eulogies for artists he describes as imbuing their media with deeper significance. According to Fry, the "elaborate mechanism" of technique in fifteenth-century art fused with its religious import: "No splendour of transparent or opalescent colour patterned with burnished gold but would be appropriate to the idea of the angel."[58] Titian plays a special role: he is the greatest "*painter*", the greatest handler of paint as distinct from the greatest artist. While other artists may convey the "artistic idea" through the design, "with Titian the idea is inextricably interwoven with the material considerations of pigment, and depends on the subtlest variations of impasto, on the liquidity or fatness of the touch, and, above all, on the infinite modulations, the unanalyzable combinations of colour".[59]

No modern painter won such wholehearted praise from Fry in the years up to 1906. The perfect fusion of material beauty with the "artistic idea" remained a prelapsarian ideal for the return of which it would be presumptuous even to hope. But Fry was not exceptional in setting the standard of achievement in the past, among the old masters. One essential mark of the professional critic's expertise was the serious study of the art of the past, providing the critic not only with a 'trained eye' but with a broader standard of comparison than that of contemporary art. The years around 1900 represent a unique moment in the history of English 'artwriting',[60] one in which the critic could benefit from the extraordinary proliferation of art-historical research in the past few decades, but before the functions of critic, art historian and connoisseur began to fragment into separate specialisms, practised respectively in the newspapers, the universities and the art market.[61] Most of Fry's colleagues among professional art critics practised all of these disciplines to some extent, but Fry was pre-eminent for his virtually equal competence in all three spheres. Indeed his knowledge of the old masters was, and probably remains, unsurpassed among periodical critics.

Fry's reviews of old master exhibitions and books on the art of the past are dazzling displays of exacting scholarship; frequently they verge on the pedantic, or on the patronizing, as Fry 'corrects' attribution after attribution with devastating efficiency. In a single article on an old master exhibition at the Royal Academy he dismisses attributions to Raffaellino del Garbo, Francia, Antonello da Messina, Andrea del Sarto, Cima da Conegliano and Pollaiuolo, and reassigns the same pictures to an anonymous Ferrarese, Amico Aspertini, Alvise Vivarini, Pontormo and pupils of Cima and Pollaiuolo.[62] These complex displays of one-upmanship over other scholars may now seem beside the point, as these and similar attributions have been repeatedly contested and revised in subsequent research. But Fry himself seems to have believed devoutly in the possibility of arriving at the "absolute truth" of attribution.[63]

57. Roger Fry, 'Tempera Painting', *The Burlington Magazine*, VII, June 1905, p. 176.

58. Roger Fry, 'Art and Religion', *Monthly Review*, VII, May 1902, p. 132.

59. Roger Fry, review of George Gronau's *Titian*, *The Athenaeum*, no. 4011, VII, 10 September 1904, p. 355.

60. I borrow the term from David Carrier, who offers an interesting perspective on Fry's 'formalism' in his *Artwriting*, Amherst (University of Massachusetts Press) 1987, pp. 27–29.

61. For a similar tripartite division see Bann, 'Art History in Perspective', *History of the Human Sciences*, II, no. 1, February 1989, pp. 2–3.

62. Roger Fry, 'The Old Masters at Burlington House', *The Athenaeum*, no. 3873, 18 January 1902, pp. 89–90.

63. See, for example, Fry's review of books on Donatello, *The Athenaeum*, no. 3982, 20 February 1904, p. 248, where he takes an author to task for forgetting "that it is a question of arriving, however slowly, at absolute truth, not at a kindly mutual arrangement among critics".

Fig. 17 (Cat. 33) Paul Cézanne, *Still Life with Plaster Cupid, c.* 1894. Oil on paper, laid down on board, 70.6 x 57.3 cm. Courtauld Gallery.

He notably avoided the term 'connoisseurship', which he seems to have associated with a more dilettantish appreciation of works of art and with the vagaries of the art market.[64] For Fry attribution is the basis of art history and has at least some of the characteristics of a science. In this respect he follows the tradition of Morelli, extended in Fry's own generation by the work of Bernard Berenson; alone among periodical art critics, Fry could match wits, and eyes, with such experts as these.[65]

Yet, for all its pretensions to scientificity, attribution for Fry is not an end in itself. He vividly describes the compulsiveness of the process of sifting the evidence, and the keen pleasure of the moment when a single name seems to emerge with certainty.[66] All of this, though, is but a means to the more important aesthetic implications of the works under scrutiny. Fry compares the art historian to an archaeologist and to a *chiffonier*, but he insists that we must then "turn round and compute the exact value" of the researches, which are "but the raw material out of which we can build up our aesthetic appreciation".[67] In his review of Berenson's *Study and Criticism of Italian Art*, Fry elaborates:

In the first place, an attribution arrived at on purely internal evidence is in itself a summing up of innumerable aesthetic judgments on the work in question. In the second place, that judgment, when once it is arrived at, casts a reflected light, so to speak, on all the aesthetic experience which has led up to it. At once, a hundred minute characteristics which we had scarcely been able to observe start into prominence The right attribution of pictures, then, is not a mere parlour game; attributions have their value in stimulating and setting free purely aesthetic perceptions.[68]

At the end of the twentieth century, academic art history has largely excluded questions of aesthetic value from its specialized province, leaving them to newspaper criticism and the art market. But in Fry's approach the incessant process of close looking binds critical judgement, connoisseurship and art history together.

By the time he came to write his monograph on Cézanne, in 1927, Fry had left his brief career as a regular art critic far behind him. Arguing the cause for which he was by then famous, his writing has an urgency and conviction that had appeared only intermittently in his earlier work. Yet the characteristic concerns of his period at the *Athenaeum* are perceptible in a more complex fusion. He deftly elevates Cézanne to a privileged position among the few, roots his argument in the artist's handling of his medium, and situates Cézanne's achievement in the wider perspective of the old master tradition:

So perfect a correspondence of material quality to the idea ... is by no means of common occurrence in art One might almost say that it is only at certain moments in the history of art or in the career of a particular artist that

64. See, for example, Roger Fry, 'Dutch Masters at the Burlington Fine Arts Club', *Pilot*, 30 June 1900, p. 546.

65. For Fry's views on Morelli's 'scientific method' see 'Andrea Mantegna', *Quarterly Review*, CXCV, January 1902, pp. 140–41; for his estimate of Berenson see, for example, his review of Berenson's *The Study and Criticism of Italian Art* in *The Athenaeum*, no. 3864, 16 November 1901, pp. 668–69.

66. See, for example, Roger Fry, 'Mantegna as a Mystic', *The Burlington Magazine*, VIII, November 1905, p. 87.

67. Roger Fry, 'Art Before Giotto', *Monthly Review*, I, October 1900, p. 126.

68. Roger Fry, *The Athenaeum*, no. 3864, 16 November 1901, p. 668.

everything concurs to produce it And one must, I think, venture to proclaim boldly that [Cézanne's work] represents one of the culminating points of material quality in painting If, on the one hand, his voluptuous feeling for colour reminds one of the seductive sweetness of Chardin, on the other hand for him, if possible more than for Rembrandt, there are no parts of the surface more or less expressive than others, for his sensibility is active throughout.[69]

Fry's name and the term 'formalism' have become inseparable in the historiography of modernism. In one sense his early writings confirm the link; they show an internally consistent approach to the critical problem of the formal autonomy of the work of art. At the same time, though, they warn us against oversimplifying the category; however consistent, Fry's formalism is not a monolithic ideology. It is neither identical to other varieties of formalism, nor static throughout Fry's own career, as other essays in this catalogue demonstrate (see Christopher Green's essay, above, and Anna Gruetzner Robins's, below). We might locate Fry's early criticism historically as a middle point on a trajectory from the expansive and diffuse notion of art's autonomy in nineteenth-century Aestheticism to the highly specific formulations of Clement Greenberg's 'Modernist Painting'. Pater was content to suggest fidelity to the sensuous medium as a criterion for autonomy; Fry elaborated this into a minutely nuanced scrutiny of the physical properties of particular media; Greenberg took the idea to an extreme conclusion, eventually narrowing down his criteria to a single property, the flatness of the picture's support.[70] This narrative need not be figured as progressive. It might just as well be cast as a story of decadence, a narrowing of the potential richness and complexity of the autonomous work until the final point is reached in literal two-dimensionality. In that case what has often been seen as the privileging of aesthetic value in modernism might instead be an increasing loss of confidence in art's ability to mean anything beyond the inert materials out of which it is made.

However, we cannot account for Fry's impact simply by assigning him to a transitional role. In some respects Fry's early art criticism is merely a historical curiosity, revealing the artistic and some of the social prejudices of a tiny élite at a brief moment just after 1900. But the commitments to sustained looking and to the artwork as made object represent one of the most serious projects ever undertaken in the study of art, and one of the most influential. That this could take place in the context of routine art criticism for a widely available weekly periodical is worth noting. Despite the élitism of some of its premises, the project addressed a very wide audience, by today's standards, without diluting its intellectual and perceptual rigour.

For at least the past two decades, centrifugal approaches to the study of art have held the high ground in academic art history; Fry's reputation as an unequivocally centripetal art historian has suffered as a result.[71] Yet Fry's canon

69. Roger Fry, *Cézanne: A Study of His Development*, 2nd edn, London (Hogarth Press) 1932, pp. 43–44.

70. See Clement Greenberg, 'Modernist Painting' (1960), in John O'Brian (ed.), *Clement Greenberg: The Collected Essays and Criticism*, Chicago and London (University of Chicago Press) 1986, IV, p. 87.

71. See, for example, Watney 1983; Victor Burgin, *The End of Art Theory: Criticism and Postmodernity*, Basingstoke and London (Macmillan) 1986, pp. 10–12, 31, 147.

remains second nature, and not only in the auction rooms, galleries, and newspaper arts pages; it is built into the institutions of academic art history as well as those of the art world. At the end of the twentieth century the canon seems exclusionary – for example, feminist art historians have shown how it privileges the achievements of male artists. Centrifugal approaches to art history may create new intellectual contexts for a revaluation, for instance of the work of women artists; yet contexts, though necessary, are not sufficient. It is difficult now to remember that Fry's close attention to the work and his insistence on the importance of aesthetic value broke open the canon of a previous generation. If we desire an equally radical change to the canon we have inherited from Fry's generation, then perhaps we need a new wave of centripetal art history.

FATHERS AND SONS

Walter Sickert and Roger Fry

ANNA GRUETZNER ROBINS

Your father's a good man ... but he's old-fashioned, he's had his day
(Turgenev, *Fathers and Sons*)

You and I both live in the firm belief that one or other of us is destined to do one of us in, and, that being the only thing that keeps us both alive, we should not do it as we should both have lost our motive for living
(Walter Sickert, quoting Roger Fry in a lecture, 'Straws from Cumberland Market', given in Southport, 23 January 1924)

VISION VOLUMES AND RECESSION

Fig. 18 Walter Sickert, *Vision, Volumes and Recession*, c. 1911. Etching. Leeds Museums and Art Galleries (City Art Gallery).

At the time of Roger Fry's Post-Impressionist exhibitions in 1910 and 1912, Walter Sickert referred repeatedly to Turgenev's classic tale of youthful revolt. Sickert first mentioned the book when he staged his own rebellion against Whistler in autumn 1896. Ten years earlier Whistler had encouraged Sickert to follow him and defy the English art establishment. Now Fry had organized another revolution, which undermined much of what Sickert held sacred. The work by Cézanne, Gauguin, Van Gogh, Matisse and Picasso that Fry brought to the Post-Impressionist exhibitions challenged the premise that art should be representational and that its function should be to give the illusion of something observed in the real world. Sickert and Fry heatedly debated their opposing views in their art criticism.

As a result Sickert is usually seen as tenaciously clinging to a late nineteenth-century position while Fry is a modern figure. But to view Sickert as old-fashioned compared to Fry is misleading. What I hope to show in this essay is that Sickert and Fry represented two contesting versions of modernism.

The New English Art Club: Common Ground

In 1892, the thirty-two-year-old Walter Sickert toasted the newcomers at the annual New English Art Club dinner. The twenty-five-year-old Roger Fry responded.[1] Sickert, the acknowledged leader of the Impressionist artists at the New English, and Fry, the future critic of Post-Impressionism, were more or less of the same generation. Both Sickert and Fry were highly literate, although Sickert never attended university and had not benefited from the Cambridge education afforded Fry. Sickert, however, had been a practising artist for over ten years, while Fry only began studying art in earnest when he attended classes in the studio of Sickert's co-Impressionist Francis Bate in 1889. Their paths crossed many times in the forty or so years that they knew each other and in some respects they had much in common. Both men were practising

Fig. 19 Photograph of Sickert (centre) and Fry (second left)

artists and both were prolific art critics. Both acknowledged the importance of each other's ideas about art while publicly disagreeing. They frequently reviewed the same exhibitions, at times contributed to the same publication, and wrote about each other's art.

In the 1890s Sickert and Fry shared a common ground. The New English way of thinking about art and various events which occurred at the club and in the London art world had a formative effect on their own ideas. Around 1910 both men effectively re-invented themselves. But neither entirely discarded their past.

The New English Art Club was founded by young artists who wanted an exhibition forum for their "French-influenced" painting. Initially it operated a democratic open-door policy to any exhibitor who was supported by two members. A ruling that allowed artists to exhibit only two works prevented anyone from making a big splash.

By the time of Fry's election in spring 1893, the club was dominated by an Impressionist clique that included Sickert, Bate, Philip Wilson Steer and others. The clique was supported by a group of critics known as the 'New Art Critics', which included D.S. MacColl, George Moore, R.A.M. Stevenson, Elizabeth and Joseph Pennell and to a certain extent Sickert himself. The Impressionist circle held Degas and Whistler in high regard. Both Sickert and Fry would denounce Whistler as an unsatisfactory, "effeminate" role model but neither lost respect for the "great and noble" Degas. He was the "strangest, most fascinating and yet most disquieting figure in the art of modern times", wrote Fry in 1923.[2] The clique knew far more about more recent developments in French art than is generally believed, but their idea of "Impressionist Art", or "Modern Art", as

NOTES

1. The dinner was reported in *The Globe*, 30 November 1892.

2. Roger Fry, 'Degas', *The Nation and Athenaeum,* 28 July 1923. Fry first met Degas in 1892 when Degas told him of his bitter disappointment at not becoming a mural painter.

3. 'Velásquez I', unpublished lecture first given 18 August 1896, Fry Papers, 9/1.

4. For a further discussion of the controversy see Ronald Pickvance, '*L'Absinthe* in England', *Apollo*, LXXVII, May 1963, pp. 395–98; Anna Gruetzner, 'Degas and George Moore: Some Observations about the Last Impressionist Exhibition', in Richard Kendall (ed.), *Degas, 1834–1984*, Manchester 1985, pp. 32–39; Kate Flint, 'The Philistine and the New Art Critic: J.A. Spender and D.S. MacColl's Debate of 1893', *Victorian Periodicals Review*, XXI, no. 1, Spring 1988, pp. 3–8; John Stokes, '"It's the Treatment not the Subject". First Principles of the New Art Criticism', in *In the Nineties*, New York, London, Toronto, Sydney and Tokyo (Harvester Wheatsheaf) 1989.

5. 'D.S.M.', 'Subject and Treatment', *The Spectator*, 70, 25 March 1893.

6. See 'G.M.', 'New Art Criticism', *The Speaker*, 25 March, 1 and 8 April 1893.

7. Roger Fry, 'Velázquez III', unpublished lecture, Fry Papers 9/3.

8. Only one of these three works has been identified: *Le Pont de Vervy*, 1888; Wildenstein, 1234; Musée Marmottan, Paris.

they sometimes called it, did not embrace the French model. Indeed, they had very particular ideas about French art and were suspicious of aspects of it, as three events that took place just as Fry joined the club in 1893 show.

"It's the treatment rather than subject treated", Fry said as he explained why the late work of Velázquez could be described as "Impressionist" in his lecture to a Cambridge University Extension audience in 1896.[3] The phrase had been bandied about in 1893 when a heated controversy about cultural and moral values blew up on the showing of *L'Absinthe* (1875–76; Musée d'Orsay, Paris) at a dealer's gallery in London. Moore said it depicted a prostitute who frequented the Paris streets, and D.S. MacColl said that Degas had depicted "two rather sodden people drinking in a café", which provoked the assistant editor of *The Westminster Gazette* and self-styled Philistine, J.A. Spender, to protest that the subject was everything and that the picture was repulsive and immoral. An extensive controversy argued by MacColl and Moore, who defended the picture, and others who were against it continued in the press for several months.[4] Explaining his view MacColl wrote: "The subject ... was repulsive as you would have seen it, *before* Degas made it his. If it appears so still, you may make up your mind that the confusion and affliction from which you suffer are incurable." Degas was the "master of character, of form, of colour". What counted was "the intonation, the accent, the expression."[5] Moore went even further in his defence of the separation of form and content, saying that it was the forms that Degas used for the composition that were the picture's chief merit.[6] This talk of formalism was too much for Fry at the time. "One feels inclined to rebel against what is tending to become a new formalism", Fry said in his closing remarks in his lecture on Velázquez.[7] Nevertheless to this controversy can be traced the roots of Fry's later aesthetic and his subsequent refusal to accept that disagreeable subject-matter counted for anything, as seen in his later comments about Sickert's depiction of subjects with a shock value (see also Elizabeth Prettejohn's essay in this volume for Fry's relationship with the New Art Critics).

Following the practice of Whistler, who invited Monet to show recent works at the Royal Society of British Artists, the New English Art Club arranged an exhibition of work by French Impressionists in April 1893. The group of two works by Degas, one by Morisot, one by Raffaelli and three by Monet was its largest showing of French art to date. This hardly compared with the huge selection of over three hundred works that Fry was to bring to London in 1910 under the heading Post-Impressionism, but the critical controversy that broke out in 1893 over the recent works by Monet – including *Le Pont de Vervy* (1888; Musée Marmottan, Paris), a grainstack of 1890–91, and a poplars picture of 1892, illustrates how complex the thinking on French Impressionism was in England in the 1890s.[8] Monet had been popular figure at the New English. Sargent bought four Monets, and Steer was an avid practitioner of Monet's techniques. Bate, who invited Monet to show in 1893, had written intelligently about Impressionist colour theory in *The Naturalistic School of*

9. D.S. MacColl ('The New English Art Club and the Messonier Exhibition', *The Spectator*, 22 April 1893) said that Monet was "lop-sided" because "all his handling goes to build up colour with the utmost of life and brilliancy ... the result is a wooley look".

10. 'W.S.' [Walter Sickert] (in 'Impressionism – True and False', *The Pall Mall Gazette*, 2 February 1889) claimed that the Neo-Impressionists were "prismatic gentlemen of the latest Paris pattern", who followed fashion in order to be "*dans le mouvement.*"

11. George Moore, 'Impressionism', *The Hawk*, 17 December 1889.

12. 'G.M.', 'Decadence', *The Speaker*, 3 September 1892.

13. See Roger Fry, 'Review of George Moore's *Modern Painting*', *The Cambridge Review*, 1893, reprinted in Eric Homberger, William Janeway and Simon Schama (eds.), *The Cambridge Mind: Ninety Years of the 'Review of George Moore's Modern Painting, Cambridge Review' 1879–1969*, London (Jonathan Cape) 1970, p. 213.

14. In a letter to Edward Alkmann (25 September 1892), Fry claimed that he had "learned all the latest theories of the Indépendants, Symbolistes, members of the Society Rose Croix, Sâr Péladan and Wagnerites"; quoted in *Virginia Woolf Quarterly*, no. 1, 1972, p. 6.

15. Roger Fry to D.S. MacColl, 3 February 1912, in *Letters* I, p. 353.

Painting, 1887, a book that Fry owned. At the end of the book, however, Bate expressed his distrust of all exaggerated brush techniques. Monet's brilliantly coloured canvases with their highly visible, densely woven brushwork were, therefore, a shock. Both Moore and MacColl expressed their dislike. They particularly distrusted the heavily pigmented surface of the pictures.[9] Indeed, there was a growing aversion to textured paint surfaces and individualistic handling among the New Art Critics. They were hostile not only to Monet's recent pictorial experiments but also to the pointillist technique of the Neo-Impressionists, which Sickert labelled "prismatic mannerism".[10]

Moore also complained about the fashionable appeal of the new ways of painting in France. His 1889 list, which includes "Decadents, Symbolists, Impressionists, Sensationists, Intentionists, &c.", reflects a well informed knowledge of French art. He predicted that none of these schools would last. "Three or four years is the limit of life of these schools of thought; towards the close of the third year, sometimes even earlier, the light of the school on which the hopes of the rehabilitation of French art were based, begins to wane, or it is obscured by some newer glory."[11] What lay behind this decline was the increasing emphasis on colour at the expense of drawing. In two damning articles Moore attacked Monet for his "crude colouration", Sisley, "who follows Monet in his pursuit of colour", and Pissarro, who Moore claimed had told him that he had only taken up with the Neo-Impressionists because "it was necessary to keep up with the young ones". Moore concluded "these new schools – the symbolists, the decadents, the dividers of the tones, the professors of the rhythm of gesture" were a failure because there was a "separation of the method of expression from the idea expressed", which was "a sure sign of decadence".[12] Moore republished these essays in *Modern Painting*, 1893, and Fry's review of the book shows that he was fairly knowledgeable about Neo-Impressionist colour theory. He chastised Moore for misrepresenting the theory but basically he agreed that Moore was right to mock the "absurdities of the scientific doctrinaires who practise the 'division of the tones'."[13] This first introduction for Fry to Monet and Neo-Impressionism helps explain his subsequent aversion to works by Monet, which he never entirely abandoned, and his lingering doubts about Seurat, which were still in evidence at the time of the first Post-Impressionist exhibition.

Fry had his own ambitions to take the New English by storm with a picture painted in the newest fashion. It was an important moment when he submitted *Blythburgh, the Estuary* to the selecting jury in spring 1893 (fig. 20). The flat arabesque patterning of the estuary and surrounding land and the sinuous stylized trees is comparable to landscapes by Paul Serusier and others in Gauguin's circle who were included on the list of French movements that Fry claimed to be acquainted with as he worked on the picture in 1892.[14] His hopes came to nothing when the jury rejected it, and Fry was to remember that his "next rebellion ... lay in the direction of our archaism".[15] Little has

Fig. 20 (Cat. 70) Roger Fry, *Blythburgh, the Estuary*, 1892–93. Oil on canvas, 59 x 71.6 cm. Private collection.

been said about this "next rebellion". However, descriptions of lost pictures exhibited at the New English Art Club during the later part of the 1890s reflect a growing interest in art of the past and a willingness to pastiche different 'old master' styles, including those of Corot, Richard Wilson, Watteau, William Muller and other masters of the eighteenth century in England and of the Italian Renaissance. Fry was not alone in looking to the art of the past. As early as 1893 Moore had predicted that modern English artists would follow this trend:

The pendulum has swung back. Fifteen years ago it was customary to speak slightingly of the old masters ... yet the old masters hold their own, and not withstanding their mistakes make Monet's modern skies and trees seem very

hollow and superficial. All this has been noted, and members of the New English Art Club have been discovered reading Reynolds's 'Discourses'.[16]

The New English headed the revival of interest in Reynolds, and in 1905 Fry brought out his own edition of Reynolds's *Discourses*.[17] In his introduction Fry stressed what could be described as a modern sensibility towards art of the past. He dismissed the art of "revolt" because of "its extravagant individualism, its feverish and quickly exhausted energy, its waste of power in fruitless experiment, and its small actual accomplishment". Here Fry echoes Moore's low opinion of the value of progress, of "the revolutionary forces" which made it seem "worthwhile to destroy and liberate".[18]

Like his New English colleagues Fry placed no historical or nationalist constrictions on what he found pertinent to the modern sensibility. Such an approach was always part of the aesthetic of the Impressionist circle in England, and Fry was not alone when he argued that Velázquez was an Impressionist. Whistler and Sickert shared this view and R.A.M. Stevenson made it a central point in his major monograph *The Art of Velásquez* of 1895. When this Impressionist circle argued for a wide-ranging definition of Impressionist art they had to concentrate on the visual effect of a picture in order to justify their claims. They expressed a new interest in the quality of the picture surface. Velázquez's handling, which delighted the eye without being too showy or intrusive in the modern French manner, was perfection. It could be argued that the English Impressionists' willingness to group themselves with past masters influenced Fry's commitment to pan-cultural and pan-historical inclusiveness when making his selection in 1920 for *Vision and Design*. This, the first anthology of his criticism, includes essays on Italian, French, Spanish and German artists from the fifteenth to the twentieth century in addition to essays on architecture and non-European art.

Finally, I want to argue that Hermann Helmholz's influential theories of perception, which had wide currency within the English Impressionist circle in the 1890s, had a lasting effect on Fry's thinking. Whistler, who first came across Helmholz in the 1860s, introduced his ideas to a younger group of artists, including Sickert. Helmholz's theory of the unity of vision postulates that the eye is only capable of a single viewpoint. More important for Fry was his theory of binocular vision, which the English Impressionists used to explain that seeing is a process of framing and flattening. This was the linchpin of their practice.

Fry read Helmholz in the early 1890s and his early writings contain many indirect references to his theories.[19] Initially he expressed certain reservations about the English Impressionists' adaptation of Helmholz's theories. He was suspicious of what he saw to be a restrictive method which reduced the experience of seeing to a geometric model based on a scientific theory of perception. Evidence suggests, however, that Fry subsequently rethought his position and that the English Impressionists' use of what Sickert described as

16. 'G.M.', 'The New English Art Club', *The Speaker,* 15 April 1893. D.S. MacColl also constantly referred to the *Discourses* in his writing of the 1890s.

17. Another view of Reynolds is provided by Edmond Gosse. In his introduction to Reynolds's *Discourses,* 1884, he doubted that Reynolds had much to offer the modern artist; see Edmond Gosse (ed.), *The Discourses of Sir Joshua Reynolds,* London (Kegan, Paul, Trench & Co.) 1884.

18. 'Introduction' in Roger Fry (ed.), *Discourses Delivered to the Students of the Royal Academy by Sir Joshua Reynolds, Kt.,* London (Seeley & Co.) 1905; reprinted in Reed 1996, p. 46.

19. Helmholz's *Physiological Optics* was published in German in 1866. His writings on perception were first published in English as *Helmholz's Popular Lectures on Scientific Subjects,* 1881. Fry refers to Helmholz in '*Some Problems in Phenomenology and its application to Greek Painting, a dissertation by R.E. Fry,*' 1891, Fry Papers 1/13. I am grateful to Christopher Green for this reference.

20. Walter Sickert, 'Mesopotamia – Cézanne', *The New Age,* 5 March 1914.

Fig. 21 (Cat. 29) Paul Cézanne, *The Montagne Sainte-Victoire*, c. 1887. Oil on canvas, 66.8 x 92.5 cm. Courtauld Gallery.

"an architectural formulae of eternal beauty" was particularly in his mind as Fry developed his critical view of Cézanne.

When Fry introduced Cézanne in 1910, at the time of the first Post-Impressionist exhibition, within an early modernist context he famously ignored Cézanne's links with the French Impressionist movement. Sickert spoke out against what he regarded as an essential error of judgement: "To us born in parts of the Impressionist movement, Cézanne has always been a dear, a venerated and beloved uncle".[20] Sickert has been vindicated and Cézanne's links with French Impressionism are undeniable. But Fry understood, and this made him unique in England at the time, that Cézanne's art demanded a new critical language. Cézanne's pictures had an order that was lacking in French Impressionist landscapes – which Fry thought by comparison were unintelligible. Frequently it has been assumed that Fry based his new interpretation on Cézanne's reported remarks about seeing the cone, the cylinder and the sphere in nature. But this is too simplistic, and Fry's perception of the underlying geometric structure in Cézanne's art has more

than a passing similiarity to the architectural formulae discussed and used by the devotees of Helmholz's theories within the English Impressionist circle. From 1908, when Fry first explained Cézanne's art to a bewildered English public, he drew on a geometric model. Cézanne, he claimed, "disentangled the simplest elements of design" when observing nature.[21] He drew attention to what he perceived as the geometric ordering of "atmospheric" effects in Cézanne's *Bay at L'Estaque* (Philadelphia Museum of Art), writing that it looked as though it had been "cut in some incredibly precious crystalline substance, each of its facets different, yet each dependent on the rest".[22] And in 1927 he paid tribute to Cézanne, who had "that sense of ordered architectural design".[23] "Under the double impulse of his analysis of coloured surfaces and of his native feeling for large structural unities Cézanne created a new pictorial beauty."[24]

Sickert, Fry and Post-Impressionism

I have argued that Fry did not discard the aesthetic of the New English circle entirely.

Nevertheless it is undeniable that Fry looked again at much of what had been dismissed by the familiar circle of his youth and saw it with new eyes in his middle years. Moreover, remembering his dismissal of the value of progress in art as late as 1905, it is remarkable that he was able to reassess his position and embrace an evolutionary model of art as he did at the time of the two Post-Impressionist exhibitions. Most of Fry's New English circle were horrified by Fry's enthusiastic embracing of Cézanne, Gauguin, Van Gogh, Matisse and Picasso and many, including MacColl, spoke out against Post-Impressionism.[25]

Sickert, who was used to playing a rebellious role, was more ambivalent. Between 1898 and 1905, when he lived in France and Italy, Sickert was in contact with Degas, Bonnard and Vuillard, and became better acquainted with some aspects of recent French art. On his return to England he hoped to introduce a new, younger group of artists, known as the Camden Town Group, to his newly invented model of modern art. After Fry's Post-Impressionist exhibitions, however, Sickert's version of modern art seemed old-fashioned to the best painters in the group – to Harold Gilman and to Spencer Gore, who joined the rapidly growing Cézanne bandwagon. Sickert now spoke with increasing disenchantment about what he regarded as formulaic theories being used indiscriminately by a new generation. For ammunition he loaded his criticism with detailed factual knowledge about the French art world and set up an opaque screen of heavy intelligence, using a mixture of quotations and phrases in French, German, Italian and Latin, which would suddenly collapse when he reverted to slang and remarks about popular culture. His critical approach could not have been more different than Fry's. Sickert did not dismiss all the artists in Fry's Post-Impressionist shows. He expressed great admiration for the art of Gauguin and he had a reserved liking for Cézanne's pictures. But he remembered the number of artists who had

21. Roger Fry, 'The Last Phase of Impressionism', *The Burlington Magazine,* 1908, reprinted in J.B. Bullen, *Post-Impressionism in England,* London and New York 1988, p. 46.

22. Roger Fry, 'The Post-Impressionists – 2', *The Nation,* 3 December 1910, in Bullen 1988, pp. 28–29.

23. Roger Fry, *Cézanne,* New York 1958, 1960, p. 32.

24. *Ibid.,* p. 44.

25. For a discussion of these exhibitions see Anna Gruetzner Robins, *Modern Art in Britain 1910–1914,* London 1997.

adopted Whistler's imposed design in England, which he likened to "the Cézanne boom". For this he blamed Fry, as Fry actively promoted Cézanne in England, proclaiming him the father of modern art, a catchphrase that is still in use today. Sickert spoke out against what he regarded as Fry's essential error of judgement. Sickert disliked the links being forged between Cézanne and other modern artists. Cézanne "was made to cover the impudent theories of Matisse and Picasso, who, talented themselves, have invented an academic formula which is the salvation of all *arrivistes*."[26] It must have been around this time that Sickert penned *Lines to an Expert*:

> If he proves a simple codger,
> Unload Steer, and load up Roger!
> And he'll like you all the better if you do!
> For Rogers you may trust in,
> Though the Cézanne boom be bustin',
> And he'll like you all the better if you do![27]

It is sometimes forgotten that Matisse and Picasso were included under Fry's Post-Impressionist umbrella. To these artists Sickert expressed nothing but hostility and suspicion. He was outraged when Bernard Berenson praised Matisse as a "magnificent draughtsman",[28] and he blamed Berenson for convincing Fry that Matisse was a great artist. He denounced both men "who gravely advocate Matisse" for their enthusiasm, which "renders all their previous utterances suspect".[29] What Sickert distrusted most was Matisse's draughtsmanship. "If you will look at M. Matisse's drawings, you will see that he has acquired the most fluent school facility, just the kind of school facility that you do not find in good drawings or great drawings." Sickert continued, "Matisse has all the worst art school tricks ... the instinct of self-preservation must have dictated to him that this slickness of empty perfection would never make its mark ... we have wilful distortions [which] arrest if they do not please."[30] Picasso was poorly represented in the first Post-Impressionist exhibition, when Sickert dismissed him as a "minor international painter" who produced in *Portrait of Clovis Sagot* (1909; Kunsthalle, Hamburg) a "superficial and very feeble caricature of Cézanne's failings."[31] As Sickert became more familiar with Picasso's later Cubist works, including the *papier collé* ones, his rage grew. Picasso was an "archfumiste" whose canvases with their "bits of cloth, and bits of tin, and bits of glass" recall in less amusing fashion "the tinsel of our grandfathers".[32] When an exhibition of recent works by Fry opened at the Alpine Gallery in 1915, Sickert expressed further disbelief. "What business had Mr. Fry, who was all indicated by his age and erudition to share our ease and dignity, to play the common detrimental and the firebrand?" asked Sickert. "What was the point of *Essay in abstract design*, 1914–15 [fig. 95], a collage of torn sheets of paper painted in oil and bus tickets?" It was "surprising that a painter who has the double advantage of

26. *The New Age,* 5 March 1914.

27. The poem is published in Robert Emmons, *The Life and Opinions of Walter Richard Sickert*, London 1941, p. 269.

28. Berenson praised Matisse in a letter to *The Nation*, 12 November 1908.

29. Walter Sickert, 'Solomon J. Solomon. Amplification', *The Art News*, 17 March 1910.

30. Walter Sickert, 'The Post-Impressionists', *The Fortnightly Review*, January 1911, p. 82.

31. *Ibid.*

32. Walter Sickert, 'Transvaluations', *The New Age*, 14 May 1914.

Fig. 22 Pablo Picasso, *Child with a Dove*, 1901. Oil on canvas, 73 x 54 cm. © The National Gallery, London.

33. Walter Sickert, 'Roger Fry', *The Burlington Magazine*, December 1915, p. 18.

34. *The New Age,* 14 May 1914.

35. Fry's collection of drawings was sold at Sotheby's, London, 11 April 1935.

36. Roger Fry, 'Line as a Means of Expression in Modern Art', *The Burlington Magazine*, February 1919, reprinted in Reed 1996, p. 333.

37. See Christopher Reed, 'The Fry Collection at the Courtauld Institute Galleries', *The Burlington Magazine*, November 1990, p. 768.

38. Walter Sickert, 'Art in Oxford: Passive and Active Study', *The Morning Post,* 12 June 1922.

39. Roger Fry, 'Walter Sickert A.R.A.', *The New Statesman,* 17 January 1925.

power and erudition should continue to treat seriously *fumisteries à la* Picasso (framed posies of tram tickets, &c.). 'Why we quit that junk in Paris seven years ago', as I heard the wisest American I know say the other day."[33] But Fry's admiration for Picasso was only one failing on Sickert's list of misdemeanours, and he asked "the Neo-pied Piper of Fitzroy Square" if he did not have "qualms of regret" for misrepresenting Gauguin, for confusing "the appreciation by the great British public of the great qualities of Cézanne by building on his palpable and tragic defects a nonsense-theory", and for diverting "a whole choir of innocents from serious study".[34]

Whatever Fry thought of Sickert's attacks he included him in his essay 'Line as a Means of Expression', illustrated with drawings by Matisse, Picasso, Sickert, Modigliani, Duncan Grant, Nina Hamnett and others (many of which came from Fry's own collection).[35] There he pointed out that, "as regards the quality of his calligraphy, Sickert is not far removed from his younger contemporaries". Fry cannot have forgotten his early lessons in drawing at his own Chelsea Life School, where Sickert preached that "the backbone of a drawing is line". But he still distinguished between Sickert who was "a pictorial artist" because he clung to nineteenth-century ideas about representation and Matisse, "a pictorial plastic artist" who had freed himself from these constraints.[36] The following year, 1919, Fry acquired Sickert's *Queen's Road Station, Bayswater* (fig. 140) and gave it a central place over his sitting-room mantelpiece.[37]

By the 1920s Sickert was publicly expressing his respect for Fry. "No sooner do I see the feet of Roger Fry upon the mountains than I scamper bleating to sit at them", Sickert wrote in a letter defending Fry published by *The Morning Post* in 1922.[38] And Fry paid his own back-handed compliment to Sickert, who was "whimsical, capricious, wilfully subjective in his opinions and humorously unreasonable in his upholding of them".[39] There were even moments when they agreed about the art they saw on exhibition. Sickert's early art criticism frequently appeared in 'little' periodicals and other avantgarde publications. In later life he wrote for the same establishment press that published Fry's criticism – *The Burlington Magazine, The Nation and Athenaeum* and others. It is interesting to compare Sickert's and Fry's review of an 'Exhibition of the Works of Some of the Most Eminent French Painters of To-Day', one of several exhibitions at the Lefevre Gallery in the 1920s with works by Cézanne, Matisse, Picasso and some of the other French artists Fry had favoured in his two Post-Impressionist exhibitions. Sickert found it easier to accept 'Post-Impressionist' works by Matisse and Picasso and artists of their generation with a stronger representational element. Writing in *The Burlington Magazine*, Sickert confessed himself to be a "lover of French art, past, present and to come". He declared that Matisse was "a great painter", said that Picasso's *Child with a Dove* (1901; fig. 22) "has feeling and movement as a drawing", but rejoined "nothing has been added, to what the photograph gives, by its execution in oil paint". He praised other works by Vlaminck, Marchand, the

Fig. 23 Henri Matisse, *Le parebrise sur la route de Villacoublay*, 1917. Oil on canvas, 38.2 x 55.2 cm. © The Cleveland Museum of Art, Bequest of Lucia McCurdy McBride, in memory of John Harris McBride II (1972.225).

"exquisite" Derain, and Braque, who "finds salvation in a delicate and exquisite economy of means". He praised works by Friesz, Utrillo,and Bonnard.[40]

Fry's review appeared in *The Nation and Athenaeum*. Like Sickert, Fry loved Matisse's *La conduite interiéur* (1917, now known as *Le parebrise sur la route de Villacoublay*; fig. 23). He agreed with Sickert, who thought Matisse's *Féte des fleurs à Nice* (private collection, Switzerland) a failure. He also liked the works by Utrillo, Derain, Vlaminck, Vuillard and Bonnard. Unlike Sickert, he thought the Picasso was "a rather dull work". And unlike Sickert, who did not mention Rouault, he devoted a paragraph to the three works by him, which, he said, were "the great discovery of the exhibition".[41]

At the beginning of this essay, I suggested that Fry and Sickert represented two contesting versions of modernism. Baudelaire's challenge to the painter of modern life, in which Fry had no interest, remained an essential aspect of Sickert's art. Between 1910 and 1914 when Fry's Post-Impressionist exhibitions had a significant effect on the kind of art being produced in England, Sickert

staged a series of one-man shows. They provoked a hostile response which matched the one incited by Fry's two shows. But this was for different reasons. In the 1880s Sickert had tested the conventions of the English art establishment by depicting the music hall. Between the 1910 and 1914 he stretched these boundaries again by depicting murder, prostitutes, poverty and commercial sex.[42] Fry was never fully reconciled to this aspect of Sickert's art. He thought it perverse that Sickert should continue to defend the need to represent the more depressing aspects of modern urban life, combined more often than not with a literary element. Like many others he recognized that Sickert owed more to Post-Impressionism than Sickert cared to admit, and there is an underlying hope in his writing that these pictorial aspects might prove to be enough. He was to be disappointed. In Fry's last published comment on Sickert, written in 1931, he expressed resigned despair. Provoked by Sickert's etching entitled *Vision, Volumes and Recession* (fig. 8), a satiric caricature of an intense and enthusiastic Fry – hair flying, pointer posed, lecturing to an unseen audience – Fry discussed Sickert's "sad fate":

Protesting vehemently as he does that painting is nothing but illustration, consigning the whole apparatus of three-dimensional design, of volumes, of recessions to the devil the moment he begins to paint, he lands himself in the enemy's camp. I cannot imagine the uninitiated being arrested by his account of the charms of his model, and he cannot prevent some of us from being fascinated by the intriguing and felicitous space composition. His infallible painter's instinct is always betraying the perversity of his aesthetic theories.[43]

It could be said that the controversy surrounding *L'Absinthe* provoked two quite different responses in Fry and Sickert. Fry avoided the nasty and unpleasant while Sickert, who was disgusted that a picture of the quality of *L'Absinthe* should be rejected for its subject-matter, made the depiction of prostitutes a major aspect of the art of his middle years. But whatever they said in print about each other there was still enormous respect. It is a mark of the high regard that Fry had for Sickert that when Woolf was planning Fry's biography she thought of having different people write on different phases of his life and listed Sickert and Clive Bell for Fry's Post-Impressionist period.[44] Indeed, that great modernist Virginia Woolf understood that Sickert, "probably the best painter now living in England", who painted "pictures full of stories", was both a modern painter *and* a literary one.[45] Although in the 1920s Fry attempted to accommodate the literary in his theory of art, he could not accept such a view of Sickert. Only in the late twentieth century are we beginning to appreciate both Fry's and Sickert's points of view.[46]

40. Walter Sickert, 'Modern French Painting', *The Burlington Magazine*, December 1924.

41. Roger Fry, 'French Pictures at Lefevre Gallery', *The Nation and Athenaeum*, 29 December 1924.

42. Fry made this point in a lecture delivered in Leeds in 1931; unpublished lecture notes, Fry Papers, 4/9.

43. Roger Fry, 'Samples of Modern British Art', *The New Statesman and Nation*, II, 14 November 1931, p. 641.

44. See Woolf's diary entry for 1 November 1934 in Anne Olivier Bell (ed.), assisted by Andrew McNeillie, *The Diary of Virginia Woolf*, London (Penguin) 1983, IV: 1931–35, p. 258.

45. Virginia Woolf, *Walter Sickert: A Conversation*, London [1934] 1992, p. 23.

46. Christopher Reed, 'Through Formalism: Feminism and Virginia Woolf's Relation to Bloomsbury Aesthetics', in Diane F. Gillepsie (ed.), *The Multiple Muses of Virginia Woolf*, Columbia and London (University of Missouri Press) 1993, p. 25. Reed points out the importance of Virginia Woolf's essay on Sickert for an understanding of the constant evolution of Bloomsbury's formalism.

FROM "ART-QUAKE" TO "PURE VISUAL MUSIC"

Roger Fry and Modern British Art, 1910–1916

RICHARD CORK

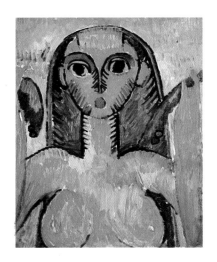

Fig. 24 (Cat. 128) Duncan Grant, *Head of Eve*, 1912. Oil on board, 75.6 x 63.5 cm. © Tate Gallery, London, 1999.

Anyone listening to Roger Fry lecturing at the Royal Academy in 1934 might well have felt despondent about his attitude to British art of the past. Although a grand historical survey of painting in Britain was on display at Burlington House, he did his best to puncture the mood of patriotic celebration. "When I consider the greatness of British civilization as a whole", Fry declared, "I have to admit sadly that British art is not altogether worthy of that civilization. Again and again, as it seems to me, British artists have failed to recognise the responsibilities of their calling; again and again they have sacrificed to the demands of their contemporary public what was meant for posterity and mankind at large. There has been in this country a low standard of artistic conscience."

When he delivered that crushing judgement, Fry was still the most influential art critic in Britain. By arriving at the mournful conclusion that "ours is a minor school", compared with the achievements of Western painting as a whole, he reinforced a long-held inferiority complex about home-grown British art. Deploring the fact that "no English painter can possibly be supposed to belong" to the class of artists typified by Giotto, Raphael, Titian, Rembrandt and Velázquez, Fry went on to declare that "in sculpture our position is even less satisfactory. If we were suddenly asked to mention a great English sculptor there is no name of sufficient resonance to rise instantly to our minds."[1]

Fry's low opinion might seem to be further borne out by his major publications. Apart from Duncan Grant, his favourite in the emergent generation of British artists, Bellini, Cézanne and Matisse were the painters he deemed worthy of book-length study. Even in *Vision and Design*, his best-known collection of criticism, Blake and Beardsley are the only English artists accorded essays of their own in a volume that ranges widely over the history of art.[2] He devotes more space to the minor French painter Jean Marchand than to any living British practitioner. Indeed, throughout *Vision and Design* Fry seems to shy away from discussing contemporary work, preferring to concentrate on the art of the past and reserve his greatest praise for painters safely sanctified by time.

But anyone who examines what this tireless individual had been doing, for at least a decade before *Vision and Design* was published in 1920, soon appreciates just how much he stimulated the growth of a more adventurous art in England. It was an unexpected departure for a man who initially established himself, during the late nineteenth century, as a respected historian and connoisseur of Renaissance art. His reputation was so high that in 1906

Fig. 25 (Cat. 131) Duncan Grant, *The Post-Impressionist Ball*, 1912. Pen and oil on headed writing paper, 18.4 x 38.1 cm. The University of Leeds Art Collection

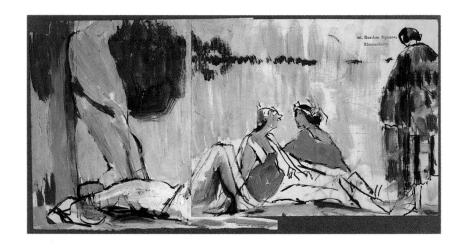

NOTES

1. Roger Fry, *French, Flemish and British Art*, London, 1951, pp. 137–38.

2. The two essays are 'Three Pictures in Tempera by William Blake' and 'Aubrey Beardsley's Drawings'.

3. The Cézannes, shown at the New Gallery, were a still life and a landscape; see Frances Spalding, *Roger Fry: Art and Life*, London, Toronto, Sydney and New York 1980, pp. 116–17.

4. Fry made the confession about Seurat in his 'Retrospect' essay in *Vision and Design*.

5. Desmond MacCarthy, 'The Art-Quake of 1910', *The Listener*, 1 February 1943.

6. *Ibid.*

the directorship of the National Gallery was offered to him – an invitation he declined, because he had already accepted a post as Curator of Painting at the Metropolitan Museum of Art in New York. He became converted to the dynamic of modern painting only after encountering two of Cézanne's canvases in an exhibition the following year.[3] Here, at the age of forty, he cast his former scepticism aside and began to convince himself that Cézanne, as well as being the true heir of tradition, pointed the way forward. Fry agreed with the prominent German critic Julius Meier-Graefe, whose widely influential book on *Modern Art* was published in English in 1908, that Van Gogh, Gauguin and Cézanne were "expressionists" who had inherited Manet's mantle and renewed his revolutionary initiative.

If the Grafton Galleries had not suddenly found a gap in their programme, however, Fry might never have mounted an exhibition so revelatory that its influence on the subsequent course of British art is incalculable. *Manet and the Post-Impressionists* was put together in a hurry, and Fry's collaborator Desmond MacCarthy later confessed that he had "never seen the work of any of the artists exhibited". Even Fry was still learning about the painters he now busied himself requesting from the Paris dealers. Looking back on the process of selection, he afterwards regretted his failure to acknowledge the true stature of Seurat, who was only represented by two pictures at the Grafton.[4] Acute pressure of time meant that he let MacCarthy travel alone to choose the Van Goghs from the collection of the artist's sister-in-law in Amsterdam. And the crusading confidence that guided the show's selection was not accompanied by any certainty over its title. MacCarthy related how he, Fry and "a young journalist who was to help with publicity" met to consider the show's name. Following Meier-Graefe's example, Fry "first suggested various terms like 'expressionism', which aimed at distinguishing these artists from the Impressionists; but the journalist wouldn't have that or any other of his alternatives. At last Roger, losing patience, said: 'Oh, let's just call them Post-Impressionists; at any rate, they came after the Impressionists'."[5]

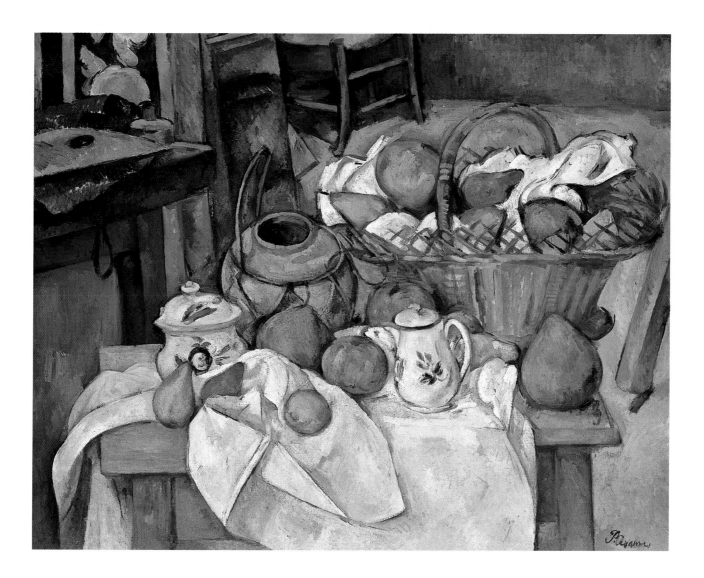

Fig. 26 (Cat. 31) Paul Cézanne, *Still Life with Basket*, c. 1890. Oil on canvas, 65 x 81 cm. Musée d'Orsay, Paris, Legs Pellerin. Photo © RMN – Hervé Lewandowski.

In this rushed, almost off-hand way, Fry coined the label that henceforth became generally applied to the three painters dominating his show. Positioning Manet as their forerunner, he devoted most of the wall space to an extensive range of canvases by Cézanne, Van Gogh and, with the most generous number of works, Gauguin. The impact of this great triumvirate amounted to "the Art-Quake of 1910", as MacCarthy described it, explaining that the show aimed at "no gradual infiltration, but – bang! an assault along the whole academic front of art".[6] All the same, Fry demonstrated remarkable caution over the younger artists on view, the even more heretical progeny whom the Post-Impressionists were supposed to have sired. Picasso and Matisse had only two or three paintings each, and Fry entirely omitted the mature Cubist work that Picasso was then producing. Its exclusion doubtless reflected Fry's own reservations about the increasingly austere and arcane development of Cubism. But, contrary to his opponents' claims that he was

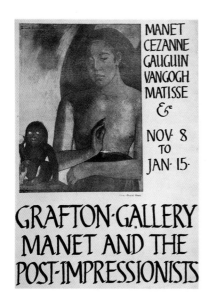

Fig. 27 Grafton Gallery poster (for *Manet and the Post-Impressionists*), 1910. 76.3 x 50.9 cm. Courtauld Gallery (HHF 261).

7. *The Times*, 7 November 1910. The anonymous critic was C.J. Weld-Blundell.

8. Bateman's cartoon appeared in *The Bystander*, 23 November 1910.

9. John Singer Sargent, quoted in *Art News*, 16 January 1911.

10. Robert Ross, *The Morning Post*, 7 November 1910.

merely iconoclastic, Fry may also have decided that Post-Impressionism was more than enough for the public to cope with in this particular exhibition.

He was right. Neither Fry nor MacCarthy could, however, have foreseen the astonishing antagonism and notoriety aroused by the show. On 5 November 1910, the art critic of *The Times* visited the press view of an event that would prove as subversive, in its way, as the Gunpowder Plot had been on the same day centuries before. Unlike Guy Fawkes's thwarted Parliamentary explosion, though, Fry's show succeeded in its aims. Reeling from the discharge of the paintings assembled at the Grafton Galleries, my stunned and angry predecessor declared in *The Times* that the exhibition "throws away all that the long-developed skill of past artists had acquired and perpetuated". By this time incandescent with fury, he concluded that "it begins all over again – and stops where a child would stop ... it is the rejection of all that civilisation has done".[7] Other reviewers were no less alarmist, and during its three-month run *Manet and the Post-Impressionists* quickly became the most scandalous art show ever mounted in Britain. It ultimately shaped the sensibilities of an entire generation, but few of the hundreds of visitors who streamed through the Grafton's rooms every day saw the exhibits in such revelatory terms. As the exhibition secretary, MacCarthy had to supply a special book where they could write down their apoplectic comments, and the newspaper cartoonists were equally uninhibited. H.M. Bateman's sprightly drawing, headlined "Post-Impressions of the Post-Impressionists", showed a top-hatted gentleman arriving at the exhibition looking dapper and dignified, only to totter out with buckled legs, gaping mouth and uncontrollable perspiration.[8]

Why did so many members of the British public react as if they had been exposed to some appallingly infectious disease? Part of the answer lies in their ignorance of the art on display. Although the exhibits had largely been produced a quarter of a century before, they seemed to the Grafton's shell-shocked visitors as alien and unexpected as the very latest eruptions in contemporary art. Manet, whose *Bar at the Folies-Bergère* provided the survey with the first of its many masterpieces, was disturbing enough to eyes not yet at ease with Impressionism. But Van Gogh's vehement distortions, Cézanne's brusquely simplified forms and Gauguin's flat, pattern-like colours launched an unprecedented assault on the viewers. The cumulative effect of the 228 images on display amounted to a flagrant denial of everything they valued about art.

Some of the most virulent condemnations came from Britain's senior artists, who felt professionally threatened by Post-Impressionist innovations. Even John Singer Sargent, who had befriended Monet decades before, opined of the exhibits in a letter to *The Nation* that "I am absolutely sceptical as to their having any claim whatever to being works of art".[9] As for Charles Ricketts, he resisted Robert Ross's proto-Nazi suggestion that the paintings should be burned like "the source of the plague".[10] But he argued in favour of their preservation only because they might be useful to "the doctors of the body

Fig. 28 (Cat. 124) Paul Gauguin, *Te Rerioa*,
1897. Oil on canvas, 95 x 130.2 cm.
Courtauld Gallery.

and the students of the sickness of the soul".[11]

In the light of such inflammatory comments, it may seem surprising that
the police did not descend on the Grafton, bolt its doors and arrest Fry at
once. But the furore succeeded only in magnifying the show's scandalous
attraction and sending even larger crowds surging through the gallery's
portals. While astounded by what they found there, many visitors would have
secretly savoured the illicit *frisson* of gazing at pictures which some even
regarded as symptoms of political unrest. The hysterical E. Wake Cook,
fulminating in *The Pall Mall Gazette*, came to the paranoid conclusion that
Post-Impressionism was "the exact analogue" to the "criminal Anarchism
which accompanies Socialism like its shadow".[12] What purported to be an art
exhibition was nothing less than a dastardly smokescreen, veiling a threat to
the very stability of the British Empire and all its institutions. In establishment
circles Fry found himself shunned as a pariah, even by many of those whom
he had earlier counted among his friends.

But he was about to find new allies among a younger generation of artists.
Despite the vilification it aroused, *Manet and the Post-Impressionists* soon came
to be seen as a landmark event. Britain was at last forced to shed its insular
ignorance and confront the radically changing direction of European painting.
"There comes a point when the accumulation of an increasing skill in mere
representation begins to destroy the expressiveness of the design", argued the
catalogue preface, explaining how the adventurous artist "begins to try to
unload, to simplify the drawing and painting by which natural objects are

11. Charles Ricketts to Charles Holmes,
quoted in Holmes, *Self and Partners
(Mostly Self)*, London 1936, p. 280.
12. E. Wake Cook, letter to *The Pall Mall
Gazette*, 10 November 1910.

Fig. 29 (Cat. 73) Roger Fry, *The White Road*, 1912. Oil on canvas, 64.8 x 80.6 cm. The Scottish National Gallery of Modern Art, Edinburgh.

evoked, in order to recover the lost expressiveness and life".[13] This, for Fry, was the essential ambition uniting all the diverse artists in the show, and many emergent painters in Britain were decisively impressed by the work they found on visits to the Grafton Galleries. The old guard at the Royal Academy may have denounced it as "nightmare art", but the most enterprising young painters realised that the so-called madness of Post-Impressionism had transformed the possibilities open to them as they asserted their right to challenge orthodox ideas in the first decade of a new century. David Bomberg, soon to become one of the most audacious artists of his generation, later admitted that the Grafton exhibition helped to bring "the revolution ... to fruition". Like most of his contemporaries, he "had never hitherto seen a work by Cézanne",[14] and this experience alone must have exerted a transforming influence on the work that he went on to produce.

Bomberg himself would never become close to Fry, but several other young painters found themselves working with the critic on an ambitious project only months after *Manet and the Post-Impressionists* had opened. Invited by his old friend Basil Williams to produce a Post-Impressionist mural scheme for the students' dining-room at the Borough Polytechnic in London, Fry responded by enlisting the involvement of five artists: Bernard Adeney, Frederick Etchells, Macdonald ('Max') Gill, Duncan Grant and Albert Rutherston. They joined him with alacrity, and all six men tackled surprisingly large canvases with an enthusiasm that compensated for their lack of experience. Fry himself, who had recently painted a ceiling decoration for a house in Scotland belonging to Sir Andrew Noble, was the most seasoned in terms of working on an architectural scale: as early as 1895 he had painted a chimney-breast in the drawing-room of a house designed by C.R. Ashbee for his mother in Cheyne Walk. Prompted no doubt by his admiration for a mosaic cycle in the church of the Kariye Djamii at Constantinople, Fry suggested that a forceful geometric border run round all the Borough Polytechnic paintings. It lent them a unity they might not otherwise have possessed, but the most outstanding decoration in a generally disappointing scheme was produced by Grant. His energetic *Bathing* scene proved how much he had learnt from Matisse, whose studio he visited when the first version of *Dance* was in progress. Fry would have approved of this influence: around January 1911 Wyndham Lewis drily observed that, after the "melodramatic Christmas Press Pantomime" surrounding *Manet and the Post-Impressionists*, "Roger Fry distinguished himself by at once becoming a pupil of Matisse".[15] At any rate, Grant rapidly became a favourite of Fry, who also demonstrated his high regard for Etchells's *Hip bath* after it was exhibited at the Friday Club in February 1912.

Delighted to realise that Post-Impressionism was firing a significant number of young artists in Britain, Fry befriended them and in May 1912 organized a Paris exhibition of their work at the Galerie Barbazanges. Aside from Etchells, Fry himself, Ginner, Gore, Grant and Lewis, they included Vanessa Bell, who would, for a while, become most closely allied with Fry. He described them with a distinct hint of paternalism as "my little group of English artists" in April 1912, declaring that Grant "certainly has genius, perhaps Etchells also; the others like myself have but a little talent and at least goodwill".[16] Etchells, who had left the Royal College of Art only the previous year, must have been immensely heartened and flattered by the attentions of such a distinguished critic. "We dropped in on each other quite a lot", Etchells recalled, describing how he rented "a house at West Horsley in Sussex which was quite near Fry's Guildford home".[17] But when Fry invited artists to collaborate on murals in the entrance hall of his house, he chose only Bell and Grant to work with him. By this time, the three friends had become so like-minded that the three monumental nudes they painted there were remarkably similar in style.

For the garden of his house, designed in 1910 by himself with help from Gertrude Jekyll, Fry turned to a young sculptor whose work had only just

13. 'The Post-Impressionists', introduction to the catalogue of *Manet and the Post-Impressionists*, Grafton Galleries, London, 1910.

14. David Bomberg, unpublished writings, *c.* 1956, Tate Gallery Archives; see Richard Cork, *David Bomberg*, New Haven and London 1987, p. 16.

15. Wyndham Lewis to Sturge Moore, *c.* January 1911, Sturge Moore Papers, University of London Library.

16. Roger Fry to Charles Vildrac, 1 April 1912, *Letters*, I, p. 356.

17. Frederick Etchells, interview with Richard Cork, 2 June 1970.

Fig. 30 Eric Gill, *Mulier*, 1912. Portland stone, 213.4 x 55.9 x 48.3 cm. The Franklin D. Murphy Sculpture Garden, University of California, Los Angeles, acquired through the Michael J. Connell Memorial Fund, 1965. Photo © Grey Crawford.

arrested his attention. When Eric Gill held his first solo exhibition at the Chenil Gallery, Chelsea, in January 1911, he had been carving for a remarkably short time. Fry, however, was so impressed that he reviewed the show with great enthusiasm, extolling Gill's "simple, sincere and deeply-felt images" before focusing on a Portland stone mother and child and asking, "... has anyone ever looked more directly at the real thing and seen its pathetic animalism as Gill has? Merely to have seen what the gesture of pressing the breast with the left hand means, as he has, seems to me a piece of deep imagination."[18] Accordingly, Fry commissioned a full-length stone figure for his garden (fig. 30). But the completed statue of the Virgin, with ample breasts exposed and one hand guarding her genital area, was turned down.[19] For all the temerity he had shown in organizing the Grafton show, Fry proved surprisingly timid about causing offence to "totally unartistic people coming to the house for my sister's philanthropic meetings and I can't have a largely provocative question mark stuck up for them on the way".[20] Gill reacted with understandable impatience, telling a friend that Fry was "frightened of it and, as my brother said, it hardly goes with strawberries and cream and tea on the lawn at Guildford".[21] Even when Gill stayed the night at Durbins to discuss a replacement, he fell out with his Quaker host on religious grounds and noted in his diary: "Fry v. antagonistic re. Catholicism".[22]

Fry was by no means automatically well-disposed towards artists in sympathy with innovative developments. When Jacob Epstein's nude carvings on the façade of Charles Holden's British Medical Association building in the Strand were threatened by prudish censorship in 1908, Fry had responded swiftly to an urgent plea for a letter of support. The statues were "serious attempts to treat the figure in a manner harmonious with its architectural setting", he wrote, emphasizing that "I failed to find anything approaching 'suggestiveness', and I sincerely hope that such a praiseworthy attempt to solve a difficult artistic problem, and one so full of hope for the future, will not be checked in deference to an agitation which I believe no serious artist or student of art would endorse".[23] Four years later, though, Fry reacted far less favourably to Epstein's *Maternity (unfinished)* when the monumental carving was first exhibited at the Allied Artists' Association in the summer of 1912. Although his friend Clive Bell considered that it would "secure for its author pre-eminence among British sculptors",[24] Fry decided that the pregnant figure lacked "vitality" and lamented that "it is terrible that such a talent and such a force of character and intellect as Mr. Epstein has remained ineffectual".[25]

The other focus of controversy in the Allied Artists' show, however, drew from Fry a notably brave, open-minded and searching response. Wyndham Lewis's *Kermesse*, almost nine feet square in size and by far his most audacious painting to date, excited a great deal of vituperative comment from reviewers. Fry, by contrast, deplored the "serious lack of courageous experiment" in an exhibition where the contributors should have responded to the challenge presented by the Albert Hall's arena. "One artist, and one only, Mr. Wyndham

Fig. 31 (Cat. 78) Roger Fry, *Portrait of Vanessa Bell*, c. 1916. Oil on canvas, 125 x 74 cm. Private collection.

Fig. 32 (Cat. 127) Duncan Grant, *Dancers*, 1912. Oil on canvas, 91.5 x 71 cm. Private collection.

Lewis, has risen to the occasion presented", wrote Fry in one of the most illuminating passages he ever devoted to a living British painter.

"His design of a Kermesse, originally intended for the Cave of the Calf, the new Cabaret Theatre, is the only thing that survives the ordeal of being placed in such ample surroundings. All the rest of the pictures disappear – they might have something to say in other surroundings, but they do not attain to any sufficient constructive unity to impose a definite idea here. Mr. Lewis, on the other hand, has built up a design which is tense and compact. His quantities and volumes have decisive relations to one another: long before one has begun to inquire what it represents, one has the impression of some plastic reality brought about by deliberately intentional colour oppositions. When we begin to look more closely, we find indeed that the rhythm of these elementary geometric forms is based upon the rhythm of the human figure. The rhythm is not merely agreeable and harmonious, but definitely evocative of a Dionysiac mood. For the moment, doubtless, many people will fail to

18. Roger Fry, *The Nation*, January 1911.

19. The rejected garden statue – *Mulier B.V.M.*, is now in the Sculpture Garden at the University of California, Los Angeles.

20. Roger Fry to Eric Gill, 23 June 1911, quoted by Judith Collins, *Eric Gill: The Sculpture*, London 1998, p. 73.

21. Eric Gill to William Rothenstein, 15 July 1911, Clark Library, UCLA.

22. Eric Gill, diary, 8 August 1912, Clark Library, UCLA.

23. Roger Fry, letter in *British Medical Journal*, 4 July 1908.

24. Clive Bell, *The Nation*, 27 July 1912.

25. Roger Fry, *The Nation*, 20 July 1912.

26. *Ibid.*

27. Roger Fry, *The Nation*, 2 August 1913.

Fig. 33 Vasily Kandinsky, *Improvisation No. 30 (Cannons)*, 1913. Oil on canvas, 109.2 x 109.9 cm. The Art Institute of Chicago, Arthur Jerome Eddy Memorial Collection (1931.511).

allow themselves to be influenced by this design, simply because they are not accustomed to exert the passive attention to such a rhythmic disposition of abstract units of form as this art demands. They are familiar enough with such an attitude in music, but they are apt to turn crusty when it is demanded of them by a painter. Fortunately, in the Albert Hall there is a method by which any willing spectator may get a new *aperçu* of such methods of design. Let him look down into the arena from the gallery, and at this vast distance he will not be disturbed by the absence of merely descriptive form, and may see how expressive of a particular mood this abstract harmony is; also, it may dawn upon him that it has a singular force and beauty of colour".[26]

The subsequent loss of *Kermesse* means that Fry's comments cannot be measured against the painting itself. The most reliable surviving study suggests, however, that dancing figures played a more legible role in the canvas than Fry indicated. He was caught up in the pursuit of theories that led him, a year later, to claim that Kandinsky's contributions to the Allied Artists' salon were "pure visual music, but I cannot any longer doubt the possibility of emotional expression by such abstract visual signs".[27] The most important of Kandinsky's exhibits, *Improvisation No. 30 (Cannons)* (fig. 33), now seems

riddled with references to the European military escalation that would soon lead to world war. But Fry preferred to concentrate on a Pater-like celebration of advanced art's musical aspirations. It also enabled him to overcome whatever reservations he may have felt about Picasso and Braque's recent Cubist work, defending it in essentially abstract terms and giving it a substantial presence in his *Second Post-Impressionist Exhibition* at the Grafton Galleries.

Opening in October 1912, this major survey intended, according to Fry's catalogue introduction, to survey Post-Impressionism "in its contemporary development not only in France, its native place, but in England, where it is of very recent growth".[28] In reality, though, the exhibition went a great deal further, including Picasso's most demanding new work and a magnificent selection of recent paintings and sculpture by Matisse. They were the two undoubted titans of the show, and the Francophile Fry left Clive Bell to deal with the "English Group" in a separate catalogue essay.[29] But the selection of artists in this home-grown section undoubtedly reflected Fry's own predilections, ranging from the now inseparable trio of Bell, Fry and Grant to Etchells and his sister Jessie, Gill, Gore, Henry Lamb and Lewis. The prominence accorded to Gill, whose second attempt at a *Garden statue* carving for Fry enjoyed a favoured place in front of Matisse's *Dance I* and two bronzes by the same artist, was countered by the unfortunate absence of Epstein. But the "English Group" was adventurous enough to include two young Slade students: Stanley Spencer, represented by *John Donne arriving in Heaven*, and Edward Wadsworth, added when the exhibition was revised and extended in January 1913.

Within a year, several student contemporaries of Spencer and Wadsworth would make a forceful impact on British art at its most rebellious. Their generation at the Slade were hugely stimulated by Fry's 1912 exhibition, and the lectures he gave at the school on 'The Appreciation of Design in the History of Art' encouraged them to think about Cézanne as much as the early Italian masters. Always at his most eloquent in conversation, Fry would have been invaluable to students restless and enquiring enough to benefit from his presence at the Slade. He offered further encouragement by inviting them to show work alongside Bell, Grant and himself at the Friday Club, a Bloomsbury society which organized a provocative exhibition in 1912 described by one disconcerted reviewer as "a very Witches' Sabbath of fauvism or post-impressionism".[30]

So far as the Slade teachers were concerned, however, the new movements amounted to an appalling threat. Paul Nash, a student there but not yet ready to be won over by the experimental momentum, later recalled how "the Slade was then seething under the influence of Post-Impressionism" and the "professors did not like it at all. The students were by no means a docile crowd and the virus of the new art was working in them uncomfortably. Suppose they all began to draw like Matisse? Eventually, Tonks made one of

28. Roger Fry, 'Introduction', Catalogue for the *Second Post-Impressionist Exhibition*, Grafton Galleries, London, 1912.

29. The exhibition also included a Russian group, selected by Boris Anrep.

30. *The Observer*, 11 February 1912.

his speeches and appealed, in so many words, to our sporting instincts. He could not, he pointed out, prevent our visiting the Grafton Galleries; he could only warn us and say how very much better pleased he would be if we did not risk contamination but stayed away." Since Fry's exhibition triggered what Nash described as "a national upheaval", in which "every canon of art, as understood, was virtually shattered",[31] Tonks can hardly have expected his students to avoid such an explosive event. But he was mortified by the show, and reacted with horror when his old friend George Moore suggested that he ought to be less dismissive of new developments. "My dear Moore," snapped Tonks, "you're untroubled by a conscience, and will never understand a certain side of life. I cannot teach what I don't believe in. I shall resign if this talk about Cubism doesn't cease; it is killing me."[32]

For his part, Fry continued to play an admirably subversive role at the Slade. Between 1913 and the following year he gave talks to the students on subjects as inflammatory as 'The Problem of Representation and Abstract Form', 'Palaeolithic and Children's Drawing' and 'Elements of Abstract Design'.[33] Even Nash, who confessed that he was "left untouched by the second Post-Impressionist exhibition, as by the first",[34] found after leaving the Slade that Fry was surprisingly positive in responding to the watercolours he showed at the 1913 New English Art Club exhibition. Fry met him soon afterwards, telling a friend that he had arranged for Nash "to come later on and try his hand at decorative work" for the newly formed Omega Workshops. "We shall see how he turns out", wrote Fry. "It's a good test of where his power lies. He has imagination of some kind if he can only find the way in which to use it. And he's very sympathetic and I should like to have him with us."[35] Nash felt at this stage even more delighted with Fry, whom he described as "immediately enthusiastic Of course he's the most persuasive & charming person you could ever meet. Dangerous to work with or for but a frightfully shrewd and brilliant brain and pleasant as a green meadow."[36] Nash ended up contributing to the Omega Workshops in 1914, concentrating on Fry's protracted attempts to restore Mantegna's *Triumph of Caesar* paintings at Hampton Court. But the two men's cordial relationship later deteriorated, and when Anthony Bertram told Fry in 1922 that he was writing the introduction to the first book on Nash, Fry "made it clear that he could not expect the support of Bloomsbury in general if he undertook the project".[37]

Alongside his undoubted ability to befriend and encourage artists far younger than himself, Fry could sometimes generate hostility on a spectacular scale. The eruptive walk-out at the Omega Workshops, so soon after they were established, is discussed by Judith Collins elsewhere in this book (see pp. 73–84). Wyndham Lewis's own art-political ambitions may well have heightened the rhetoric in the "round robin" he issued, along with Etchells, Cuthbert Hamilton and Wadsworth, in October 1913. The bitterness in their denunciation of Fry was fuelled by resentment of the extraordinary influence his views now commanded. Some British artists with Post-Impressionist

31. Paul Nash, *Outline. An Autobiography and Other Writings*, London 1949, pp. 92–93.

32. Joseph Hone, *The Life of Henry Tonks*, London 1939, p. 103.

33. From an offical brochure, Fry Papers.

34. Paul Nash, *Outline. An Autobiography and Other Writings*, London 1949, pp. 92–93.

35. *Letters*, I, no. 377.

36. Paul Nash to Gordon Bottomley, 27 December 1913, in *Poet and Painter. Being the Correspondence between Gordon Bottomley and Paul Nash, 1910–1946*, Oxford 1955, p. 68.

37. Andrew Causey, *Paul Nash*, Oxford 1980, p. 83.

allegiances, like J.D. Fergusson, S.J. Peploe and other members of the Fauvist *Rhythm* group, were excluded from the *Second Post-Impressionist Exhibition* because Fry found their work "turgid and over-strained".[38] But Frank Rutter, the art critic of *The Sunday Times* and Fry's main English rival as a champion of the avantgarde, included them in the *Post-Impressionist and Futurist Exhibition* he organized at the Doré Galleries. Opening in the very same month as the Omega walk-out, it struck an implicit blow against Fry's views. Not only were Bell, Fry and Grant excluded from Rutter's representation of the "new movement in English painting";[39] he also made sure that his view of new developments was far wider than Fry's. Futurism, largely dismissed by Fry, was given its place in Rutter's exhibition. So was German Expressionism, along with an exuberant painting of *The Cardiff Football Team* by another artist Fry had ignored, Robert Delaunay (Musée d'art moderne de la Ville de Paris). The modern machine-age world, scarcely admitted to the *Second Post-Impressionist Exhibition*, gave Rutter's show much of its force. And he was prepared to include young artists like Nevinson, whose work already displayed a clear involvement with the urban dynamism of the Futurists' vision. In all, twenty-five British artists were included in Rutter's exhibition, a far greater number than the select members of the "English Group" deemed worthy of display alongside their French and Russian contemporaries at the Grafton Galleries a year earlier.

Despite Fry's refusal to acknowledge the vital contribution made by the Vorticists after the pugnacious advent of *Blast* in 1914, he remained open to the merits of some artists associated with Lewis's belligerent circle. When Bomberg displayed his precociously assured *In the Hold* (fig. 34) at the London Group, Fry singled out the twenty-three-year-old painter in his review of the exhibition:

Of Mr Bomberg it would be rash to prophesy as yet, but this much may be said, that he has the ambition, the energy and brain power to strike out a line of his own. He is evidently trying with immense energy and concentration to realize a new kind of plasticity. In his colossal patchwork design, there glimmers through a dazzling veil of black squares and triangles the suggestion of large volumes and movements. I cannot say that it touched or pleased me, but it did indicate new plastic possibilities, and a new kind of orchestration of colour. It clearly might become something, if it is, as I suspect, more than mere ingenuity.[40]

Even Henri Gaudier-Brzeska, who had aligned himself far more closely with the Vorticist cause than Bomberg, was given a generous tribute by Fry after the young sculptor's death in the First World War. While declaring that the attempt "to treat organic forms with a system of plasticity derived from mechanical objects" was not "in line with Gaudier's special gifts and artistic temperament", Fry conceded that it was "only natural that the experiments of

38. Roger Fry, *The Nation*, 11 November 1911.

39. Frank Rutter, foreword, *Post-Impressionist and Futurist Exhibition*, exhib. cat., Doré Galleries, London, 1913.

40. Roger Fry, *The Nation*, 14 March 1914.

Fig. 34 David Bomberg, *In the Hold*,
1913–14. Oil on canvas, 198 x 256.5 cm.
© Tate Gallery, London, 1999.

41. Roger Fry, 'Gaudier-Brzeska,' *The
Burlington Magazine*, XXIX, 1916,
pp. 209–10.

42. Walter Sickert, Introduction, *Exhibition
by S.J. Peploe, Leslie Hunter, F.C.B. Cadell
and J.D. Fergusson*, London, Leicester
Galleries, 1925.

Cubism, and its offshoot Vorticism, should attract him". Fundamentally, Gaudier was "seeking to create a classic art, one of purely formal expressiveness", and his "talent was sufficiently formed, his future sufficiently outlined, to make us feel how terrible a waste the loss of such a life is".[41]

Such a tribute, from a writer whose standpoint Gaudier had often opposed, goes some way towards exonerating Fry from the common accusation that he used his formidable influence solely to boost the careers of his friends among the artists of early twentieth-century England. Sickert once wrily observed that, "while Post-Impressionist painters in France have been not inconveniently divided into Fauves and Faux-Fauves, the corresponding division in England may be said to have been practically established as between Post-Impressionists licensed by Mr. Fry, and those unlicensed by Mr. Fry".[42] He could at times be woundingly dismissive, and those who found themselves banished far beyond Bloomsbury's aesthetic boundaries often bridled at their marginalization. But the beneficent effect of Fry's two great Post-Impressionist exhibitions is indisputable, and the sympathetic insights in his critical reviews of contemporary British artists are as manifold as they are valuable. Even when not writing directly about them, Fry could provide vital inspiration for young

practitioners seeking a fruitful path through the proliferating thickets of experimentation.

Perhaps the truth about his effect on modern British art is summed up in the most balanced way by Henry Moore. Late in life, he recalled that "when I came to London as a raw provincial student, I read things like *Blast* and what I liked was to find somebody in opposition to the Bloomsbury people, who had a stranglehold on everything".[43] At the same time, though, Moore emphasized that Fry had already been a transforming influence. Remembering his time at Leeds School of Art after the First World War, he described how "*Vision and Design* was the most lucky discovery for me. I came on it by chance while looking for another book in the Leeds Reference Library." Excited in particular by the essay on African carvings, he discovered that "Fry opened the way to other books and to the realisation of the British Museum".[44] Moore's work as an outstanding young sculptor was about to commence, and he explained in retrospect that "once you'd read Roger Fry the whole thing was there".[45]

43. Henry Moore, conversation with Richard Cork, 23 October 1972.

44. Henry Moore, statement in *Partisan Review*, XIV, no. 2, March-April 1947, quoted in Richard Cork, *Vorticism and Abstract Art in the First Machine Age*, vol. 2, London 1976, p. 551.

45. Henry Moore, conversation with John and Vera Russell, *The Sunday Times*, 17 and 24 December 1961.

ROGER FRY'S SOCIAL VISION OF ART

JUDITH COLLINS

Fig. 35 (Cat. 145) Duncan Grant, *Omega Workshops Signboard*, May 1915. Oil on wood, 104.1 x 63.2 cm. The Victoria and Albert Museum.

In April 1909 Roger Fry and six prominent figures in the London art world met at the home of Philip and Lady Ottoline Morrell to discuss the founding of the Modern Art Association, which had as its aim the encouragement of young living British artists by purchasing their recent work and by organizing exhibitions of it around the country. The following year the group settled on the name of the Contemporary Art Society, in which Fry was the major figure and one of the first purchasers for the Society. 1910 was also the year of Fry's first Post-Impressionist exhibition, and his friend and colleague Clive Bell noted that "One result of the first Post-Impressionist exhibition was that Roger Fry became the animator and advocate of the younger British painters ... to him they looked for advice and encouragement and sometimes for material support."[1] Fry was not a rich man, but with his Quaker background he was animated by a generous sense of public duty and philanthropy. When in 1913 he set up his Omega Workshops, a decorative arts workshop that employed young artists part-time for three half-days a week to produce designs for household objects and interiors, he was sometimes hard pressed to find the money to pay their weekly wages of 30s. each. This was equivalent to the average weekly wage of an office worker, and Fry's daughter remembered that their gardener was paid a guinea a week in 1913. Fry was therefore providing a generous subsidy for his Omega artist employees, as well as leaving them sufficient time to practise their main professions as painters and sculptors. The Omega provided for them in a more practical way than the Contemporary Art Society could. It also provided an opportunity for Post-Impressionism to enter into domestic decorations and furniture.

In February 1911 Fry was offered the post of Keeper of the Tate Gallery on the retirement of D.S. MacColl. He declined the offer and in a letter to his mother explained his reasons for doing so: "I simply couldn't have managed on the salary 350 rising to 500 [pounds], as it would have stopped all my other work, and really I think I can do more outside. So I must give up the idea of official life and titles and honours, which I very willingly do, so long as I can manage somehow to get along as regards money. I once wanted those things but now I feel quite indifferent to them."[2] Although Fry was one of the most important figures in the British art world, he never joined the great state institutions such as the National Gallery or the Tate Gallery, preferring instead to remain a private agent. This gave him the freedom to examine the way

museums and galleries functioned, and he found much to challenge and criticize. He made his criticisms of state patronage and the moribund role of art in contemporary society widely known both by his writings and his actions. His most significant texts on these matters are 'Art and Socialism', written in 1912; 'Art in a Socialism', published in *The Burlington Magazine* in April 1916; 'The State and the Artist', published in *The Nation* in February and March 1924; *Art and Commerce*, published by the Hogarth Press in 1926, and 'Art and Industry', published as a memorandum in the Gorell Report on the 'Production and Exhibition of Articles of Good Design and Everyday Use' in 1932. His actions included setting up the National Art Collections Fund in 1903, saving *The Burlington Magazine* the same year, and setting up the Contemporary Art Society in 1910 and, most significantly, the Omega Workshops in 1913. Kenneth Clark wrote of Fry at the time of his death in 1934: "In so far as taste can be changed by one man, it was changed by Roger Fry."[3]

Fry was vehemently opposed to state art colleges, believing that they stifled individual creativity and experimentation. He wrote an article entitled 'Teaching Art' in 1919, which began: "The words sound wrong, somehow, like 'baking ices', 'polishing mud' or 'sliced lemonade' The Royal College of Art, for many years has absorbed considerable amounts of public money, and has produced, not artists, but – it breeds true to type – only more 'Art Teachers'. And apparently the more 'Art Teachers', the less art."[4] Fry thought that the state should set up "for young men who have shown special aptitude in this direction, and who desire to adopt design as a profession, a Laboratory of Design rather than a School of Design. I imagine an institution where all necessary apparatus, which is by no means complicated or expensive, for making designs would be supplied, where also there would be a certain small staff fully equipped with the purely technical knowledge of the exact requirements of various industries ... how a design must be made so as to repeat on a textile fabric, what are the conditions for a woven as opposed to a printed design and so forth."[5] Fry wrote these sentences with a deep and hard-won knowledge of such matters, having overseen the production of textiles and other applied arts for the six years of the Omega's existence, from July 1913 to July 1919. With the setting up of his Omega Workshops Fry believed that he was providing the prototype for a larger "Laboratory of Design", but no one else took up the challenge when the Omega closed.

One of the main thrusts of Fry's influence was his abhorrence of skill in art, and this idea sat unhappily with the British public. He first announced his espousal of this notion in his introduction 'The French Group' in the catalogue which accompanied the Second Post-Impressionist Exhibition in 1912. In this he reminded his readers that the English public had become aware in 1910, at the time of *Manet and the Post-Impressionists*, of a new movement in art that "implied a reconsideration of the very purpose and aim as well as the methods of pictorial and plastic art. It was not surprising therefore that a public which has come to admire above everything in a picture the skill with which the

NOTES

1. Clive Bell, *Old Friends,* London (Chatto and Windus) 1956, p. 83.

2. *Letters*, I, p.341.

3. *Last Lectures*, p. ix.

4. Roger Fry, 'Teaching Art', *The Athenaeum,* 12 September 1919, p. 887.

5. Roger Fry, 'The State and the Artist', *The Nation*, 1 March 1924, p. 762.

Fig. 36 (Cat. 104) Roger Fry and Duncan Grant, *Lilypond Screen*, *c.* 1913. Four-fold screen, each panel 175 x 60.5 cm. Courtauld Gallery.

artist produced illusion should have resented an art in which such skill was completely subordinated to the direct expression of feeling."

In his most general art history book, *The Arts of Painting and Sculpture*, Fry wrote that art can be made for two reasons, first "with biological or business ends in view", and secondly "in response to the free impulse which we may call the aesthetic impulse If this impulse is so overpowering that the artist is quite incapable of modifying his imagery in any way in order to satisfy the

exigencies of other people, we may call him a pure artist."[6] He noted that works of art which ostentatiously reveal that they are the result of prolonged and skilled labour are really objects of luxury used to convey social superiority. Fry acknowledged on more than one occasion that he had read Thorstein Veblen's book *The Theory of the Leisure Class*, published in 1899. In his 1926 Hogarth Press essay *Art and Commerce* Fry drew attention to Veblen's ideas about the consumption of works of art:

the warrior caste in any primitive society had a right to the biggest spoils of successful warfare. A man was known as a member of that caste by the trophies he was able to display on his own person and the persons of his womenkind and dependents. Modern societies have not altogether forgotten these facts, and, consequently, the gentleman is known by the hints – sometimes blatant, sometimes subtle – which he throws out to all the world that he possesses spoils and is one of our conquering class Societies of all kinds no less than individuals have recognised this fact Big banking firms encase their offices in marble, and load their doors with chased bronze; town councils expand the façades of their town halls, and have frescoes advertising the glory of the town's history painted on their walls; nations flaunt their Law Courts and pile up expensive national memorials in their capitals.[7]

Later, in *Art and Commerce*, Fry invented two words, "opificer" and "opifact", to describe makers and objects that could not be accommodated easily within the aesthetics of the pure art world. An "opificer" was a person who could not be dignified by the appellation of artist or craftsman, but who made things, "opifacts", solely for conspicuous consumption and display. Fry identified two historical periods, the ancient Roman Empire and the nineteenth century, when opificers produced opifacts in great numbers to satisfy social and moral needs. In his essay 'Retrospect', the coda to the collection of essays *Vision and Design* published in 1920, Fry reminded his readers that he had been accused of attacking the social and cultural values of London by mounting the two Post-Impressionist exhibitions:

I found that the cultured public which had welcomed my expositions of the works of the Italian Renaissance now regarded me as either incredibly flippant or ... slightly insane. In fact, I found among the cultured who had hitherto been my most eager listeners the most inveterate and exasperated enemies of the new movement. The accusation of anarchism was constantly made I was for long puzzled to find the explanation of so paradoxical an opinion and so violent an enmity. I now see that my crime had been to strike at the vested emotional interests. These people felt instinctively that their special culture was one of their social assets. That to be able to speak glibly of Tang and Ming, of Amico di Sandro and Baldovinetti, gave them a social standing and a distinctive cachet It was felt that one could only appreciate Amico di

6. Roger Fry, *The Arts of Painting and Sculpture,* London (Gollancz) 1932, p. 19.

7. Roger Fry, *Art and Commerce,* London (Hogarth Press) 1926, p. 90.

Sandro when one had acquired a certain considerable mass of erudition and given a great deal of time and attention, but to admire a Matisse required only a certain sensibility. One could feel fairly sure that one's maid could not rival one in the former sense, but might by a mere haphazard gift of Providence surpass one in the second. So that the accusation of revolutionary anarchism was due to a social rather than an aesthetic prejudice.[8]

In another essay on the same topic, 'Culture and Snobbism', included in the collection *Transformations* in 1926, Fry again speculated on the social use and abuse of art and how this affected the production of works of art:

The artist, in whose breast the divine flame is kindled, finds himself confronted with these two religions of culture and snobbism What I have elsewhere defined as the "Opificer" is backed by considerable funds, both from the patronage of the State and other public bodies, and from the private patronage of the Philistine. But the pure artist finds that, apart from the support of those few individuals who not only have cultivated by careful study a natural love of art but possess the means to gratify their passion, almost the only fund on which he can rely depends on the favour of snobbism In modern life great works of art have generally been produced in defiance of the tastes and predilections of society at large. The artist, therefore, except in those cases where he possesses inherited means, must be able to live and function on an extremely small sum. He must exist almost as sparrows do, by picking up the crumbs that fall from the rich man's table.[9]

Of all Fry's writings, the one that came closest to explaining his reasons for establishing the Omega Workshops was his 1912 essay 'Art and Socialism'. This was written as a contribution to *The Great State*, a collection of essays edited by H.G. Wells and devoted to an examination of social issues in all areas of contemporary life in Britain. Here Fry investigated the position of the artist in the modern state, and tried to discover how ideally the state might best make use of the artist's creativity. His conclusion was that the state should not be involved at all, in the light of its poor record to date: "... the tradition that all public British art shall be crassly mediocre and inexpressive is so firmly rooted that it seems to have almost the prestige of a constitutional precedent." Further on in the article Fry wrote:

I suppose that in the Great State we might hope to see such a considerable levelling of social conditions that the false values put on art by its symbolising of social status would be largely destroyed, and, the pressure of mere opinion being relieved, people would develop some more immediate reaction to the work of art than they can at present achieve. Supposingly it was found impossible, at all events at first, to stimulate and organise the abstract creative power of the pure artist, the balance might after all be in favour of the new

8. Roger Fry, *Vision and Design*, London 1920, pp. 234–35.

9. 'Culture and Snobbism', *Transformations*, 1926, p. 83.

order if the whole practice of applied art could once more become rational
and purposeful.[10]

Having proposed that it might be easier to bring about a change in the public
attitude to art if priority and patronage of a kind were given to the applied
rather than the pure fine arts, he also stated with great conviction that "the
greatest art has always been communal, the expression – in highly individual
ways no doubt – of common aspirations and ideals".[11]

Although this text predates the Omega by a year, Fry had by then
attempted to put some of his views on the position of the artist in society into
practice. In the summer of 1911 he secured a commission for the mural
decoration of the students' dining-room at the Borough Polytechnic, at the
Elephant and Castle, London, through the acquaintance of an old Cambridge
friend, Basil Williams. The painters he chose for the murals were Bernard
Adeney, Frederick Etchells, Duncan Grant, Macdonald Gill and Albert
Rutherston, as well as himself. In autumn 1911 Fry gave a lecture at the
Polytechnic on modern painting and its possibilities with regard to murals and
interior design. It seems that the student response was not over enthusiastic at
the unveiling of the murals, but Virginia Woolf in her biography of Fry
recorded that he believed that his lecture had converted a sceptical audience
to his view of the function of art in the modern state. The views he put
forward must have been similar to those aired in 'Art and Socialism', which he
was probably writing at that time. The notion of a communal artistic
workshop – the Omega Workshops – seems to have evolved from the

10. Roger Fry, 'Art and Socialism', in *Vision
and Design*.
11. *Ibid.*, p. 49–50

community spirit that Fry witnessed among the painters he employed to create the Borough Polytechnic murals.

In an interview with a journalist in April 1913, just when Fry was announcing the formation of the Omega Workshops, he referred back to the Borough Polytechnic mural experience. Speaking of the Omega, Fry said:

I hope to get a group of young artists to work together, freely criticising one another, and using one another's ideas without stint. I think it very important that they should work together in this way, and that we should cease to insist on the extreme individuality of artists. This was borne in upon me very much when I got a group of young artists to decorate the Borough Polytechnic. They all worked together, taking their ideas from one another, developing them along their own lines, and feeling so thoroughly all the time that the work was a common effort that they refused to sign the pictures, saying "No, these we did together; let there be no individual signatures".[12]

He seems to have overlooked the fact that both Grant and Rutherston signed their murals, although Grant's name is mainly obscured by brushstrokes. Fry revived this idea of withholding artist's identities when he set up the Omega Workshops; all designs and products were signed with the Omega symbol and were anonymous. The communal spirit was paramount, not the individual.

Just before the opening of the Omega, in March 1913, Fry organized an exhibition of the work of his young painter friends at the Alpine Club Gallery in Mill Street. Besides Fry himself, other exhibitors included Vanessa Bell, Duncan Grant, Frederick Etchells, Wyndham Lewis, Cuthbert Hamilton and Edward Wadsworth. He invented the name of the Grafton Galleries Group as if to announce solidarity among the artists and had the bold idea of exhibiting the work without labels. The catalogue stated, "It has been thought interesting to try the experiment of exhibiting the pictures anonymously in order to invite the spectator to gain at least a fresh impression of the several works without the slight and almost unconscious predilection which a name generally arouses".[13] Fry's notion of anonymity brought with it some problems. All the artists of the Grafton Galleries Group were early employees at the Omega, but after a couple of months Lewis led a revolt and took away with him Etchells, Hamilton and Wadsworth to found a rival decorative arts workshop, the Rebel Art Centre.

The idea of artistic communities, to help the plight of young practising artists who could not live by painting pictures alone, was in the air just prior to the beginning of the First World War. Arthur Clutton-Brock, art critic for *The Times*, author of a book on William Morris and a friend of Fry, was in favour of a communal scheme, but it did not reach reality. Augustus John and his friend Stewart Gray, an ex-lawyer, conceived of a philanthropic project to help young artists who were not making a living selling their work. Gray bought cheaply the end of a lease of a large house in Ormonde Terrace in Primrose Hill, and

12. *The Pall Mall Gazette,* 12 April 1913.

13. Virginia Woolf, *Roger Fry: A Biography,* London (Hogarth Press) 1940, p. 173.

14. G.B. Shaw Collection, The British Library.

15. *The Observer,* 14 December 1913.

16. Omega Workshops Prospectus, September 1913, Tate Gallery Archive, unpaginated.

Fig. 38 (Cat. 134) Duncan Grant, *Flowers in a Vase* (design for a fire-screen), 1913–14. Pastel on paper, 63.5 x 47.8 cm. Courtauld Gallery (PD 95).

Fig. 39 (Cat. 149) Nina Hamnett, *Interior with Painted Walls and Elephant Tray*. Oil on card, 46.9 x 30.8 cm. Courtauld Gallery.

let the rooms at a nominal rent to struggling young painters. But Fry's Omega Workshops was the grandest, and most successful in terms of what it offered and what it drew from its grateful employees. A fundraising letter exists, which Fry sent to Bernard Shaw on 11 December 1912, which gave details of the projected financial structure of his venture: "I calculate that the total expenses of running this workshop will be about £600 to £700 a year. I require about £2000 capital to give the scheme a fair chance; for at the end of three years it will be evident whether I am right in believing that there is a real demand for such work I shall hope to arrange later for a co-operative or profit-sharing scheme among the workers."[14] Shaw wrote on the letter "Sent £250", and by the end of December 1912 Fry had raised £850. The Omega Workshops were set up on 14 May 1913 as a limited company with its registered office at 33 Fitzroy Square, and with a capital of £1000 in £1 shares, so Fry did not reach his £2000 total. On 11 July a Return of Allotments paper was drawn up, with five shareholders listed; Fry with 300, Sir Alexander Kay Muir with 100, Vanessa Bell with 50, Lady Ian Hamilton with 50 and Duncan Grant with 1. On 14 July Fry, Vanessa Bell and Duncan Grant signed a document listing them as Directors of the Omega Workshops Limited. A profit-sharing scheme did not materialize, although the Workshops lasted for longer than the three years cited in Fry's letter. In order to announce the existence of the Omega Workshops in Fitzroy Square to the London art world, Fry asked Duncan Grant to paint a large signboard to hang outside the front door at no. 33, a door that shocked local residents with its bright-red colour. Grant's first attempt at a signboard is lost, but the art critic P.G. Konody described it as "an emaciated Byzantine youth who swings upon the signboard ... with lettering of the stodgy pattern dear to the twentieth century tradesman."[15] Fry, Grant and Bell were interested in Byzantine art , especially its communal, anonymous mural schemes, and Grant's odd youth was probably made in homage to this. However, it was rejected in favour of one with a schematized still life with flowers on one side and the Omega symbol riding on top of stylized marbling and diagonal stripes on the other (fig. 35).

Two prospectuses were printed and one contains a mission statement:

The Omega Workshops Ltd is a group of artists who are working with the object of allowing free play to the delight in creation in the making of objects for common life. They refuse to spoil the expressive quality of their work by sand-papering it down to a shop finish, in the belief that the public has at last seen through the humbug of the machine-made imitation of works of art. They endeavour to satisfy practical necessities in a workmanlike manner, but not to flatter by the pretentious elegance of the machine-made article. They try to keep the spontaneous freshness of primitive or peasant work while satisfying the needs and expressing the feelings of the modern cultivated man.[16]

This was Fry on his favourite topic of skill versus freshness and freedom of

TOP Fig. 40 (Cat. 214) Omega-ware, *Soup tureen*, undated. Painted with blue glaze; 22.5 x 29.8 cm. (with lid). Courtauld Gallery (0.1935 RF 180).

ABOVE Fig. 41 (Cat. 211) Omega-ware, *Bowl with cover*, undated. Blue glaze, 10.8 x 14.7 cm (with lid – 15.3 x 15.9 cm). Courtauld Gallery (0.1935 RF 173).

RIGHT Fig. 42 (Cat. 19) Vanessa Bell, *Vase*, undated. Blue and pale turquoise glaze, height 36.5 cm. Courtauld Gallery (0.1935 RF 175).

17. *Ibid.*
18. Omega Workshops Descriptive Catalogue, October 1914, Tate Gallery Archive, unpaginated.

expression. He was "against the obliteration of traces of the actual strokes made by the artist's tools in the execution of his work" because this "implies servitude to a master" and an adherence to the notion of "shop-finish". Polishing and smoothing away irregularities were, he felt, absolutely contrary to the aesthetic impulse, because they denied "a fundamental need of that impulse, the need to express sensibility".[17] The second and larger Omega prospectus listed the types of decorative objects and schemes available with prices – Decorative Painting and Sculpture, Mosaic, Stained Glass, Dress, Furniture, Textiles, Printed Linens, Pottery, Carpets, Doormats, Toys and Miscellaneous Items – along with eleven black-and-white photographs of some items.[18]

Fry felt very strongly that, among the applied arts, pottery was a good indicator of the aesthetic state of the nation. He wrote significant articles about historic and contemporary pottery, and in autumn 1913 began to take lessons in potting himself, which led to the production of an impressive body of glazed earthenware for the Omega Workshops. One of his notable texts on pottery was 'The Art of Pottery in England', published in *The Burlington*

Fig. 43 (Cat. 105) Roger Fry, *Marquetry cupboard*, c. 1915–16. Maker, J. J. Kallenborn. 162 x 106.7 x 35.5 cm. Manchester City Art Galleries.

19. *The Burlington Magazine*, XXIV, March 1914, p. 333.

20. Omega Workshops Descriptive Catalogue, October 1914, Tate Gallery Archive, unpaginated.

21. *Ibid.*

22. Winifred Gill, taped conversation with Stephen Chaplin, 1962; transcript in collection of the National Art Library, Victoria and Albert Museum.

Magazine in March 1914. It was partly a review of an exhibition of *English Pottery* at the Burlington Fine Art Club, but also a manifesto of what good pottery could be, and how it could play an important social role: "... pottery is of all the arts the most intimately connected with life, and therefore the one in which some sort of connexion between the artist's mood and the life of his contemporaries may be most readily allowed." The exhibition revealed that between the thirteenth and fifteenth centuries "one kind of pottery was made apparently alike for rich and poor", but in later centuries two kinds were made, one that satisfied the rich and one that functioned for the poor.[19] In the preface to the Omega Workshops Catalogue of products which Fry produced in October 1914, his short introductory text contrasted the lack of finish in an African pot with modern Sèvres china:

It will become apparent that the negro enjoyed making his pot .. and you share his joy in creation, and in that forget the roughness of the result. On the other hand the modern factory products were made almost entirely for gain, no other joy than that of money making entered into their creation. You may admire the skill which has been revealed in this, but it can communicate no disinterested delight. The artist is the man who creates not only for need but for joy, and in the long run mankind will not be content without sharing that joy through the possession of real works of art, however humble or unpretentious they may be.[20]

Fry announced in the paragraph on pottery in the Omega prospectus that "Omega pottery is made on the wheel by artists and ... not merely executed to their design. It therefore presents, as scarcely any modern pottery does, this expressive character".[21] Fry, Grant and Bell took lessons from a potter called George Schenck in Mitcham, south London, from autumn 1913 to autumn 1914. Then, through a Quaker friend, Fry met Roger Carter, a member of the family who ran Poole Potteries in Poole, Dorset. Bell and Grant stopped trying to make pots but Fry persisted and the superior facilities at Poole enabled him to attempt a wider range of pottery shapes. With Schenck, Omega pottery had been earthenware covered with a white-tin glaze, some pieces enlivened with hand-painted decoration. Poole Potteries were able to offer Fry assistance in making items in bulk, such as dinner and tea sets, because they made moulds from his originals. Fry was not against such mechanization because the casting methods still retained "the nervous tremor of the creator". Fry's distinguished dark cobalt blue glazed pottery was introduced in 1915 and black dinner services and vases appeared in 1916 (figs. 40, 41, 42).

Fry turned to two more firms to help produce two other categories of Omega items, printed linens and marquetried furniture. Winifred Gill, Fry's assistant at the Omega, remembered that the marquetried furniture was "made by a Pole called Kallenborn, who worked for Ambrose Heal [of Heal's & Co.] in nearby Tottenham Court Road".[22] John Joseph Kallenborn started his furniture business in 1905 at 65 Stanhope Street, just across the Euston Road

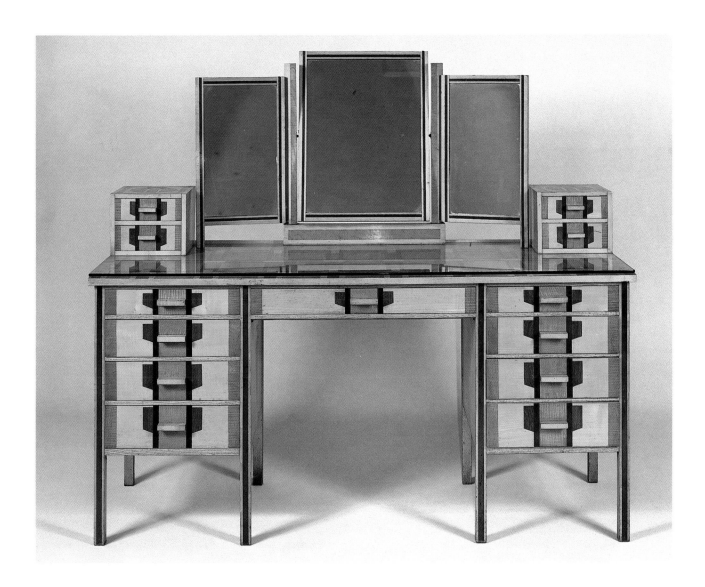

Fig. 44 (Cat. 106) Roger Fry, *Marquetry dressing-table with mirror*, c. 1915-16. Maker, J. J. Kallenborn.
135.75 x 149.8 x 52.1 cm. The Victoria and Albert Museum, London.

from Fitzroy Square, and he worked creatively with the Omega, helping to produce some of its most handsome and idiosyncratic pieces. They were also the most expensive items: an occasional marquetried table with tray underneath was listed at £9.9s.0d. Unique pieces could be commissioned and a marquetry cupboard sporting two giraffes was made for Lady Tredegar (fig. 43). The Omega produced a range of six printed linens; unable to find an English firm willing to work in the loose expressive way required, Fry discovered a French colour printers, the Maromme Print Works in Rouen, "... who specially adapted and modified the ordinary technical processes so as to retain as much as possible the freedom and vitality of the original drawings".[23] It has been assumed that the technical processes utilized printing from wooden blocks covered with felt. Fry was extremely pleased with the Omega linens and he donated pieces of them to the Victoria and Albert

23. Omega Workshops Descriptive Catalogue, October 1914, Tate Gallery Archive, unpaginated.

24. Accession files, Department of Textiles, Victoria and Albert Museum.

ABOVE Fig. 45 (Cat. 113) Roger Fry, *Mechtilde*, 1913. Printed linen, 55 x 79 cm. The Gallery of Costume, Manchester City Art Galleries (Omega 1940.253).

TOP RIGHT Fig. 46 (Cat. 110) Roger Fry, *Amenophis III*, May 1913. Printed linen, 46 x 80 cm. The Whitworth Art Gallery, University of Manchester (Omega T.19.84).

RIGHT Fig. 47 (Cat. 111) Roger Fry, *Amenophis Vb*, May 1913. Printed linen, 82.5 x 53.5 cm. The Whitworth Art Gallery, University of Manchester (Omega T.20.83).

Museum in November 1913 to show during evening lectures there. They were then accessioned by the Museum as it was felt that they might "become great curiosities in the future".[24] Fry registered all six printed linens on 9 July 1914; they were called Margery, Amenophis, Pamela, Maud, Mechtilde and White (figs. 45, 46, 47).

The Omega was established in order to communicate a sense of joy through the colourful and expressive decoration of humble and unpretentious household objects. It lasted for six years, 1913 to 1919, through the difficult years of the First World War, and was a noble and unique experiment. Only someone with Fry's energy, passion and sense of social commitment would have dared to attempt it.

PART II

ESSAYS ON ROGER FRY:
REMAKING THE CANON

ROGER FRY AND EARLY ITALIAN PAINTING

CAROLINE ELAM

Fig. 48 Antonello da Messina, *Pietà*, *c.* 1475. Oil on panel, 117 × 85 cm. By kind permission of the Museo Correr, Venice.

FACING PAGE Fig. 49 Roger Fry, *Desco da parto*, 1900. Oil on panel, diameter 46 cm. Berenson Collection, Florence, reproduced by kind permission of the President and Fellows of Harvard College.

Fry's contribution to the study of early Italian art and the art of the old masters has understandably received less attention than his role as champion of Cézanne, Post-Impressionism and the arts of non-Western civilizations. In the context of the history of twentieth-century taste, Fry the student of Italian 'primitives' was only one among many, whereas in his advocacy of modern art and the art of other cultures his position is rightly seen as seminal. However, Fry's approach to earlier art is distinctive in character, and worth studying in its own right. It has often been pointed out, not least by Fry himself, that his taste for the 'primitives' fed into his modernist aesthetic choices, but the assumption that those choices can then be consistently read back into his views of earlier art can produce unhelpful distortions. In a sense these were again encouraged by Fry in the sparse and sometimes surprising selection he chose to make of his earlier writings for *Vision and Design* in 1920 and for *Transformations* in 1926.[1] As a consequence, relatively little is now readily available (although there has been a welcome reprint of his book on Bellini)[2] and much of his best work on earlier art remains buried in the periodical literature and in unpublished lectures.

The formation of Fry's views on Italian art

It was at Cambridge that Fry's visual responses and his concern with aesthetics were first awakened,[3] and he was already writing at the beginning of his second year reading Natural Sciences about the "value ... of pure aesthetics as apart from the emotional end". Significantly, this letter was to the future arts and crafts designer C.R. Ashbee, who never forgot their intense discussions.[4] Fry was already writing on art and contemplating an artistic career, perhaps as an architect. At this stage he had a soft spot for the Pre-Raphaelites, expressing enthusiasm for Millais, Burne-Jones, Rossetti and G.F. Watts ("the greatest modern painter").[5]

During his first trip to Italy in 1891, Fry's taste was relatively uncertain and unformed. He travelled all over the peninsula, but felt particularly at home in Venice, where he revelled in Tintoretto, Veronese and Tiepolo, and was teased by John Addington Symonds.[6] It was during his second Italian visit, in 1894, that he began to study in earnest, preparing for the first University Extension Lectures on Leonardo and Florentine Art that he gave the same year. He worked hard at Uccello and Masaccio, who he hoped would help him "to a better idea of drawing", while secretly yearning for "some big, sloppy modern like Velazquez or Gainsborough".[7]

NOTES

I am very grateful to Chris Green, Nicholas Penny, Cathy Pütz and Richard Shone for their help, and to Walter Kaiser for his hospitality at Villa I Tatti, Florence, which enabled the completion of this essay.

1. In *Vision and Design*, the Giotto essay is seminal, but it is hard to see why he included 'The Art of Florence' or 'The Jacquemart-André Collection' over some of the pieces considered below. In *Transformations*, 'The Seicento' is a conflation of Fry's review of Wölfflin's *Renaissance und Barock* with his essay wrongly entitled 'Settecentismo', while 'Fra Bartolommeo' stitches together some smaller pieces on the artist into a new overview.

2. Roger Fry, *Giovanni Bellini* [1899], introduction by David Alan Brown, afterword by Hilton Kramer, New York 1995.

3. For Fry at Cambridge, and his biography in general, see Woolf 1940 and Spalding 1980.

4. *Letters*, I, p.110, Fry to C.R. Ashbee, 22 October 1886. In his obituary notice of Fry (*The Times*, 12 September 1934), Ashbee quoted this and other letters, of which he had reminded Fry when he was appointed Slade Professor at Cambridge in 1933, as providing a good start for making "an acceptable body of aesthetics".

5. *Letters*, I, pp. 113, 117, 123, 158.

6. *Letters*, I, pp. 125–48. Fry found himself reluctantly defending Botticelli. "Symonds ended by saying 'Of course we are all very thankful to Botticelli for having inspired those pages of Walter Pater', and then ... 'That is the worst thing I've yet said about Botticelli'" (p. 146).

7. *Letters*, I, pp. 159–60, Roger to Margery Fry (1894).

8. Roger Fry, *Giovanni Bellini*, London 1899; for the reprint, see note 2.

9. For a superb analysis, see Donata Levi, *Cavalcaselle: il pioniere della conservazione dell'arte italiana*, Turin 1988.

10. For Morelli, see Richard Wollheim, 'Giovanni Morelli and the Origins of Scientific Connoisseurship', in *On Art and the Mind*, Cambridge MA 1974; *La figura e l'opera di Giovanni Morelli*, Bergamo 1987. Fry's comment, which referred to the collector Ludwig Mond, but at least partly to himself, is in Roger Fry, 'The Mond Pictures at the National Gallery', *The Burlington Magazine*, XLIII, May 1924, p. 234.

It seems, then, that initially Fry was impelled towards "the early men" more by the tide of the times and current scholarship than by natural inclination. But what began as a duty turned into a passion. He discovered a natural gift for lecturing and gave a course on the early Venetians. Out of these came his first book, on Giovanni Bellini, published in 1899,[8] which is a relatively conventional production, but already evinces some of Fry's characteristic strengths, his sympathetic understanding of technique, his brilliant evocation of colour, and his ability to sum up the emotional expressiveness of a painting in a single sentence.

The success of his first book plunged him into an arduous routine of lecturing, writing regular criticism, first for the *Pilot*, then for *The Athenaeum*, as well as struggling to paint, while his wife Helen's mental state continued to cause him untold anguish. Occasionally there was an opportunity to write at greater length, as when the *Monthly Review* asked him to rework his lectures on Giotto for publication. Studying early Italian (and Flemish and French) art continued to be one of his main preoccupations until the First World War, and never ceased to concern him for the rest of his life.

Fry and 'scientific criticism'

The serious study of Italian renaissance art had been put on a new footing by Crowe and Cavalcaselle with their series of volumes published in English in the 1860s and 1870s, written by Crowe, but based largely on Cavalcaselle's intensive first-hand study of the works.[9] But the books that inspired Fry's generation were above all those of Giovanni Morelli and Bernard Berenson. Morelli, with his restrictionist view of the oeuvres of artists, his elimination of unworthy works from the canon and his self-proclaimed scientific method relying on detailed morphology (he had been trained as a doctor and comparative anatomist), appealed, as Fry later observed, "to men of a positive and scientific bent".[10] Fry never met Morelli, who died in 1891, but in 1894 he studied his work intensively in Italy with Augustus Daniel,[11] and was delighted to run into Morelli's editor and curator, Gustavo Frizzoni, and to be able to see his collection.[12] Berenson, in some sense Morelli's heir, had decided to dedicate his "entire life to connoisseurship", which he defined as distinguishing "between the authentic works of an Italian painter of the fifteenth and sixteenth century and those commonly ascribed to him".[13] He proved to be of even greater importance to Fry as they became for a time friends and *confrères*. Although Fry expressed private doubts about Berenson's "theories" as early as 1898,[14] he had the greatest respect for his connoisseurship and must to some extent have been influenced by his views on form.

There was also, of course, a flourishing understanding of Italian art in Great Britain, among private collectors and museum officials. It focused on the Burlington Fine Arts Club (of which Fry became a member) and its remarkable exhibitions of old master paintings held at its premises in Savile Row.[15]

11. Fry wrote to Basil Williams: "We work here at the galleries all day long and read Morelli in the evening" (quoted in Woolf 1940, p. 61).

12. *Letters*, I, p. 159, Fry to Lady Fry from Bologna, November 1894: 'As Morelli is dead there is probably no one who knows as much as Frizzoni. I think he was delighted that I had studied Morelli so carefully".

13. Ernest Samuels, *Bernard Berenson, the Making of a Connoisseur*, Cambridge MA and London 1979, pp. 104–05. For a more iconoclastic view of Berenson, see Meryl Secrest, *Being Bernard Berenson*, New York 1979.

14. *Letters*, I, p. 171, no. 80, Fry to R.C. Trevelyan, 1 March 1898. Earlier in the letter Fry writes: "You seem to think from your letter that I expressed strong disapproval of Berenson, which is not the case. I have always rather believed in him and what you say of him."

15. See Francis Haskell, 'Exhibiting the Renaissance at the End of the Nineteenth Century', in Max Seidel (ed.), *Storia dell'arte e politica culturale intorno al 1900*, Venice 1999, pp. 111–17. Unfortunately it is not clear whether Fry saw the Ferrarese show of 1894 that Haskell discusses.

16. Bernard Berenson, *Venetian Painting, Chiefly before Titian, at the Exhibition of Venetian Art, the New Gallery (1895)*, London 1895, reprinted in *The Study and Criticism of Italian Art*, London 1901, reprinted 1930, I, pp. 90–146.

17. Roger Fry, 'Andrea Mantegna', *Quarterly Review*, January 1902, pp. 139–58.

18. *Letters*, I, pp. 171–72, Fry to Trevelyan, 1 March 1898. See note 14 above.

19. Bernard Berenson, *The Venetian Painters of the Renaissance*, New York and London 1894; *Lorenzo Lotto*, New York and London 1895; *The Florentine Painters of the Renaissance*, New York and London 1896; *The Central Italian Painters of the Renaissance*, New York and London 1897.

20. Fry Papers, 3/13, Berenson to Mrs Fry, 3 July 1899.

21. Roger Fry, *Giovanni Bellini*, London 1899, p. xiii: "to Mr Bernhard Berenson for his generous encouragement and learned advice at the outset of this undertaking".

Berenson cannot have endeared himself to the London connoisseurs by his very severe, privately printed review of the New Gallery's exhibition of Venetian art in 1895, although Herbert Cook, who was to be a firm ally of Fry's, wrote the preface to it.[16] Fry was undoubtedly to suffer in the English art establishment from his association with Berenson.

The word 'connoisseurship', from which associations with snobbery and aristocratic taste are hard to rub off, does not appear often in Fry's writings. He was more inclined to a term such as 'scientific criticism', but was also alert to its misleading aspects. In an article mainly devoted to books on Mantegna published in the *Quarterly Review* in 1902,[17] Fry surveyed the current state of the study of fifteenth-century art, acknowledging that Morelli's "actual results" may have been less impressive than those of the less methodologically pretentious Crowe and Cavalcaselle. What for Fry was appealing about Morelli was his combativeness and readability (as opposed to Crowe's "colourless style") and his attempt to explain the principles underlying his judgements, as well as his concentration (shared by Crowe and Cavalcaselle) on the "internal evidence of the pictures themselves as the supreme test", rather than reliance on documentary evidence. Nonetheless Fry conceded that the famous Morellian use of morphological details such as ears and hands was unlikely to prove diagnostic for, while details vary, "what is constant is rather what an artist would call a feeling for form than a particular and easily definable form itself". Thus, in the end, "scientific criticism" amounts to a "a more careful and searching scrutiny of an artist's drawing and modelling" and might, Fry concludes, better be termed "systematic criticism".

Fry, Berenson and Horne

The two experts on Italian art to whom Fry was initially closest and from whom he learnt most were Bernard Berenson and Herbert Horne. The complications and professional jealousies involved in this triangular relationship resulted in a serious rift between Fry and Berenson which never really healed, although their friendship survived in some form until around 1916. With Horne Fry remained on good terms, never closer than during his years buying pictures for the Metropolitan Museum, when he was thrown into the art market, and Horne proved a useful guide and agent. The profound differences between the three men's approaches to the study of Italian art became ever more apparent, and an account of the ups and downs of these friendships may prove to be revealing.

Berenson's name first appears in Fry's letters in 1898 in a letter to R.C. Trevelyan, who may well have introduced them around that time.[18] By then Berenson's first three essays on the regional schools of Renaissance art had appeared, as well as his monograph on Lotto,[19] and Fry would certainly have read them all. By summer 1899 Berenson was visiting Fry's family for lunch while in England,[20] and he is profusely thanked in the preface to the Bellini monograph.[21] Fry became very fond of Mary Berenson (a fellow Quaker), and

22. *Letters*, I, 101, Fry to Mary Berenson, 23 January 1902: "I will really give you the *Desco da Sposalizio* at the next time ..."; Fry Papers, 3/13, Mary Berenson to Fry, 26 January 1903: "Your desco looks extremely well in BB's inner sanctum."

23. Mary Berenson, *A Self Portrait from her Diaries and Letters*, ed. B. Strachey and J. Samuels, New York and London 1983, p. 100.

24. *Letters*, I, p. 200, Fry to Mary Berenson, 21 January 1903. Her reply of 26 January 1903 is in Fry Papers, 3/13; for Douglas's hurt exchanges with Fry, see *ibid.*, 3/49.

25. Langton Douglas, 'A Forgotten Painter', *The Burlington Magazine*, I, March–May 1903, pp. 306–18; 'A note on the Recent Criticism of the Art of Sassetta', *ibid.*, III, September–October 1903, pp. 265–75; Bernard Berenson, 'A Sienese Painter of the Franciscan Legend – I', *ibid.*, pp. 3–35; 'II', *ibid.*, III, November 1903, pp. 171–84; for the row, see Meryl Secrest, *Being Bernard Berenson*, New York 1979, pp. 201–02.

26. *Il Trecento Riminese*, exhib. cat., ed. D. Benati, Museo della Città, Rimini, 1995. For the *Nativity*, which Benati gives to Baronzio, see cat. 43, p. 246.

27. Fry Papers, 3/13, Mary Berenson to Fry, 12 May 1903.

28. I Tatti, Berenson archive, Fry to Berenson, 2 June 1903.

29. Letter of November 1902 in Denys Sutton (ed.), 'Letters from Herbert Horne to Roger Fry', *Apollo*, August 1985, p. 136.

30. Only part of one of Fry's letters on the subject is published by Sutton (*Letters*, I, pp. 209–10, 29 June 1903); the other five are in the I Tatti archive. Mary's letters to Fry are in Fry Papers 3/13.

the high point of their relationship was probably the first two and a half years after Berenson's marriage to Mary in December 1900: Fry painted them a charming pastiche Quattrocento birth salver or *desco da parto*, which is still at I Tatti (fig. 49).[22]

However, by the time the *desco* arrived, the Berensons were already becoming irritated at Fry's raids on their expertise and photographs and, although Mary wrote in January 1902, "The quarrel with Roger certainly won't come from our side",[23] of course it did. The crisis arose over articles for the nascent *Burlington Magazine*. The first bone of contention was Langton Douglas's proposed article on the Sienese artist Sassetta, which, oddly enough, Mary had advised the editor, Robert Dell, to publish. But Berenson became convinced that Douglas had stolen unpublished attributions from him – a suspicion Fry unwittingly aroused in an ill-judged letter.[24] Berenson declared himself unable to publish in a journal that also published Douglas, but in fact the matter was resolved by Berenson himself contributing a further article on Sassetta's Borgo San Sepolcro altarpiece, of which he now possessed the central panel.[25]

Hard on the heels of this row followed Fry's altercation with Berenson over an article they had been planning to write together about the Gambier Parry paintings at Highnam Park, Gloucestershire. Fry had taken Berenson to see the collection (now in the Courtauld Gallery) because he wanted him to look at the panel of the *The Nativity and Adoration of the Magi* (fig. 50), now attributed to the Trecento Riminese School (and sometimes given to Giovanni Baronzio), which he thought was very close to Giotto (this was not a foolish suggestion, as Giotto's influence in Rimini was very direct).[26] Having looked at a number of the early pictures there, it was agreed that they should write a series of joint articles for *The Burlington* about them – which were duly flagged in the magazine's prospectus. Berenson had by now decided that the Nativity was by the 'pseudo-Giotto', the so-called St Cecilia Master.

In May 1903, just as Berenson was beginning to "get into full swing" on these Trecento problems, Mary wrote that he had become ill and was forbidden to work by his doctors.[27] He was still waiting for a photograph of the 'pseudo-Giotto', and Mary promised that when it arrived she would send Berenson's notes for Fry to write up. At this point Fry put the cat among the pigeons by referring casually on a postcard to his plan that their article should come out accompanied by a note by Horne "on the two altarpieces by the same hand".[28] Fry had been shown these paintings by Horne when he was last in Florence, and they had been in correspondence since about the "*cognato di Giotto*", as Horne mischievously called their painter (mocking Berenson's sobriquets for anonymous artists).[29] The Berensons were outraged, this being the first they had heard of Horne's proposed note, though he had recently shown suspiciously keen interest in Berenson's views on the artist. Moreover, they became (wrongly) convinced that a photograph of the Highnam picture had been sent to Horne rather than to them, in a deliberately underhand way.

Fig. 50 (Cat. 159)
Giovanni Baronzio, *The
Nativity and Adoration of
the Magi*, c. 1325.
Tempera, gold leaf on
panel, 45.5 x 27.8 cm.
Courtauld Gallery,
Gambier Parry Collection.

Fig. 51 (Cat. 160) Bernardo Daddi, Polyptych, *The Crucifixion with Saints* (detail), 1348. Tempera, gold leaf on panel, 155.8 x 52.4 (centre) 138.2 x 82.8 (left) 138.3 x 32.5 cm (right). Courtauld Gallery, Gambier Parry Collection.

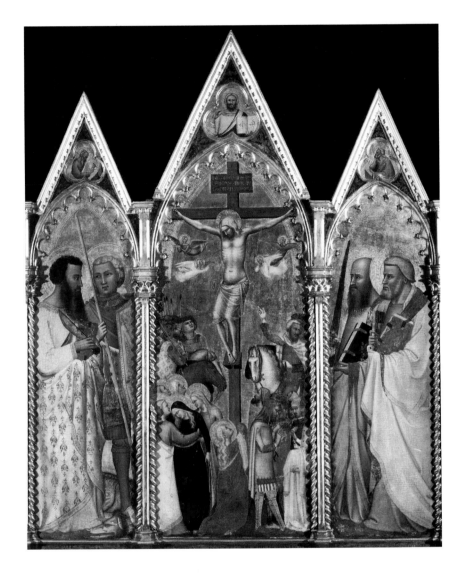

31. I Tatti, Berenson archive, Fry to Berenson, 29 June 1903: "[Horne] seems not at all keen soon to bring out the Sta Margherita ones and says he's nothing much to say about them". The two altarpieces are *St Margaret and six scenes from her legend*, and *The Virgin and Child with two saints and two angels*, in Santa Margherita a Montici, just south of Florence, still given to the St Cecilia Master; see Richard Offner, *Corpus of Florentine Painting of the Fourteenth Century*, Florence 1931, III:1, pls. VIII and XIX.

32. Roger Fry, 'Pictures in the Collection of Sir Hubert Parry, at Highnam Court near Gloucester: Article I – Italian Pictures of the Fourteenth Century', *The Burlington Magazine*, II, July 1903, pp. 117–31.

33. Roger Fry, 'Notes on the Italian Exhibition at Burlington House – I', *The Burlington Magazine*, LVI, February 1930, pp. 72–89.

This absurd storm in a tea-cup took a dozen letters to sort out,[30] and undoubtedly had an enduring legacy. Ironically, Horne, who worked very slowly and refused to be hurried, was not in the least anxious to publish on this subject: it had been Fry's idea that he should.[31] The Berensons did, however, send their notes to Fry, who published without Berenson's co-authorship what proved to be his only article on the Gambier Parry collection.[32] In the end he decided that the *Nativity* was not by the 'pseudo-Giotto' after all, but he continued to be fascinated by this picture, returning to it as late as 1930 in his review of the exhibition of Italian art at Burlington House, by which time Osvald Sirén had rightly placed it in the Riminese school.[33] In his 1903 article on the Gambier Parry pictures Fry also published the signed Bernardo Daddi altarpiece (fig. 51) and correctly attributed the beautiful predella panels of *The Visitation* and *The Adoration of the Magi*

Fig. 52 (Cat. 162) Lorenzo Monaco, *The Visitation, c.* 1409. Tempera, gold leaf on panel, 21 x 33.5 cm. Courtauld Gallery, Gambier Parry Collection.

34. Mary Berenson, *A Self Portrait from her Diaries and Letters*, ed. B. Strachey and J. Samuels, New York and London 1983, pp. 113–14.

35. *The Athenaeum*, 12 November and 3 December 1904.

(figs. 52, 53) to Lorenzo Monaco, although neither he nor anyone else until 1950 recognized the much earlier *Coronation of the Virgin* (fig. 54) as being by that artist.

The 'pseudo-Giotto' incident reveals Fry's ingenuousness, Horne's somewhat Machiavellian secretiveness and, above all, Berenson's paranoia. Fry's relationship with the Berensons cooled. Mary wrote on 10 December 1904 to her family: "It is as clear as daylight, even to me now, that we can't really work with Roger, nice as he is. He is not clever, he won't face a situation and take an open position. Nor will he for an instant try to see what B.B. really means."[34] From then on Berenson ceased entirely to write to Fry, though Mary maintained the correspondence for some years.

Fry's admiration for Berenson's connoisseurship was not impaired by these crises. But, in his reviews of Berenson's publications, something of the intellectual differences between them come out. Discussing Berenson's *magnum opus* on the *Drawings of the Florentine Painters*,[35] Fry took the opportunity to register disagreements in detail (for example over the attributions of the female profile portraits in the Poldi Pezzoli, Milan, and the National Gallery, London, discussed below) and regret at omissions (for example Lorenzo Monaco's drawings in Berlin, "the most beautiful and poetic works of the late Trecento"); he also disapproved strongly of Berenson's near

RIGHT Fig. 53 (Cat. 162) Lorenzo Monaco,
detail from *The Adoration of the Magi*,
c. 1409. 20.9 x 32.5 cm. Courtauld
Gallery, Gambier Parry Collection.

FACING PAGE Fig. 54 (Cat. 161) Lorenzo
Monaco, *Coronation of the Virgin*, *c.* 1390.
Tempera, gold leaf on panel, integral
frame with gabled top, 195 x 154.7 cm.
Courtauld Gallery, Gambier Parry
Collection (GP 59).

36. *The Burlington Magazine*, XII, 1908, pp.
347–79. For his review of Berenson's
rather uneven *Studies in Medieval Painting*,
see *ibid.*, LVIII, 1931, p. 249.

37. Tate Gallery Archives, Fry to Bell, 10
May 1920. I am grateful to Richard Shone
for this reference.

dismissal of Fra Bartolommeo; nonetheless, he rightly pays tribute to
Berenson's greatness, which is indeed seen at its height in this massive work –
praising his synthetic mind and his love of order, even if this went with a
desire to be over-decisive. However, in his review in *The Burlington* of
Berenson's *North Italian Painters of the Renaissance*,[36] after a laudatory
preamble, Fry registered profound unease with Berenson's overall use of
"prettiness" and "illustration" to characterize an extremely heterogeneous
group of often powerful painters, and drew attention to the weaknesses in his
account of some of Fry's favourites – Pisanello, Mantegna and Correggio – as
well as his dismissive view of early Flemish painting. By 1920 Fry was writing
to Vanessa Bell, in response to her hilarious account of her visit to I Tatti with
Duncan Grant: "He [B.B.] makes the appreciation of art a matter of social
distinction which is intolerable. I'm so glad I never see him."[37]

Fry's sympathy for Herbert Horne was perhaps closer and more sustained
than his feeling for Berenson. Horne was a man of many facets, an Arts and

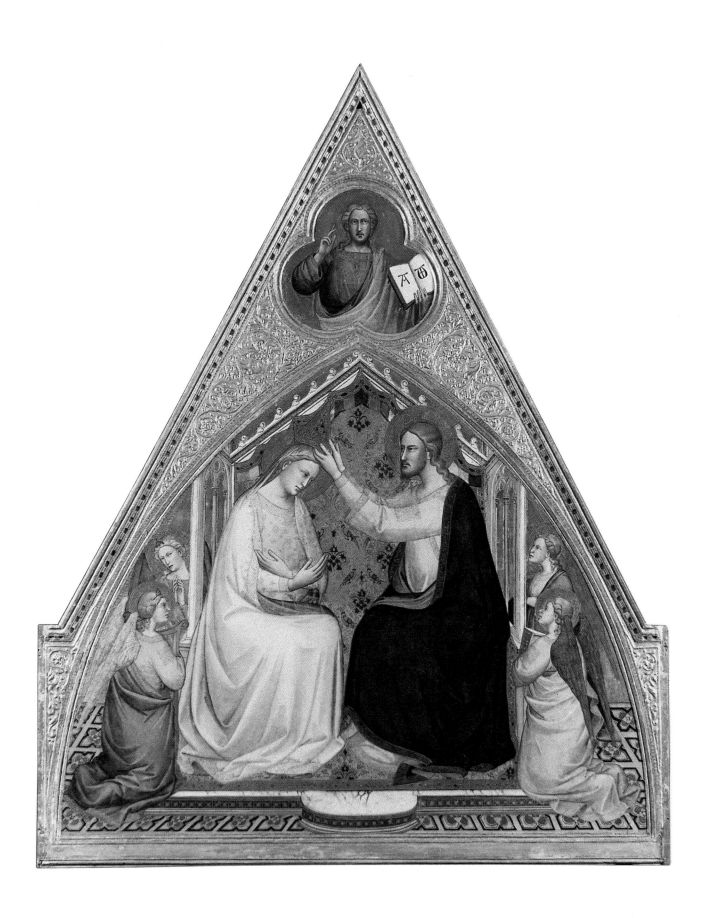

95

Fig. 55 Sandro Botticelli and studio, The Trinity Altarpiece, *c.* 1490–95. Tempera on panel, 214 x 192.4 cm. Courtauld Gallery, Lee Collection.

38. See Denys Sutton, 'Herbert Horne. A Pioneer Historian of Early Italian Art', *Apollo*, August 1985, pp. 130–35; Ian Fletcher, *Rediscovering Herbert Horne, Poet, Architect, Typographer, Art Historian*, Greensboro NC 1990.

39. H.P. Horne, *Botticelli*, London 1908; reprinted with an introduction by John Pope-Hennessy, Princeton, 1980.

40. See Carl B. Strehlke, 'Bernard and Mary Berenson, Herbert P. Horne and John G. Johnson', *Prospettiva*, LVII–LX, 1989–90, pp. 427–38; Denys Sutton (ed.), 'Letters from Herbert Horne to Roger Fry', *Apollo*, 1985, pp. 146ff.

41. H.P. Horne, *Botticelli*, London 1908, p. 317.

42. Aaron Scharf, *Filippino Lippi*, Vienna 1933, ch. 2, 'Amico di Sandro', pp. 11–22.

43. Denys Sutton (ed.) 1985, p. 150, letter of 4 August 1913. Horne published the panels in *Rassegna d'Arte*, XIII, September 1913, pp. 147–54.

Crafts architect, designer and typographer as well as a scholar, collector and *marchand amateur*.[38] As an art historian, Horne was extremely unusual in combining the most meticulous archival research with a very refined aesthetic sense, and his book on Botticelli of 1908 is both an enduring monument of positivistic scholarship and one of the most beautifully designed and printed works of art history ever published.[39]

It was through Horne that Fry acquired for J.G. Johnson in 1909 the four predella panels by Botticelli now in the Philadelphia Museum of Art (fig. 56).[40] Horne had seen them the previous year with the dealer Grassi in Florence, and had immediately associated them with the altarpiece for the nuns of the Convertite in Florence, described in the early sources and discussed in his book.[41] When Johnson agreed to buy the panels (they had been turned down by the Metropolitan), Horne allowed Fry to take the middleman's percentage (although no doubt he had his own arrangement with Grassi). Unfortunately, Berenson, who was to catalogue the collection, then told Johnson that he believed the predella to be by his mythical 'Amico di Sandro' (largely a conflation of early Filippino Lippi and some Botticelli school works).[42] Horne, entirely confident in his own opinion, promised to publish the panels in *The Burlington*, but of course never did so. Eventually Berenson changed his mind, but according to Horne infuriated Johnson because, "having begun by telling him that the panels were the most delightful works of art, but not by Botticelli, he now goes about saying that they are by Botticelli but poor things at that".[43] In fact, as Horne and Fry saw, these paintings are exceptionally beautiful, not only in the delicacy and refinement of their technique and colour, but also in their masterly architectural settings. Indeed they appear superior in quality to what is generally identified as the main panel, now in the Courtauld Gallery, which was first associated with them and the Convertite commission when in Lord Lee of Fareham's collection in 1925–26.[44]

Fry wrote an acute review of Horne's *Botticelli*, and an appreciative obituary of him when he died,[45] but the account of his friend most revealing of his own views comes in his analysis of Yukio Yashiro's book on Botticelli,[46] which he contrasted most unfavourably with Horne's. Stung by Yashiro's disparagement of Horne's "encyclopaedia", Fry characterized Horne as "a poet who, out of a kind of Quixotic bravado, posed as a dry-as-dust". Fry saw the aridity of Horne's writing as a reaction against his beginnings in Walter Pater, a kind of self-abnegating sacrifice of his own nature on the altar of truth. If in Horne's published writings "his incomparable subtlety and directness of response to the quality of any work of art he encountered" failed to be communicated, this was itself the expression of a kind of secret aesthetic ideal.

When Horne died in 1916 there was a deathbed reconciliation between himself and Berenson. At Mary's suggestion, Fry took the occasion to write to Berenson that it would be unfortunate if they too waited "for death to put the perspective right".[47] Apparently, Berenson was touched by the letter, but Mary felt it incumbent on her to point out to Fry the "thorns in B.B.'s character" –

Fig. 56 Sandro Botticelli, *Conversion of the Magdalen, Feast in the House of Simon, Noli me tangere, Last Moments of the Magdalene*, c. 1490–95. Oil on panel, 18.8 × 42.5 cm; 18.5 × 42.5 cm; 18.5 × 42.3 cm; 18.5 × 42.5 cm. Philadelphia Museum of Art, The John G. Johnson Collection. Photo © 1992 Joe Mikuliak.

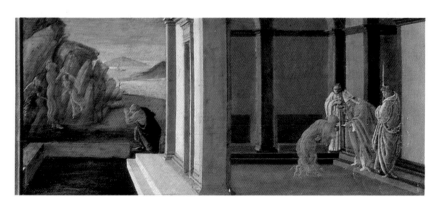

44. Yukio Yashiro, *Sandro Botticelli*, London 1925; see also 'A Newly Discovered Botticelli', *The Burlington Magazine*, XLVI, April 1925, pp. 157–67; for Fry's review of Yashiro, see below. The dating of the Convertite altarpiece remains a puzzle. Horne and Yashiro thought it was early, although the documents relating to the new high altar in the church are of 1490–91. It is dated in the 1490s in R.W. Lightbown, *Sandro Botticelli*, London 1978, II: *Complete Catalogue*, cat. nos. B62–66.

45. *The Burlington Magazine*, XIII, May 1908, pp. 83–87; ibid., XXIX, May 1916, pp. 81–82.

46. Roger Fry, 'Sandro Botticelli', *The Burlington Magazine*, XLVIII, April 1926, pp. 196–200.

47. *Letters*, I, p. 396, Fry to Berenson, 21 April 1916. A fragment of Mary's letter to Fry describing the deathbed scene is in Fry Papers, 3/13.

48. Mary Berenson, *A Self Portrait from her Diaries and Letters*, ed. B. Strachey and J. Samuels, New York and London, 1983, pp. 209–10, Mary to Alys Russell and Logan Pearsall Smith, 27 April 1916, with copy of her letter to Fry of the same day. Berenson's comments in his late diaries on Fry's perceived perfidy and disloyalty reveal a bitterness that only grew with time; Bernard Berenson, *Sunset and Twilight: From the Diaries of 1947–1951*, New York 1963, pp. 208, 233, 282, 394, 455, 489.

49. See Flaminia Gennari Santori's essay in this catalogue pp. 107–18.

50. Especially by John Pope-Hennessy, 'Roger Fry and the Metropolitan Museum', in E. Chaney and I. Ritchie (eds.), *Oxford, China and Italy: Writings in Honour of Sir Harold Acton*, London 1984, pp. 229–40.

51. In his book on Bellini of 1899 (see note 8), Fry had followed the traditional view.

52. G. Ludwig, 'Antonello da Messina und deutsche und niederländische Künstler in Venedig', *Jahrbuch der preussischen Kunstsammlungen*, XXIII, 1902, p. 26. See also F. Sricchia Santoro, *Antonello e l'Europa*, Milan 1986, p. 165, for the attributional history. Fry was on good, collaborative terms with Ludwig; see *Letters*, I, p. 197, Roger to Helen Fry, 10 October 1902; letters from Ludwig to Fry of 1903–04 are in Fry Papers, 3/108.

53. Fry Papers, 3/13, Berenson to Fry, 16 November 1901.

none of them unfamiliar to her correspondent – "which may still prick him".[48]

Fry's discoveries

It was inevitable that Fry should himself be drawn into the practice of attributing paintings and, after his appointment as curator at the Metropolitan Museum, making acquisitions and advising private collectors.[49] His achievements in this area have not been universally admired,[50] but a look at a few of his successful attributions will bring out some particular characteristics of his judgement that provide a more general key to his approach to Italian art.

One of the identifications of which Fry was most proud was his recognition that the *Pietà* in the Museo Correr in Venice (fig. 48) was by Antonello da Messina rather than Giovanni Bellini.[51] The attribution to Antonello was actually published by Gustav Ludwig in 1902,[52] but Fry had evidently come to the same conclusion the previous year, for Berenson wrote to him in November 1901 referring to a photograph of "your Antonello", which must be this picture.[53] Over twenty years later, when Vanessa Bell was visiting Venice, Fry urged on her the picture that was "my discovery", noting that it had been "utterly scorned by BB at the time".[54] In fact Berenson acknowledged his mistake about the "sublime Pietà from the Correr Museum" and paid a handsome tribute to Fry after visiting the Antonello exhibition many decades later in 1953: "All honour to the late Roger Fry for having been the first to find it."[55] History has drawn a merciful veil over a second attribution to Antonello made by Fry in 1923, of a fat-faced, fat-handed, vaguely Peruginesque Madonna in Nancy.[56] Fry was in the city to see the quack doctor Coué for his famous digestive problems, and anxiety may have induced a double gullibility in this case.

Probably Fry's most brilliant attribution was of the profile *Portrait of a Lady in Yellow* in the National Gallery, London (fig. 83), to Alesso Baldovinetti. He published this finding in *The Burlington Magazine* in 1911,[57] but had already come to the conclusion a decade earlier, and had treated the audience of his Cambridge University Extension lectures to the same compelling and eloquent arguments he was to use in his article, here given extra vividness by the freshness of the discovery.[58] Fry had recently returned from Paris, where the Louvre had acquired a *Madonna and Child* by Baldovinetti formerly attributed to Piero della Francesca.[59] Having studied the surface of that picture with minute attention, Fry was amazed to discover on his next visit to the National Gallery that exactly the same idiosyncrasies of technique were to be found in the profile portrait, then given by the gallery to Piero, but thought by Cavalcaselle, Richter and Berenson to be by Uccello. Fry pointed above all to the tiny stippled spots in the highlights, "a constellation of tiny dots", which appear to be unique to Baldovinetti among fifteenth-century Florentine artists, also drawing attention to the "strawy yellow" of the flesh, and the apparent use of a mixed medium, "neither oil nor tempera" proper – all characteristics

found in the Louvre picture. He went on to an acute assessment of the "bas relief" quality of the profile, which "relies for its effect on the purity and perfection and decorative quality of the silhouette as a whole".[60]

In his *Florentine Painters of the Renaissance* of 1896, Berenson had been dismissive of Baldovinetti, "in whose scanty remaining work no trace of purely artistic feeling or interest can be discerned",[61] although he modified his view somewhat after the public appearance of the Louvre picture, and his own acquisition of a Madonna which he initially believed to be by that master, although it turned out to be a significant work by Domenico Veneziano.[62] In 1896 Berenson had observed of Baldovinetti that his attention was largely devoted to "problems of vehicle", *i.e.* medium: "the side of painting which is scarcely superior to that of cookery". This disparaging view is typical of Berenson's almost total lack of interest in questions of technique. In fact, in his article 'Rudiments of Connoisseurship', written in 1894 and published in 1902, he specifically dismissed it (along with "types, general tone" and "composition") from the valid criteria of connoisseurship on the grounds that artists of the same school or "clique" tended to use almost identical techniques and that most early Italian paintings had suffered so much at the hands of restorers that details of surface handling had been obliterated.[63]

Fry's own views could hardly have been more different, and one of the most distinctive aspects of his writing on Italian art is the way he weaves an understanding of the artist's individual technique and use of media into a general assessment of his style. This approach is intimately connected with his own practice as a painter and a restorer. He had early on devoured Charles Eastlake's book on the materials of Italian painters,[64] and was a supporter of Christiana Herringham, who edited Cennino Cennini and pioneered the revival of tempera.[65] It should be said that Cavalcaselle, also a gifted artist, had been extremely attentive to technique and, in the particular case of Baldovinetti, had noted in passing the mixed medium of the flesh tones in the Cafaggiolo altarpiece in the Uffizi, "of an even yellow tone, stippled with most minute lines, even in the lights".[66] But the quality of "general flatness" discerned by Cavalcaselle in this painting is also, alas, characteristic of Crowe's attempts to render his colleague's acute observations into English prose, and nowhere in their volumes do the two authors achieve the synthetic encapsulation of style and technique that is so remarkable a feature of Fry's writing. In the last thirty years, as art historians have taken increasingly to collaborating with conservators, this approach has been taken up once more with outstanding results. Fry did not have the benefit of modern diagnostic techniques, but arrived at his conclusions by intense scrutiny of the picture surface.

Fry published numerous other convincing and enduring attributions. One example is Sassetta's *Journey of the Magi* now in the Metropolitan Museum in New York, on which he wrote a brief article in 1912–13.[67] Fry had been made aware of Sassetta by Berenson over a dozen years earlier and the painter's personality had first been defined in *The Burlington* in 1903 in rival articles by

54. Letter from Roger Fry to Vanessa Bell, 7 June 1926, Tate Gallery Archive (kindly drawn to my attention by Richard Shone): "I hope too you've admired the Pietà by Antonello at the Correr. That was my discovery – utterly scorned by B.B. at the time & I think published by him without acknowledgment later. But what matters is that it's so superb." Berenson referred to the Correr painting in 'A Madonna by Antonello da Messina', in *The Study and Criticism of Italian Painting*, London 1917, reprinted 1927, III, p. 87 ("a ruin if ever there was one, and yet of such sublime design as scarcely to suffer from ruin"). By this time the attribution was widely accepted and there was no particular reason to credit Fry.

55. Bernard Berenson, *The Passionate Sightseer,* London 1960, p. 58: "I cannot understand how all of us art critics failed to recognise the mind and hand of Antonello in the Correr 'Pietà'. Perhaps because it is so overwhelmingly Bellinesque. Nevertheless what remains of the landscape and architecture as well as something in the head of the angels and the Byzantine design of their wings should have given us the clue to the right attribution."

56. Roger Fry, 'An Antonello da Messina at Nancy', *The Burlington Magazine*, XLII, 1923, pp. 181–82. Fry had written to Vanessa Bell from Nancy on 5 November 1922 about his visit to Coué. For Fry's notorious gullibility, and the Coué cure of repeating "*ça passe*" six hours daily, see Woolf 1940, p. 247. Fry had a love affair with one of Coué's patients, who committed suicide.

57. Roger Fry, 'On a Profile Portrait by Baldovinetti', *The Burlington Magazine*, XVIII, March 1911, pp. 311–12; see also Martin Davies, *National Gallery Catalogues: The Earlier Italian Schools*, 2nd edn, London 1961, pp. 42–43; Ruth W. Kennedy, *Alesso Baldovinetti*, New Haven 1938, p. 131. Kennedy notes that, despite the convincing proof offered by Fry, the gallery had continued to vacillate about the attribution, reverting to Uccello in the 1930s. Kennedy's monograph follows Fry's example in its minute analysis of Baldovinetti's technique.

58. Fry Papers, Lectures 1/66/5, lecture on Baldovinetti (kindly drawn to my attention by Chris Green). These ten lectures on later (*i.e.* mid to late fifteenth-century) Florentine art can be dated to 1900–01 from the references to Langton Douglas's book on Fra Angelico, published in 1900, and to the newly acquired Baldovinetti painting in the Louvre, which Fry must have seen on his trip to Paris in summer 1901 (*Letters*, I, p. 198). There are references to the Cambridge lectures in letters of 18 February 1900, 9 May 1900, and 14 March 1901 (*ibid.*, pp. 177–79).

59. Ruth W. Kennedy, *Alesso Baldovinetti*, New Haven 1938, p. 120.

60. The quotations here are taken from the lecture (see note 58 above), but the text is very close indeed to the 1911 article 'On a Profile Portrait by Baldovinetti'. Fry mentioned the attribution in passing in his review of Berenson's *Drawings of the Florentine Painters* in *The Athenaeum*, 12 November 1904. E.M. Forster must surely have attended Fry's Cambridge lectures, for in *A Room with a View* (1908) there is an outing to find the source of Baldovinetti's Val d'Arno landscape views (see A. Smart, 'Roger Fry and Early Italian Art', *Apollo*, April 1966, pp. 262–71, note 45).

61. Bernard Berenson, *The Florentine Painters of the Renaissance*, New York and London 1896, p. 47.

62. Both pictures are discussed in Bernard Berenson, 'Alessio Baldovinetti', first published in the *Gazette des Beaux-Arts*, 1900, reprinted in *The Study and Criticism of Italian Art*, London 1902, reprinted 1931, II, pp. 23–38. For the attributional history of the I Tatti *Madonna and Child*, see Helmut Wohl, *Domenico Veneziano*, Oxford 1980, p. 117.

63. Bernard Berenson, 'Rudiments of Connoisseurship' (1894), in *The Study and Criticism of Italian Art*, London 1902, II, p. 124.

64. See Spalding 1980, p. 51, letter from Fry to his mother, 4 March 1894 (not in *Letters*).

65. Mary Lago, 'Christiana Herringham and the National Art Collections Fund', *The Burlington Magazine*, CXXXV, 1993, pp. 202–11; Roger Fry, 'Tempera Painting', *ibid.*, VII, 1905, pp. 175–76. This point is made by Smart in 'Roger Fry and Early Italian Art', *Apollo*, April 1966, pp. 262–71.

Langton Douglas and Berenson, over which there had been, as we have seen, considerable unpleasantness.[68] In his own note, Fry treats Sassetta as a favoured child rather than a serious artist, stating with rather Berensonian loftiness: "The history of art would have been almost the same if he had not existed. We do not rely on him for any essential truth of form or any great discovery in design." But this did not lessen the pleasure of recognizing a picture which bore "so unmistakably in every point the stamp of Sassetta's peculiar charm".

A fifteenth-century artist whose "poetic madness"[69] and almost surreal architectural formalism have had a particular appeal for the twentieth century is the Milanese Bramantino. The 1911 exhibition of old masters at the Grafton Galleries, which was sandwiched between Fry's two Post-Impressionist shows, and in which he was also deeply involved,[70] included a Bramantino *Madonna and Child* lent from Paris by Count Victor Goloubew (whose fine collection of Indian and Persian miniatures is now in the Museum of Fine Arts, Boston). Fry drew attention to the picture in his review of the exhibition in the Burlington,[71] and it was acquired by the Metropolitan Museum the following year. In 1913 he published an earlier and rather more interesting Bramantino *Madonna* (fig. 57), then belonging to the dealer Percy Moore Turner, expressing the wish that it might remain in Britain, although "at the present time there is too little appreciation in this country of the more personal if less flattering primitive paintings to give us any hope of such an acquisition".[72] (The National Gallery acquired its first and only Bramantino, the very fine but damaged *Adoration of the Kings*, as part of the Layard Bequest in 1916.)[73] Fry emphasized the Mantegnesque quality of this early Madonna, typical of Bramantino's "refreshing asperity and sharpness of accent". His (perhaps slightly disingenuous) fear that the picture would leave England was rapidly justified: it was acquired the same year by the Boston Museum of Fine Arts.

The true ends of criticism

Although making successful attributions could be thrilling, for Fry it was never the end of the affair. He had realised this as early as 1894, during his concentrated Morellian studies with Daniel. "I consider his *end*", he wrote of Daniel to G.L. Dickinson, "only the beginning of true criticism which is the appreciation of the painter's intention and the emotional equivalent of the picture."[74] Such sentiments recur over and over again in his published writings and are expressed, surely under Fry's influence, in Robert Dell's first Editorial in *The Burlington Magazine*: "The danger is lest this scientific activity ... should come to be looked at as an end in itself, and not as the means to quite a different end, aesthetic satisfaction, and the exercise of the aesthetic faculty: these an attitude of mere scientific curiosity may even atrophy."[75]

But the end for Fry was not merely personal aesthetic satisfaction, but the communication to others of the qualities of an artist or a work of art. This he was to achieve throughout his life in his writing and, above all, in his lectures.

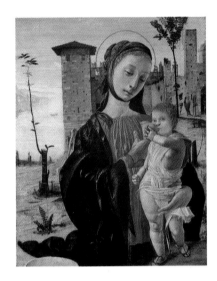

Fig. 57 Bartolomeo Suardi, called Bramantino, *Madonna and Child, c.* 1485. Oil and tempera on panel, 45.9 x 35.2 cm. © 1999 The Museum of Fine Arts, Boston.

66. J.A. Crowe and G.B. Cavalcaselle, *A History of Painting in Italy. Umbria, Florence and Siena from the Second to the Sixteenth Century, IV. Florentine Art of the Fifteenth Century,* ed. L. Douglas, London 1911, p. 210. This passage, like many others, was inserted by Cavalcaselle into Crowe's text; see Levi, *Cavalcaselle: il pioniere della conservazione dell'arte italiano,* Turin 1988, pp. 199–202.

67. Roger Fry, 'The Journey of the Three Kings by Sassetta', *The Burlington Magazine,* XXII, 1912–13, p. 131. The picture then belonged to the Marchioness of Crewe; it was acquired by the Metropolitan Museum of Art with the Griggs bequest in 1943 (see F. Zeri and E. Gardner, *Italian Paintings. A Catalogue of the Collections of the Metropolitan Museum. Sienese and Central Italian Schools,* New York 1980, p. 85).

68. See note 25.

69. Bernard Berenson, *North Italian Painters of the Renaissance,* New York and London, 1907, pp. 104–05. Berenson opposes Bramantino's "fascination" to his "flimsiness" and "intrinsic inferiority".

He first signed up to do lecture courses for the Cambridge University Extension System (the forerunner of the Extra-mural Board) in 1893, and persisted with them for over seven years. He longed to give the Slade Lectures in either Oxford or Cambridge, but was continually blackballed by some enemy or other (as late as 1927 he was told by Robert Bridges that his chances would be better if he made it clear that he did not intend to reside in the university).[76] When he was finally appointed in Cambridge in 1933 he embarked on an ambitious course which would have covered the whole history of art, but tragically died while still immersed in late antiquity. There are many testimonies to his compelling qualities as a lecturer: his thrilling voice, his infectious enthusiasm. By the late 1920s he was reaching new audiences through the radio, and packing halls with thousands of listeners. But it still remains a matter of regret that his early lectures for Cambridge on Florentine art, which contain some of his freshest and most engaged writing (the earlier ones on Venetian art are less compelling), remain largely unpublished, apart from the justly famous account of Giotto that appeared in the *Monthly Review* and was reprinted in *Vision and Design* in 1920.

Formal purity versus dramatic expression

While Fry was deeply interested in the twentieth-century canon of Italian 'primitives' – Masaccio, Uccello, Piero della Francesca – he wrote with passion and conviction about a more intense strand in early Italian art, represented, for example, by certain works of Mantegna and Signorelli, and his early account of Giotto concentrated so much on him as an artist of dramatic narrative that he felt he had to recant when republishing it in *Vision and Design*. It is now generally acknowledged that Fry's 'formalism', once adopted about 1911, was not an enduring position, and an analysis of his discussion of early Italian art may cast some light on the necessary limitations of formalism as Fry began to acknowledge them later in his life.

It seems appropriate to begin the discussion with the modernists' paragon of fifteenth-century painting, Piero della Francesca. Fry saw the Arezzo frescos for the first time in May 1897, the year in which Berenson published his appreciation of Piero's "impersonal" and "unemotional" art – akin to Velázquez or the artists of the Parthenon. Fry wrote in similar terms to his father that he and his wife Helen "both admire him almost more than any other Italian painter (he certainly comes closer to the Greeks than any other Italian)". In later years he made the inevitable comparisons with Cézanne and Seurat,[77] and, after revisiting Arezzo and Sansepolcro with the Bells and Duncan Grant in 1913, he wrote to Goldy Dickinson, "I've no doubt now that Piero della Francesca is the greatest artist of Italy after Giotto, incomparably beyond all the men of the High Renaissance. He's an almost pure artist with scarcely any dramatic content or indeed anything that can be taken out of its own form."[78]

It is perhaps rather surprising, then, that Fry should have written so little

70. *A Catalogue of an Exhibition of Old Masters in aid of the National Art-Collections Fund*, exhib. cat., ed. R.E. Fry and Maurice W. Brockwell, Grafton Galleries, London, 1911. A prefatory note explains that the cataloguing and the bulk of the organization was due to Brockwell, the hanging to Fry.

71. Roger Fry, 'The Exhibition of Old Masters at the Grafton Gallery I', *The Burlington Magazine*, XX, 1911, p. 77. See G. Mulazzani, *L'opera completa di Bramantino e Bramante pittori*, Milan 1978, p. 92, cat. 22, dated 1505–07.

72. Roger Fry, 'Bramantino', *The Burlington Magazine*', XXIII, 1913, p. 317. See Mulazzani, 1978, p. 87, cat. 1, dated 1485 as Bramantino's earliest work.

73. Martin Davies, *National Gallery Catalogues: The Earlier Italian Schools*, 2nd edn, London 1961, p. 128.

74. *Letters*, I, p. 162, Fry to G.L. Dickinson, 7 November 1894.

75. 'Editorial', *The Burlington Magazine*, I, March 1903, p. 1. For Fry's role in *The Burlington*, which he helped to found, saved from bankruptcy, co-edited from 1909 to 1919, and wrote for and advised till the end of his life, see Benedict Nicolson, '*The Burlington Magazine*', *Connoisseur*, March 1975, pp. 175–83; Gail Sibley, 'Roger Fry and *The Burlington Magazine*: An Investigation into the Formative Years of *The Burlington Magazine* from 1903 to 1919, and the Role played by Roger Fry in its Development and Character', M.A. thesis, Queen's University, Kingston, Ontario, 1989.

76. *Letters*, II, p. 606, Fry to Helen Anrep, 26 August 1927, and to Bridges, 27 August 1927.

77. See Fry's articles on Cézanne in *The Nation*, 19 November and 3 December 1910; and 'Seurat', *The Dial*, September 1926, reprinted with an introduction by Anthony Blunt, London 1965.

78. *Letters*, II, p. 369, Fry to Dickinson, 31 May 1913.

79. *The Athenaeum*, 3 August 1901.

80. Fry Papers, I/66/IV and V.

81. For a very thorough recent account, see Luciano Cheles, 'Piero della Francesca in Nineteenth-century Britain', *The Italianist*, XIV, 1994, pp. 218–60.

about Piero in print, apart from a review in *The Athenaeum* of a mediocre book on the artist by W.G. Waters.[79] There he does, however, make acute observations about the transformations in Piero's technique, based on his study of the *The Baptism* and the *The Nativity* in the National Gallery, London, noting the change from the use of pure tempera over *terra verde* in the flesh areas, with a finely hatched surface in the former, to a Flemish-influenced technique of semi-opaque layers over a brown ground in the latter. He made just these points in the second of a two-part lecture on Piero in his Florentine series for the Cambridge Extension lectures that same year.[80] Indeed (showing that he was not indifferent to Herbert Horne-ish archival evidence) he began the second by reading out to his audience the contract with Piero for a confraternity banner which – most unusually for the period – specified that the painting was to be in an oil medium.

Despite the abundant evidence that Piero was highly regarded in the mid-nineteenth century,[81] it is still often assumed that he was 'rediscovered' in the twentieth. It is amusing, then, to find Fry concluding his lecture to an audience of non-specialists: "Piero della Francesca's work is so universally appreciated nowadays that probably each admirer has found some quality that appeals to him personally and I shall not pretend to sum up all his excellencies." He had begun his first lecture with the acquisition of the *Nativity* by the National Gallery in 1874, with Disraeli's help, at a time when Piero was not widely known, since "Artists in England were too pre-Raphaelite to look much at the precursors of Raphael"; although in France, as Fry noted appreciatively, Puvis de Chavannes "had seen in Piero's works the most certain guide to the principles of monumental decorative design". This is a fascinating lecture, in which Fry pays tribute to Piero's "purity", his sense of gravitation and mass, his feeling for the "plastic beauty of the figure" – all critical terms that would recur in his formalist writings – as well as beautifully characterizing his "high key of tone and flatness of tonality", his pure, pale colouring "with an effect almost approaching plein air". But he also writes of Piero's limitations, his apparent lack of curiosity about "the desires or impulses of human nature", adding that "his cold indifference on that score amounts almost to inhumanity". The Arezzo frescos demonstrate both "the highest reaches of his imagination and its rigid limitations". The superb scene of *The Death of Adam* reveals Piero's modernism, his predominantly "plastic" imagination, but "One has only to think of how intimately, with what tender humanity of feeling Giotto would have treated this to feel how strictly limited was Piero's command of psychological expression". Significantly, Fry could in 1901 still permit himself this reservation, in tune with the view of Giotto in his *Monthly Review* article of the same year.

Despite his homage to Piero, it would appear that Fry in some ways felt a greater personal affinity for Piero's pupil Luca Signorelli,[82] whose artistic personality was so very different from that of his master. It is worth attempting to analyse why this should be so. When Fry first went to Orvieto in 1891, he

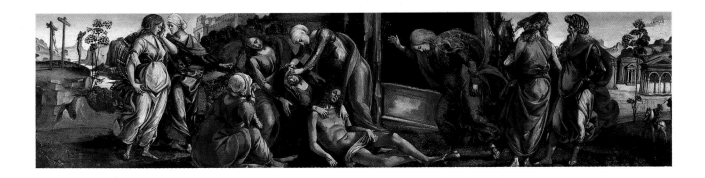

Fig. 58 Luca Signorelli, *Lamentation over the Dead Christ*, 1498. Tempera on panel, 29.8 x 119.1 cm. Glasgow Museums, The Stirling Maxwell Collection, Pollok House.

82. See Alastair Smart, 'Roger Fry and Early Italian Art', *Apollo*, April 1966, p. 263; Smart gives a fine account of Fry on Signorelli.

83. Letter to G.L. Dickinson, April 1891, *Letters*, I, pp. 138–39, also mentioned by Smart (see preceding note).

84. Bernard Berenson, *The Central Italian Painters of the Renaissance*, New York and London 1897 p. 78.

85. Review of Burlington Fine Arts Club Umbrian exhibition, *The Burlington Magazine*, XVI, February 1910, pp. 267–74, 'A tondo by Luca Signorelli', *ibid.*, XXXVIII, 1921, pp. 105–06, and again, XL, 1924, pp. 134–45; *ibid.*, XX, November 1911, p. 72–73 (Grafton Galleries exhibition); *ibid.*, XLIV, 1924, pp. 234–46 (Mond collection).

86. Roger Fry, 'The Symbolism of Signorelli's *School of Pan*', *Monthly Review*, no. 5, December 1901, pp. 109ff. Fry was the first to make this connection, still recognized to be the key to the painting's subject. I am grateful to Tom Henry for clarifying this point.

87. See pp. 88f above.

admired the sculpture on the façade of the cathedral "done by men who knew very little about the human form but who seemed to divine instinctively, and without inductive knowledge, the secrets of expression" almost more than Signorelli's frescos of *The Last Judgment* inside.[83] But Signorelli's work stayed with him, no doubt reinforced by Berenson's strong advocacy in the *Central Italian Painters of the Renaissance* (1897) of his mastery of the nude, in which Berenson saw "a certain gigantic robustness and suggestions of primeval energy", as well as an austere vision and a sense of form that "is our own".[84] Fry constantly returned to discuss individual paintings by Signorelli, writing superb critical appreciations of the Stirling Maxwell *Lamentation* (fig. 58), the two panels of nudes from the Cook collection (now in Toledo), and the Esther and Ahasuerus predella in the Mond collection (now National Gallery, London). He also published a Signorelli tondo of the Madonna and Child,[85] and one of his first contributions on the artist was an iconographical study of the *School of Pan* (Berlin, destroyed), which he related to a passage in Servius.[86] As Alastair Smart has pointed out, Fry constantly stressed Signorelli's "modernity", but I would disagree that he was mainly attracted by the Umbrian artist's "severely intellectual and analytical" qualities. Instead he was drawn to Signorelli's "tense, nervous and vehement drawing", his "exhilarating bluntness", his "reckless force of hand", and he saw even the artist's moments of carelessness and shoddiness as enhancing the expressive directness of his work. If Signorelli is for Fry "akin to El Greco, Goya and the greatest of the moderns", it is as much or more because of the dramatic intensity of the work as because of its analytical qualities.

Fry's early attraction to the darker strand in early Italian art emerges again in some very remarkable pieces he wrote in the first decade of the century about Mantegna. In 1901 he surveyed a clutch of publications on the artist, including Paul Kristeller's magisterial monograph, a much slighter account by Charles Yriarte and a short book by Maud Cruttwell, which Fry took to be heavily influenced by Berenson's views. He threw in for good measure the first volume of the last's *Study and Criticism of Italian Art*, and made the review the occasion for the general reflections on "scientific criticism" discussed above.[87] While writing it, he became absorbed in the notoriously difficult question of

Mantegna's chronology and bombarded Berenson with queries which were answered rather cursorily. Berenson did, however, respond at length on the subject of the drawing of *St James Led to Martyrdom* then in the Gathorne Hardy collection, which Fry was rightly inclined to judge, with Kristeller, as an autograph study by Mantegna for his fresco in the Eremitani in Padua, while Berenson persisted in seeing it as "some decades later" and by an imitator.[88]

In the review as published, Fry rethought Mantegna's development in a masterly way, starting from fixed points, attempting to slot in the problem pictures, and then returning to encapsulate the artist's qualities. As he pointed out, it was not possible with Mantegna to use changes in technique and handling as the key, since "his method changes less than that of any other great master"; he clung tenaciously to his dry tempera. At the end of the review, Fry adapted Burke's dichotomy between the sublime and the beautiful to isolate a strand of fifteenth-century artists who arouse "ideas of terror" – Castagno, Pollaiuolo, Signorelli, Ercole de' Roberti and Mantegna himself, than whom, he concluded, no artist of the century "leaves a deeper, more incisive impression ... attacks our feelings so persuasively, stirs our imagination out of its habitual attitude more irresistibly, or compels us to adopt so entirely the intense reality of fresh images".

Some of these ideas were developed further in 'Mantegna as a Mystic', published in *The Burlington* four years later,[89] which, for anyone who still regards Fry as a consistent advocate of 'pure art' and formalism, is perhaps the most surprising piece he ever wrote. In his review, Fry had pointed out that writers on Mantegna since Vasari had concentrated on his obsession with classical antiquity and "cold formality", and had ignored a Dantesque "tendency to mysticism" in some of his work. In the article he analyses that "vein of sentiment" in works such as the Bergamo *Madonna and Child*, the Simon *Madonna* in Berlin, the Mond *Holy Family* (now National Gallery, London), and the *Adoration of the Magi* now in the J. Paul Getty Museum (fig. 59), where Fry discerned a quality of "strangeness and mystery far stronger than any recognizable emotion", underlined by the abstracted remoteness of expression of the Madonnas with their almond eyes. Here he is on the *Adoration of the Magi*:

Not a little of the sense of mystery comes indeed here as in the Mond picture from this curious compression of the figures within the smallest possible space The effect of thus crowding all the heads together round the figure of the Infant Christ, of making all these directions of movement and look converge on a central point, is strange and disquieting. It impresses us with a sense of the mystery and significance of the event, a sense which is conveyed to us moreover by the awful intensity of the expression of the kings themselves, the searching profundity of their regard. Here once more the note of remoteness and aloofness is given in the Virgin's face, with its slit-like eyes and compressed lips.

88. Fry Papers, 3/13, 6 and *Letters*, I, pp. 184–85 (21 November 1901).

89. Roger Fry, 'Mantegna as a Mystic', *The Burlington Magazine*, VIII, 1905, pp. 87–98. A distinct oddity of this article must be pointed out. Although reproducing *The Adoration of the Magi* then in Castle Ashby, now in the J. Paul Getty Museum, as the work in question, Fry refers in the text to the version in the J.G. Johnson collection, which is a copy. See R. W. Lightbown, *Mantegna*, Oxford 1986, cat. 43.

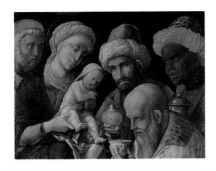

Fig. 59 Andrea Mantegna, *Adoration of the Magi, c.* 1495–1505. Distemper on linen, 48.5 x 65.6 cm. The J. Paul Getty Museum, Los Angeles.

It is instructive to compare this account of Mantegna with Fry's analysis of Giovanni Bellini in his monograph of 1899. Nineteenth-century writers on Bellini, especially Ruskin, had emphasized him as the painter of "devout Madonnas", and Fry set his face against this view. After an early tendency to pathos influenced by Mantegna and Donatello, Bellini becomes for Fry an unecstatic artist of common sense, who transmutes the metaphysical into the naturalistic, finally "able to import into a religious picure the new feelings of untroubled delight in sensuous beauty", as in the San Zaccaria altarpiece. Whatever the justice of this analysis, it is clear from the very different, and more probing account Fry gives of Mantegna, that he was far from indifferent to the religious content of early Renaissance art.

Fry concludes 'Mantegna as a mystic' with an account of the characteristic fine linen support of the *Adoration*, and its "scarcely perceptible marks of tempera dried to a dead surface", pointing out the perfect appropriateness of the technique to the spiritualized nature of the picture, and the affinity with Flemish art both in Mantegna's early realism and in his later mysticism.

Between the two articles, in autumn 1902, Fry had paid his first visit to Mantua and had been bowled over by the freshness of colour and gaiety of the Camera degli Sposi, "really about the best wall decoration I know".[90] It is unfortunate that our view of his relationship with Mantegna should be so coloured in retrospect by his misguided attempts at restoring the *Triumphs of Caesar* in Hampton Court.[91] It may be true, as Blake wrote, that "each man kills the thing he loves".

Like all writers on art Fry had his blind spots, even within his favoured periods and schools, and we would not go to him for a sympathetic assessment of Filippo (or Filippino) Lippi, Botticelli, Domenico Veneziano – and certainly not Raphael, to whom he always found it difficult to warm. His distressing tendency to make sweeping judgements about national schools led him to underestimate the qualities of early Netherlandish painters, especially Jan van Eyck, although he could write with eloquence about Roger van der Weyden. At the great 'Primitifs Flamands' exhibition of 1902, he and Helen fell with relief on a *Pietà* they thought to be Provençal, which "suddenly made us realize ... how hungry the Flemish art even at its best leaves one for want of that indescribable bigness of style which this Frenchman had got, from Italian art I suspect".[92] It has often been observed that Fry was "completely out of sympathy" with German art and culture.[93] And his revisionist views of ancient Greek and Roman art[94] are, to this reader at least, exasperating. As Kenneth Clark justly observed, "Fry was a greater critic when praising than when condemning".[95]

Fry's study of the early Italians alerted him to the importance of formal values in art, but his continued thoughtfulness about these and other 'old masters' made it impossible for him to espouse pure formalism with any consistency. When first writing about Giotto in his *Monthly Review* articles of 1901, he posed himself the following question, which continued to haunt him

90. *Letters*, I, p. 193, Roger to Helen Fry, Autumn 1902.

91. Andrew Martindale, *The Triumphs of Caesar by Andrea Mantegna*, London, 1979, pp. 117–18, 127. Fry's letter to Cust of 17 February 1910 taking on the task for *c.* £20–50 is in Fry Papers, 3/49. He decided to stop work in 1921 (*Letters*, II, p. 507).

92. *Letters*, I, p. 191, Fry to Mary Berenson, 3 September 1902.

93. Kenneth Clark, Introduction to Roger Fry, *Last Lectures*, p. xxiv.

94. As expounded in *Last Lectures*, ch. X.

95. Clark in *Last Lectures*, p. xxvii.

96. Bernard Berenson, *The Florentine Painters of the Renaissance*, New York and London 1896, pp. 4–8. Berenson's wording, "the error of judging a picture by its dramatic presentation of a situation ... a good *illustration*" makes it certain that Fry's reference is to him.

97. 'A New Theory of Art', *The Nation*, 7 March 1914, pp. 937–39, reprinted in Reed 1996, pp. 158–62.

98. I quote from the 1923 edition of *Vision and Design*, p. 131. In 1920, as Smart has noted ('Roger Fry and Early Italian Art', *Apollo*, April 1966, p. 271, note 1), this passage was rendered even more baffling by the misprint 'without' before 'recognition'.

99. D.S. MacColl, 'A Note on Roger Fry', *The Burlington Magazine*, LXV, 1934, pp. 231–35; see also Frances Spalding, 'Fry and his Critics in a Post-modernist Age', *The Burlington Magazine*, CXXVIII, 1986, pp. 489–92.

100. Roger Fry, 'The Meaning of Pictures I – Telling a Story', *The Listener*, II, no. 38, 2 October 1929, pp. 429–31, reprinted in Reed 1996, pp. 393–400; see Christopher Reed's discussion, p. 319.

101. D.S. MacColl, 'A Note on Roger Fry', *The Burlington Magazine*, LXV, 1934, p. 232.

all his life: "It is customary to dismiss all that concerns the dramatic presentation of subject as literature or illustration which is to be sharply distinguished from the qualities of design. But can this clear distinction be drawn in fact?" Here there is an implicit reference to Berenson's *Florentine Painters of the Renaissance* of 1896, where a discussion of Giotto's "tactile values" precedes a dismissal of "illustration" and an insistence on form as the principal source of aesthetic enjoyment, at least in Florentine art.[96] But Fry discovers it to be impossible, when analysing Giotto's Arena Chapel *Pietà* or *Noli me tangere*, to confine himself to "volume and mass" or "plastic unity". Similarly, in his 1914 review of Clive Bell's *Art*,[97] Fry ironically casts doubt on Bell's attempts to separate out the purely aesthetic emotions aroused by Giotto's frescos, using the *reductio ad absurdum* of great literature. To "make his theory complete", he concludes, "it would have been Mr. Bell's task to show that the human emotions of 'King Lear' and 'The Wild Duck' were also accessory, and not the fundamental and essential qualities of these works".

Six years later, however, Fry famously went back on this view when republishing his essay on Giotto in *Vision and Design* in 1920. "I should be inclined to disagree", he wrote there, "wherever in this article there appears the asumption not only that the dramatic idea may have inspired the artist to the creation of his form, but that the value of the form for us is bound up with recognition of the dramatic idea."[98] As D.S. MacColl was probably the first person to point out, in his obituary of Fry,[99] "this state of mind ... could not be permanent" for anyone who thought hard about Giotto (let alone Rembrandt), as Fry's talks and lectures of the later 1920s and early 1930s reveal. In his radio series 'The Meaning of Pictures', broadcast and published in 1929, Fry starts with 'Telling a Story', and the "dramatic situation" of Giotto's *Noli me tangere* with its "strange intensity" is once more allowed to take its rightful place at centre stage.[100] When I say rightful, I am not implying that content is more important than form in art but rather, as MacColl argued with Fry into the small hours, the two must be "inextricably combined".[101]

EUROPEAN 'MASTERPIECES' FOR AMERICA

Roger Fry and the
Metropolitan Museum of Art

FLAMINIA GENNARI SANTORI

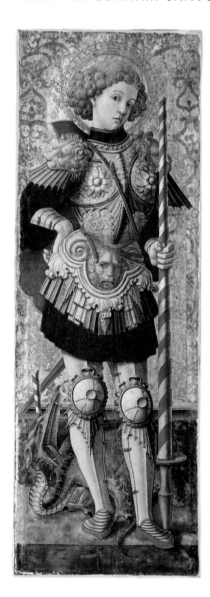

Fig. 60 Carlo Crivelli, *St George* (panel from a dismembered polyptych). Tempera on wood, tooled gold ground, 96.5 x 33.7 cm. The Metropolitan Museum of Art, Rogers Fund (05.41.2). Photo © 1986.

Soon after arriving in New York, in February 1906, Roger Fry wrote to his wife Helen about his first day as a curator of paintings at the Metropolitan Museum of Art: "... having to see reporters and sit for my photograph in between whiles and being careful to give them a lot of fluff with nothing inside it. They began on the dock before my luggage was cleared, a whole pack of them hunting together like wolves. The worst gang I disposed of beautifully."[1] One of the gang must have been a *New York Times* reporter to whom Fry explained his views regarding what kind of paintings the Metropolitan should buy. "He believes", wrote the reporter, "that the thing to do is to buy pictures that are not being sought by rich men – in other words, that the public is paying him for his good judgement, and that it is the object of a museum not only to provide the public with things that are already admired, but to educate the public taste."[2]

Between 1906 and 1910, when Fry was advising the Metropolitan Museum on his purchases, collectors such as Frick, Widener and Altman were beginning to build painting collections around 'important' works by great masters.[3] Fry's ideas about what the Metropolitan should acquire pointed in the opposite direction of what was becoming the canon of American collecting of old master paintings.[4] Many critics, then and more recently, believed that, while at the Metropolitan, Fry bought too much and with scarce discrimination.[5] Although this might be true to a certain extent, Fry had a project for the Metropolitan Museum and he bought and acted, as much as he could, according to it.

His connection with the museum lasted until 1910, but it was only in 1906 that Fry was active as a 'curator' and not only as a "buyer" or adviser.[6] In that year alone he bought 56 paintings, discovered forgotten ones in the deposits of the museum, restored 13 paintings of the collection and arranged a new gallery on the model of the Louvre Salon Carré. In Gallery XXIV, opened in April 1906, Fry gathered the paintings he thought were the most relevant in the collection. His explicit intention was to demonstrate to the Trustees and the public that there existed such a thing as serious art, as opposed to frivolous or sentimental art, which in his opinion made up the majority of the Metropolitan holdings at the time of his arrival.

Roger Fry went to New York for the first time in January 1905 to raise money for *The Burlington Magazine*. The first negotiations with the Metropolitan Museum for the post of assistant director started on that visit, but they did not come to fruition.[7] At the time the Metropolitan Museum was undergoing a complete reorganization, triggered by the election of John

NOTES

I wish to thank Pat Rubin and Chris Green.

1. *Letters*, I, p. 249, Roger to Helen Fry, February 1906.

2. 'Curator Fry Hopes to Educate Taste', *The New York Times*, 11 February 1906.

3. D.A. Brown, *Raphael and America*, Washington DC, 1983, pp. 15–103; W.J. Constable, *Art Collecting in the United States. An Outline of a History*, London 1964, pp. 91–140; G. Harvey, *Henry Clay Frick, the Man*, New York 1928, pp. 331–43; F. Haskell, 'The Benjamin Altman Bequest' in *Past and Present in Art and Taste. Selected Essays*, New Haven and London 1987, pp. 186–206.

4. The Johnson collection in Philadelphia made the exception to the rule: see note 3 and C.B. Strehlke, 'Bernard and Mary Berenson, Herbert P. Horne e John J. Johnson', *Prospettiva*, vols. 57–60, 1989–90, pp. 427–438. For Fry's relationship with Johnson see *Letters*, *passim*, and Spalding 1980, pp. 96–100.

5. J. Pope Hennessy, 'Roger Fry and the Metropolitan Museum of Art' in E. Chaney and N. Ritchie (eds.), *Oxford, China and Italy, Writings in Honour of Sir Harold Acton*, London 1984, pp. 229–40.

6. Spalding 1980, pp. 80–95, 101–06; C. Tompkins, *Merchants and Masterpieces. The Story of the Metropolitan Museum of Art*, New York 1970, pp. 103–10.

7. Cf. *Letters*, I, pp. 232–35; Spalding 1980, p. 85. The editors of *The Burlington Magazine* hoped that a large diffusion in the United States would sustain them financially: to this end, in June 1905 the magazine begun the publication of an American section edited by Frank Jewett Mather.

8. Tompkins 1970, pp. 95–102. See also C. Duncan, *Civilizing Rituals: Inside Public Art Museums*, London and New York 1995, pp. 60–65.

9. W. Rankin, 'Metropolitan Museum, Expert Criticisms of its Chief Collections', *The New York Post*, 17 December 1904; 'The Metropolitan Museum', *The Nation*, LXXX, no. 2063, 12 January 1905, pp. 27–28; 'Wanted: A School for Art Collectors', *The Nation*, LXXV, no. 1952, 27 November 1902, pp. 416–417.

10. Tompkins 1970, pp. 102–103.

11. *Ibid.*, pp. 90–91.

Pierpont Morgan as president in 1904. The museum had been created in 1870 on the model of the South Kensington Museum (now Victoria and Albert Museum) as an institution devoted primarily to the education of artisans and manufacturers through casts and reproductions. With the new century, casts were banished and the emphasis shifted to management by experts and to the establishment of standards of quality and authenticity in the acquisitions.[8] American collecting was generally undergoing a fast 'professionalization', and such a change in the Metropolitan management was demanded by an influential segment of the New York press, namely the daily *New York Post* and the weekly *Nation*: it was perceived that the Museum was the institution entitled to establish the 'standard of taste' for the whole country, and the direction in which the taste of the country was going was a major concern in American public debate.[9]

In 1905 Sir Purdon Clarke, former director of the South Kensington Museum, became director of the Metropolitan and at the end of that year Fry was offered the position of curator of paintings.[10] In 1904 the museum received a huge donation for the acquisition of art works and books, the Rogers fund, which amounted to $5 million and produced an annual income of $200,000.[11]

Fry's conditions to accept the post of curator of paintings were: an honorarium of £500 a year to give the museum "the *first choice* of all desirable works" of which he knew in the art market; a commission of 5% on the paintings purchased for less than £5000 and 3% on paintings above £5000; and the liberty to propose to other buyers paintings refused by the Metropolitan Trustees.[12] Although these conditions were accepted, misunderstandings regarding the length of time Fry was supposed to spend in New York began straight after his arrival. Not only was he in a constant state of anguish about his wife's health, but also, in the early months of 1906, after he had accepted the Metropolitan offer, he was offered the post of director of the National Gallery in London. Predictably, the possibility of having such a prestigious job in London lessened his enthusiasm for the Metropolitan Museum.[13]

Nevertheless, New York excited Fry. Already in 1905 he was writing to Helen:

I never met more understanding and sympathy and never felt freer from all the trammels of our vested interests. The feeling that if you have grasped an idea you can realise it, instead of beating your head against the bars of prejudice and prestige, is most invigorating There is going to be an immense boom here in art: everything is shaping and arranging itself for it and I am regarded as the person who can give the direction to it in lots of ways.[14]

A year later, when he realised that he could not take the National Gallery offer, he wrote to Helen: "We may be aiming at something bigger than National Ideas. It may be really that the future lies over here and that this is my work I can do ten times as much here as at the National Gallery and I suppose I

12. *Letters*, I. p. 246, Fry to Sir Purdon Clarke, 31 December 1905.

13. Spalding 1980, pp. 88–89; *Letters*, I, p. 248, Fry to his mother, 25 January 1906; p. 254, Roger to Helen Fry, 2 March 1906. Unpublished letter to Helen, not dated but written between 18 and 27 February 1906, Fry Papers.

14. *Letters*, I, p. 231, 13 January 1905.

15. *Letters*, I. p. 253, 27 February 1906.

16. *Letters*, I. p. 261, Roger to Helen Fry, 12 April 1906.

17. 'Wanted: A School for Art Collectors', *The Nation*, LXXV, 27 November 1902, pp. 416–17; 'Psychology in the Salesroom', *The Nation*, LXXVI, no. 1962, 3 February 1903, pp. 106–07.

18. To have an idea of the prominence of the old master paintings in the American press, see the *New York Times* index.

19. On William Laffan, see *Letters*, II, p. 730, and Spalding 1980, p. 81. On A.F. Jaccaci, see G. McCoy, 'The Price of a Small Motorcar', in *Fenway Court, Isabella Stewart Gardner Museum*, 1972, pp. 26–32.

20. On Cortissot and Mather, see H.W. Morgan, *Keepers of Culture: The Art-Thought of Keynon Cox, Royal Cortissot and Frank Jewett Mather Jr.*, Kent OH and London 1989.

21. *Letters*, I, p. 233, 21 January 1906; p. 257, 13 March 1906.

22. *Letters*, I, p. 272, 10 November 1906.

23. *Letters*, I, p. 254, to his father, 2 March 1906. On Morgan's impact on the press, see N. Harris, 'Collective Possession: J Pierpont Morgan and the American Imagination', in *Cultural Excursions, Marketing Appetites and Cultural Tastes in Modern America*, Chicago and London 1990, pp. 250–75.

have big ambitions."[15] Although he found the millionaires despicable, the artists incapable and provincial, the women loud, and almost everybody too sentimental and wanting imagination, he could write home: "One thing is wonderful here and that is the responsiveness of people to new ideas when they are given from the right sources."[16] And while in New York he believed himself to be the embodiment of the right source. He also believed, or maybe he wanted to convince himself, that he had a mission: to establish a standard of honesty in the booming and ruthless New York art market. The demand for antiques had never reached such proportions and several American commentators lamented a lack of standards both in the quality of the art works available and in their pricing.[17] Moreover, acquisitions of art works were becoming a subject for front-page headlines, and, as Fry remarked in his letters, this had a significant impact on the New York art system.[18]

Fry described the New York art system as a ruthless arena, where a few "honest" people were trying to change the rules of the game. The individuals Fry mentioned most often as his allies, besides his assistant Bryson Burroughs, were William Laffan, trustee of the Metropolitan and close acquaintance of John Pierpont Morgan and, above all, August Floriano Jaccaci, a sort of impresario of art historians, former art editor of the magazine *McClure's* and editor with the artist John La Farge of the book *Noteworthy Paintings in American Private Collections*, a luxurious publication in which European "experts" assessed the value of old masters and modern paintings owned by Americans.[19] Among Fry's allies there were also Frank Jewett Mather, editor of the American section of *The Burlington Magazine* and art critic of *The New York Post*, and Royal Cortissot, art critic of *The New York Tribune*.[20] In his letters to Helen, Fry described himself as the champion of the "honest party".[21] In November 1906 he wrote to her:

Indeed, I feel as though the indignation against the arrogance of wealth is growing incessantly, and the old ideas of justice are beginning to look up again. Will it mean a revolution? ... You see, it can't help to be a mighty interesting world where there is so much in the atmosphere, and the museum is becoming rather a centre of decent-minded people who won't succumb to the golden calf.[22]

Probably more than in England, the daily press had a significant impact on those involved. The activities of the Metropolitan Museum, not to mention those of John Pierpont Morgan, made the headlines, Sir Purdon Clarke was terrified of the press and Fry remarked that "everyone seems nervous about public opinion".[23]

In this overheated environment, Fry set out to create a new gallery in the Metropolitan. "I am getting ready a great gallery, a sort of *Salon Carré*, where all the real things will be seen in the hopes that it might throw a lurid light on the nameless horrors of modern art which fill the remainder. New York is

24. *Letters*, I, p. 259, undated.

25. Roger Fry, 'Ideals for a Picture Gallery', *The Bulletin of the Metropolitan Museum*, I, March 1906, pp. 58–60.

26. Tompkins 1970, pp. 71–72.

27. 'Notes for six lectures given in New York', Fry Papers, lecture, sheet 40. Fry referred to them in a letter to his mother and in a letter to D.S. McColl, see *Letters*, I, pp. 292 and 315.

28. 'Lecture Number II, Epic', Fry Papers, sheet 8.

29. For the Marquand collection, see Tompkins 1970, pp. 73–75; and E. Fahy, 'How the Paintings Got Here', in M. Ainsworth and K. Christiansen (eds.), *From Van Eyck to Brueghel: Early Netherlandish Painting in the Metropolitan Museum of Art*, New York 1998, pp. 63–75, especially p. 65.

30. Roger Fry, 'Ideals for a Picture Gallery', *The Bulletin of the Metropolitan Museum*, I, March 1906.

31. Roger Fry, *An Outline of the Aims and Ideals Governing the Department of Paintings*, p. 4. The pamphlet was for internal circulation. It is located in the Department of European Paintings, Metropolitan Museum of Art.

32. *Ibid.*, p. 5.

33. *Ibid.*

34. F. Zeri and E. Gardner, *Italian Paintings: A Catalogue of the Collections of the Metropolitan Museum of Art, Venetian Schools*, New York 1973, pp. 21–22, cat. 05.41.1, 05.41.2.

35. F. Zeri and E. Gardner, *Italian Paintings: A Catalogue of the Collections of the Metropolitan Museum of Art, Northern Italian Schools*, New York 1986, pp. 73–75, with bibliography; cat. 05.2.1–12. *Letters*, I, p. 263, Roger to Helen Fry, 17 April 1906.

36. Zeri and Gardner 1986, p. 77. The portrait is now ascribed to a painter of northern European origin who worked in Venice in the 1250s; cat. 06.1324. *Letters*, I, p. 251, Roger to Helen Fry, 18 February 1906. Fry wrote about the painting in *The Bulletin of the Metropolitan Museum*, I, p. 73.

getting wildly excited at what I am doing and going to do. I am quite the sensation of the season", he wrote to his friend Goldsworthy Dickinson in mid-March 1906.[24] In the essay 'Ideals for a Picture Gallery', published the same month in the new *Metropolitan Museum Bulletin*, Fry declared that "the sentimental and anecdotic side of nineteenth century painting" was the only genre adequately represented in the Metropolitan,[25] thanks to the Vanderbilt loan and the huge Wolfe collection donated in 1887.[26] These are the terms that Fry chose also in a unique definition of "plutocratic" taste given in 1907. In December, during a short stay in New York, he delivered a series of lectures in which he used the categories of epic, dramatic, lyric and comedic in order to analyse European paintings "from the point of view of their emotional content".[27] The introductory lecture was developed to become *An Essay in Aesthetics*, and the others were never published. In the second one, devoted to the 'epic', in which he began with Byzantine art and ended with Michelangelo, Fry gave a definition of imperial Roman painting using a slide with the mosaic from Praeneste:

Here we have the work of the typical artist of the Empire working for plutocrats who had more money than culture. The artist could not afford to make any demand for serious effort on thought or feeling ... he could not hope to compel any imaginative exaltation of mood. All he could do was to represent pleasant and vaguely romantic scenes. Here for instance, life on the Nile ... the artist treated this in a gaily decorative and slight manner which curiously resembles that of modern impressionist or modern Japanese art.[28]

It also resembled the paintings Fry saw in the Metropolitan. However, nineteenth-century sentimental painting was not the only genre represented in the museum: in 1889 Henry Marquand, late president of the Metropolitan, had donated his extraordinary collection of old masters, with beautiful paintings by Vermeer, Hals and Rembrandt, not to mention several remarkable fifteenth-century Italian and Flemish works.[29] Besides the Marquand collection there were others, such as that of the Coudert brothers, donated in 1888, which provided interesting paintings for Fry to exhibit in his new gallery in April 1906.

Nonetheless, the Metropolitan old master paintings collection was far from being representative of the development of European painting. Fry was sceptical regarding the possibility of acquiring "masterpieces": the competition among private collectors had lately raised the prices enormously and the funds available did not permit the museum to step into the competition. Besides, Fry's project was of a different nature. As he wrote in 'Ideals for a Picture Gallery', the museum should focus on showing the "connecting links" between different schools and periods of European painting, in order to increase the public's "susceptibility to the finest artistic expression".[30] Again, in November 1906 he wrote a report for the Metropolitan Trustees in which he outlined the goals of the paintings department: "... getting genuine and fine

Fig. 61 Michele Giambono, *Man of Sorrows*, mid-15th century. Tempera on wood, incised wounds, 54.9 x 38.8 cm (with frame). The Metropolitan Museum of Art, Rogers Fund (06.180). Photo © 1994.

Fig. 62 Carlo Crivelli, *St Dominic* (panel from a dismembered polyptych). Tempera on wood, gold ground, 97.2 x 32.4 cm. The Metropolitan Museum of Art, Rogers Fund (05.41.1). Photo © 1986.

examples of the less reputed and less advertised masters; finding first rate examples of little known schools which have not yet attracted the eye of the fashionable dealer".[31] Fry conceived the galleries of the museum as the place where the American public was going to acquire a familiarity with the different schools of European paintings and for that kind of visual lesson masterpieces were not necessary.[32] As he explained in his report to the trustees he believed that the museum should be innovative in its purchasing policy and set the fashion instead of following it. In this respect he mentioned the fifteenth-century Catalan school and Italian and French painting of the seventeenth century as periods to which to devote more attention.[33]

During 1906 Fry bought fast following these principles. He began to advise the Metropolitan as early as 1905, but it is not clear what role Fry had in that year's acquisitions. In 1905 the museum bought in London two panels from a polyptych by Carlo Crivelli, of *St George* and *St Dominic* (figs. 60, 62); they came from the Ashburton collection, auctioned in 1905, but they were bought from the dealers Dowdswell & Dowdswell.[34] From the Willett collection, auctioned at Christie's, the museum bought a *Frieze of Twelve Heads* then attributed to Bramantino, coming from the palace of San Martino Gusnago, near Brescia. These profiles of famous men and women had been exhibited in London and had been published several times in the early years of the century.[35]

In January 1906, while he was still in London, Fry bought three paintings from Dowdeswell & Dowdeswell. The first one was a portrait of a man he attributed to Lotto.[36] Then he bought the so-called *Virgin of Salamanca*, then believed to be by the Master of Flémalle (later identified as Robert Campin) and now thought to be a fifteenth-century copy of a lost Campin painting. As in other cases, before shipping the painting to New York, Fry transferred the panel on to canvas.[37] The third painting he bought was *Ariadne in Naxos* by George Frederick Watts.[38] Still in London, he bought from Knoedler one of the finest purchases of that year, the *Portrait of Don Sebastian Martinez* by Goya.[39]

He also made several purchases in New York. In the middle of March he wrote to Helen: "We've just bought a whole batch of pictures which I found here at a dealer's and which he offered at ridiculous prices for the *réclame* of getting into the Museum: 1, a Bugiardini, a superb great Guardi, a Mireveldt, a huge Murillo, such a good one that even I had to get it, a Carlo Caliari and a W.M. Hunt".[40] The dealer was Eugène Fishof; unfortunately, except for the "Bugiardini", a beautiful *Madonna with San Giovannino* now ascribed to the early years of Fra Bartolomeo,[41] the other paintings Fry bought from him were probably the worst purchases he made in 1906.[42]

In New York Fry bought much better from Louis Ehrich, of the Ehrich Galleries, from whom he purchased an imposing *Portrait of a Woman* by Nicholas Maes.[43] Also in New York, but we do not know from whom, he bought a remarkable *Man of Sorrows* by Giambono (fig. 61).[44] The last important purchase he made in the winter of 1906 was *Le Chant du berger* by Puvis de Chavannes (fig. 64), which he bought from Durand Ruel.[45]

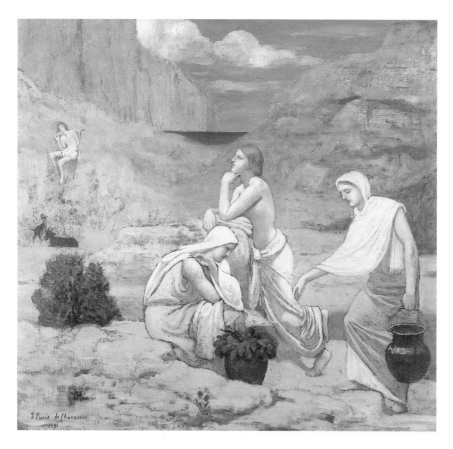

ABOVE Fig. 63 Piero di Cosimo, *A Hunting Scene*. Tempera and oil on wood, 70.5 x 169.5 cm. The Metropolitan Museum of Art, Gift of Robert Gordon (75.7.2). Photo © 1981.

LEFT Fig. 64 Pierre Puvis de Chavannes, *Le Chant du Berger*, 1891. Oil on canvas, 104.5 x 109.9 cm. The Metropolitan Museum of Art, Rogers Fund (06.177). Photo © 1980.

RIGHT Fig. 65 Adriaen Isenbrandt, *Christ Crowned with Thorns and the Mourning Virgin*, early 16th century. Oil on canvas, transferred from panel, 105.4 x 92.7 cm. The Metropolitan Museum of Art, Rogers Fund (04.32). Photo © 1998.

FAR RIGHT Fig. 66 Fra Filippo Lippi, *Portrait of a Man and a Woman at a Casement*. Tempera on wood, 64.1 x 41.9 cm. The Metropolitan Museum of Art, Marquand Collection (89.15.19). Photo © 1992.

Fig. 67 Roger Fry, *Sketch of the Salon Carré*, 1906. Fry Papers. Modern Archive, King's College, Cambridge.

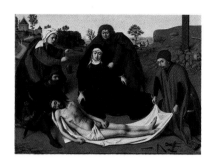

Fig. 68 Petrus Christus, *The Lamentation*,
mid-15th century. Oil on wood,
25.7 x 35.6 cm. The Metropolitan Museum
of Art, Marquand Collection (96.26.12).
Photo © 1998.

37. E. Fahy in Ainsworth and Christiansen
1998. The painting was previously owned
by Sir Edward Robinson, first director of
the South Kensington Museum. Fry
considered the panel support a
disadvantage for the painting, as he wrote
to the Paris art dealer M. Brauer on 24
June 1906. The letter is in the Department
of European Paintings, Metropolitan
Museum of Art.

38. Cat. 05.39.1.

39. Fry described the painting in *The
Bulletin of the Metropolitan Museum*, I,
p. 73; H.B. Wehle, *A Catalogue of Italian,
Spanish and Byzantine Paintings*, *The
Metropolitan Museum of Art*, New York
1940, pp. 246–47, cat. 06.289.

40. *Letters*, I, p. 257, Roger to Helen Fry,
16 March 1906.

41. F. Zeri and E. Gardner, *Italian
Paintings: A Catalogue of the Collections of
the Metropolitan Museum of Art, Florentine
Schools*, New York 1971, p. 187, cat.
06.171. Eugène Fishof is mentioned in W.
Towner, *The Elegant Auctioneers*, New York
1970, p. 157.

42. None of these paintings is still in the
Metropolitan Museum catalogue.

43. Cat. 06.1325. As was common, Ehrich
presented a gift to the museum in order to
smooth his business relationship. It was an
Allegory by Carlo Caliari. *Letters*, I, p. 251,
Roger to Helen Fry, 18 February 1906.

44. *Letters*, I, p. 261, Roger to Helen Fry, 3
April 1906. All the records list the
painting's provenance as from a Naples
collection, but it is not clear how it arrived
in New York. Zeri and Gardner 1973,
p. 26, cat. 06.180.

Moreover, in the deposits of the Metropolitan Fry found some very
interesting paintings. He wrote to Helen about his discoveries: "I have been
going through the stores of old pictures shoved away among piles of incredible
rubbish. I have found a splendid German Crucifixion, Matthias Grunevald [*sic*]
I think, a huge Giovanni di Paolo, a school of Simone Martini, a huge Murillo
which will absolve me from buying another, and other niceish things."[46] The
German *Crucifixion* is now ascribed to the master of Lucas de Leiden, Cornelis
Engelbrechtsz, who painted it around 1525. Fry identified the school and the
master and he wrote to Jacques Hulin to propose his hypothesis.[47] Both this
Crucifixion, and his other "discovery", the Giovanni di Paolo panels with *St
Francis and St Matthew*, had been a gift of the Coudert brothers.[48] The "school
of Simone Martini" – a panel divided in three, with *St Giles, Christ Triumphant
over Satan* and *The Mission of the Apostles* – was exhibited by Fry in an appendix
to his 'Salon Carré' as an example of the Early French School that showed the
influence of Simone Martini.[49] More recently it had been ascribed to an
unknown Valencian painter of the early fifteenth century.[50]

With all his new purchases and discoveries, Fry set out to arrange his gallery
of "masterpieces".[51] In March 1906, with the assistance of Bryson Burroughs,
he restored thirteen paintings in the collection, mostly cleaning them.[52] He
taught Burroughs his restoration methods as well as teaching the gilders
working in the museum how to treat the frames using the Cellini method.[53]
Fry's duties as a curator, in fact, implied not only the restoration of the
paintings but also the decoration of the galleries, which he regarded as a very
important aspect of his new arrangement in Gallery XXIV.[54]

The 'Salon Carré' exhibition was introduced in March by the short essay,
'Ideals for a Picture Gallery', published in the *The Bulletin of the Metropolitan
Museum*. Fry rhetorically asked himself what "the man of the street" looked for
when entering a museum; he quickly dismissed the possibility that it could
have something to do with entertainment or the idle pleasure of strolling
around, and he gave a definition of the museum's functions: to make the
public "acquire definite notions about the historical sequence of artistic
expression" and/or "increase [one's] susceptibility to the finest artistic
expression by a careful attention, fixed with all patience and humility, upon
the works of the great creative minds".[55] In its existing condition, the
Metropolitan Museum could not provide for either of these functions, not only
because of the nature of the collection, but also because of the way in which
the paintings were arranged. The question of display was becoming central for
Fry and it was strictly intertwined with his educational aims: "We must, in
fact", he wrote, "so arrange the galleries that it shall be apparent to each and
all that some things are more worthy than others of prolonged and serious
attention".[56] The models here were the Salon Carré in the Louvre and the
Tribuna in the Uffizi, and in general an aesthetic criterion was to be preferred
to an historical one in arranging the galleries. Quality was given precedence,
ultimately, above historical narrative.

45. C. Sterling and M. Salinger, *French Paintings: A Catalogue of the Collections in the Metropolitan Museum of Art*, New York 1966, II, p. 231; cat. 06.177.

46. *Letters*, I, p. 251, Roger to Helen Fry, 18 February 1906.

47. Roger Fry to Jacques Hulin, undated, Department of European Paintings, Metropolitan Museum. Fry sent Hulin a photograph of the painting.

48. F. Zeri and E. Gardner, *Italian Paintings: A Catalogue of the Collections of the Metropolitan Museum of Art, Sienese and Central Italian Schools*, New York 1980, pp. 19–20, cat. 88.2.111; Ainsworth and Christiansen 1998, p. 352, cat. 88.3.88.

49. Roger Fry, *Catalogue of a Temporary Exhibition in Gallery XXIV*, New York, April 1906, note 45.

50. H.B. Wehle, *A Catalogue of Italian, Spanish and Byzantine Paintings, The Metropolitan Museum of Art*, New York 1940, p. 214, cat. 76.10; the painting was a gift of J. Bruyn Andrews and came from the St. Juan Hospital in Valencia.

51. *Letters*, I, p. 255, Roger to Helen Fry, 2 March 1906.

52. Roger Fry, *Report, To the Board of Trustees*, 30 April 1906, Department of European Paintings, Metropolitan Museum.

53. *Letters*, I, pp. 255, 261.

54. *Letters*, I, p. 263, Roger to Helen Fry, 17 April.

55. Roger Fry, 'Ideals for a Picture Gallery', *The Bulletin of the Metropolitan Museum*, I, March 1906 p. 59.

56. *Ibid.*

57. See, for example, 'A Selective Art Museum', *The Nation*, LXXXII, no. 2134, 24 May 1906, pp. 422–23, and 'The Boston Museum' *The Burlington Magazine*, VII, 26 May 1905, p. 94; B.I. Gilman, *Museums' Ideals of Purpose and Method*, Boston Museum of Fine Arts 1918; although this essay by the director of the Boston Museum was published later, it was conceived in earlier years. On these topics, see N. van Holst, *Creators, Collectors and Connoisseurs*, London 1967, pp. 285–88, and C. Duncan, *Civilizing Rituals: Inside Public Art Museums*, London and New York 1995, p. 16.

58. Roger Fry, 'Ideals for a Picture Gallery', *The Bulletin of the Metropolitan Museum*, I, March 1906, p. 60.

This was the direction in which several museums in the world from Boston to Berlin were going, and it implied a new emphasis on the experience of the museum visit itself, displacing the traditional focus on the clear unfolding of historical developments in the arts. Obviously the term 'experience' did not appear in the debate over the matter of museum display, and the explicit goal of the new principles of installation was to separate what provided a high standard of quality from what did not.[57] In fact, in 'Ideals for a Picture Gallery', Fry sounded like a high-priest of the new cult for standards: "The aim we should set before ourselves is the establishment of standards of truth and beauty, and the encouragement of a keener discrimination and a firmer faith. A discrimination between the bad and the good, and a faith in the existence of something more universal in art than a merely casual and arbitrary predilection".[58]

Gallery XXIV opened on 19 April 1906; it was a great success. A reviewer pointed out that the paintings in the gallery "embodied the ideas from which one gets the greatest pleasures in art" and that "Something must be gained even for the uninitiated by having these ideas presented with a certain concentration, undisturbed by the juxtaposition of paintings marred and cheapened by the signs of artistic poverty".[59] Fry's educational intent had been well received. Unfortunately photographs of the show do not survive, but we know that the walls of the gallery had been covered in an olive-coloured canvas and that they were bevelled above, curving up to the skylight.[60] In the centre of the room there was a large sixteenth-century Italian table in cipollino marble, lent by Eugene Glaenzer, bearing two Rodin bronzes lent by a New York collector;[61] on the walls were displayed forty-two paintings: Italian, Flemish, Dutch, Spanish, English and French, from the fifteenth to the nineteenth century. Fry drew a little sketch of the disposition of the paintings in a letter to his wife (fig. 67). On the four doors of the gallery were placed the Lombard panels with the frieze of heads, while on the four walls the paintings were arranged differently, according to their particular compositional principles, colour or handling.

If we match the sketch with the accurate description given in a review, we have a fairly good idea of how Gallery XXIV looked.[62] On the east wall, around *Le Chant du Berger* by Puvis de Chavannes, Fry gathered all the 'primitives': the Giambono, the Petrus Christus *Lamentation* (fig. 68) from the Marquand collection, the *Crucifixion* by Cornelis Engelbrechtsz, the two panels by Piero di Cosimo with scenes of primitive life (fig. 63), which had been in the museum since 1875,[63] The *Virgin of Salamanca*, the two *Saints* by Crivelli he bought in London, the *Ecce Homo* by Isenbrandt (fig. 65), in the collection since 1904,[64] the *Portrait of a Man and a Woman at a Casement* (fig. 66), now ascribed to Filippo Lippi, from the Marquand Collection,[65] and a *Madonna and Child in a Niche* from the same collection (attributed by Fry to Jan van Eyck, now considered an early sixteenth-century variant of Van Eyck's *Virgin and Child at the Fountain*).[66] On the same wall, the most crowded, were a *Portrait of a Woman* by Ambrogio de Predis, from the Marquand Collection,[67] and the new 'Lotto'.

59. E.L. Carey, 'Gallery Number XXIV', *The Script*, I, no. 9, June 1906, pp. 289–93, especially p. 289.

60. *Ibid.*

61. *Catalogue of a Temporary Exhibition in Gallery Number 24, Metropolitan Museum of Art, New York City, April 1906*, New York (The Gilliss Press) 1906, p. 3. Glaezner was an art dealer based in Paris and New York. Fry referred to him as a member of the "honest party"; see *Letters*, I, pp. 223 and 718.

62. E.L. Carey, 'Gallery Number XXIV', *The Script*, I, no. 9, June 1906, pp. 289–93.

63. Zeri and Gardner, 1971, pp. 176–80; cat. 75.7.1; 75.7.2.

64. Ainsworth and Christiansen 1998, p. 374; cat. 04.32.

65. Zeri and Gardner 1971, pp. 85–87; cat. 89.15.19.

66. Ainsworth and Christiansen, 1998, p. 220; cat. 89.15.24.

67. Zeri and Gardner 1986, pp. 54–55; cat. 91.26.5.

68. The first Rembrandt is cat. 91.26.7, the second cat. 89.15.3 ("Rembrandt Style"; see *Rembrandt not Rembrandt in the Metropolitan Museum*, New York 1995, pp. 89 and 138, where it is argued that the second portrait is an ancient forgery); Maes, cat. 06.1325; Hals, *Portrait of a woman*, cat. 91.26.10, *Hillebobbe*, bought in 1871, cat. 71.76; Vermeer, cat. 89.15.21.

69. The Jan Steen is attributed to Peter Wtewael, cat. 06.288; the landscape by Wilson lent by Morgan could be the *View of Dolbadarn Castle and Llyn Peris* today in the National Gallery of Victoria, Melbourne; see W. G. Constable, *Richard Wilson*, London 1953, p. 176.

70. Cat. 89.15.11.

71. Zeri and Gardner 1986, pp. 75-76, cat. 91.26.2.

72. J. Caldwell and O.R. Roque, *American Paintings in the Metropolitan Museum of Art*, pp. 181-82; the painting was bought in 1905 with its companion piece by the Ehrich gallery in New York; cat. 05.40.2.

73. Cat. 02.24.

74. El Greco, cat. op. 05.42, see H.B. Wehle, *A Catalogue of Italian, Spanish and Byzantine Paintings, The Metropolitan Museum of Art*, New York 1940, p. 230; Piombo, cat. 00.18.2; Manet, cat. 89.21.2, gift of Erwin Davis.

On the south wall, Fry disposed a series of beautiful Dutch paintings: two *Portraits of a Man* by Rembrandt, and a *Portrait of a Woman* by Nicholas Maes; two Hals, a *Portrait of a Woman* and the *Hillebobbe*; and the *Woman at a Window* by Vermeer – all but the Maes from the Marquand collection.[68] Then on the same wall Fry assembled various landscapes (including Turner's *Saltash*, from the Marquand collection, and a landscape by Richard Wilson lent by Pierpont Morgan), an allegory by Tiepolo already in the museum, a Murillo with *St John the Evangelist* (one of the bad paintings bought in 1906) and a *Kitchen Scene* purchased in 1906, which Fry attributed to Jan Steen.[69]

On the west wall were more portraits but of a quite disparate nature: Van Dyck's *Portrait of James Stuart* from the Marquand collection,[70] Goya's portrait of *Don Sebastian Martinez*, a Maratta *Portrait of Pope Clement IX*, lent by Mrs Huntington, and a *Portrait of a Man* from the Marquand collection attributed by Fry to Torbido and now ascribed to an unidentified Brescian painter.[71] The same wall ended with the 'Guardi' Fry bought in New York and the only American painting in the exhibition, *Portrait of Mrs Joseph Anthony* by Gilbert Stuart.[72]

The north wall was the "impetuous" one, as the reviewer put it. There was Rubens's *Holy Family*,[73] El Greco's *Adoration of the Shepherds*, bought by the museum in 1905, Titian's *Portrait of Aretino* lent by Henry C. Frick, a portrait by Sebastiano del Piombo of *Columbus*, given to the museum by J.P. Morgan, and the *Boy with a sword* by Manet.[74] Fry added an appendix to his gallery, in a small room, where he placed three panels found in the deposits of the Metropolitan, the Giovanni di Paolo of *St Francis and St Matthew*, the panel from Valencia which he thought was French, and one with *Stories of Saints*, which he ascribed to the Austrian School of the fifteenth century. This last is part of a polyptych with stories of *St Remigius* painted in Switzerland in the first half of fifteenth century.[75]

Gallery XXIV is a unique example of Roger Fry's activity as a curator of old master paintings. It seems clear that on this occasion his main interest was an educational one: the 'Salon Carré' arrangement, albeit in tune with the most recent examples of museum display, was an attempt to present European paintings, crossing schools and periods, according to its "emotional content".[76] For Fry, this was the most direct way of engaging the New York public in what he conceived as serious art.

In November 1906 Fry concluded his year as a curator of painting with a report to the Trustees of the Metropolitan.[77] Besides his suggestions for an acquisition policy, Fry was quite specific about the arrangement of the paintings in the gallery. The museum should aim at reproducing the model of the Berlin museum, with its galleries mainly divided by schools and periods but arranged according to aesthetic principles and decorated with period furniture and *objets d'art*. In the meantime it was already possible to create some "historic" galleries in the Metropolitan that would complement the main Gallery XXIV. He envisioned a gallery for all the European paintings before

75. Cat. 71.33ab, 71.40ab.

76. 'Notes for six lectures given in New York', Fry Papers, lecture, sheet 40.

77. *Letters*, I, p. 273, Roger to Helen Fry, 20 November 1906.

78. Roger Fry, *An Outline of the Aims and Ideals Governing the Department of Paintings*, pp. 6–8.

79. *Letters*, I, p. 274, Roger to Helen Fry, 28 November 1906.

80. Edward Robinson to Roger Fry, 27 June 1906, Department of European Paintings, Metropolitan Museum of Art.

81. *The Bulletin of the Metropolitan Museum*, I, p. 104.

82. 'At the Museum: A Survey of Conditions under the New Regime', *The New York Daily Tribune*, 22 April 1906.

83. 'A Progressive Museum', *The New York Post*, 25 April 1906.

84. *Letters*, I, p. 278; Spalding 1980, p. 95.

85. Giovanni di Paolo, cat. 06.1046, F. Zeri and E. Gardner, *Italian Paintings: A Catalogue of the Collections of the Metropolitan Museum of Art, Sienese and Central Italian Schools*, New York 1980, pp. 20–21; Holbein, cat. 06.1038; Cranach, cat. 08.19.

86. Some letters to and from Brauer are in Department of European Paintings, Metropolitan Museum of Art.

87. C. Sterling and M. Salinger, *French Paintings: A Catalogue of the Collections in the Metropolitan Museum of Art*, New York 1966, pp. 149–52, cat. 07–122; *Letters*, I, p. 284; Spalding 1980, p. 100. Fry wrote about the painting in *The Bulletin of the Metropolitan Museum*, II, p. 102–04.

88. Bellini, cat. 08.183.1; Zeri and Gardner 1973, pp. 4–5; Cranach, cat. 08.19.

89. Zeri and Gardner 1986, pp. 8–10, cat. 12.211.

90. Fry to Bryson Burroughs, 21 February 1909, Department of European Paintings, Metropolitan Museum of Art.

1500, one for the Dutch school and one for the English and French schools of the eighteenth century.[78] The main obstacle to this rearrangement was that many collections had been donated or loaned to the Metropolitan with restrictions: they could not be dismembered and they could not be selected. But Fry finally obtained permission for the curator and his assistant, with the Director's agreement, to withdraw paintings from their galleries.[79] He also proposed some changes regarding the lighting of pictures; from his correspondence with Edward Robinson, the assistant director, we know that in 1906 Fry was very active in designing the galleries in the new wing of the museum.[80]

According to the reviews of the April show, Fry's New York experiment had been a success: in the month of April 1906, 88,000 people visited the museum, and probably most of them went into Gallery XXIV.[81] Not only did *The Burlington Magazine* report monthly on his acquisitions, but whatever he did had extensive and mostly positive coverage in the American press. However, one of his most loyal critics, Royal Cortissot of *The Tribune*, thought that his purchases were "less ambitious" than they should have been, although he found that in Gallery XXIV "the whole scheme promises to envelop the visitor in a stimulating atmosphere".[82] Also Frank Jewett Mather, who as editor of the American section of *The Burlington Magazine* was very supportive of Fry, thought that, although he was getting at "standard museum values", in his purchases he had "a tenderness toward the bargain" that damaged his general scheme.[83]

At the end of 1906, Roger Fry changed his position from that of curator of painting to that of European adviser.[84] Between 1907 and 1910, acting in this capacity, Fry bought several important paintings for the Metropolitan: the *Paradiso* by Sano di Pietro, and the *Portrait of Benedict von Hertenstein* by Holbein in 1906.[85] The Sano di Pietro was bought from the Paris dealer Brauer, who provided many works of art for Morgan and the museum and with whom Fry was in close contact in those years.[86] The most important acquisition of 1907 was the portrait of the *Famille Charpentier* by Renoir, the most 'modern' painting so far bought by the Metropolitan, which stirred some anxieties among the trustees.[87] In 1908 he bought a *Madonna* by Giovanni Bellini, and Cranach's *Portrait of the Duke of Saxony*.[88] In the same year he advised the museum to buy an altarpiece with *Saints Peter, Martha, Magdalen and Leonard* by Correggio in the Ashburton collection; it would make the only purchase of 1912.[89] Fry and Burroughs exchanged several letters on the matter. Fry insisted, quite rightly, that it was probably the most important acquisition the museum could make in those years; besides, as he asserted in other letters, they needed altarpieces as centrepieces for their gallery. The correspondence with Burroughs over the Correggio gives an insight into the difficult relations between Fry and the Trustees: the painting, at £17,000, was not very expensive by the standards of those days but in 1908 the budget of the museum was not sufficient for its purchase.

Fry suggested a public subscription, as had been done for the Holbein's portrait in 1906, but this time the Trustees did not accept the proposal. Fry was exasperated; in February 1909 he wrote to Burroughs:

We ought really to buy that. It is a cheap picture and one that the public when once given the hint would come to admire enormously The Correggio is a picture for a public gallery – it is not the point to say that rich men don't want to possess it. If they did we should have no chance. You see one is on the horns of a dilemma. If rich Trustees like a thing they want it for themselves and if they don't they don't want the museum to have it".[90]

During his connection with the Metropolitan Museum Fry had several differences of opinion with some of the trustees. His strongest opponent was George Arnold Hearn, who in 1907 presented the museum with a fund to buy works of living American painters. After Fry left New York in April 1906, Hearn questioned his cleaning methods in a Trustees meeting.[91] A few weeks later, Charles M. Kurtz, a painter and art critic, violently attacked Fry in the journal *Academy Notes* for having ruined some paintings in the Metropolitan. All the main New York newspapers reported on the matter and the animosity of the debate shows that Fry had not succeeded in assuring a secure position for himself within the New York art scene.[92]

After reading his letters, Fry's biographers have identified John Pierpont Morgan as his main antagonist at the Metropolitan: the American financier was described as the museum's dictator, the avid accumulator of treasures he was not able to appreciate, the plutocrat par excellence.[93] In fact, on several occasions Morgan sustained Fry against the other Trustees,[94] even though it was a bitter quarrel over a Fra Angelico *Madonna and Child*, which Morgan wanted for his collection and Fry thought should be acquired by the museum, that severed Fry's contact with the Metropolitan.[95] That was in February 1910, when the first Post-Impressionist show was about to open.

As Fry declared in his first American interview, he believed that his duty as a curator was to educate the public to make its own judgements. In order to do so, he went beyond his personal taste and hierarchies, buying and showing in the museum a wide variety of schools and genres. Although his choices were partly shaped by the conditions of the art market and the limited funds at his disposal, Fry, I believe consciously, went in the opposite direction of contemporary American collecting: instead of searching out 'important paintings' he looked for the 'connecting links'. This choice implied a specific idea of what the museum public needed: to be stimulated to "careful attention"[96] and exposed to unexpected connections. What he wanted was to encourage critical viewers to have the patience to look closely, and to make up their own minds. He aimed to open the canon to scrutiny, not to perpetuate it in a fixed form.

91. Edward Robinson to Roger Fry, 30 April, 10 May and 23 May 1906, Department of European Paintings. On Hearn, see *Letters*, I, p. 256; *The Bulletin of the Metropolitan Museum*, II, 1907; Tompkins, 1970, *passim*.

92. Several press cuttings on the matter can be found in Fry Papers. On the event, see Spalding 1980, pp. 91–92; *Letters*, I, p. 264.

93. Virginia Woolf, *Roger Fry: A Biography*, London 1991, pp. 140–46; Spalding 1980, pp. 90, 95.

94. *Letters*, I, pp. 278, 288, 291. For the Morgan and Fry relationship, see also J. Strouse, *Morgan: American Financier*, New York 1999, *passim*.

95. *Letters*, I, pp. 324, 327; Spalding 1980, pp. 104–06; the painting came from the collection of King Leopold of Belgium and it was on sale at Kleinberger's in Paris.

96. Roger Fry, 'Ideals for a Picture Gallery', *The Bulletin of the Metropolitan Museum*, I, March 1906, p. 59.

EXPANDING THE CANON

Roger Fry's Evaluations of the 'Civilized' and the 'Savage'

CHRISTOPHER GREEN

Fig. 69 (Cat. 1) Fang (Cameroon), *Female Reliquary Figure*. Wood, height 68 cm. Collection Musée de l'Homme, Paris (Legs Saint-Paul. Inv. No.M.H.97752.1). Photograph by José Oster.

"I spent the afternoon in the Louvre", Roger Fry wrote to Helen Anrep in 1925. "I tried to forget all my ideas and theories and to look at everything as though I'd never seen it before and took the risk of having to say to myself that ... Murillo [was] better than Rembrandt. It's only so one can make discoveries but it needs some heroism."[1]

Fry suspected all canonical evaluations of works of art, including his own. He is often charged with having erected a canon, but actually disliked the very idea of canons. Five years after the letter quoted above, he wrote to the editor of *The Burlington Magazine* setting out his hopes for "the scheme for the foundation of a faculty of art-history in London University", the Courtauld Institute. What he hoped for in this new discipline was a "scientific" rather than a "literary attitude" from which could develop an "applied aesthetics" capable of treating all judgements with equal scepticism. He was especially against "dogmatic valuations, however respectable their traditional backing" He declared:

It is essential that the art-historian should be able to contemplate any object which can claim in any way to be a work of art with the same alert and attentive inquisition as one which has already been, as it were, canonized. For this reason, however intensive the specialization may become at the end of the course, there should be a considerable period of study in which the student is led to contemplate typical works of art of all periods and all countries in the same spirit of perceptive enquiry[2]

He thus linked his suspicion of canons directly to the expansion of the field of art history into regions beyond history and beyond Europe. He envisaged a discipline of world art history always open to re-evaluations. Inevitably, the Courtauld Institute, like Fry, has, in fact, erected and sustained canons by the very act of fixing attention on the visual art of certain cultures and individuals, but, especially in recent years, it, too, has been open to the expansion of the canon and the questioning of canonical judgements. The Institute, however, left behind Fry's vision of a world art history not long after its foundation, despite the scope of the lectures he regularly gave there in 1933–34. My intention in this essay is to look at that vision, for it is perhaps the most direct route to an evaluation of Fry's attitude to evaluation – to the canon.

Fry's public embrace of non-European cultures alongside Western art was a

Fig. 70 (Cat. 133)
Duncan Grant,
Female Dancer (design for a painted
screen), 1913–14.
Oil on paper, 34.8 x 22.9 cm.
Courtauld Gallery (PD 72).

NOTES

1. *Letters*, II, p. 565: Fry to Helen Anrep,
Le Havre, 20 April 1925.

2. Roger Fry, 'The Courtauld Institute of
Art', *The Burlington Magazine*, LVII,
December 1930, pp. 317–18.

3. See J.B. Bullen (ed.), *Post Impressionists
in England*, London 1988.

feature of his campaign for his invention of "Post-Impressionism", especially in 1910 with the first Grafton Galleries exhibition. He might have been most unequivocal and most earnest in his elevation of Cézanne, but the 1910 show was, in fact, marketed around the figure of Gauguin, who supplied a Tahitian image for the poster and, as J.B. Bullen has shown, critical attention focused above all on Gauguin and Van Gogh.[3] What Fry believed that he had found in Gauguin, Van Gogh and Cézanne was a new generation that re-fastened the link between the modern and the structured composing he most valued in earlier European art, especially that of Quattrocento Italy. What many in the press believed, however, encouraged by that poster, was that Fry had found, not a new order, but something savage, a return to the infancy of culture,

Fig. 71 (Cat. 136)
Duncan Grant,
Male Dancer (design for a painted screen),
1913–14.
Oil on paper, 31.7 x 23.7 cm.
Courtauld Gallery (PD 73).

4. Anon., *The Times*, 7 November 1910, cited in Virginia Woolf, *Roger Fry: A Biography*, ed. Diane F. Gillespie, Oxford 1995, p. 123.

5. See especially her analysis of the work of Alfred Haddon and Henry Balfour, in Annie E. Coombes, *Reinventing Africa: Museums, Material Culture and Popular Imagination in Late Victorian and Edwardian England*, New Haven and London 1994, pp. 48–50, 55, 120, 127, 142–55.

which they located outside modern Europe. The critic of *The Times* put it this way: "Really primitive art is attractive because it is unconscious; but this [the work on view at the Grafton Galleries] is deliberate – it is the rejection of all that civilization has done, the good with the bad ...".[4]

At the turn of the century, the term 'primitive' was used by art historians and critics broadly within an evolutionary conceptual framework that applied to all cultures. As Annie Coombes has shown, evolutionary theories dominated English anthropological as well as art-historical representations of the development of art: theories which required stages between 'primitive' beginnings and higher, more mature developments.[5] In this context, the norm was to refer to Italian art from Giotto to the later Quattrocento as 'primitive',

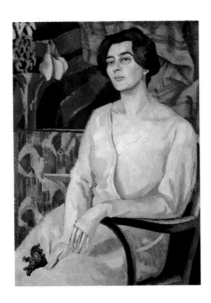

Fig. 72 (Cat. 77) Roger Fry, *Portrait of Lalla Vandervelde*, c. 1916. Oil on canvas, 85 x 106.7 cm. Private collection.

and 1904 saw the invention by the French of a school of 'French Primitives' to bolster the strengthening nationalist image of a highly evolved French tradition.[6] The terms 'savage' and 'barbaric' carried very different meanings. For an anthropologist such as Henry Balfour, the "savage and barbaric" was defined in simple contradistinction to what was supposed to be a "general advance towards civilization".[7] For the promoters of shows making a spectacle of Africa for mass audiences, savagery went with exoticism as a major attraction, as Coombes demonstrates, for instance in the performance put on at Olympia in 1899–1900 with the title 'Briton, Boer and Black Savage South Africa'.[8] Evolutionary thinking and racist stereotyping combined in the idea of the 'savage' or 'barbaric' as something 'other', in the sense of uncivilized, something that was anterior to evolution and that carried a threat that many civilizations had known: the threat of barbaric invasion and the destruction of all evolved culture. Many responses characterized the paintings of Gauguin and Van Gogh at the 1910 Post-Impressionist exhibition as "savage" and "barbaric". In *The Morning Post*, for instance, Robert Ross underlined the distinction between notions of the 'primitive' and the 'barbaric' by calling Van Gogh's colour "barbaric rather than primitive".[9] Theodore Bulkeley Hyslop, Physician Superintendant of the Royal Hospitals at Bridewell and Bedlam, wrote in the periodical *Nineteenth Century*: "This craving for what is crude and elementary is nevertheless significant of a return to the primitive conditions of children, and sometimes betrays an atavistic trend towards barbarism".[10] The idea of barbarism, which almost always went with hostile responses, ushered in the prospect not of an idealized return to innocence, but of a degenerative regression into childishness.

Those words 'savage' and 'barbaric', therefore, carried with them the fear of degeneration, either as a result of Gauguin's wilful rejection (as it appeared) of European culture or as a result of Van Gogh's madness (often alluded to). Again, as Coombes demonstrates, the counterpart of evolutionary theory at the turn of the century in England (as in continental Europe) was degeneracy theory: the idea that evolution could be undone by regressive processes.[11] Hyslop made a point of alluding to Max Nordau, one of the key figures in the development of European degeneracy theory. He saw what for him was the "childish" "barbarism" of Van Gogh's and Gauguin's painting as directly analogous to the art of the insane – a clear manifestation, therefore, of the degenerative dangers in modern society. Even critics were to be understood in these terms. "Critics", he warns, "who fall into raptures and exhibit vehement emotions over works which are manifestly ridiculous and degrading are themselves either imposters or degenerates. Excessive emotionalism is a mental stigmata of degeneration."[12] For him, Roger Fry was plainly a degenerate.

Fry himself tended to be guarded in his use of the term 'barbaric', but he was happy to accept the alignment of the modern with the 'primitive' along with all its connotations of regression; and "emotionalism" was an explicit feature of what he understood as 'primitive'. He answers Hyslop and the critic

6. An exhibition was mounted at the Pavillon Marsan with this explicit intention, 'Les Primitifs français'. Fry was distinctly sceptical about the claims for "a great continuous French school of painting" beginning in the 11th century, as he makes clear in Roger Fry, 'Exhibition of French Primitives in the Pavillon Marsan', *The Athenaeum*, 30 April 1904, p. 508. Fry was altogether sceptical about the term "primitive" as applied to Italian art between 1300 and the end of the 15th century. See also below, 'Italian Primitives', p. 182.

7. I quote here from Balfour's 'Notes on the Arrangement of the Pitt Rivers Museum' (1893), as cited in Coombes 1994, p. 120.

8. *Ibid.*, p. 86.

9. Robert Ross, 'The Post-Impressionists at the Grafton: Twilight of the Idols', *The Morning Post*, 7 November 1910, cited in Bullen 1988, p. 101.

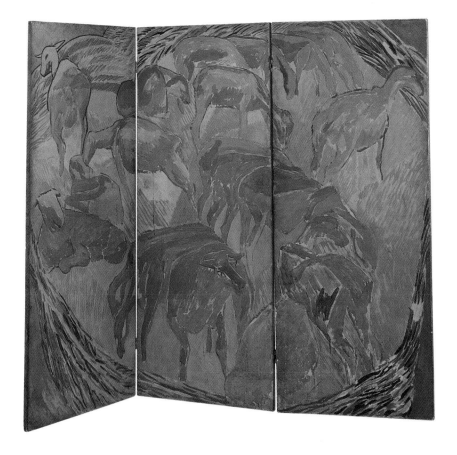

Fig. 73 (Cat. 146) Duncan Grant, *The Blue Sheep*, 1915. Three-fold screen, gouache on paper laid on canvas, 106.2 x 205 cm. The Victoria and Albert Museum.

10. Theodore Bulkeley Hyslop, 'Post-Illusionism and the Art of the Insane', *The Nineteenth Century*, February 1911, in Bullen 1988, pp. 209–22.

11. Coombes shows that, in the aftermath of the Boer War in 1902, great concern was expressed about the possible fate of the " 'imperial' Aryan race"; see Coombes 1994, p. 56.

12. Hyslop in Bullen 1988, p. 221.

13. Roger Fry, 'The Grafton Gallery – I', *The Nation*, 19 November 1910, pp. 331–32.

of *The Times* by taking up their rhetorical questioning in his own way: "Why", he asks, "should the artist wantonly throw away all the science with which the Renaissance and the succeeding centuries have endowed mankind? Why should he wilfully return to primitive, or, as it is derisively called, barbaric art? The answer is that it is neither wilful nor wanton but simply necessary, if art is to be rescued from the hopeless encumbrance of its own accumulations of science; if art is to regain its power to express emotional ideas."[13] Fry would always maintain that the primitive was characterized by a capacity for unmediated emotional expression, and that any return to it was justified by the need to recuperate for the civilized that expressive capacity.

As I show in the opening essay in this book, Fry never relinquished the ideal of civilization. English Post-Impressionism, indeed, is at its most pugnaciously 'primitive' when Fry and his friends, Duncan Grant especially, are designing, under the insignia of Omega, for the English middle classes at their most civilized. Grant's Dionysian dancers (figs. 70, 71), among his most brutally direct primitivizing inventions, were probably painted as designs for Omega decorations, and therefore, like his painted screen *The Blue Sheep* (fig. 73), were meant for the drawing-rooms of the suitably civilized. During the 1914–18 war, Omega's ideal client would arrive, Lalla Vandervelde, wife of the

Fig. 74 (Cat. 107) Roger Fry, *Lalla Vandervelde's bed*, September/October 1916. Oil on wood, 45.7 x 91 x 201 cm. The Victoria and Albert Museum, London.

Belgian ambassador, who Fry painted as the quintessence of modern civilized refinement (fig. 72) after having designed her a bedroom in a characteristically 'barbaric' Omega vein (fig. 74).

At the turn of the 1880s and 1890s, Fry's approach to culture, specifically Western culture, had been evolutionary and progressive in the simplest Darwinian sense.[14] In 1891, and then in 1894, just before and after the unsuccessful submission of his fellowship dissertation to King's College, Cambridge, he made a detailed study of Leonardo da Vinci's scientific writings on colour and light, arriving at an idea of scientific and artistic progress as closely parallel processes. Jottings in a notebook dedicated to Leonardo read (quoted without correction):

Painting whatever its *aim* has for *means* the representation of *objects* on a *flat surface*. We do not see the third dimension we know it. *Early* drawing & childrens an attempt to state the *facts known*. History of art as a gradual giving up of this point of view. The beginning of perspective in Greek art in Uccello. L.B. Alberti Lionardo. Divisions of Persp. Linear – Tone – colour – Linear due to structure of eye tone & colour to air. Lionardo's not a mere empirical statement but a general theory.[15]

Fry's view is the conventional one of the later nineteenth century: the history of art follows the evolution of a science of representation punctuated by successive attempts to formulate general principles.

Within a very few years, in 1897, a lecture from his series of Cambridge Extension lectures, 'Transition from Classical to Modern Art', hints heavily at a serious re-thinking of the idea of a single, continuing evolution in the art of the West. Fry is reflecting on the apparent cultural reversal demonstrated by the shift from the highly skilled naturalism of late Roman wall-painting (for instance at Pompeii) to the Early Christian paintings in the catacombs of Rome:

We see there in fact the transition from the art of grown up people to the elementary symbolism of a child's drawings. I do not say this was a misfortune for art, it is scarcely possible to see what new development could have come from the sophisticated accomplishment of the later Roman painters, who knew so much more than they felt; moreover it was only by such a return to elementary symbolism that the great painting of Italy could be provided with that basis of rigid and traditional formalism which so far as we know is the necessary antecedent of all the great periods of artistic development: indeed if the art of to-day could take such a backward step without the help of barbaric invasions and without having to wait a thousand years for the process of expansion to begin again I for one would not be discontented.[16]

In 1910 and 1912, many, as we have seen, would be in no doubt that Fry himself had led a kind of "barbaric invasion" into the Grafton Galleries, while

14. J.E. McTaggart had read Herbert Spencer, a major Evolution theorist, before he arrived at Clifton College, where he and Fry became best friends. Almost certainly, Fry had read Spencer, too, before he went up to Cambridge.

15. The notebook concerned has a black cover, with a label inscribed "Lionardo [*sic*]. notes on writings. Giotto"; Fry Papers, 4/1/1. These jottings are in pencil. The early date is confirmed by the misspellings, which are characteristic of Fry's early handwritten manuscripts .

16. J.B. Bullen dates this series 1897; see note 17, below. That it is early is corroborated by the misspellings of names, notably Leonardo as "Lionardo" in Lecture III, as in the notebook discussed in note 15. See Fry Papers, 1/65.

17. At the time of writing, I have seen J.B. Bullen's work on Fry and Byzantine art only in manuscript. It is to be published in *The Burlington Magazine* in November 1999. I am very grateful to him for allowing me to see this material before publication; it has enormously clarified things for me, as well as introducing me to an important figure in the development of Fry's analogy between the Byzantine and the modern, Matthew Prichard. The key texts exploring the Byzantine–modern parallel by Fry are: Roger Fry, 'The Last Phase of Impressionism', letter to the editor, *The Burlington Magazine*, XII, March 1908, pp. 374–75 (where the term "proto-Byzantine" is coined); and the first lecture in the series, 'Monumental Painting', written for the Slade School in 1911; Fry Papers, 1/88. In the material I have seen, Bullen does not point to Fry's anticipation of his later position on Byzantine art in his 1897 lecture.

18. Roger Fry, 'An Appreciation of the Swenigorodskoi Enamels', *The Burlington Magazine*, XXI, August 1912, pp. 290–94. See also 'Byzantine Art', below, p. 142.

19. Roger Fry, 'The Grafton Gallery – I', *The Nation*, 19 November 1910.

he for his part would be in no doubt that this "invasion" was aimed precisely to inspire himself and others to take "such a backward step" – a step that he by then would understand to be back to the essentials of emotional expression.

Fry's refusal of metaphysics and acceptance of scientific empiricism – a career-long position, as shown in my first essay – did not lead him to identify art with science. His 1920 essay 'Retrospect' aligns his commitment to science with progress, but at the same time decisively separates science from art, as I also show in my first essay. Invoking anthropology, he asserts that science has now demonstrated the essentially irrational character of art, from which, of course, it follows that the history of art cannot be understood on the progressive evolutionary model of science. It was, in fact, to an explicitly regressive, not progressive, idea of historical change that, by 1910, he had attached his idea of the emergence of modern, Post-Impressionist painting. J.B. Bullen has recently charted the development in Fry's writing, between 1908 and 1910, of a compelling new analogy relating past and present. Fry's epiphany in front of the paintings of Cézanne and his subsequent decision to take the painting of Van Gogh and Gauguin seriously, too, convinced him that the current situation in European art in broad terms parallelled the situation immediately after the fall of the Roman Empire as he had outlined it a decade earlier. What he had hoped for in 1897 was actually occurring; he had simply not been able to see it. A "proto-Byzantinism" was succeeding the scientific sophistication (as he saw it) of an especially extreme form of naturalism, Impressionist painting, and it was happening at a speed far in excess of developments in European art between the third and sixth centuries, without the anarchy of barbarian invasions to help in the destruction of the new naturalism. [17]

When Fry decided to use one of Matisse's most explicitly 'Byzantine' works, his *Marguerite with a Black Cat*, for the cover of the *Second Post-Impressionist Exhibition* catalogue in 1912, the point was hammered home. Just a few months before he had published an appreciation of a group of tiny enamel medallions from a twelfth-century icon frame which had been bought by Pierpont Morgan in New York. He dismissed altogether the idea that these were merely "quaint" and "curious", and found in them instead a "vitality" and "expressiveness", an "extreme modernity" (cat. 20).[18]

Fry's Byzantine–modern parallel revealed, in effect, what appeared to be a general historical principle: that periods of high naturalism created the conditions for a return to the simple, the hieratic, 'the primitive', since with the elaboration of a science of representation there went the atrophy of emotional expression. At any such moment, a return to 'the primitive' was imperative if the expressive power of art was not to be lost. For Fry in 1910, regression in art was a necessity, and regression meant sloughing off skill, where skill was the adjunct to representational science. His answer to his critics was clear: "And there is at least this consolation, if we must surrender that too complex language of complete naturalistic representation ... namely, that the

20. Fry's study of Leonardo's and Leon Battista Alberti's writings in the early 1890s (see note 15 above) was directed towards the idea of a measurable standard of beauty. Further, one of his papers for the Society of the Apostles is entitled: 'Are we compelled by the true and Apostolic Faith to regard the standard of beauty as relative?'. Here he argues that there is "a standard of beauty" beyond "the slough of individual caprice", but, in keeping with his phenomenological position, that it is apprehensible only through "the structure of our sense organs"; Fry Papers, 1/10. See also 'Reynolds (Sir Joshua)', below, p. 202.

21. Spalding notes that Fry must have read Tolstoy's 'What is Art?' by the time he wrote his New York lecture series on art under the headings 'Epic', 'Dramatic', *etc*, which were delivered in December 1907; Spalding 1980, p. 110.

22. The term "significant form" first appears in Bell's preface to the English section of the catalogue of the *Second Post-Impressionist Exhibition*, but, of course, is first fully discussed along with "aesthetic emotion" in Clive Bell, *Art*, London 1914. Fry's response to these ideas is discussed in my first essay in this book.

23. Bell makes this clear by the range of examples he chooses to deploy in the passage in *Art* where he introduces both significant form and aesthetic emotion.

24. Roger Fry, 'Modern Paintings in a Collection of Ancient Art', *The Burlington Magazine*, XXXVII, December 1920, pp. 303–09.

25. Roger Fry, 'Negro Sculpture at the Chelsea Book Club', *The Athenaeum*, 16 April 1920, p. 516; reprinted with the title 'Negro Sculpture' in *Vision and Design*, p. 85. Torgovnik sees this passage, with its metaphor of nakedness, as advocating a simple return to savagery, missing the subtleties of Fry's 'civilized' position; see Marianna Torgovnik, *Gone Primitive: Savage Intellects, Modern Lives*, Chicago 1989.

26. Roger Fry, 'Children's Drawings', *The Burlington Magazine*, XXX, June 1917, pp. 225–31.

biggest things demand the simplest language, and Cimabue could tell us more of the divine, and Giotto more of human love than Raphael or Rubens."[19]

To sum up: with its invention at the Grafton Galleries in 1910 and 1912, Post-Impressionism was seen as, on the one hand (from the outside), "barbaric" to the point of the infantile, and on the other (from the inside), as a first step in an historical process of regression, a process that entailed the rejection of scientific models of progress in art. In both respects it can seem that difference is accented: brutally apparent differences that separate expressive art from representational science, the 'primitive' from the sophisticated, the child from the adult, beginnings from conclusions. In fact, both temporally – across history – and spatially – across geographical boundaries – Fry's rhetoric was a rhetoric much more of cultural conjunction – similitude – even if, as I shall show, there is a deeper level at which he accepts cultural difference. He projects on to all those kinds of art that he finds significant, in distant conditions, times or places, his own distinctively early twentieth-century, European, indeed English set of aesthetic values. He makes all art 'modern' on his terms, fusing very many different human cultures and conditions. It is this structure of pan-cultural conjunction that I now want to explore.

At the centre of Fry's English set of values, the product as I argued in my first essay of the passionate rationalism of his late 1880s Cambridge milieu, was the notion of civilization. As I will explore later in this essay, for him the 'primitive' was not 'barbaric' in the sense of being a threat to Western culture; it offered the stimulus for the rebuilding in broader terms of the European tradition. Fry, for some the promoter of degeneration, presented himself always as the sanest of the civilized. And yet, in his view, the starting-point for his expansion of the canon was actually Tolstoy's questioning of the idea of a definite standard of beauty, so much a mainstay of the eighteenth- and nineteenth-century discourse of civilization.[20] The first step was, as Fry put it in 1920, the realisation, on reading Tolstoy's 'What is Art?' around 1906–07, that art has "no special or necessary connection with what is beautiful in nature".[21] The second was to place the stress not on the object depicted in any work of art – nature – but on the work of art as such. These two steps joined one which had been made earlier: the decision to base any judgement of works of art on subjective response – unmeasurable subjective emotion, not the objective and the measurable. The conclusion was now clear: works of art were no longer to be evaluated by measuring their relationship either to what they depicted or to any standard of beauty.

It was at this point in the argument that Clive Bell inserted his notions of "significant form" and "aesthetic emotion" (from 1912): art being defined as that which arouses "aesthetic emotion", and the one common characteristic of everything that does this being identified as "significant form".[22] Fry recognized the circularity of this argument and had his doubts about the

Fig. 75 (Cat. 3) Kota (Gabon), *Reliquary Figure*. Wood covered with brass and copper, 60 x 30.5 cm. Courtauld Gallery, Fry Collection.

purity of significant form, but together the idea of significant form and aesthetic emotion consolidated his developing cross-cultural project for art history, since Bell's theory made it absolutely clear that significant form could be a property of the cultural products of any period and culture, from Giotto's frescos at Padua to a Matisse, and from a Matisse to Hagia Sophia in Istanbul.[23] It was the ground not merely for stylistic comparisons across cultures but for what can be called affinity comparisons: comparisons which brought cultures together at a level so profound and all-embracing that differences were rendered seemingly irrelevant.

This is ultimately what came to validate Fry's judgements as a collector – the judgements that led him to buy Persian pottery, 'barbaric' metalwork and African carvings as well as Italian 'primitive' panel paintings and modern paintings by Derain or Picasso. It was the support, as well, for his admiration for a collection like the one built up in Paris by Kelekian, which combined major paintings by Matisse and Picasso with Oriental textiles and pottery and Egyptian, Romanesque and early Chinese artefacts. Of Kelekian Fry wrote in 1920: "Here is a man whose whole life has been spent in the study of early art, who at a given moment had the grace to see its implications, to see that principles precisely similar to those employed by early Persian potters and Fatamite craftsmen were being actually put into practice by men of the present generation. He had the sense to put modern French artists beside Romanesque sculpture and Byzantine miniatures and to feel how illuminating to both the confrontation was."[24]

There was a consequence of particular importance that followed from Fry's pan-cultural openness; it takes me back to the notions with which I began, the 'primitive', the 'savage' and the child-like. Fry's openness undercut existing conventional hierarchies. With the idea of 'beauty' was jettisoned the idea of the superiority of the European classical tradition. Nowhere is the point more trenchantly made than when he introduces his 1920 essay an African sculpture in *Vision and Design*, a review of an exhibition of West African carvings from Paul Guillaume's collection at the Chelsea Book Club. "What a comfortable mental furniture, the generalisations of a century ago must have afforded!" Fry writes. "What a right little, tight little, round little world it was when ... Greek art, even in Roman copies, was the only indisputable art, except for some Renaissance repetitions! ... And now, in the last sixty years, knowledge and perception have poured upon us so fast that the whole well-ordered system has been blown away; and we stand bare to the blast, scarcely able to snatch a hasty generalisation or two to cover our nakedness for a moment "[25] Three years earlier, he had opened an article on an exhibition of children's art at the Omega Workshops with precisely this point. The end of the old hierarchy is here represented as the result of a process of cultural regression, by which the community of the civilized in England (Fry and his predecessors) have travelled backwards, opening themselves successively "first to Gothic art, then the painting of the primitives and the early miniaturists, then the

Fig. 76 David John, *The Snake*, reproduced in *The Burlington Magazine*, June 1917.

27. Unpublished fragment of a paper headed 'Children's Drawings', Fry Papers, 1/23, p. 7. On the verso of sheet 7 is the copy of a circular letter relating to the exhibition of children's drawings at the Omega Workshops; it is dated 18 May 1917, and indicates a probable 1917 date for the fragment.

28. He must refer here to Lucien Lévy-Bruhl, *Les Fonctions mentales dans les sociétés inférieures*, Paris 1910. There is no evidence that Fry read Lévy-Bruhl's follow-up volume, the more succinct consolidation of the theories elaborated in 1910, *La Mentalité primitive*, Paris 1922.

29. In Fry, 'Negro Sculpture', in *Vision and Design*.

30. Roger Fry, 'Children's Drawings', *The Burlington Magazine*, XXX, June 1917, pp. 225–31.

31. Roger Fry, 'Children's Drawings', *The Burlington Magazine*, XL, January 1924, pp. 35-41. More than five thousand drawings collected by her are now held in the Marion Richardson Archive at the Institute of Art and Design in the University of Central England, Birmingham. She later became an inspector of art for the LCC in London, where she promoted her methods. Fry wrote about her again when artwork related to her LCC activities was exhibited. See Roger Fry, 'Children's Drawings at the County Hall', *The New Statesman and Nation*, 24 June 1933, pp. 844–45. Such an approach to children's art, with the emphasis on bringing out the child's expressive capacities, was not new in 1917. Marion Richardson's own methods built on practices advocated by Robert Catterson-Smith at the Municipal School

Byzantines, then early Oriental art, and finally Aztec and negro art".[26] Child art is, of course, what comes after that, and the image of a return to savagery is sustained when, in an unpublished fragment, probably related to the 1917 article, he defined child art as " ... the drawings which children make for their own pleasure from about four years of age upward until the moment when they begin to be taught or to teach themselves by deliberately imitating the work of grown-ups. I mean ... the purely native and untouched art of that tribe of mild barbarians, which is always at the heart of civilization."[27] Fry's writings on African art and child art, both of which he thought of as 'barbaric', find in them lessons for the adult and the civilized, but do so – and this is the crucial point – without questioning at any level the logocentric and Eurocentric idea of civilization.

There is nothing in Fry's published or unpublished writings on children's art to suggest that he was aware of the child psychology of Jean Piaget, emerging in the 1920s, but he was certainly aware of current anthropological writing, including Lucien Lévy-Bruhl's major critique of the 'social Darwinian' view of the 'primitive'; he names Lévy-Bruhl in a note on his planned reading during the war years.[28] The focus of such psychological and anthropological studies was on the magical functioning of thought, often expressed in visual images. Fry's commitment to "significant form" meant, of course, the sidelining of all such considerations. In his writing on children's art, his focus, as we shall see, is on its direct expressiveness – its capacity to transmit emotions about things – and its decorative control. In his writing on African carving, his focus is on what he calls its "plastic freedom" – its fully three-dimensional character, its freedom from bas-relief – which he sees as far exceeding that attained by almost all European sculpture since 1200.[29] A look at what he has to say about children's art can clarify the way he constructed an origin for art.

In his 1917 article, Fry picks out a drawing of a snake by David John, the nine-year-old son of Augustus John (fig. 76); it was shown at the exhibition of children's drawings at the Omega Workshops that led to the article. The child, says Fry, has realised "the snakiness of the snake" with an intensity that cannot be missed. His first and central point about children's drawing is that, so long as it is not guided by instruction, it is characterized by a "vivid directness of feeling". The myth of innocence still holds true for Fry, and corroborates his conviction that emotion is the origin of all art.

We can all of us recollect the time when we lived in an animistic world, when every object in the home had a personality, was either friendly or menacing, was on our side or against us This habit of attributing strong emotional values to all the objects surrounding them is what makes the visual life of children so much more vivid and intense than the visual life of almost all grown-up people. And if nothing is put in the way to hinder its expression the child translates these vivid visual perceptions with an extreme directness and simplicity[30]

Fig. 77 (Cat. 37) Winnie Bloomer, *Street Scene with Street Lamp*, 1921. Watercolour on paper, 21 x 23 cm. Marion Richardson Archive, School of Art & Design Education, University of Central Birmingham.

of Art in Birmingham, though his orientation was more to the crafts, and the Omega Workshops' interest in showing children's drawing had a precedent of which Fry was well aware, Paul Poiret's Ecole Martine in Paris, where children in their early to mid-teens produced designs for production. For an analysis of Fry's published writings on children's drawings, placed in a broad European context, see Richard Schiff, 'From Primitivist Phylogeny to Formalist Ontogeny: Roger Fry and Children's Drawings', in Jonathan Fineberg (ed.), *The Innocent Eye: Essays on Children's Art and the Modern Artist,* Princeton 1996.

32. My thanks to John Swift, Professor at the Institute of Art and Design in the University of Central England, Birmingham, for drawing this to my attention, and to Daniel Porter, who wrote an M.A. dissertation on Marion Richardson and Omega at the Courtauld Institute in 1999, for informing me about the brochure advertising her teaching at Dalmeny Avenue. As a student at the Municipal Art School in Birmingham around 1910, she had met Margery Fry, who was the warden of the student residence where she lodged. She knew Margery, therefore, long before she met Roger at the Omega Workshops, and it was Margery who invited her to stay at Dalmeny Avenue. For further information on Fry and children's drawings and on Marion Richardson, see also 'Children's Drawings', pp. 147–48.

His enduring support for a school teacher who visited the 1917 Omega exhibition, Marion Richardson, was secured because of her refusal, as he saw it, to put anything in the way of expression in her teaching at Dudley, near Birmingham. She and the children she taught were the topic of a later article on children's drawing, published in 1924. Her charges were not infants or children of primary school age; they were between ten and sixteen, so her methods were aimed especially at preserving an expressive directness believed already to be there against the pressures of adolescence. Fry's commentary insists above all on her resistance to teaching-as-instruction, the kind of teaching that increasingly took over to the secondary stage. "Miss Richardson", he wrote there, "has found out how *not* to impose a ready-made pictorial formula on the all too suggestible child-mind. That is, I think, the most essential discovery she has made – she has found how not to teach and yet to inspire."[31] She and Fry were close enough for her to stay with him and his sister Margery at the home they shared in Dalmeny Avenue, Holloway, in 1923, when she was suffering from exhaustion. She actually advertised private art teaching for children from their address.[32]

Marion Richardson's method (which, in fact, always included an element of direction) encouraged the drawing, not of objects, but of ideas: images suggested by stories or memories. For Fry, it was above all instruction in the drawing of objects that was counter-productive, since the desire to draw came from the child's emotional attachment to things, which the child took possession of mentally in emotionally charged mental images (certain aspects distorted, accentuated or enlarged – heads, for instance, always seen full-face).[33] He wanted to leave untouched the language of signs found in such drawings as *Street Scene with Street Lamp* (fig. 77) by Winnie Bloomer, a child from one of Marion Richardson's Dudley classes, with its flattening of space and its control of movement rigidly parallel to the picture-plane. This emotional directness and its 'realist' yet highly conceptualized language of representation Fry separated absolutely from what he himself called the "formalism" of children, their need for "design". If children produced "significant form" (and he insisted that they did more often than adults trained in drawing), this was not, he maintained, their primary intention; it was the result of the coming together of the emotional "realist" impulse with a complimentary decorative impulse; it was inadvertent, like the art he found in the paintings of the Douanier Rousseau.[34]

Fry's admiration of children's art raises a simple question, one which is fundamental to grasping how he conceived the relationship of the 'civilized' to the 'primitive' altogether. If children were so good at producing emotionally charged significant form, why did he not himself, with his artist-friends, aspire to a sustained return to what they understood to be the condition of children – at least as artists? For the fact is that, after 1919 – indeed very shortly after Fry's first piece on children's art in 1917 – with Grant and Bell he turned back from the primitivizing modernism of their experimental pre-war

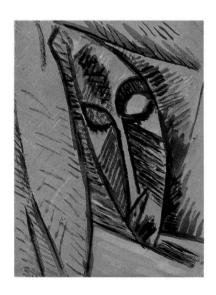

Fig. 78 (Cat. 62) Pablo Picasso, *Head*, 1907. Gouache and watercolour on brown paper, 31 x 24.5 cm. Museo Thyssen-Bornemisza, Madrid.

33. As Daniel Porter points out in his M.A. dissertation (see note 32), Fry's analysis of conceptual sign-making in children's drawing was founded on his reading of the 1907 English translation of a book first published in German, Emmanuel Loewy's *The Rendering of Nature in Early Greek Art*.

34. See also 'Rousseau (Henri)', below, p. 206.

35. Fry (19 November 1910; cit. note 13).

36. Torgovnik 1989.

37. E.M. Forster, *Goldsworthy Lowes Dickinson and Related Writings*, London 1934 and 1974, p. 95. Fry designed the cover of the periodical.

38. G. Lowes Dickinson, *Letters from a Chinaman* [1901], London 1928, pp. 6–7. Dickinson's adopted persona, "a Chinaman", was readily seen through in Britain, but not when the letters were published in the USA, where speculation circulated that the author was the Chinese ambassador.

39. Virginia Woolf quotes a letter from Fry to Dickinson. See Woolf 1995, p. 159. The four articles pubished in *The Manchester Guardian* formed part of G.Lowes Dickinson, *Albert Kahn Travelling Fellowships. Report to the Trustees*, London (University of London Press) 1913.

phase, as I show in my first essay, to produce work like his portraits of Nina Hamnett and his Provençal landscapes of 1919 that were quickly welcomed in the press as a return to the sophisticated representation of appearances. The answer to this question is that Fry never held up 'barbarism' in any form, including the infantile, as a model to be emulated; and this comes over most clearly in the way he wrote about the 'primitive' in relation to the 'civilized'. Ultimately, despite his and Bell's pan-cultural rhetoric of affinity, the perception of difference underlay their concept of the 'primitive' whenever it overlapped with what they persisted in seeing as the childlike and the 'barbaric'.

Even as early as 1910, in the very month of the opening of the First Post-Impressionist exhibition, Fry declares that he sees regression as merely a return to a starting-point from which modern art can evolve again. The Post-Impressionists, he writes, "are not destructive and negative, but intensely constructive And so if all the accumulated science of representation, all the aids of perspective, all the anatomical diagrams, all the lore about atmospheric values goes, it will, no doubt, be built up again one day, but with passionate zest and enthusiasm, as it was once before "[35] And for Fry, the power to make this happen could only be in the hands of the 'civilized', like himself and his friends. Clearly, the condition of the 'primitive' was not, as such, to be desired.

Marianna Torgovnik, the first to have looked at Fry's treatment of the 'primitive' through a post-colonial lens, has produced a brutal caricature of a personality immured in the deep residual racism of his imperial British society.[36] Fry was, in fact, a committed anti-imperialist by the early 1900s; in 1903, he was involved with his close friend and fellow Cambridge Apostle, 'Goldie' Lowes Dickinson, in *The Independent Review*, a periodical founded to combat "the aggressive imperialism and the Protection campaign of Joe Chamberlain", as E.M. Forster's biography of Dickinson puts it.[37] Dickinson had already, in 1901, mounted a Swiftian attack on Western imperial policy in China, his *Letters from a Chinaman*, which imagined the view of European civilization from outside and condemned utterly its expansionist materialism. "The cash nexus ... is the only relation you recognise among men", he had written in the guise of "a Chinaman", continuing with a mischievous inversion of Western perceptions, "... To us of the East ... this is the mark of a barbarous society".[38] And when in 1913 Dickinson followed up his spoof letters with a series of *Manchester Guardian* articles on his recent travels in India, China and Japan, which tackled race issues, too, Fry wrote to him of the pleasure they gave him.[39] And yet neither Dickinson nor Fry could escape the sense of cultural superiority and the racist stereotypes endemic in early twentieth-century Britain. We have already encountered, for instance, the ease with which Fry aligned children's art with African art, an especially obvious and objectionable mark of colonial paternalism. And in the Slade lectures at Cambridge of 1933–34, the 'Last Lectures', cultural difference is habitually seen as the direct expression of racial difference, for instance in the way he

approaches African alongside both Indian and Chinese art.[40]

For Fry, the difference between the 'civilized' and the 'savage' was marked out by one key trait: the capacity for dispassionate, logical analysis and judgement. In France the anthropologist Marcel Mauss was already anticipating Lévy-Strauss's structuralism by pointing to the complex structures shaping much so called 'primitive' thinking and so demonstrating the falseness of such a distinction, but Fry instead echoed Lévy-Bruhl's argument for a "primitive mentality" defined as "pre-logical" in contrast to the mentality of "developed" peoples defined as logical.[41] His own passionate rationalism – that of the late 1880s Apostles mentality explored in my first essay – ensured the profound attraction of such a distinction. It is unmistakably the underpinning of his conclusion in the 1920 piece on African sculpture:

It is curious that a people who produced such great artists did not produce also a culture in our sense of the word. This shows that two factors are necessary to produce the cultures which distinguish civilized peoples. There must be, of course, the creative artist, but there must also be the power of conscious critical appreciation and comparison It is for want of a conscious critical sense and the intellectual powers of comparison and classification that the Negro has failed to create one of the great cultures of the world, and not from any lack of the creative aesthetic impulse, nor from lack of the most exquisite sensibility and the finest taste.[42]

Exquisite "sensibility" and fine "taste", the actual ability to produce "Art" (significant form), none of this sanctioned the epithet "civilized". Indeed, for Fry, critical detachment – disinterestedness – was *the* precondition of aesthetic experience, without which such experience was beyond reach. To find in "the Negro" no capacity for detached reflection was indeed to echo racist stereotypes which were then commonplace, as Coombes has shown.[43] It kept "Art" firmly under the control of the "civilized", along with science. Almost certainly included among the African pieces shown at the Chelsea Book Club in 1920 were Fang reliquary figures comparable with one Fry probably knew then in the Paris collection of Paul Haviland, a close friend of Gertrude Stein (fig. 82). Though a Yoruba piece was illustrated when the article was first published, it is especially to such Fang figures, so prized in the Guillaume circle, that Fry's observations concerning the "plastic freedom" of African sculpture apply. It is worth noting that social anthropological fieldwork has established that, in fact, Fang carvers and their communities had quite enough "conscious critical appreciation" to formulate what Fry would have called design principles.[44] The ignorance he shared with all early twentieth-century African sculpture enthusiasts allowed him his conclusion: that such carvers might produce "Art", but that they did so for magical purposes irrelevant to "Art": they literally could not experience the "Art" in their "art".

In a sense, Fry's own development as an artist, and that of Grant and Bell,

40. *Last Lectures.*

41. Mauss's new position is already clear in some of the analyses found in Marcel Mauss (with H. Hubert), *Esquisse d'une théorie générale de la magie*, Paris, 1902–03. Lévy-Bruhl's theory of "primitive mentality" was fully set out in Lucien Lévy-Bruhl, *Les fonctions mentales dans les sociétés inférieures*, Paris 1910.

42. *Vision and Design.*

43. Coombes quotes Charles Read, *Handbook to the Ethnographic Collection of the British Museum* (1910): "The mind of primitive man is wayward, and seldom capable of continuous attention His powers of discrimination and analysis are undeveloped, so that distinctions which to us are fundamental, need not be obvious to him"; see Coombes 1994, p. 89.

44. I am grateful to John Picton, who brought to my attention James Fernandez's work on the Fang, and especially a footnote recording the criteria for a carving given by a Fang carver, Ayang Ndong: "A statue has six cutting points: 1. Forehead to chin, 2. chin to knee, 3. back of head to buttocks, 4. buttocks to tip of calf, 5. tip of feet to knees, 6. tip of calf to ankles. All of these cutting points should be in line." See James Fernandez, 'The Exposition and Imposition of Order: Artistic Expression in Fang Culture', in Warren L.d'Azevedo (ed.), *The Traditional Artist in African Societies*, Bloomington IN and London 1973, p. 219.

could have been seen itself as a demonstration of how an evolved art could develop from 'primitive' beginnings, given the advantages of critical "disinterestedness". To do so, it would have been necessary to take account of his views on a kind of art considered more "primitive" even than children's drawing, paleolithic art and the rock-paintings of the bushmen of the Kalihari desert, on the latter of which Fry published in 1910. These images posed a problem, for they seemed to reverse the usual understanding of the development of art from conceptual signs to naturalism. Fry's solution to it was the hypothesis that such peoples were so intensely engaged in their world – as the source of food and terrible danger – that they possessed the capacity quite literally to project images of the things they desired or feared on to surfaces, almost as if photographically. Here was, he said, an unmediated Impressionism actually outside evolution.[45] A decade later, Fry applied the same theory to paleolithic art in the first of a new series of lectures for the Slade, and argued that only with the development of conceptual sign-making did the need to organize images – the design impulse – emerge. Only subsequent to that, he went on, with the application of the detached critical faculty, could this lead to real cultural development: the evolving art of a civilization.[46] The regression of the English Post-Impressionists around Fry was a step taken self-consciously with the critical disinterestedness he understood as the mark of the "civilized". It had nothing to do with beating a retreat from civilization, quite the reverse; and by 1920, the date of the piece on African sculpture, it had led to a kind of painting that was unequivocally "civilized", a European painting that asserted its difference from all that could be called "barbaric".

If Fry admired African carvings, he had no desire to identify with African peoples. It is a telling confirmation of his sense of difference, and its foundation in his idea of civilization, that, in close emulation of Lowes Dickinson, he not only admired but liked to identify with the Chinese. Dickinson's *Letters of a Chinaman* presents a highly idealized alternative, Chinese model of civilization; it is a model that finds clear echoes thirty years later in Fry's 'Last Lectures'. Here Fry treats Eastern and Western societies as equally civilized, equally manifestations of "a rationalist conception of the world" – he finds it easy to compare his own pair of T'ang Dynasty dancers to thirteenth-century French sculpture. But in the Chinese he finds at the same time a "sensitivity" and a vitality in the apprehension of form much closer to his idea of the "primitive". It was just such a fusion of the rational and the "sensitive" that was his hope for the future of European art, and he actually pictures that fusion as a coming together of East and West. "In these two centres civilization developed almost independently", he writes. "Perhaps", he adds, "we are to-day witnessing the process of the joining up of these two poles into a single world-wide system – indeed this may be the great hope for the future."[47] In the end, it was only within what he understood as "civilization" that Fry found real affinities across cultures.

45. Roger Fry, 'Bushman Paintings', *The Burlington Magazine*, XVI, March 1910, pp. 334–38; reprinted as 'The Art of the Bushmen', in *Vision and Design*, pp. 74ff.

46. Fry Papers, 1/90. See 'A Lecture by Roger Fry', pp. 214–221.

47. *Last Lectures*, p. 97.

PART III
ROGER FRY'S CANON
FROM AFRICAN SCULPTURE
TO MAURICE VLAMINCK

ROGER FRY'S CANON – FROM AFRICAN SCULPTURE TO MAURICE VLAMINCK

CHRISTOPHER GREEN

ABOVE Fig. 79 (Cat. 61) Juan Gris, *Glass, Cup and Newspaper*, 1913. Oil on canvas, 46.5 x 27.5 cm. Courtesy of Michelle Rosenfeld Gallery, New York.

FACING PAGE Fig. 80 (Cat. 103) Roger Fry, *Papier-Collé Composition*, undated. Collage with embossed and printed textured paper, 26.5 x 33.7 cm. Courtauld Gallery (PD 37).

What follows is a catalogue of the exhibition *Art Made Modern: Roger Fry's Vision of Art*, which features the artists and broad categories of visual culture that figured more or less importantly in Roger Fry's canon. Each entry discusses Fry's view of the artist or category in question, where possible using his own words. If there were developments in Fry's views, as often there were, account is taken of them. The entries are arranged alphabetically to avoid either chronological or hierarchical ordering, in line with Fry's own conviction that works of art are to be seen as equivalently comparable, whatever their status, and whatever the period or culture that produced them. Four categories take in particular artists selected for the exhibition, who are not given individual entries: Caricature takes in Beerbohm, "Quizz" and Roberts; Cubism takes in Picasso and Gris; Impressionism takes in Degas, Manet and Renoir; and Italian Primitives takes in Bernardo Daddi, the Riminese painter Giovanni Baronzio, Lorenzo Monaco and Paolo Veneziano. It should also be noted that there are no entries on Walter Sickert and Omega, as Fry's attitudes to both are more than adequately discussed in Anna Gruetzner Robins's and Judith Collins's essays (pp. 45–56; 73–84). In these instances, therefore, catalogue information is given under the relevant heading, with a cross-reference and no entry. Catalogue information on documents displayed in the exhibition is given at the end.

Given the necessarily limited nature of the selection, no claim can be made that this is a comprehensive coverage of Fry's canon. Among the most important omissions are Fra Angelico, Giovanni Bellini, Chardin, Constable, Correggio, Giotto, El Greco, Mantegna, Poussin, Rubens, Signorelli and Uccello. Material on some of the Italians in this list can be found in Caroline Elam's essay; the fragility of early panel paintings has very much militated against their inclusion in the exhibition.

Note: Material on artists' showings at the first and second Post-Impressionist exhibitions depends largely on Anna Gruetzner Robins, *Modern Art in Britain 1910–1914* (London 1997).

African Sculpture

Cat. 1 Fang (Cameroon), *Female Reliquary Figure.* Wood, height 68 cm. Collection Musée de l'Homme, Paris (Legs Saint-Paul. Inv. No.M.H.97752.1). Photograph by José Oster.

Cat. 2 Fang (Gabon), *Male Reliquary Figure.* Wood, brass and iron, height 60.9 cm. Trustees of the British Museum (1956. Af.27.246).

Cat. 3 Kota (Gabon), *Reliquary Figure.* Wood covered with brass and copper, 60 x 30.5 cm. Courtauld Gallery, Fry Collection.

Cat. 4 Fang (Gabon), *Head of a Reliquary Figure.* Wood, coated with egg and dust, height 27.8 cm. Courtauld Gallery, Samuel Courtauld Collection (O.1948.SC.236).

Cat. 5 Ivory Coast. *Spindle* (bust surmounted with unidentified animal). Wood, height 20.1 cm. Courtauld Gallery (0.1935.RF 120).

Cat. 6 Tanzania. *Dance Mask.* Wood, 61.6 x 36.5 x 23.5 cm. Courtauld Gallery.

Cat. 7 *Bowl.* Wood, 23.3 x 41.4 cm. Courtauld Gallery (0.1935.RF 117).

Cat. 8 *Bottle with cover.* Wood, 13.1 x 9.3 x 9.3 cm. Courtauld Gallery (0.1935.RF 121).

ABOVE Fig. 81 (Cat. 7) RIGHT Fig. 82 (Cat. 2)

Fry's interest in African sculpture had probably begun by 1912, but he did not publish on it before 1920. It is not known when he began to form his small collection of African pieces, though one purchase, a dance mask (cat. 6), can be dated to 1924. While his celebration of African sculpture – which included, for him, objects of use, such as bowls and other vessels – constituted a radical critique of existing Eurocentric hierarchies of taste, and while he rejected colonialism, Fry could not escape the simplistic generalizations and the focus on racial stereotypes dominant in British attitudes to Africa at the time.

Fry's most important writings on the subject are 'Negro Art' (*The Athenaeum*, 16 November 1920; reprinted in *Vision and Design*), 'Negro Sculpture at the Lefevre Gallery' (*The Burlington Magazine*, June 1933), and 'Negro Art', one of his 1934 Slade lectures (*Last Lectures*). He deals with it most fully in *Last Lectures*. Here, his understanding of African ritual and religion is exposed as a highly simplified version of late nineteenth-century English anthropological theories, most obviously those of J.G. Fraser. Moreover, he fails to discriminate at all either between the peoples of Africa or between the artefacts of different regions, and he works with a hugely simplified racial stereotype: the "Negro mind". This he characterizes as focused entirely on "the action of spirits" and incapable of "materialism", identifying it as the determining factor behind the anti-naturalism of African art in its figurative forms: "No fact or set of facts about the human face are regarded as peculiarly essential or important. The artist may lay hold of any aspect which he can bend to his purpose ... provided it creates in the end this illusion of the spirit's life." The "Negro mind" (an offensive term today, of course) becomes at this late stage his explanation of why African sculpture possesses the quality he first spelled out as essential to his appreciation of it in the article of 1920, a quality he considered fundamental to all sculpture but rare in that of Europe. In 1920 he defined that quality as "the power to create expressive plastic form", and also as "plastic freedom", by which he meant the ability to work fully in three dimensions, free from the planar limitations of bas-relief. This came, he argued, of a readiness in carving the figure to ignore natural proportions and to reduce limbs "to a succession of ovoid masses sometimes scarcely longer than they are broad", allowing "the utmost amplitude and relief [to be given to] all the protruberant parts of the body, and to get thereby an extraordinarily emphatic and impressive sequence of planes".

Baldovinetti (Alesso)

Cat. 9 *Portrait of a Lady in Yellow, c.* 1465. Egg tempera and oil on wood, 63 x 41 cm. National Gallery, London.

Few securely attributed works survive by this Florentine painter (*c.* 1426–1499). One of these is *Portrait of a Lady in Yellow* (*c.* 1465; fig. 83), which was first attributed in print to Baldovinetti by Fry in 'On a Portrait by Baldovinetti' (*The Burlington Magazine,* March 1911). He anticipated his entire case here in a lecture dealing with Piero della Francesca and Baldovinetti in the series 'Florentines II' written in 1900–01 for the Cambridge Extension programme (Fry Papers, 1/66; see 'Piero della Francesca', p. 196).

Both the unpublished lecture and the article are exemplary displays of Fry's technically adept version of Berensonian connoisseurship (see Caroline Elam's essay). The attribution is based on the isolation of a technique (neither purely oil nor purely tempera) specific to Baldovinetti, observed by Fry in, for instance, the Louvre's *Madonna and Child,* and characterized by the "*pointilliste*" use of tiny dots in certain areas. In *Lady in Yellow,* he finds it in the modelling of flesh highlights, in the necklace and along the edges of the drapery (where it becomes purely "decorative"). In the lecture Fry notes that the orthodox use of the quick-drying medium of tempera led Baldovinetti's contemporaries to use "hatched strokes like the shading of a lead pencil", and claims that by substituting his "minute spots for hatched strokes [Baldovinetti] ... undoubtedly obtained ... a more

invisible modulation from light to dark". Paired with Piero in the lecture, Baldovinetti is found by Fry to be an artist of "very distinct charm and real merit", the addition of new works to his corpus making him "certainly one of the rising artists of the quattrocento". Whereas in Piero Fry stresses "a feeling of noble indifference" appropriate to "monumental designs", in Baldovinetti he finds a balance between "breadth and simplicity of design" (for him the essence of Florentine painting of this kind) and a love of "microscopic detail". He described *Lady in Yellow* as "surely one of the most splendid examples of what one may call bas-relief painting that we possess", noting the way "the only partial solidity" of forms allows attention to rest on "the purity and perfection and the decorative quality of the silhouette as a whole. The effect depends", he continues,

not only on a perfect balance and intimate correlation of the curves of the outline, but upon a nice calculation of the values of the tones of the figure in relation to the tone of the background. And in all these points Baldovinetti has here shown the most perfect tact, the most discriminating selection. He has shirked nothing of the peculiarities of his model but he has turned all to his own decorative purposes. How well he has balanced the prominent sinuous nose by the free curves of the hair behind, how wisely he has insisted on the straightness of the neck that the sudden salience of the bosom shall contrast with the long undulating line of the back. It is certainly a masterpiece of design in flat tones ...

Fig. 83 (Cat. 9)

Bell (Vanessa)

Cat. 10 *A Conversation*, 1913–16. Oil on canvas, 86.3 x 81.3 cm. Courtauld Gallery, Fry Collection.

Cat. 11 *Roger Fry and Julian Bell Playing Chess*, 1930–31. Oil on canvas, 60.3 x 80.6 cm. By kind permission of the Provost and Fellows of King's College, Cambridge.

Printed linen

Cat. 12 *White VI*, 1913. Printed linen, 80.5 x 51 cm. The Whitworth Art Gallery, The University of Manchester.

Works on paper

Cat. 13 *Eurythmics*. Oil on paper, undated. 35.7 x 50.8 cm. Courtauld Gallery (PD 85).

Cat. 14 *Composition in Buff, Green and Blue-Grey*, undated. Pencil on paper, 56.5 x 48.1 cm. Courtauld Gallery (PD 86).

Cat. 15 *Design for a carpet*, undated. Gouache and pencil on paper, 42.3 x 74.9 cm. Courtauld Gallery (PD 88).

Cat. 16 *Design for an oval tray*, undated. Pencil and gouache on paper, 28.2 x 20.2 cm. Courtauld Gallery (PD 50).

Cat. 17 *Design with disks*, undated. Pencil and wax crayon on paper, 20.3 x 26 cm. Courtauld Gallery (PD 94).

Pottery

Cat. 18 *Madonna and Child*, c. 1915. Glazed earthenware, 22.5 x 11.5 x 18cm. The Charleston Trust.

Cat. 19 *Vase*, undated. Blue and pale turquoise glaze, height 36.5 cm. Courtauld Gallery (0.1935.RF 175).

Vanessa Bell (1879–1961), like Duncan Grant, was one of the young artists whose example encouraged Fry's development as an experimental painter and formalist thinker in the period 1910–14. She was also one of the most productive of his collaborators in the Omega Workshops, not only executing painted screens and other designs, but also working alongside Fry as a potter in London and Poole. Fry's friendship with her, begun in 1910, developed into an affair in 1911, which petered out in 1913–14, as she gravitated towards Grant and back to her husband, the critic Clive Bell. Fry continued to be close to her, and always respected her views on paintings, especially his own. His major published piece on her as an artist was 'Vanessa Bell and Othon Friesz' (*The New Statesman*, June 1922, pp. 237–38; Reed 1996, pp. 347–50), which was almost wholly dedicated to Bell. It was a review of Bell's exhibition in 1922 at the Independent Gallery that confirmed her post-1919 retreat from experiment (alongside Fry and Grant).

The quality Fry picks out in her work is "honesty", by which he means that she is never tempted "to cover up some gap in design by a plausible camouflage". He explains further: "She follows her own vision unhesitatingly and confidingly, without troubling at all whither it may lead her. If the result is not very legible, so much the worse; she never tries to make it out any more definite or more vividly descriptive than it is." This "honesty" is contrasted with John Singer Sargent's ability "to give an illusion of appearance by a brilliant shorthand of the brush". Dishonesty is aligned with skill and being "clever": "she is a very pure artist, uncontaminated with the pride of craftsmanship". He doubts whether "she makes any great or new discoveries in design", but her design is "always rightly adjusted and almost austerely simple and direct". Finally, he misses "in her present work" "a peculiarly personal feeling for the architectural opposition of large rectangular masses and bare space" that he had found in certain pre-1914 pictures, and hopes that "what I take to be her instinctive bias in design will again reassert itself ...".

11

Fig. 84 (Cat. 10)

Byzantine Art

Cat. 20 Byzantine (Constantinople?), *Five medallions from an icon frame depicting Jesus Christ, Saint John the Precursor, Mary Mother of God, Saint Paul, Saint Peter*, late 11th to early 12th century. Gold, silver and cloisonné enamel, diameter 8.3 cm. Metropolitan Museum, New York, Gift of J. Pierpont Morgan, 1917.

Cat. 21 *White bowl with foot.* Glazed earthenware, 10.5 x 14.5 cm. Courtauld Gallery (RF 138).

In a lecture for the Cambridge Extension scheme series 'Transition from Classical to Modern Art', written in 1897, Fry first sets out his view of Byzantine art as a reaction to the naturalism of late Roman painting that, by "a return to elementary symbolism", provided the "basis of rigid and traditional formalism" necessary for the development of "the great painting of Italy", and speculated that such a return might be possible again (Fry Papers, 1/65). In 1891 he had visited Ravenna for the first time, and in 1897 made trips to Pompeii, Naples and Sicily; he already knew the mosaics of Santa Maria Maggiore in Rome. His reading on the subject included N.P. Kondakov's *Histoire de l'art byzantin* (French edn. 1886) and, by 1905, Jean Paul Richter and Alicia Cameron Taylor's *The Golden Age of Byzantine Art* (1904). When, in 1908, he came out as a modernist with his open letter 'The Last Phase of Impressionism' (*The Burlington Magazine*, March 1908, pp. 374–75; Reed 1996, pp. 72–75), for the first time he made a direct

parallel between the shift from Roman naturalism to Byzantine "formalism" and the development of a new art to succeed Impressionism, dubbing Cézanne and Gauguin "proto-Byzantine". In the spring of 1911 he, Vanessa Bell and Duncan Grant went to Turkey, partly to see Byzantine mosaics, and, with Grant, he visited Sicily, being especially impressed by the twelfth-century mosaics at Monreale. Also that year Fry wrote his most comprehensive analysis of Byzantine art, the opening lecture in a series on 'Monumental Painting' for the Slade School, which shows how aware he was of its religious dimension and iconography (Fry Papers, 1/88).

The following year Fry published 'An Appreciation of the Swenigorodskoi Enamels' (*The Burlington Magazine*, August 1912, pp. 290–94), the topic of which is eight enamel medallions of the twelfth century from an icon frame just purchased by J. Pierpont Morgan (fig. 85). As in his letter of 1908 to *The Burlington*, he is at pains to assert that the divergence between these images and appearances is not the result of a "feeble" lack of skill. For him, it is probable that "the asymmetry and strangeness of these designs is purposeful", and he points to the skill needed to "bend and fix the tiny gold *cloisons* in the robe of Christ". He presents the medallions, indeed, as cautionary lessons for "modern artists", which demonstrate that "vitality" can come only from "original invention."

Fig. 85 (Cat. 20)
RIGHT *Jesus Christ*
BELOW *Mary Mother of God*
BELOW RIGHT *Saint John the Precursor*

Fig. 86 (Cat. 22)

Caricature

Cat. 22 Max Beerbohm, *Caricature of Roger Fry: "We needs must love the highest when we see it"*, 1913. Pencil and watercolour on paper, 30.5 x 39.5 cm. By kind permission of the Provost and Fellows of King's College, Cambridge.

Cat. 23 "Quizz" (Powys Evans), *Caricature of Roger Fry: "Before the footlights of aestheticism"*, published in *The Saturday Review*, 30 December 1922. Pen and ink, 39.4 x 24.5 cm. By kind permission of the Provost and Fellows of King's College, Cambridge.

Cat. 24 William Roberts, *The Art Master: Satire of Roger Fry*, undated. India ink and watercolour on paper, 55.5 x 45.2 cm. Southampton City Art Gallery.

Fry's early criticism shows a willingness to give caricature serious attention, in particular that of Beerbohm, whom he called "our one and only caricaturist" ('Recent Publications: *The Poets Corner* by Max Beerbohm', *The Athenaeum*, 28 May 1904). Fry was unapologetic about "taking Mr Max Beerbohm more seriously than he has ever taken himself", writing: "Caricature is the most fitting relation that art can have to actuality, to the life of the moment" ('Mr Max Beerbohm's Caricatures at Messrs Carfax's', *The Athenaeum*, 14 December 1901). This, however, would be precisely his reason for dismissing it later, despite the formal qualities he admired in Daumier's as well as Beerbohm's drawings. Fry's opinion of the caricatures inspired by his own features is unknown.

Cézanne (Paul)

Cat. 25 *Apples*, c. 1877–78. Oil on canvas, 17.1 x 24.1 cm. By kind permission of the Provost and Fellows of King's College, Cambridge, Keynes Collection (on loan to the Fitzwilliam Museum, Cambridge).

Cat. 26 *Self-Portrait*, 1879. Oil on canvas, 48.5 x 41.5 cm. National Gallery, London.

Cat. 27 *Houses in Provence*, 1882–85. Oil on canvas, 84.4 x 100.3 cm. National Gallery of Art, Washington DC, Collection of Mr and Mrs Paul Mellon (1973.68.1).

Cat. 28 *Trees at the Jas de Bouffan*, c. 1883. Oil on canvas, 65 x 81 cm. Courtauld Gallery.

Cat. 29 *The Montagne Sainte-Victoire*, c. 1887. Oil on canvas, 66.8 x 92.5 cm. Courtauld Gallery.

Cat. 30 *Pot of Flowers and Pears*, c. 1888–90. Oil on canvas, 46 x 56.25 cm. Courtauld Gallery.

Cat. 31 *Still Life with Basket*, c. 1890. Oil on canvas, 65 x 81 cm. Musée d'Orsay, Paris, Legs Pellerin. Photo © RMN – Hervé Lewandowski.

Cat. 32 *The Card-Players*, c. 1892–95. Oil on canvas, 60 x 73 cm. Courtauld Gallery.

Cat. 33 *Still Life with Plaster Cupid*, c. 1894. Oil on paper laid down on board, 70.6 x 57.3 cm. Courtauld Gallery.

Cat. 34 *Apples, Bottle and Chairback*, c. 1900–06. Pencil and gouache on paper, 45.8 x 60.4 cm. Courtauld Gallery.

Fry's conversion to modernism is routinely associated with the experience of seeing two paintings by Cézanne (1839–1906) at the International Society Exhibition in London of January 1906. Though his was probably not the largest showing (fifteen pictures have been identified), Fry made Cézanne the focus of the first Post-Impressionist exhibition in 1910. Indeed, Fry seems to have designed his selections of Matisse, Derain and Vlaminck to consolidate the image of Cézanne as *the* point of origin for Post-Impressionism. That year Fry published a translation of Maurice Denis's key essay of 1907 on Cézanne ('Cézanne', *The Burlington Magazine*, January 1910). In the 'Introductory Note' that preceded it (pp. 207–09; Reed 1996, pp. 76–80), he identified "a new conception of art, in which the decorative elements preponderate at the expense of the representative", adding: "It is generally admitted that the great and original genius ... who really started this movement ...

Fig. 87 (Cat. 25)

was Cézanne." From Denis, Fry took the idea of Cézanne as modern "classic", with classicism understood to be a balance of the intelligent and the intuitive before nature, with Poussin as the paradigm. Fry wrote frequently about Cézanne thereafter, but his most fully considered text on the painter is *Cézanne: A Study of his Development* (London 1927), which was an expanded version of an article on the works by Cézanne in the collection of Auguste Pellerin published in *L'Amour de l'art* (Paris, December 1926). It starts by dubbing Cézanne the "tribal deity" of the new movement (p. 1).

Certainly there was awe in Fry's and his friends' response to the tiny *Apples* (fig. 87), bought by J. Maynard Keynes at the Paris sale of Edgar Degas's collection in 1917, though Fry's language is restrained when he claims no more than that it "comes up to the highest level" at the Burlington Fine Arts Club five years later (*The New Statesman*, 27 March 1922, pp. 210–11).

Fry's monograph of 1927 represents the early "Baroque" Cézanne as a necessary failure, which allowed Cézanne, after his "Impressionist" return to nature, to realise his "classic" structural vision of nature. He describes this transformation as one from inner psychological to outer visual concerns, and from Baroque "artifice" marred by technical incompetence to the "sincerity" of a direct confrontation with nature which abhors ease and skill. His focus is on Cézanne between the later 1870s and the earlier 1890s, and he picks out for special attention *Houses in Provence* (fig. 88), which, after a passage capturing the experience of the painting as "an unbroken succession" of planes, leads to a model summing up of his understanding of the "classic" Cézanne:

We may describe the process by which such a picture is arrived at in some such way as this: the natural objects

145

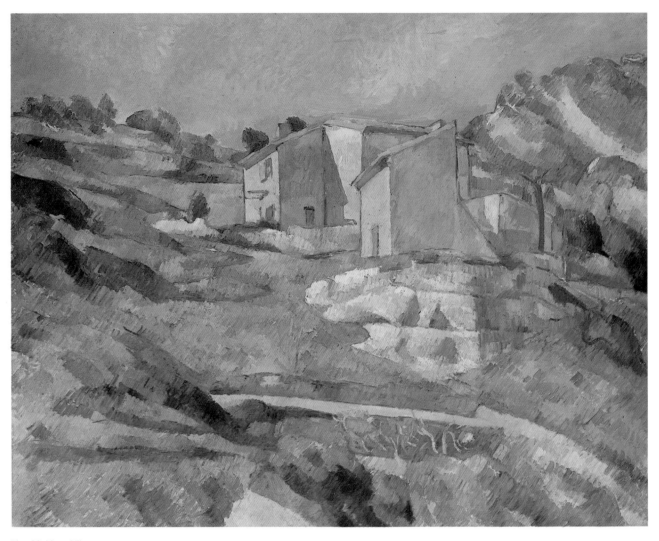

Fig. 88 (Cat. 27)

presented to the artist's vision are first deprived of all those specific characters by which we ordinarily apprehend their concrete existence – they are reduced to pure elements of space and volume. In this abstract world these elements are perfectly co-ordinated and organized by the artist's sensual intelligence, they attain logical consistency. These abstractions are then brought back into the concrete world of real things, not by giving them back their specific peculiar tics, but by expressing them in an incessantly varying and shifting texture. They retain their abstract intelligibility, their amenity to the human mind, and regain that reality of actual things which is absent from all abstractions. Of course, in laying all this out one is falsifying the actual processes of the artist's mind. In reality, the processes go on simultaneously and unconsciously – indeed the unconscious is essential to the nervous vitality of the texture.

Children's Drawings

Cat. 35 M. Abbis (age 15). *Street Scene*, dated 2 October, *c.* 1916–20. Watercolour on paper, 38 x 39.8 cm. Marion Richardson Archive, School of Art & Design Education, University of Central England, Birmingham.

Cat. 36 Anon., *Portrait of Marion Richardson*, Dudley Girls' High School, *c.* 1917–22. Wash on paper, 27.2 x 36.7 cm. Marion Richardson Archive, School of Art & Design Education, University of Central England, Birmingham.

Cat. 37 Dudley Girls' High School, *Beauty Hunts*, *c.* 1918–21. No. 4707 anon., *Furnace on Hill and Houses*, *c.* 1918. Watercolour and gouache on paper, 17 x 25.5 cm.; No. 8012 Winnie Bloomer, *Pavement Scene, with Street Lamp*, 1921. Watercolour on paper, 21 x 23 cm. Marion Richardson Archive, School of Art & Design Education, University of Central England, Birmingham.

Cat. 38 Dudley Girls High School, *Mind Pictures: Geometrical*, *c.* 1918–21. No.4133 by Beryl Stansbie, 1919; No. 4131 by M. Smart, 1921; No. 7333 by J. Worton; No. 7255 by W. Bennett; No. 7237 anon.; No. 7231 by E. Fellows. All watercolour on paper, 62.5 x 87 cm (framed). Marion Richardson Archive, School of Art & Design Education, University of Central England, Birmingham.

Cat. 39 Dudley Girls' High School, *Word Pictures (Diaghilev Ballet)*, 1919. No. 4454 anon.; No. 4471 by M.Freakley. Both watercolour on paper, 63 x 84 cm (framed). Marion Richardson Archive, School of Art & Design Education, University of Central England, Birmingham.

Cat. 40 Dudley Girls' High School, *Word Pictures (Diaghilev Ballet)* 1919. No. 4473 by Gladys Swinton?; No. 4473 by I. Bowdler? Both watercolour on paper, 63 x 84 cm (framed). Marion Richardson Archive, School of Art & Design Education, University of Central England, Birmingham.

Cat. 41 Dudley Girls' High School, *Mind Pictures: Organic*, *c.* 1919–22. Nos. 4106A, 4106B and 4106C by K. Lathe; No.4104 by D. Millard; No. 4135 by G. Priest, 1919; No. 4048 by Beryl Stansbie, 1919; No. 7300 by E. Dallow; No. 4047 by I. Whitehouse, 1919; No. 7327 by I. Oliver, 1919. All watercolour on paper, 62.5 x 87 cm (framed). Marion Richardson Archive, School of Art & Design Education, University of Central England, Birmingham.

Cat. 42 Winifred Edwards (age 12), *The Boxing Match*, Dudley Girls' High School, early 1920s. Watercolour on paper, 24.7 x 27.8 cm. Marion Richardson Archive, School of Art & Design Education, University of Central England, Birmingham.

Cat. 43 Dudley Girls' High School, *Observation and Memory Drawing*, 1920s. No. 8105 by Rachel Phillips, *Teacher and Children*, *c.* 1920. Watercolour on paper, 33 x 30.5 cm. Marion Richardson Archive, School of Art & Design Education, University of Central England, Birmingham.

Fig. 89 (Cat. 44)

Cat. 44 Dudley Girls' High School, *Studies from Art*, mid-1920s. No. 8165 by Florence Hornfray, *Madonna and Child*, early 1920s. Gouache on paper, 25.5 x 21 cm. Marion Richardson Archive, School of Art & Design Education, University of Central England, Birmingham.

Cat. 45 Anon., *Design for Lampshade*, Dudley Girls' High School, undated. Watercolour on shaped card, 19.5 x 38.8 cm. Marion Richardson Archive, School of Art & Design Education, University of Central England, Birmingham.

For Fry, the origin of all art lay in the need not to depict things accurately but to express strong emotions, and the clearest demonstration of this were children's drawings. He suggests as much in the first of his 1897 lecture series, 'Transition from Classical to Modern Art', when he compares Roman catacomb paintings with "the elementary symbolism of a child's drawings", and represents them as a return to the "felt" after the "sophisticated accomplishment of the later Roman painters" (Fry Papers, 1/65). The point is made as the foundation for a non-representational aesthetic theory in 'An Essay on Aesthetics' (*The New Quarterly*, April 1909, pp. 171–90; reprinted in *Vision and Design*): "That the graphic arts are the expression of the imaginative life rather than a copy of actual life might be guessed from observing children. Children, if left to themselves, never, I believe, copy what they see, never, as we say, 'draw from nature', but express, with a delightful freedom and sincerity, the mental images which make up their own imaginative lives."

In 1917 Fry put on an exhibition of children's drawings at the Omega Workshops, and published 'Children's Drawings' (*The Burlington Magazine*, June 1917, pp. 225–31; Reed 1996, pp. 266–70). An article with the same title followed several years later (*The Burlington Magazine*, January 1924, pp. 35–41). The latter was a response to the work of the schoolteacher Marion Richardson (1892–1946) with children at Dudley Girls' High School in the Black Country, near Birmingham. Fry had become her supporter when she visited Omega in 1917; examples of drawings by the girls she taught were shown there before the end of that year, and a couple were reproduced with the 1917 article. Marion Richardson worked at Dudley from 1912 to 1930 with girls between the ages of ten and sixteen, not children in the earliest stages of development. An archive of work collected in a career that included a spell as Art Inspector for London County Council in the 1930s exists in the Institute of Art and Design at the University of Central England, Birmingham. Her child-centred methods were geared to preserving the imaginative and expressive qualities of children's drawing into adolescence. Her teaching included what she called "mind pictures", "word pictures" and "beauty hunts". "Mind pictures" were the result of asking the children to close their eyes and paint whatever came into their head; she assured them that such images need not be things seen in the world, and this, coupled with colour exercises she developed with the girls, led to remarkable results (cat. 38, 41). "Word pictures" were produced in response to descriptions; an especially memorable series survives, stimulated by her descriptions of performances she saw on the visit of Diaghilev's Ballets Russes to London in 1919 (cat. 39, 40). "Beauty hunts" were teacher-led walks in the locality resulting in classroom work produced from memory: the aim was to find significance in the familiar, which in Dudley was the landscape of the industrial Midlands (fig. 77).

Fry's article of 1924 was concerned with an exhibition of work by Marion Richardson's Dudley charges at the Independent Gallery, a gallery that showed contemporary work, including Fry's own. In this piece he stresses her appeal to the children's imaginations and (something he tended to exaggerate) her abstention from instruction; when he wrote about her in 1933 ('Children's Drawings at the County Hall', *The New Statesman and Nation*, 24 June, pp. 844–45), he stressed her determination to ensure that "the overwhelming influx of ideas and facts which are necessary to fit the child for social life [do not] ... completely destroy the acuteness and even the desire for aesthetic satisfaction." In the 1924 piece he gave special attention to two drawings, which he also reproduced (figs. 89, 90): one a Madonna and Child "vaguely inspired by some photograph of an Italian primitive", the other inspired by "a paragraph in a newspaper describing a prize-fight in a modern amphitheatre". Of the first he writes: "There is no suggestion of stylistic imitation but the immediate directness of statement, the precision of tone, the sharpness of contour of primitive art came naturally to the child". In the case of the boxing-match, it is the complex, multi-viewpoint construction of the space and the cohesion of the design that engages him. There is, he finds, "a curious blending of a diagrammatic method with a partial application of perspective ... not unlike ... [the method] of some early oriental artists", and, "Like them, too, our child artist has organized this curiously mixed vision into something that at least has a strongly marked formal unity though only of a decorative nature."

As Fry's article of 1917 had established, he believed that children's drawings showed a basic aesthetic need for design as well as for emotional expression, a need more easily satisfied in them than adults because of the highly simplified conceptual sign language they used. The design qualities of the work produced by Marion Richardson's girls at Dudley clearly confirmed and were in turn confirmed by the work produced at Omega. In 1917 she took back from her visit to the Workshop a design for a lampshade, possibly one of Duncan Grant's (cat. 189), which quickly became the springboard for new ideas generated by the children (cat. 45).

Fig. 90 (Cat. 42)

Chinese Art

Cat. 46 *Pair of animals from horse harnesses*, 1st Century BC. Bronze, diameter 5.5 cm. Courtauld Gallery (0.1935.RF 109).

Cat. 47 Northern Chinese. *Ornament, animal style,* 1st century BC. Bronze, 2.8 x 2.8 cm. Courtauld Gallery (0.1935.RF.111).

Cat. 48 Chou Dynasty, *You,* 11th –10th century BC. Bronze, 34.2 x 29.7 x 17.8 cm. The Victoria and Albert Museum, London.

Cat. 49 Han Dynasty, *Horse bridle cheek-piece.* Bronze, diameter 11 cm. Courtauld Gallery (0.1935.RF 112).

Cat. 50 T'ang Dynasty *Two Chinese funerary figures,* 7th–8th century. Terracotta, 36 x 16.6 x 12 cm (figure with side bunches and ponytail), 35.9 x 14.5 x 12 cm (figure with top knot at side). By kind permission of the Provost and Fellows of King's College, Cambridge (on loan to the Fitzwilliam Museum, Cambridge).

Cat. 51 T'ang Dynasty, *Horse.* Unglazed, moulded and baked clay, 33 cm x 27 cm. Private collection.

Cat. 52 T'ang Dynasty*, Male figure.* Unglazed, moulded and baked clay, height 25 cm. Private collection.

Cat. 53 Sung Dynasty, *Glazed dish.* Clay, diameter 8.4 cm. Courtauld Gallery (0.1935.RF 128).

Cat. 54 Sung Dynasty, *Pot on three feet.* Clay, with grey glaze, 8.7 x 8.8 cm. Courtauld Gallery (0.1935.RF 125).

Cat. 55 Ming Dynasty, *Bowl.* Green-blue glaze, diameter 8.4 cm. Courtauld Gallery (0.1935.RF 131).

Cat. 56 *Vase,* 18th century. Grey glaze, with craquelure, height 32 cm. Courtauld Gallery (0.1935.RF 132).

Fry knew and read the work of many of those involved in the early twentieth-century development of sinology in Britain, including Laurence Binyon and Arthur Waley. His close friend Goldsworthy Lowes Dickinson was an active champion of traditional Chinese culture from the publication in 1901 of his *Letters of a Chinaman.* Fry was especially ambitious in his collecting of Chinese artefacts, his biggest purchase being in 1913, a Kuan-yin stone Buddha of the sixth century, which he later sold to the Worcester Art Museum, Massachusetts, keeping a cast (now at Charleston in Sussex). Like Dickinson, he believed Chinese culture in many respects to be superior to Western culture, something already clear in a review of a Chinese pottery show at the Burlington Fine Arts Club in 1910 (*The Nation,* 23 July 1910, pp. 593–94). Here he dwelled on the glazes in a Sung bowl, and then

ABOVE Fig. 91 (Cat. 56) RIGHT Fig. 92 (Cat. 48)

considered "the men for whom these pots were made", wondering (no doubt with his recent experience of J. Pierpont Morgan in mind) "what other rich men and lovers of luxury have ever been so ascetic and so intellectual in their sensuality as these patrons of the Sung potters?"

Fry was especially drawn to early Chinese sculpture, aligning it with Mayan and Aztec sculpture in 1918 as an example of the "sensitive" and the "reasoned" brought into balance ('American Archaeology', *The Burlington Magazine,* November 1918, pp. 155–57; reprinted in *Vision and Design*). This ideal of balance, now described as a "balance between geometric regularity and sensibility of an almost unique kind", underpins his lecture 'Early Chinese: Yin and Chou Periods' (*Last Lectures,* pp. 97–131), his final and fullest treatment of the topic. Here he gives special prominence to 'yous' (bronze ritual drinking-vessels) of the Chou Dynasty (twelfth to third century BC). He treats them as works of sculpture and picks out as "a masterpiece of design" an example then in the Ermofopoulus collection (fig. 92). Echoing his view of Cézanne and Maillol as "classic", he writes that it stands for "what I call the classic quality of Chinese art". Having stressed its abstraction and refinement, he concludes: "We no longer feel inclined to talk of barbarism – rather of a naïve sensibility heightened by conscious aesthetic purpose."

Claude Gellée, called Claude Lorrain

Cat. 57 *Landscape Study with a Road Skirting a Sea Coast, c.* 1635. Black chalk with pen and brown ink and wash on white paper, 59.9 x 45 cm. Ashmolean Museum, Oxford (PI407).

Cat. 58 *Landscape Study with Tree*, early 1640s. Black chalk with pen and brown ink and wash on white paper, 45 x 59.9 cm. Ashmolean Museum, Oxford (PI404).

Fry first outlined in print his view of Claude (1600–1682) in 'The Old Masters at Burlington House, III' (*The Athenaeum*, 1 February 1902, pp. 152–53), and then confirmed it with a longer monographic piece five years later ('Claude', *The Burlington Magazine*, June 1907, pp. 267–72; reprinted in *Vision and Design*). The later piece was illustrated with drawings about which he appended notes; they included figs. 93 and 94.

Fry's view of Claude was certainly unorthodox, though in 1907 he acknowledged a starting-point in Ruskin's "exaggerated paradox that Claude's drawings look like the work of a child of ten". All the essentials are there in 1902:

He [Claude] is, indeed, strangely paradoxical among the great original geniuses of the world – as remarkable for his stupidity, his limitations, his inability to do what any decently trained artist can do with ease, as he is for his genius which made rare virtues of his unusual defects ... But he was like those stammerers whose hesitation gives them time to point their epigrams. His very helplessness in the face of the thing seen is, we believe, the key to his supreme power ... the obtuseness of his sensations went with a rare intensity of feeling. Though to the end of his days he knew very little about the actual shape of a tree, he felt, as no one else has felt with the same force, the poetical emotions that a tree can arouse ... Given the intensity and purity of his poetic feeling about nature, his want of facility was almost a help.

In 1907 Fry argued that it is "in the cumulative effect

Fig. 93 (Cat. 57)

of the perfect co-ordination of the parts none of which is capable of absorbing our attention ... that the power of a picture by Claude lies", and that this is the outcome of a charmed "naïvety", which allowed him to study the trees he loved in the most general terms, reduced to "mental images", and then combine them as "abstract symbols", which can "arouse in us more purely than nature herself can the mood of pastoral delight". His appreciation of Claude anticipated his later enthusiasm for Henri Rousseau, and his modernist argument that the qualities of "design" have nothing to do with skill.

Fig. 94 (Cat. 58)

Cubism

Fig. 95 (Cat. 75)

Fry's first published response to Cubism was in 1911; he was unimpressed ('The Autumn Salon', *The Nation*, 11 November 1911, pp. 236–37). He could not see why the Cubist room at the Salon d'Automne had provoked "such a sensation, since experiments in cubism have appeared for some years past". However, he acknowledged that "the Parisian cubists use this reduction of complex surfaces to their elementary geometric statement in a new way. They do not regard it as a stepping stone to a completer rendering of actual form, but as a means of expression in itself." In this review he praises the painting of André Lhote, and in the second Post-Impressionist exhibition sub-Cubist pictures by Lhote and Jean Marchand (fig. 13) were included. At the same time, however, he regretted the absence from the 1911 Salon d'Automne of "the most successful cubists", naming Picasso as one.

Having figured marginally in the first Post-Impressionist exhibition, Picasso was given a key role with Matisse in the second, and in his preface to the French section of the catalogue Fry identified his most recent Cubist work as a demonstration of how close painting could get to "a visual music" (in *Vision and Design*). He had a slide made of one such work in the show, *Head of a Man with a Moustache* (fig. 12); it was used in his lectures of the 1920s to sum up his later view of Cubism at, for him, its most extreme. In 'Modern Art', the final lecture in his Slade School series 'Some Principles of Design', written in the early 1920s, the slide "G.R." is noted in the margin (clearly this picture), after

a passage comparing Picasso's manipulation of planes to the pulling and twisting of "plastic texture" according to "feeling" in El Greco (Fry Papers, 1/90). Fry writes: "Picasso's calm assumption of an ideal plasticity pervading space is really a franker proceeding on precisely simpler lines. And having once posited it he plays all sorts of melodies in the various plastic rhythms suggested to him by objects."

By 1921 Fry considered the flat planar construction of Cubist paintings, especially Picasso's, too lacking in "plastic" (three-dimensional) substance and too limited spatially, as he made clear in 'Picasso' (*The New Statesman*, 29 January 1921, pp. 503–04), though he accepted the variety achieved by the Cubists at "M. Léonce Rosenberg's gallery" with "the materials which Picasso quarried". And yet, between 1912 and 1915, it seems to have been the flattest kinds of Cubist work that most attracted him. In January 1914, Picasso's

Fig. 96 (Cat. 60)

155

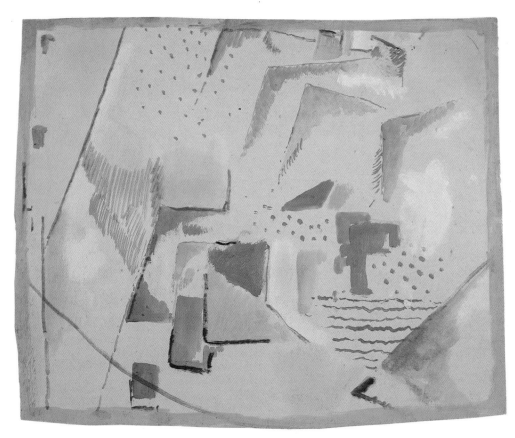

Fig. 97 (Cat. 188)

Head of a Man (fig. 96), a *papier-collé* composition without *papier collé*, was shown with the Grafton Group at the Alpine Gallery in London, and he bought it. Fry was organizer of the Group, and his awareness of Cubist developments at their most advanced is underlined by the fact that press reviews confirm that the exhibition included photographs of Picasso's brand-new constructions, evidently sent by his dealer Kahnweiler ("'sculpture' devised by M. Picasso by means of egg-boxes and other *debris*", *The Athenaeum*, 10 January 1914). Almost certainly at this time, too, Fry bought a little still life of late 1913 by Juan Gris (fig. 79). The fanned structures of his Gris and his Picasso *Head* are

unmistakably echoed in Fry's own most ambitious Cubist experiment, *Bus Tickets* (fig. 95). It was Cubism as an art of flat planar "design" that made an impact on Omega designing (figs. 97, 98). C.H. Collins Baker anticipated its impact as such when he picked out the Picasso *Head* in his review of the Grafton Group show, recalling how he had asked the Group's secretary, Nina Hamnett, "where is this man's head?", to receive the answer "that in Mr. Roger Fry's opinion ... the painter ought not to have called it 'Head of a man', but rather 'A Design'" (C.H. Collins Brown, 'The Grafton Group Academy', *The Saturday Review*, 31 January 1914).

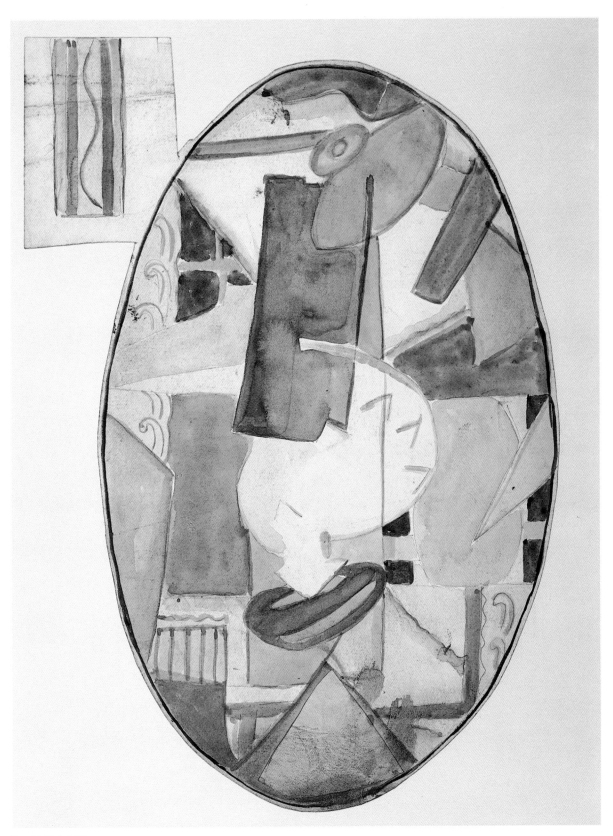

Fig. 98 (Cat. 190)

Daumier (Honoré)

Cat. 63 *The Print Collector*, 1860–63. Oil on canvas,
35.5 x 25.4 cm. Glasgow Museums, The Burrell Collection.

In 1926, Fry made a watercolour by Daumier
(1803–1873) a key test-case for the relation of "design"
to "illustration" in the lead essay of the anthology
Transformations. Fry's analysis is distinctly positive, and
Daumier is placed here in a sequence that includes a
Poussin and Rembrandt's *Ecce Homo* (fig. 133). Indeed,
in 1922, when reviewing a Paris exhibition put on by
Paul Rosenberg, Fry exclaimed at the waste of his
"genius ... by society", and illustrated the oil *Don Quixote
and Sancho Panza*, later bought by Samuel Courtauld, to
show "what his tragic humour might have accomplished
had he been able to work at painting with the continuity
and persistence of Rembrandt" ('French Art of the
Nineteenth Century – Paris', *The Burlington Magazine*,
June 1922, p. 277). Daumier was given a leading role in
Fry's 1932 lectures on 'The Characteristics of French Art',
but he is most comprehensively treated in an
unpublished text, evidently written as a short
monograph (Fry Papers, 1/50). The fact that there is a
typescript version indicates a date in the 1920s or later.
Here Fry plays down the caricatures as sentimental,
however "sympathetic": the product of a Romantic "as

ardent, as devoted as any"; it is in them that society is
seen to have wasted his "genius". "Daumier", he writes,
"is at his greatest when his theme does not lend itself to
moral indignation or to any specific moral reaction." He
then picks out the connoisseur pictures, possibly
referring to the image illustrated here:

One might almost say that he is moving in proportion as
he himself remains unmoved or rather is moved only by
the contemplation of some significant accident of light
and dark. Thus amongst his finest works are the many
designs for 'the connoisseur' ... There is no moral or
dramatic issue here, only a gentleman leaning over a
portfolio to turn over a print and yet from the
unconsciousness and concentration of the pose, from
something in the way the light glances on the hand and
falls on the wrap round the man's neck, from the black
silhouette of his top hat against the white wall and the
light reflected upward on to his face from the prints,
from a thousand subtle modulations of light and shade
throughout the whole design, from all these purely
pictorial qualities there emerges an atmosphere of
strange and disquieting humanity, a feeling which, in
connection with so colourless a situation, it would be
absurd to call tragic but which evokes as deep and
profound a sentiment in the spectator.

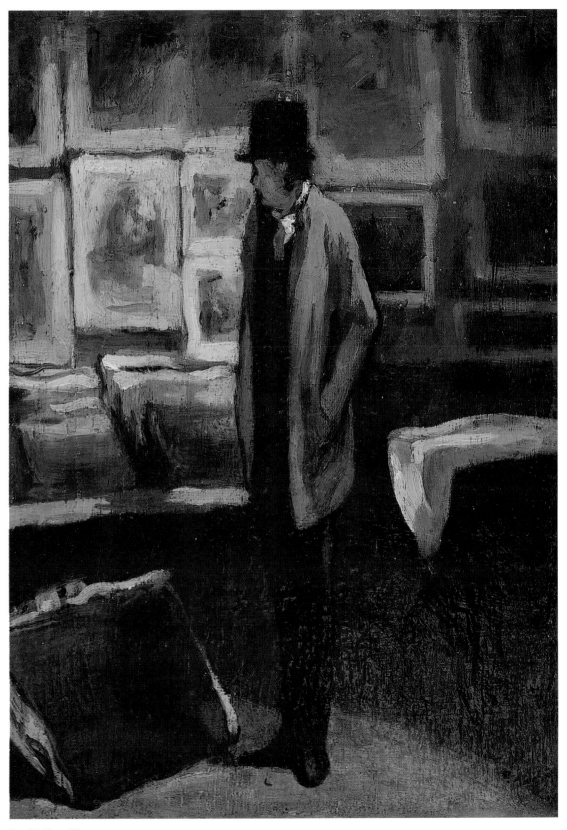

Fig. 99 (Cat. 63)

Derain (André)

Cat. 64 *The Park at Carrières Saint-Denis*, 1909. Oil on canvas, 54.1 x 65 cm. Courtauld Gallery, Fry Collection.

Cat. 65 *Picasso's House at Avignon*, 1914. Oil on canvas, 30.5 x 40.6 cm. Private collection.

Derain (1880–1955) figured in both the first and the second Post-Impressionist exhibitions, and Fry bought *The Park at Carrières* (cat. 64) from the first. Though in Fry's estimation Derain remained a less important painter than Matisse, he always recognized his importance, especially in the late 1910s and early 1920s. In 1919 he bought another work by him, the little *Picasso's House at Avignon* (fig. 100), and that year especially Fry saw a lot of the painter in London and Paris. From 1919 into the 1920s, on his Paris visits, Fry regularly stayed in a little hotel on the rue Bonaparte found for him by Derain and close to the latter's studio.

Only one of the five works by Derain identified as having been in the Post-Impressionist exhibitions could be called Fauvist. Two of those known to have been included in 1910 were painted when Derain was working with Georges Braque in 1909, and used tone to build compositional structures with masses, in the case of cat. 64 recalling Cézanne's *sous bois*; the two known to have been included in 1912 were explicitly evocative of the European "primitives", Quattrocento Tuscans such as Baldovinetti and Piero della Francesca especially. Fry's selection seems thus to have underlined the relationship between current Post-Impressionism and both Cézanne and Italian Renaissance art. When he made his purchase in 1919, he wrote to Vanessa Bell: "It's very slight and wasn't at all expensive ... But I think it's a very lovely thing. Very much like a Fra Angelico" (*Letters*, II, p. 459). And it is as a "primitive", the sophisticated counterpart of Henri Rousseau, that Fry analyses Derain in his surveys of modern art for lecture audiences after 1919. Thus, in a lecture on 'The Development of Modern Art' delivered at University College, Bangor (18 January 1927; Fry Papers, 1/117), he speaks of Derain, "one of the most brilliantly accomplished and highly sophisticated of modern painters going to school with the ex-custom house officer [Rousseau], learning from him and also from negro sculpture how to build designs out of the lowest, most elementary conception of objects". He then turns to a landscape, which might be fig. 100: this "is more in the vein of the European primitives, but it is no copy, no mere revival – it has none the less a definitely modern note. The mood is as complicated and as subtle, as decadent, if I may use that word without any sense of reproach, as the expression is simple". His enthusiasm for Derain's current work had by then waned because, for him, it had come too close to its sources, which were now in the seventeenth century and later.

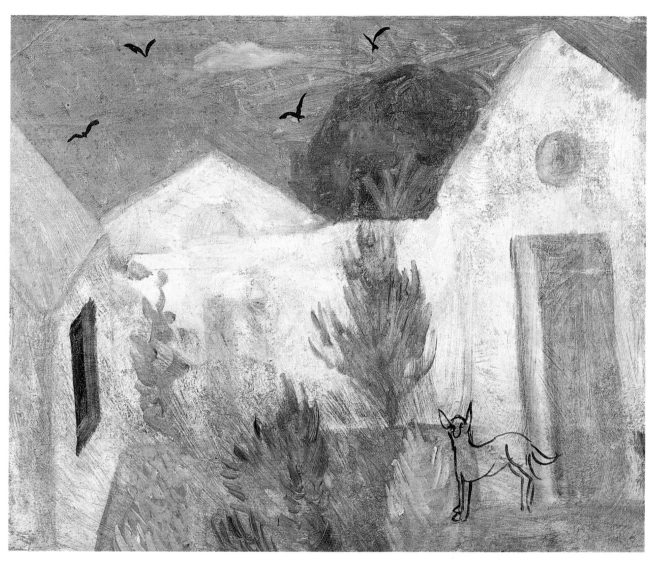

Fig. 100 (Cat. 65)

Fig. 101 (Cat. 66)

Dobson (Frank)

Cat. 66 *Reclining Nude* , 1925. Marble, 17.7 x 50 cm.
Courtauld Gallery, Samuel Courtauld Collection (S.1948.SC.202).

Fry was not a promoter of English sculpture. His article
'An English Sculptor' (*The Nation*, 28 January 1911; Reed
1996, pp. 133–35) made a strong case for Eric Gill, but
his enthusiasm was short lived, and his support for Jacob
Epstein against "the philistines" was always qualified.
Henri Gaudier-Brzeska, with whom he worked at Omega,
was, of course, French (see 'Gaudier-Brzeska (Henri)',
pp. 168–69). In 1925, however, he gave unequivocal
support to Frank Dobson (1886–1963) in 'Mr. Frank
Dobson's Sculpture' (*The Burlington Magazine*, April
1925, pp. 171–77; reprinted in *Transformations*).

Here Fry sets Dobson apart from what he represents
as the long-term failure of European sculptors, both
Northern and Mediterranean, to escape the confines of
plane and elevation and deal with form in fully three-
dimensional terms. Dobson, he says, has ignored the
predominance of drama in sculpture (which he finds in
Epstein) and decided to be "a sculptor who would
confine himself to purely sculptural plasticity". What is

more, he has gone beyond "the cold dogmatism" of his
"early Cubist essays ... to a more vital and sensitive
apprehension". One of the pieces he illustrates is fig.
101. By setting the sensual Dobson of the 1920s against
the earlier "cubist" Dobson, Fry makes what, for him, is a
fundamental distinction:

There are, roughly speaking, two avenues of approach to
a complete work of art. The artist may work through his
sensibility towards the perfect organisation of form, or he
may attack the organisation of form deliberately, and,
when once he has mastered that, allow his sensibility to
give body and substance to what began as an
abstraction. By either route the way to a perfect fusion of
the two elements, which is essential to a complete work
of art, is generally a long one – that is why so many
artists only achieve their real expression late in life – and
what is done by the way, will always be rather a work of
promise than of fulfilment. The influence of Cubism in
modern art has caused many, perhaps the majority, of
the younger generation to adopt this second route – to
begin that is, by a conscious study of organisation.
Mr. Dobson is no exception to this.

Egyptian Art

Cat. 67 18th Dynasty, *Torso*. Sandstone, 16.2 x 7.6 x 11.5 cm.
Courtesy of the Petrie Museum of Egyptian Archaeology,
University College London (UC 002).

Fry's view of Egyptian art was, perhaps surprisingly,
closely bound up with his modernist interest in children's
drawings. This is clear in his fullest treatment of Egyptian
art, his lecture on the subject in the Cambridge Slade
series of 1934 (*Last Lectures*, pp. 49–63), but it is there,
too, in the first lecture of his series, 'Some Principles of
Design', written for the London Slade School in the early
1920s. In the latter, having analysed the use of
conceptual symbols by children, where "typical aspects"
might be used to produce a "conceptual hyroglyphic" of
a man, he puts up an unspecified "Egyptian" slide to
make the point that even "a highly civilized &
sophisticated art with a continuous tradition of 2000
years [can follow] ... strictly the rules of conceptual
symbolism". In the lecture of 1934 he goes so far as to
call a Twelfth Dynasty relief "only a highly developed
and accomplished child's drawing", concluding that, in
general, "an Egyptian relief is a story told in a series of
recognized symbols ... It is essentially an art of pure
illustration." And yet he asserts that, despite its highly
literary and conventional character, Egyptian reliefs can
be "vital" and plastically "successful" in his terms, and
picks out an Eighteenth Dynasty torso (fig. 102) as
especially modern. He calls it a "little masterpiece", and
writes:

In its effortless grasp of the plastic rhythm of the body as
a whole and in the delicate sensibility of the modelling
this surpasses, I think, all that Greece was to accomplish.
It jumps the centuries and millennia. I have a cast of it
which to my delight a well-known French art-critic
believed to be by Maillol, and indeed hardly anyone
guesses that it is Egyptian.

Fig. 102 (Cat. 67)

Fig. 103 (Cat. 68)

Fry (Helen)

Cat. 68 *Florence from Fiesole, c.* 1898. Oil on canvas, 23 x 33 cm. Private collection.

Cat. 69 *Copy of Piero di Cosimo's 'Mythological Subject'* (*c.* 1495), *c.* 1902–03. Oil on canvas, 72 x 194 cm. Private collection.

Fry married Helen Coombe, a young artist, in 1896. They travelled and painted together in Italy often between 1897 and 1899, and in 1898 visited Bernard Berenson in Fiesole, where Helen's little view of Florence (fig. 103) was possibly painted. From 1899 their marriage and Helen's life were slowly destroyed by mental illness, which, in 1910, forced Fry to commit her to an asylum in York, where she died in 1937.

Fig. 104 (Cat. 87)

Fry (Roger)

Cat. 70 *Blythburgh, the Estuary*, 1892–93. Oil on canvas, 59 x 71.6 cm. Private collection.

Cat. 71 *The Pool*, 1899. Oil on canvas, 42 x 68.5 cm. Private collection.

Cat. 72 *Still Life: Flowers, c.* 1912. Oil on canvas, 96.5 x 61 cm. Tate Gallery, London (T00101).

Cat. 73 *The White Road*, 1912. Oil on canvas, 64.8 x 80.6 cm. The Scottish National Gallery of Modern Art, Edinburgh.

Cat. 74 *Still Life with Bottle and Fruit, c.* 1914–15. Oil on canvas, 21 x 14.5 cm. Private collection.

Cat. 75 *Bus Tickets, c.* 1915. Collage and oil on canvas, 36 x 26.5 cm. Tate Gallery, London.

Cat. 76 *Still Life with Coffee Pot*, 1915. Collage and oil on canvas, 50 x 37 cm. Courtauld Gallery.

Cat. 77 *Portrait of Lalla Vandervelde, c.* 1916. Oil on canvas, 85 x 106.7 cm. Private collection.

Cat. 78 *Portrait of Vanessa Bell, c.* 1916. Oil on canvas, 125 x 74 cm. Private collection.

Cat. 79 *Portrait of Nina Hamnett*, 1917. Oil on canvas, 82 x 61 cm. Courtauld Gallery.

Cat. 80 *Portrait of Nina Hamnett*, 1917. Oil on canvas, 137.2 x 91.4 cm. The University of Leeds Art Collection.

Cat. 81 *Self-Portrait, Seated*, 1918. Oil on canvas, 73.9 x 94 cm. By kind permission of the Provost and Fellows of King's College, Cambridge.

Cat. 82 *Provençal Landscape*, 1919. Oil on canvas, 91 x 117 cm. Private collection.

Cat. 83 *Portrait of Bertrand Russell, Earl Russell, c.* 1923. Oil on canvas, 54 x 45.1 cm. By courtesy of the National Portrait Gallery, London.

Cat. 84 *Copy of a Self-Portrait by Cézanne*, 1925. Oil on canvas, 35.8 x 28.6 cm. Courtauld Gallery, Fry Collection.

Cat. 85 *Self-Portrait*, 1928. Oil on canvas, 45.7 x 37.1 cm. Courtauld Gallery.

Cat. 86 *Self-Portrait*, 1934. Oil on canvas, 65.5 x 78.1 cm. By kind permission of the Provost and Fellows of King's College, Cambridge.

Works on paper

Cat. 87 *Portrait of Helen Fry*, undated. 22.5 x 28.7 cm (approx.). By kind permission of the Provost and Fellows of King's College, Cambridge (Archive cat. 4/1.23).

Cat. 88 Sketchbook, including *Drawing of The Cathedral and Houses at Laon*, 1887. Watercolour and pencil. By kind permission of the Provost and Fellows of King's College, Cambridge.

Cat. 89 *Portrait of Goldsworthy Lowes Dickinson*, 1893. Chalk, 49.5 x 40.3 cm. By courtesy of the National Portrait Gallery, London.

Cat. 90 *Design for Lalla Vandevelde's bed-head*, 1916. Pencil, 11.5 x 17.7 cm. Courtauld Gallery (PD 51).

Cat. 91 Sketchbook, including *Drawing of Pamela Fry (Diamand)*, *c.* 1917–19. Pencil. By kind permission of the Provost and Fellows of King's College, Cambridge (Archive cat. 4/8/8).

Cat. 92 Sketchbook, including *Drawing of Goldsworthy Lowes Dickinson Playing Chess with André Gide*, August 1918. Pen and ink. By kind permission of the Provost and Fellows of King's College, Cambridge (Archive cat. 4/8/9).

Cat. 93 *Sir Edward Fry on his Deathbed*, 20 October 1918. Pencil, 24.1 x 34.8 cm. Courtauld Gallery.

Cat. 94 Roger Fry. Sketchbook including *Drawing of Provençal Landscape with Village (Outskirts of Aix with View of Montagne Sainte-Victoire?)*, 1919. Pencil. By kind permission of the Provost and Fellows of King's College, Cambridge (Archive cat. 4/8/10).

Cat. 95 *Book of Twelve Original Woodcuts*, Hogarth Press, London, 1921. 21.9 x 15.1 cm (closed).

Fig. 105 (Cat. 117)

Cat. 96 *Helen Anrep*, July 1925. Pen and ink on sketchbook sheet, 19.2 x 12.3 cm. By kind permission of the Provost and Fellows of King's College, Cambridge.

Cat. 97 *Caricature of J.E. McTaggart*, undated. Pencil, pen and pastel on brown paper, 38.1 x 22.86 cm. The Master and Fellows, Trinity College, Cambridge.

Cat. 98 *Design for an interior* , undated. Gouache and pencil, 26.7 x 37.5 cm. Courtauld Gallery (PD 83).

Cat. 99 *Design for a carpet*, undated. Watercolour on tracing paper, 40.3 x 26.9 cm. Courtauld Gallery (PD 70).

Cat. 100 *Design for a carpet with insect and flowers* (with Duncan Grant [?]), undated. Gouache, 56.8 x 45 cm. Courtauld Gallery (PD 10).

Cat. 101 *Design for the Peacock stole*, undated. Coloured inks and pencil, 35.2 x 44.5 cm. Courtauld Gallery (PD 1).

Cat. 102 *Design for woodwork for the interior of the Cadena Café*, undated. Pencil and gouache, 53.1 x 68 cm. Courtauld Gallery (PD 2).

Cat. 103 *Papier-collé Composition*, undated. Collage with embossed and printed textured paper, 26.5 x 33.7 cm. Courtauld Gallery (PD 37).

Fry would never have canonized his own art. He might, however, have accepted its canonization by association, as part of something bigger: a tradition or movement. On 7 November 1894 he wrote from Bergamo to Lowes Dickinson that his "studies of Italian art" had taught him that "the vast majority of artists were quite inferior, hardly better than the average nowadays, but that owing to the strength of tradition even a feeble man didn't make a bad mess, and unless he was strong, didn't try to be original" (*Letters*, I, pp. 161–62). On 1 March 1916, lecturing in French to the Club Français de l'Université de Londres, he stressed his belief that "the art of a civilization ... results from the common effort of men of talent", and asserted that individual "genius can ... never be the sole cause" of "the movement of art" (Fry Papers, 1/97). Fry was slow to claim even talent as an artist, but certainly between 1888, when he started to train as an artist in the studio of Francis Bates, and the early 1920s, when he began to see the Post-Impressionist experiment in England as a failure, he tried doggedly to belong.

Between 1894 and his joint exhibition with The Hon. Neville Lytton at the Carfax Gallery in 1907, he tried to belong to tradition as he understood it through his highly technical study of past art, consciously emulating Girtin as a watercolourist and Gaspard Dughet or Richard Wilson as a landscapist, both kinds of work, including *The Pool* of 1899 (fig. 15), being shown in 1907. His early archaism developed in the late 1890s alongside that of Helen Fry, with whom he painted in Italy (see fig. 103). Between 1910 and 1920 he tried to belong to the new movement, the English off-shoot of which was partly due to his initiative, consciously emulating Gauguin, Matisse, even sometimes Picasso (fig. 95), but especially Cézanne (fig. 29), alongside his new young friends, among them Grant and Vanessa Bell. A letter written to D.S. MacColl on 3 February 1912, in answer to the charge that Fry's exhibition at the Alpine Gallery showed him up as a "pasticheur", brings out the way he himself saw his archaism and his modernism as linked:

I've always been searching for a style to express my *petite sensation* in ... my first rebellion against the dreary

Fig. 106 (Cat. 101)

naturalism of our youth lay in the direction of archaism. I knew that was no good, knew it at the time, but saw no other outlet for what I wanted, which was a much more deliberate and close unity of texture than any of my contemporaries tried for (*Letters*, I, pp. 353–54).

In 1912 he had found contemporaries who wanted just this, too.

One attraction of the Omega enterprise (1913–19) was the degree to which collaborative work was encouraged; the policy of marketing the designs anonymously made the primacy of the group public. And yet, some of Fry's most individual work was produced as anonymous Omega design (attributions to him are mostly posthumous), above all his designs for printed linens (see figs. 45, 46, 47), and for interiors, including Lalla Vandervelde's bedroom in 1916 (fig. 74). He saw no division between art and craft, aspiring to be an "artist–craftsman" of the kind he later idealistically described when writing on Persian pottery (see 'Islamic Art', p. 181). The activity could be, for him, itself an end. Indeed, he derived particular pleasure from being a potter, often working with Vanessa Bell. In 1914 he writes to Grant after potting with Vanessa Bell at Poole: "It's fearfully exciting when you do get it centred and the stuff begins to come up between your fingers.

V. never would make her penises long enough, which I thought odd. Don't you?"

After the demise of Omega, Fry's work as an artist became more isolated and his confidence in it declined in the face of lack of sales from his London exhibitions of 1920 and 1923, and his New York exhibition at the Brummer Gallery of 1925. His painting, however, remained profoundly important to him, and his attitude to it consistently complements his belief from 1920 that "significant form" could best be generated by responsiveness to nature. This is already clear in his letters of 1919 to Vanessa Bell from Provence, and it is further clarified by the engagement with likeness betrayed when he writes about his frequent attempts at portraiture. On 6 April 1928 he wrote to Helen Anrep of his recently finished portrait of Simon Bussy: "My portrait of Simon is staggeringly like ... I don't know how good it is in other ways" (*Letters*, II, p. 623). From his early portraits of Lowes Dickinson (fig. 6) and J.E. McTaggart (fig. 7), he had always enjoyed his flair for likeness. The question of how such a flair could be harnessed to produce work which was, in his opinion, supremely "good ... in other ways", certainly motivated at one level his copies of Cézanne's and Rembrandt's self-portraits in 1925 and 1933, as well as his own engagement with self-portraiture from 1918. As a landscapist, from around 1930 he was drawn increasingly to painting responses to light and weather. On 19 September 1930 he wrote to Helen Anrep of how he gets "one atmosphere throughout [a picture] more than I used to ... Very few of our contemporaries try to get a solid texture of atmosphere, so to speak, as the Dutch and the best of the Impressionists did" (*Letters*, II, p. 651). His late Suffolk landscapes emulate, not Cézanne, but Constable.

Gaudier-Brzeska (Henri)

Works on paper

Cat. 118 *Wrestlers*, 1913–14. Pencil, 16 x 20.7 cm. Kettle's Yard, University of Cambridge.

Cat. 119 *Wrestlers*, 1913–14. Pen and ink, 43.2 x 31.5 cm. Kettle's Yard, University of Cambridge.

Cat. 120 *Wrestlers*, 1913–14. Linocut, 22.5 x 28 cm. Kettle's Yard, University of Cambridge.

Three-dimensional objects

Cat. 121 *Wrestlers Tray*, 1913–14. Marquetry, diameter 71.5 cm. The Victoria and Albert Museum, London.

Cat. 122 *Wrestlers*, 1914. Relief cast in herculite, 72.3 x 92.7 cm. Kettle's Yard, University of Cambridge.

The French sculptor Gaudier-Brzeska (1891–1915) was based in London for only the few years 1911–15, before returning to France, where he was killed in action on 5 June 1915. The likelihood is that he was introduced to Fry and Omega by Nina Hamnett, shortly after she started working in the studio there (at that time, Nina was his model and mistress; in 1917 she would move on briefly to Fry; see 'Hamnett (Nina)', p. 176). Gaudier's involvement probably, therefore, began after the defection of Wyndham Lewis to form the Rebel Art Centre in October 1913, even though he was also involved with Lewis and in 1914–15 with Lewis's Vorticist periodical *Blast*. He sold his work through the Workshop nonetheless, but produced few Omega designs. Most significant were his designs of 1914 for marquetry trays, which were fabricated by J. Kallenborn & Sons, the cabinet-makers in Stanhope Street, where such pieces as the 'Giraffe' cupboard (fig. 43) were also made. One such tray takes the motif of wrestlers, which Gaudier explored also in a series of drawings, a lino-cut and a pair of reliefs cast in a form of plaster marketed as herculite (fig. 107).

Fry's one article on the sculptor ('Gaudier-Brzeska', *The Burlington Magazine*, August 1916, pp. 209–10) appeared after his death, occasioned by Ezra Pound's *Gaudier-Brzeska: A Memoir* (London 1916). The *Wrestlers Tray* was illustrated. Fry quotes Gaudier to support the claim that he aimed "to create a classic art, one of purely formal expressiveness". He finds in his early

Fig. 107 (Cat. 122)

"schematizing" of forms a resemblance to "early sculpture – Greek, for instance [though Brzeska hated "those damn Greeks"], but still more early Chinese." Yet, though he recognizes a "desire to push the abstraction of planes still further", which led to "a much freer deformation" with "traces of an interest in negro sculpture", Fry stresses what he sees as an adherence to "the general principles of organic form". His agenda here is transparent, as he moves on to acknowledge the attraction to Gaudier of "Cubism and its offshoot Vorticism", only to insist that Gaudier's attempt "to treat organic forms with a system of plasticity derived from mechanical objects ... was not in line with [his] ... special gifts and artistic temperament". For Fry, Gaudier has to be separated from Vorticism, especially since Pound's monograph cemented that connection. He even goes so far as to bring in a letter from Gaudier, in which he "states ... that he intends to return to organic form". It is telling also that he calls Gaudier's drawings "too superficially brilliant"; technical skill was always, for Fry, dangerous.

Gauguin (Paul)

Cat. 123 *Nevermore*, 1897. Oil on canvas, 60.5 x 116 cm. Courtauld Gallery.

Cat. 124 *Te Rerioa*, 1897. Oil on canvas, 95 x 130.2 cm. Courtauld Gallery.

Fry's enthusiasm for Gauguin's work played a leading role in his experimental phase as artist and theorist, but later, especially after 1919, he paid little attention to it. Gauguin (1848–1903) was presented with Cézanne as one of the two major figures behind the modern movement in Fry's first defence of it, his open letter 'The Last Phase of Impressionism' (*The Burlington Magazine*, March 1908, pp. 374–75; Reed 1996, pp. 72–75). Together here they are distinguished from the Neo-Impressionists as "proto-Byzantines". "They have already attained to the contour, and assert its value with keen emphasis. They fill the contour with wilfully simplified and unmodulated masses, and rely for their whole effect upon a well considered co-ordination of the simplest elements." At least twenty works by Gauguin were selected for the first Post-Impressionist exhibition in 1910, probably the largest showing by any artist. In the second of a pair of polemics, 'Grafton Galleries – I' and 'Post-Impressionism – II', Fry confessed that "there are too many Gauguins" (*The Nation*, 19 November 1910, pp. 331–35, and 3 December 1910, pp. 402–03; Reed

1996, pp. 86–94). Moreover, in the first of the two he remarked on "an occasional hint of self-consciousness, of the desire to impress and impose". "Yet", he continued there, "all this must be unsaid before his greatest designs", and he was unequivocal about Gauguin's "creation of new possibilities of pattern, and his unrivalled power of complex color [*sic*] harmony". Gauguin's work was to be an important stimulus for Omega designing after 1913.

In 1908 Fry had made a point of rejecting the idea that Gauguin was an "archaizer", remarking that "the flaw in all archaism is ... that it endeavours to attain results by methods which it can only guess at, and of which it has no practical and immediate experience". Alongside Cézanne, he is represented as a modern painter taking hold again of "the thread of tradition". By the early 1920s, when Gauguin is mentioned, very much in passing, in the last lecture of Fry's series 'Some Principles of Design' for the Slade School, he is dismissed as "deliberately decorative", using means that involve open "archaism" (Fry Papers, 1/90). When he comes up again in Fry's lecture 'Development of Modern Art', delivered at University College, Bangor (18 January 1927; Fry Papers, 1/117), Gauguin is paired not with Cézanne but with Van Gogh, and their work is jointly dismissed as "a rather superficial by-product of Cézanne's researches".

Fig. 108 (Cat. 124)

Gogh (Vincent van)

Cat. 125 *The Crau at Arles: Peach Trees in Flower*, 1889.
Oil on canvas, 65 x 81 cm. Courtauld Gallery.

Van Gogh (1853–1890) was, for Fry, a major Post-Impressionist, to be placed beside Gauguin. At least sixteen works made his one of the largest showings at the first Post-Impressionist exhibition in 1910. As with Gauguin, his importance to Fry waned after 1919, but Fry still found him an instructive case-study in the 1920s.

Desmond McCarthy wrote the catalogue preface for the 1910 Post-Impressionist exhibition from Fry's notes (Reed 1996, pp. 81–85). Fry's view of Van Gogh is summed up succinctly there: "Van Gogh's morbid temperament forced him to express in paint his strongest emotions, and in the methods of Cézanne he found a means of conveying the wildest and strangest visions conceived by any artist of our time". Such an insistence on his debt to Cézanne reads oddly today, but it went with Fry's need to put the two together as opposites. As he put it in 'Post-Impressionists – II': "If Cézanne is the great classic of our time, Van Gogh represents as completely the romantic temperament" (*The Nation*, 3 December 1910, pp. 402–03; Reed 1996, pp. 90–94). It is this unsurprising counter-image of Van Gogh as "romantic", obsessed with expressing the inner and psychogical, that made him so revealing a test-case for Fry when he reviewed the Van Gogh exhibition at the Leicester Galleries in 1923 ('Van Gogh', *The Burlington Magazine*, December 1923, pp. 306–08; reprinted in *Transformations*, pp. 178–87). Here Fry dubs him not only "romantic" but also "primitive" in his ability to "illustrate his own soul ... He works, as a child who has never been taught works, with a feverish haste to get the image which obsesses him externalised in paint." And the contrast with Cézanne is expounded at length: Cézanne is slow and reticent where Van Gogh is fast and prolix; his concerns are intellectual and "plastic" where Van Gogh's are, above all, "psychological"; his "great preoccupation" is with "construction in depth" where Van Gogh's is with "the organisation of the picture on a flat surface as a decorative unity"; but both are, for Fry, equally sincere. The problem Van Gogh now represented so clearly to Fry is summed up thus: though Van Gogh learned to regard "almost any vision as a possible basis for design ... his whole nature impelled him to regard even the most insignificant object ... as charged with dramatic significance". His "approach to nature" only "appears plastic", therefore: "In reality he is an illustrator."

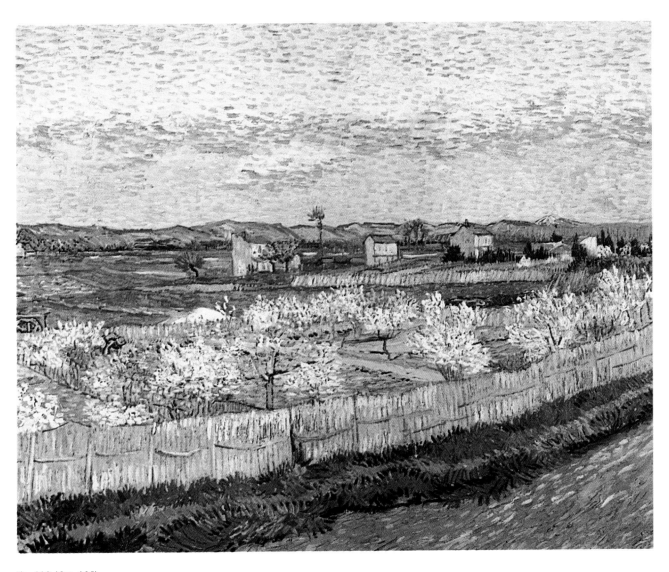

Fig. 109 (Cat. 125)

Grant (Duncan)

Cat. 126 *Copy of Piero della Francesca's 'Portrait of Federigo da Montefeltro',* c. 1904–05. Oil on canvas, 40.6 x 31.7 cm. The Charleston Trust.

Cat. 127 *Dancers,* 1912. Oil on canvas, 91.5 x 71 cm. Private collection.

Cat. 128 *Head of Eve,* 1912. Oil on board, 75.6 x 63.5 cm. Tate Gallery, London.

Cat. 129 *Portrait of Lytton Strachey,* 1913. Oil on plywood, 91.4 x 58.4 cm. The Charleston Trust.

Cat. 130 *The Kitchen,* 1914 (reworked 1916–17). Oil on canvas, 106.7 x 135.9 cm. By kind permission of the Provost and Fellows of King's College, Cambridge.

Works on Paper

Cat. 131 *The Post-Impressionist Ball,* 1912. Pen and oil on headed writing paper, 18.4 x 38.1 cm. The University of Leeds Art Collection.

Cat. 132 *Dancing Figure,* 1913–14. Gouache on paper, 56.9 x 44.3 cm . Courtauld Gallery (PD 16).

Cat. 133 *Female Dancer* (design for a painted screen), 1913–14. Oil on paper, 34.8 x 22.9 cm. Courtauld Gallery (PD 72).

Cat. 134 *Flowers in a Vase* (design for a fire-screen), 1913–14. Pastel on paper, 63.5 x 47.8 cm. Courtauld Gallery (PD 95).

Cat. 135 *Male Dancer* (design for a painted screen), 1913–14. Oil on paper, 37.6 x 17.2 cm. Courtauld Gallery (PD 71).

Cat. 136 *Male Dancer* (design for a painted screen), 1913–14. Oil on paper, 31.7 x 23.7 cm. Courtauld Gallery. (PD 73).

Cat. 137 *Carpet design in orange, blue, purple-grey, green and black,* undated. Gouache on paper, 15 x 52.8 cm. Courtauld Gallery (PD 4).

Cat. 138 *Carpet design with boat and fish,* undated. Pencil and ink on paper, 28.5 x 28 cm. Courtauld Gallery (PD 34).

Cat. 139 *Cat on a Cabbage,* undated. Gouache on paper, 72.5 x 62.3 cm. Courtauld Gallery. (PD 22).

Cat. 140 *Design for an interior (boudoir?),* undated. Watercolour on paper, 36.1 x 26.2 cm. Courtauld Gallery (PD 82).

Cat. 141 *Design for a carpet,* undated. Gouache on paper, 60.6 x 48.1 cm. Courtauld Gallery (PD 23).

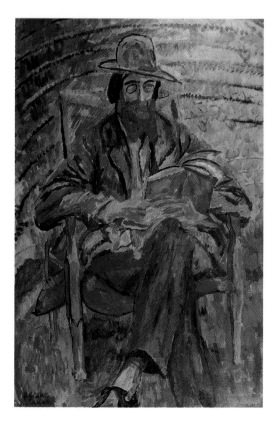

Fig. 110 (Cat. 129)

Cat. 142 Duncan Grant, *Design for a tray (giraffe),* undated. Gouache on paper, 48 x 60.7 cm. Courtauld Gallery (PD 96).

Cat. 143 Duncan Grant, *Giraffe Design,* undated. Gouache on paper, 48 x 60.7 cm. Courtauld Gallery. (PD 96).

Cat. 144 *Three Greek Figures,* undated. Oil and pencil on paper, 20.5 x 28.6 cm. Courtauld Gallery (PD 59).

Three-dimensional objects

Cat. 145 *Omega Workshops Signboard,* May 1915. Oil paint on wood, 104.1 x 63.2 cm. The Victoria and Albert Museum, London.

Cat. 146 *The Blue Sheep,* 1915. Three-fold screen, gouache on paper laid on canvas, 106.2 x 205 cm. The Victoria and Albert Museum, London.

Textiles

Cat. 147 *Rug,* 1913. 221 x 170 cm. Courtauld Gallery (T.1958.PD 267).

Fig. 111 (Cat. 147)

Like Vanessa Bell, Duncan Grant (1885–1978) was one of the young artists whose work encouraged Fry's development as an experimental painter and formalist thinker between 1910 and 1914. With Bell, he was one of the most prolific of Fry's collaborators in Omega, among his most successful designs being his painted screens (figs. 36, 73). They remained close thereafter, and Fry reserved special admiration for Grant's gifts among all his artist–friends.

Fry's fullest published response to Grant's work is a review of his first solo exhibition which was held at the Paterson-Carfax Gallery in Old Bond Street in February 1920 and included pre-1914 pictures ('Mr. Duncan Grant's Pictures at Paterson's Gallery', *The New Statesman*, 21 February 1920, pp. 586–87). He betrays regret for Grant's decision in his latest work to pursue "relations of colours not merely in and for themselves, but as expressive of the density of mass and relief", thereby eschewing "to some extent" both his "gift of a singularly sensitive and distinguished 'handwriting', and his exquisite sense of colour". At the same time, he highlights his ability to make any scribble expressive: "Mr. Grant has this gift of spontaneous and inevitable revelation. But over and above this the personality thus

expressed is peculiarly charming. It reveals itself as transparently sincere, well poised and serene. From all his work there emanates this sense of an untroubled serenity of feeling." Significantly, it is in the lecture on 'Sensibility' in his Cambridge Slade series of 1933–34 that Fry deals with Grant as a designer at Omega most tellingly. He illustrates a carpet designed by him (fig. 111), which he compares with an African textile, to bring out Grant's commitment to "surface sensibility" over formulaic regularity:

He has taken a theme of almost daring geometrical simplicity, but, not relying only on the broken quality of the knotted surface of the rug, he has deliberately broken his rectilinears by small steps up and down; he has also made his shading sometimes perpendicular and sometimes diagonal. The effect of this is to allow us to contemplate a design which, if it had been perfectly regular, we should probably sum up in the statement – seven rectangles arranged in parallel. But these perpetual slight changes prevent us from ever passing on, as it were, to the mere mathematical generalization. Here I suspect is one of the secrets of the importance in art of surface sensibility (*Last Lectures*, pp. 35–36).

Hamnett (Nina)

Cat. 148 *The Landlady*, 1918. Oil on canvas, 83.5 x 68 cm. Private collection.

Works on paper

Cat. 149 *Interior with Painted Walls and Elephant Tray*. Oil on card, 46.9 x 30.8 cm. Courtauld Gallery (No.81).

Cat. 150 *Portrait of Roger Fry Nude*, June 1918. Ink on paper, 11.2 x 33 cm. Private collection.

Fry met Nina Hamnett (1890–1954) when she came to the Omega Workshops and offered her services, probably late in 1913. She had showed as a painter for the first time that July, at the Allied Artists' Association in the Royal Albert Hall, but Fry took her on, and she worked at Omega with Winifred Gill and others, transferring designs for fabrics, lampshades, *etc.* She was trusted enough by Fry to be given the job of secretary to the group he had brought together in 1913 under the name the Grafton Group when it showed at the Alpine Gallery in January 1914. After a spell in Montparnasse, Paris, where she made friends with such artists as Modigliani, Zadkine and Brancusi, she returned to London in October 1914 with a new husband, a Norwegian artist called Edgar de Bergen. Renamed Roald Kristian on account of the Germanic overtones of de Bergen, he joined Nina working with Fry at Omega, producing, for instance, the illustrations for Arthur Clutton-Brock's *Simpson's Choice* (cat. 206). Their marriage quickly cooled, and she did nothing to prevent Kristian's eventual deportation in 1916 as an unregistered alien. Between 1916 and 1918 Nina became involved with Fry, their affair reaching a high point in mid- and late 1917, when Fry painted several portraits of her. Fry's London

Fig. 112 (Cat. 150)

base was a room in Fitzroy Street, where he and Nina were neighbours, and they worked often in each other's company, with themselves sometimes as models. It seems to have been during such a session that Nina drew Fry naked in June 1918 (fig. 112).

Fry clearly had a genuine respect for Hamnett's painting, though he never wrote about it in print. He included her in mixed Omega exhibitions, and bought from her. A picture he showed in an Omega exhibition of October 1918 was *The Landlady*. Nina painted it at her lodgings in Bath that summer (fig. 113), where she was staying to be close to Walter Sickert, another of her mentors (and lovers) in the war years. In this picture she succeeded in giving a humdrum Sickertian subject the kind of solid "plastic" structure Fry wanted from his own figure painting, including his portraits of her. It is the most ambitious picture by Nina that he bought from her.

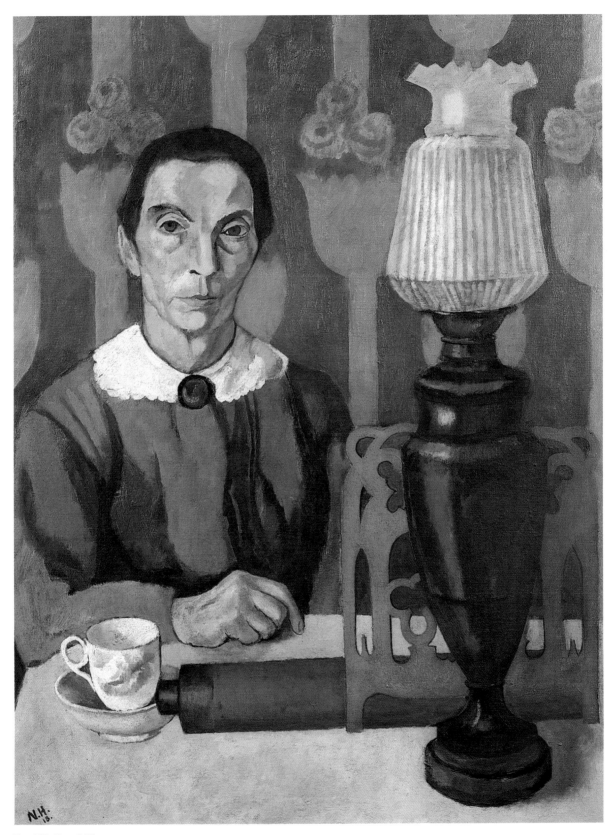

Fig. 113 (Cat. 148)

Impressionism

Cat. 151 Edouard Manet, *A Bar of the Folies-Bergère*, 1881–82. Oil on canvas, 96 x 130 cm. Courtauld Gallery.

Cat. 152 Edgar Degas, *After the Bath, c.* 1895. Pastel on paper, 67.7 x 57.8 cm. Courtauld Gallery.

Cat. 153 Pierre Bonnard, *Young Woman in an Interior, c.* 1906. Oil on canvas, 48.9 x 44.5 cm. Courtauld Gallery.

Cat. 154 Pierre-Auguste Renoir, *Woman Tying her Shoe, c.* 1918. Oil on canvas, 50.5 x 56.5 cm. Courtauld Gallery.

Sculpture

Cat. 155 Pierre-Auguste Renoir, *Woman Washing*, 1916–17. Bronze, 34 x 28 x 11.5 cm. Courtauld Gallery, Fry Bequest (S.1935.RF.108).

From late 1888, Fry received instruction at Francis Bate's Hammersmith studio. Bate's pamphlet 'The Naturalistic School of Painting' was an early English response to Impressionism, and when Fry wrote 'The Philosophy of Impressionism' in 1894, a piece not published at the time, he acknowledged it (Reed 1996, pp. 12–20). He also referred to Leonardo da Vinci and to William James's two-volume *The Principles of Psychology*. The 1894 text contains the essentials of the view of Impressionism that he held thenceforward.

Fry's approach to Impressionism here is clearly founded on the development of a phenomenological approach to colour for his King's College fellowship dissertation, 'Some Problems in Phenomenology and its Application to Greek Painting', unsuccessfully submitted in 1891 (Fry Papers, 1/13). Behind this lay other sources besides Bate, James and Leonardo (including Helmholtz). At odds with late twentieth-century approaches to Impressionism, it places all the stress on the representation of light according to scientific principles. Modernity enters Fry's 1894 account in the form of a modern "idea of the world as process", focused on "the flux of phenomena" (appearances) rather than on "separate and self-contained objects", the essence of which, as "things in themselves", can be known. He fits this modern "idea" into an overall view of art history as a progressive evolution from representing what is known to representing "appearances" – "a science of appearances". His surviving notes from Leonardo's writings (mostly, it seems, from 1894 rather than 1891)

identified him as a proto-Impressionist, moving beyond linear perspective into the scientific analysis of the "all-pervading atmosphere which modifies our perception of every single object" (Fry Papers, 4/1). In 1894, invoking Leonardo's writings, his 'Philosophy of Impressionism' dwells especially on the modification of local colour by atmosphere and adjacent colours, and on coloured shadows – violet and blue. He writes of "a new world of colour in which objects that are ugly and repulsive in themselves will often be transformed into sources of the keenest pleasure".

Fry's tone here is positive, but his deepening engagement with Italian Renaissance painting provoked a reaction against Impressionism. This "new world of colour" lacked the "design" qualities he found especially in Quattrocento Italian painting. In 1896 he wrote to Lady Fry that the "study of Italian drawings" had led him to demand "more design in a picture". He added, " ... much modern work now seems to me empty" (*Letters*, I, pp. 165–66). When he announced his commitment to Cézanne and Gauguin in 1908, he consigned Impressionism to the past as the ultimate stage in the development of the science of representation, a stage at which the fundamental principles of painting had been lost ('The Last Phase of Impressionism', *The Burlington Magazine*, March 1908, pp. 374–75; Reed 1996, pp. 72–75). Fry was now entirely negative about the science he saw in Impressionism. This went with his belief that feeling must be the starting-point for all art: "Impressionism accepts the totality of appearances and shows how to render that; but thus to say everything amounts to saying nothing – there is left no power to express the personal attitude and emotional conviction". Such is his view still when he sums up what for him was the failure of the Impressionists in his lecture 'The Develop-ment of Modern Art' delivered at University College, Bangor, nearly twenty years later (January 18 1927):

They failed to see that the only value of facts of appearance for an artist lies in what constructions his imaginative apprehension of them is capable of creating. That its value lies in the power of these constructions to express profound feelings and to transmit these feelings to the spectator (Fry Papers, 1/117).

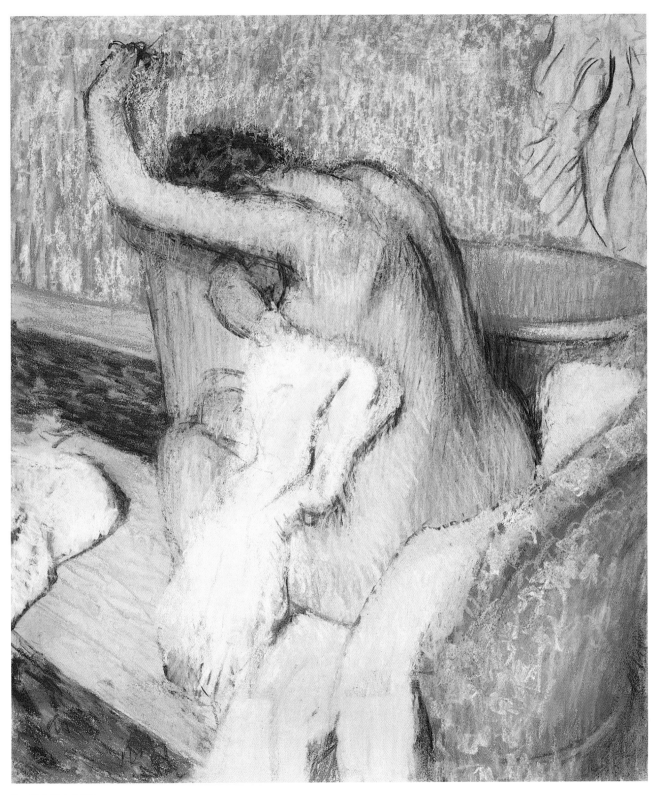

Fig. 114 (Cat. 152)

Fig. 115 (Cat. 151)

Those Impressionists canonized by Fry qualified only if he could think of them essentially as counter-Impressionist. They included Edgar Degas (1834–1917) and Pierre-Auguste Renoir (1841–1919). It was the Renoir of "the later nineties onwards" that most impressed Fry, precisely because he could dissociate this work from his notion of Impressionism. As he puts it in 1926, "more and more his pictures tend to be not so much based upon any immediate impression as the externalisations of his whole synthetic feeling for form and colour" ('Renoir', *The Nation and Athenaeum*, 24 July 1926, p. 472). The question of Edouard Manet (1832–1889) was more complex. Nine works by Manet, including *A Bar at the Folies-Bergère* (fig. 115), were selected for the first Grafton Galleries show, the title of

which was *Manet and the Post-Impressionists*. But the preface to the catalogue, written from Fry's notes by Desmond McCarthy, emphasizes Manet's Spanish seventeenth-century sources, and the "simplification of planes" in his work as a result of depicting objects frontally lit (Reed 1996, pp. 81–85). Fry's interest was not in the Manet of the *Bar*, but in the pre-Impressionist Manet – for him, the prelude to the flattenings and simplifications of Cézanne. Indeed, after the first Post-Impressionist exhibition, he made a point of contrasting the "marvellous ... illusive power" of the *Bar* at the picture's expense *against* Cézanne ('Post-Impressionism', *The Fortnightly Review*, 1 May 1911, pp. 856–67; Reed 1996, pp. 99–110).

Islamic Art

Cat. 156 Persian (Gabri ware), *Bowl*, 10th or 11th century. Glazed earthenware, bird design, diameter 17.4 cm. Courtauld Gallery (0.1935.RF 134).

Cat. 157 Persian, *Square bottle*, 17th or 18th century. Earthenware with turquoise and blue glaze, 10.5 x 7 cm. Courtauld Gallery (0.1935.RF 136).

Fig. 116 (Cat. 157)

It is not known when Fry bought the small group of Persian artefacts in his collection (fig. 116; cat. 156). His interest in Islamic art was initiated by the visit he made in July 1910 to the Munich exhibition *Mohammedan Art*, which led to two articles, one a journalistic piece for *The Morning Post* (29 July 1910, p. 9), the second a two-part piece for *The Burlington Magazine* (August and September 1910, pp. 283–90 and 327–33; reprinted in *Vision and Design*). Even in the latter, however, Fry seems uninterested in finding lessons for modern art in Islamic art. It is essentially an argument about "Mohammedan art's" importance to the history of medieval art in Europe.

Fry did not return to the subject until 1931, when he responded to a major exhibition of Persian art at Burlington House with a piece for *The Listener* ('The Astonishing Beauty of Persian Art', 4 February 1931, pp. 173–75). Here he makes Persian art strikingly relevant to modernism, recalling the priorities behind his Omega initiative between 1913 and 1919. His central argument is that there is a fundamental distinction between European craftsmen, who "have tended to aim at perfection" in carrying out ideas, and Persian craftsmen whom he calls "artist–craftsmen". The Persian artist–craftsman also "wants to impress his idea upon the matter, but his idea is not quite complete; it is not like a pattern ready drawn and handed over to someone else to execute ... The idea grows to completeness as he works the matter." Fry notes the way the simple shapes of bowls and jars in Persian pottery between the eighth and the thirteenth century allow maximum growth for decorative ideas. These are generally based on animals or "a meander of stylistic foliation", and the artist–

craftsman "executes them in a rhythm of extraordinary freedom and ease ... It is this drawing that is like a beautiful dancing that is so exhilarating and stimulating to the eye which these Persian potters have understood as few have ever done. And all the roughnesses and irregularities of their pots are really pressed into the service of the idea, they are parts of its delightful vitality and freedom of movement." Fry ends with "happy accidents": the running together of glazes, for instance. Such failures "to control his [the artist–craftsman's] material" are accepted "with delight, for his original design is so firm, so solid and self-supporting that all these accidents only add the charm of atmosphere, of a suggestiveness which stirs the spectator's imagination to active co-operation, and heightens the reality of the vision".

Italian Primitives

Cat. 158 Attributed to Paolo Veneziano, *Crucifixion*, first half of the 13th century. Tempera on panel, 33 x 38.1 cm. Private collection.

Cat. 159 Giovanni Baronzio, *The Nativity and the Adoration of the Magi, c.* 1325. Tempera, gold leaf on panel, 45.5 x 27.8 cm. Courtauld Gallery, Gambier Parry Collection.

Cat. 160 Bernardo Daddi, Polyptych, 1348. Tempera, gold-leaf on panel, 155.8 x 52.4 cm (centre), 138.2 x 82.8 cm (left), 138.3 x 82.5 cm (right). Courtauld Gallery, Gambier Parry Collection.

Cat. 161 Lorenzo Monaco, *Coronation of the Virgin, c.* 1390. Tempera, gold leaf on panel, integral frame with gabled top, 195 x 154.7 cm. Courtauld Gallery, Gambier Parry Collection (GP 59).

Cat. 162 Attributed to Lorenzo Monaco, *The Visitation and Adoration of the Magi, c.* 1409. Tempera, gold leaf on panel, integral frame of irregular shape. 21 x 33.5 cm and 20.9 x 32.5 cm. Courtauld Gallery, Gambier Parry Collection.

Cat. 163 Florentine School *c.* 1430, *The Annunciation*. Tempera, gold leaf on panel. 54.2 x 37.6 cm. Courtauld Gallery, Gambier Parry Collection (GP 59).

In the third lecture of Fry's Slade School series 'Some Principles of Design' written in the early 1920s (Fry Papers, 1/90), this is how he makes the transition between Piero della Francesca and Raphael: "We come thus to the great movement of the beginning of the 16th century which replaced what we call Primitive art ...". He adds, however: "Such a distinction has lost much of its meaning for us. We do not any longer measure the importance of a work of art by the completeness of its representation of nature. Nor do we think of the art of one period as ... existing only in order to prepare the way for another kind of art." Already in one of his 1897 Cambridge Extension lectures, 'Transition to Quattrocento' (Fry Papers, 1/65), he betrays doubt concerning the notion of "the primitive" applied to Italian art between Giotto and the end of the Quattrocento. He introduces the lecture by differentiating "Italian art as a whole" from Dutch seventeenth-century art, calling it "*constructive*" rather than "*perceptive*". In this way, he establishes a unifying factor joining Trecento to later Quattrocento painting that cuts across any evolution, and allows him to call the key points of difference – "perspective, anatomical

structure and classical accessories" – inessentials "forced upon painters by the architects and sculptors of the time" (for his view of later Quattrocento painting, see 'Baldovinetti (Alesso)', p. 138 and 'Piero della Francesca', p. 196). Fry's major two-part essay on Giotto of 1900–01 introduces no evolutionary criteria into its high aesthetic valuation of the early Trecento frescos of Assisi, even if it does consider historical development (*The Monthly Review*, December 1900 and February 1901; reprinted in *Vision and Design*). At the time of his closest relationship with Berenson (1898–1903), he began buying Italian "Primitives", including the private devotional *Crucifixion* (fig. 117) now attributed to Paolo Veneziano (first half of the fourteenth century). That by the date of his Slade School lectures in the early 1920s the "constructive" factor he found in such works now made them "modern" is demonstrated by a letter to Robert Bridges of 29 April 1919, written as he was moving into 7 Dalmeny Avenue: "I have all my French pictures hung, with a few Italian Primitives still left behind among them. It terrifies cultured people to see that they are exactly the same thing" (*Letters*, II, p. 450).

As Caroline Elam shows (see pp. 87–106), a key display of Fry's intense interest in early Italian painting was his article on the Gambier Parry Collection, now in the Courtauld Galleries, written after a visit to it with Berenson ('Pictures in the Collection of Sir Hubert Parry at Highnam Court, near Gloucester: Article I – Italian Pictures of the Fourteenth Century', *The Burlington Magazine*, July 1903, pp. 117–31). Among the works discussed are the Bernardo Daddi polyptich (fig. 51), which Fry attributes, calling Daddi "a finer artist than any other of the immediate successors of Giotto", and the *Nativity* now attributed to the Trecento Riminese painter Giovanni Baronzio (fig. 50), which he thinks comparable to the most impressive painting of the early fourteenth century, including Giotto. He also writes at length on the *Coronation of the Virgin* (fig. 54) now securely attributed to Lorenzo Monaco (*c.* 1370–*c.* 1425), thinking it by the earlier Agnolo Gaddi. This last attribution is surprising, since some of his most acute and sensitive passages in his 'Transition to Quattrocento' lecture are on Lorenzo Monaco, here characterized as "The great exponent of [the] ... anti realistic decorative art" of Florence after

Fig. 117 (Cat. 158)

Giotto, "one of the last great medieval designers and the last of those wilful and fanciful painters who felt the responsibility to their pictures so much more than the responsibility to objective nature."

A typically exacting analysis of Lorenzo's tempera technique, bringing out his use of broad semi-transparent washes of white over darker, stronger colours to give his draperies "the most exquisite milky opalescence", is followed by the observation that he is not merely neglected, but "a striking example" of the condition of painting in Italy altogether at the beginning of the fifteenth century: of what can be called a temporary retreat to medieval values. "For here we have a great artist in the 15th century designing with far less adherence to the laws of natural appearance than Giotto himself. It is distinctly further from our modern ideas of pictorial representation, distinctly more Japanese." And therefore, he might have added a decade and a half later in 1910, distinctly more "Post-Impressionist".

Low Art

Cat. 164 English, *Oviform vase*, excavated at Old Sarum (*c.* 1910), 13th century. Earthenware, 27 x 12.5 cm. Salisbury and South Wiltshire Museum, Salisbury (No.i.B.20).

Cat. 165 English, *Medieval roof finial*. Earthenware, height 33 cm. Castle Museum, City of Nottingham (NCM 1878–314).

Cat. 166 Spanish (Talavera), *Salt-cellar*, 17th century. Triangular, with circular wells; decoration in yellow, pink and green glaze, width 5 cm. Courtauld Gallery (0.1935.RF 159).

Cat. 167 Spanish, *Saucer with deep well*, 18th century. Brown on white decoration, diameter 15.9 cm. Courtauld Gallery (0.1935.RF 160).

Cat. 168 Southern Italian or Sicilian, *Jug with orange, manganese and green decoration*, 18th or 19th century. Height 36 cm. Courtauld Gallery (0.1935.RF 147).

Cat. 169 Italian, *Wine Jar with spout and two handles* (inscribed *S. Giacomo 1931*). Plant motif, green and brown on white, 24.6 x 23 cm. Courtauld Gallery (0.1935.RF 154).

Cat. 170 French, *Omelette Turner*, undated. Earthenware, with brown glaze, diameter 22.9 cm. Courtauld Gallery (RF 179).

Cat. 171 Southern Italian or Sicilian, *Jug*, undated. Height 21 cm. Courtauld Gallery (0.1935.RF 151).

Cat. 172 Moroccan, *Pottery jar and cover*, undated. 15.2 x 12.9 cm. Courtauld Gallery (0.1935.RF 140).

Cat. 173 Nomad, *Bear*, undated. Bronze, 4.2 x 6.9 cm. Courtauld Gallery (0.1935.RF 116).

Cat. 174 Nomad, *Animal*, undated. Bronze, 1.7 x 4.8 cm. Courtauld Gallery (0.1935.RF 115).

Cat. 175 Spanish (Hispano-Moresque), *Dish*, undated. Diameter 29 cm. Courtauld Gallery (0.1935.RF 157).

Cat. 176 Spanish, *Plate* undated. Decorated with leaves and festoons, diameter 21.5 cm. Courtauld Gallery (0.1935.RF 166).

Fry's formalist theory opened the way to a relativism that brought together within the same framework of aesthetic values both work from different cultures and work conventionally given a different status as either "high" or "low" art, the latter including the folk or "popular arts" of any culture. In his own collection were tiny bronze animal ornaments from the nomadic peoples of the Steppes and everyday pottery objects from many European folk traditions, including a French omelette turner and a seventeenth-century Spanish (Talavera) salt-cellar. Fry's attitude to the relativities involved and their significance for his approach to aesthetic value is revealed tellingly in an article on English pottery published as his Omega initiative gathered pace ('The Art of Pottery in England', *The Burlington Magazine*, March 1914, pp. 330–35; Reed 1996, pp. 202–06).

This is a review of an exhibition of English pottery at the Burlington Fine Arts Club. Here it is made clear that, for Fry, pottery made for "the people" is not *always* to be admired. He dismisses the "coarse Staffordshire slip-ware" of the seventeenth, eighteenth and nineteenth centuries as scornfully as he dismisses the "elegant pastiches" made for the "well-to-do". His admiration is reserved for the pottery on display from the period between the thirteenth and the fifteenth century, when, he asserts, "one kind of pottery was made apparently alike for rich and poor". He picks out two conspicuously unpretentious objects for aesthetic delectation: an earthenware vase of the thirteenth century excavated at Old Sarum, near Salisbury, and a medieval roof ornament preserved in the Castle Museum, Nottingham. Of the vase (cat. 164) he writes:

This is so like certain specimens of Chinese ware of the Tang dynasty, both in form and glaze, that it might almost be mistaken for one at first glance. It has not quite the subtle perfection of rhythm in the contour, and the decoration is rather rougher and less carefully meditated. But to be able to compare it at all with some of the greatest ceramics in existence is to show how exquisite a sense of structural design the English craftsman once possessed.

Of the roof ornament (fig. 118) he writes:

Here there is not only a singularly noble and austere rhythm in the proportions of the whole structure, but the interpretation of the face is the work not of a clumsy and farcical imitator of nature, but of a real artist, of one who has found within the technical limitations of his craft an interpretation of natural forms expressive of life and character.

Fig. 118 (Cat. 165)

Maillol (Aristide)

Cat. 177 *Etienne Terrus*, 1905. Bronze, 30 x 18.5 x 23 cm.
Collection Musée Maillol, Paris. Photo © J.A.Brunelle.

Cat. 178 *The Cyclist*, 1907–08. Bronze, height 98 cm.
Musée d'Orsay, Paris. Photo © RMN –ADAGP.

Cat. 179 *Flora*, 1911. Bronze, height 163.5 cm.
Collection Musée Maillol, Paris. Photo © J.A.Brunelle.

Works on paper

Cat. 180 *Kneeling Nude, c.* 1924. Pencil on squared paper,
30.5 x 21.6 cm. Courtauld Gallery, Samuel Courtauld Collection.

In the year of the first Post-Impressionist exhibition, Fry wrote a major article on the French sculptor Maillol (1861–1944), which gave him the leading role in modern sculpture after Rodin, equivalent to the leading role he had given Cézanne in painting after Impressionism ('The Sculptures of Maillol', *The Burlington Magazine*, April 1910, pp. 26–32). The article came months after Fry's translation of Maurice Denis's piece of 1907 on Cézanne, itself a sequel to an equally influential piece on Maillol published in *L'Occident* in November 1905. For Denis, Maillol was "a great classic", as was Cézanne, because he, too, balanced intellectual order with a "naïve" directness of sensibility.

Fry set up Maillol against Rodin in a distinctive way, despite echoes of contemporary French contrasts between the two. His emphasis is not solely on form in Maillol. He sees in his figures, as in Rodin's, "the expression of a state of consciousness – only that he moves in a different world of feeling". Maillol endeavours "to show what meaning there can be in the figure at moments of placid self-possession ...". And yet, ultimately the distinction *is* made as a contrast between feeling and form. For Fry, Rodin infuses every part of his figures with intensity of feeling, so that every part can be the epitome of the whole; while Maillol grasps "unity" in the whole through "a few elementary relations", making each part dependent on every other. This is where he finds the analogy with Denis's and his own Cézanne:

Maillol's sculptures, indeed, take up those ideas so lucidly set forth by M. Maurice Denis in his articles on Cézanne – he, too, accepts only such forms as are clearly

Fig. 119 (Cat. 177)

intelligible to the mind". Where Rodin is concerned with "the idea of ... the infinity of life", Maillol and Cézanne insist first on "the geometric intelligibility of form, believing that expression lies more in the immediate apprehension of a few closely related elements than in the emphasis on various particular characteristics". And yet, Fry adds: "He never allows the logical realisation of form to destroy the life in the material

Among the sculptures he illustrates and analyses are *The Cyclist* (cat. 178), a rare adolescent male figure executed for Maillol's German patron Count Harry Kessler in 1907–08; *Flora* (fig. 120), a new female figure piece, in 1910 still to be cast in bronze; and, from 1905, the bust of the painter Etienne Terrus (fig. 119), like Maillol from the Roussillon region in south-west France,

and from 1905 a friend, too, of Matisse. Fry stresses the "architectural unity of the structure" of the Terrus bust, obtained, he says, by just a "few synthetized planes". He accepts that its high degree of generalization means that it cannot express a "minutely particularized psychology", but declares that it is nonetheless "one of the few cases in modern art of a portrait treated in the perdurable manner proper to monumental design". In the *Flora* he finds monumentality and structural unity, too, and also a return to the principles behind the early Greek sculpture of Olympia, yet, at the same time, "a rustic simplicity and bluntness of form, which is quite distinct from the aristocratic perfection of the Greek". Fry is led by the *Flora* to broader reflections about sculpture and the significance of Maillol's refusal of Rodinesque drama:

It is indeed one of the advantages of such a conception of sculpture as Maillol's that his works have supreme qualities as decoration. With a merely representative or a too emphatically dramatic sculpture, this quality has tended to disappear, and the contorted forms and excessive gestures which may arrest one's attention in an exhibition would tire by their too detailed or too emphatic appeal on a closer, more profound acquaintance; whereas such a figure as the Flora would always retain the charm of a beautiful object, even if we disregard for a moment its quality as expression and character. This block-like simplicity, this easy continuity of contour, and placid flow of planes have the charm of discretion, which invites the spectator to a gentle contemplative effort instead of crushing him with a vehement tirade.

Fry ignores altogether any erotic charge that the *Flora* might have.

Fig. 120 (Cat. 179)

Marchand (Jean)

Cat. 181 *Still Life with Bananas*, 1912.
Oil on canvas, 59.2 x 51 cm. The Charleston Trust.

Cat. 182 *Still Life with Earthenware Jug, Loaf and Strawberries*,
c. 1918–19. Oil on canvas, 65 x 54.2 cm.
Courtauld Gallery, Fry Collection.

Fry included at least two works by Marchand
(1883–1941) in the second Post-Impressionist exhibition;
one was the *Still Life with Bananas* of 1912 (fig. 13). He
did not meet Marchand, however, until late 1919. They
were closest between 1919 and 1922, Fry writing to him
as "*Mon cher Marchand*" or "*Mon cher ami*" (Fry Papers,
3/116). He painted with him at Vence in 1920, having
published a review of a solo show at the Carfax Gallery
the previous April ('Jean Marchand', *The Athenaeum*, 11
April 1919, pp. 178–79; reprinted in *Vision and Design*).
Marchand had written to thank him for his "*bel article*"
(undated letter).

 This article takes a highly complimentary view of
Marchand's shift from the pre-war fringes of Salon
Cubism to become by 1919 "the most traditional of
revolutionaries" with such works as the still-life of
c. 1918–19 (fig. 121), which was shown and which he
bought. Fry finds all his most positive epithets for the
painter: "touching sincerity [is] in all he does"; he is
"highly self-conscious and intellectual", yet knows "that

any effect of permanent value must flow directly from
the matter in hand" – from things seen; he is, in sum, "a
classic artist", to be compared with Cézanne. Fry's
appreciation is founded on values precisely parallel to
those promoted by the French anti-Cubist critics led by
Louis Vauxcelles, and goes with an analysis of his pre-war
Cubism that sets it aside as a mere "apprenticeship" in
"the organisation of form", after which he has "thrown
away the scaffolding ... to construct palpably related and
completely unified designs with something approaching
the full complexity of natural forms ...". Fry makes a
special virtue of his choice in his recent work of "banal"
subjects, and picks out as exemplary *Still Life with
Earthenware Jug, Loaf and Strawberries*, writing of it:

However frankly M. Marchand accepts the forms of
objects, however little his normal vision distorts or
idealizes them, however consciously or deliberately he
chooses the arrangement, he does build up by sheer
method and artistic science a unity which has a
singularly impressive quality. I heard someone say, in
front of a still life which represented a white tablecloth, a
glass tumbler, an earthenware water-bottle and a loaf of
bread, that it was like Buddha. With such a description as
I give of the picture the appreciation sounds precious
and absurd; before the picture it seems perfectly just.

Fig. 121 (Cat. 182)

Matisse (Henri)

Cat. 183 *Harbour Scene, c.* 1898–99. Oil on canvas,
26.5 x 35.5 cm. Courtesy Anthony d'Offay Gallery, London.

Cat. 184 *Carmelina, c.* 1903–04. Oil on canvas, 81.3 x 59 cm.
Museum of Fine Arts, Boston, Tompkins Collection.

Cat. 185 *Joaquina,* 1911. Oil on canvas, 55 x 38.5 cm. National
Gallery, Prague.

Works on paper

Cat. 186 *Seated Woman,* 1919. Pencil, 35.1 x 25.2 cm.
Courtauld Gallery, Samuel Courtauld Collection.

Sculpture

Cat. 187 *Jeannette II,* 1909–10. Bronze, height 26.5 cm.
The National Gallery of Scotland, Edinburgh.

Fry first visited the studio of Matisse (1869–1954) in the
spring of 1909. A letter to his wife, Helen (7 May 1909),
betrays scepticism: "He's one of the neo, neo
Impressionists, quite interesting and lots of talent but
very queer. He does things very much like Pamela [their
seven-year-old daughter]" (Fry Papers, 3/58). By the
autumn of 1910, when he put together the first Post-
Impressionist show, his mind had changed, and he
selected at least three paintings and eight bronzes by
Matisse as well as one or two drawings. In 'Post-
Impressionism – II' (*The Nation,* 3 December 1910, pp.
402–03; Reed 1996, pp. 90–94), Fry wrote of him: "he is
an artist not unlike Manet, gifted with a quite
exceptional sense of pure beauty – beauty of rhythm, of
color [*sic*] harmony, of pure design", and regretted the
fact that he was only "poorly represented" in the
exhibition. Things were put right in the second Post-
Impressionist show, when Matisse was the dominant
presence; twenty-five works by Matisse have been
identified as having been included, among them
Carmelina of 1903–04 (fig. 122) and also *Joaquina,*
painted in Spain in 1911 (fig. 5). Matisse's *Margeurite
with a Black Cat* of 1910 was chosen as the cover image
for the catalogue; it consolidated Fry's case for the
profound affinity between the modern movement and
Byzantine art (see 'Byzantine Art', p. 142). The domestic
theme of *Carmelina,* with its complex sub-text of gender
relations along with its solid tonal structure, was to find
echoes especially in the work of Vanessa Bell, while the

loose facture and pale tones of *Joaquina* made its
impression on the painting of Grant, too. Also shown
were, once more, bronzes, including *Jeannette II*
(cat. 187).

Fry's view of Matisse in 1912 set the agenda for his
writing on the artist all the way to the little monograph
he published in 1930 (*Henri Matisse,* London 1930). In
1910 he had qualified his praise (cited above) with the
observation that Matisse lacked "any very strong and
personal reaction to life itself", and had called him
"almost too purely and entirely an artist". In 1912 he
accepts that Matisse is "singularly withdrawn from the
immediate issues and passions of life"; he dwells on the
"rhythm" in "the great decoration of the *Dance*", and on
the "pure colour" of the more recent pictures. Now,
however, Matisse is "essentially a realistic painter: that is
to say, his design is not the result of invention, but
almost always comes out of some definite thing seen"
('The Grafton Gallery: An Apologia', *The Nation,* 9
November 1912, pp. 249–51; Reed 1996, pp. 112–16).
In the study of 1930, the tension between Matisse's
response to plastic form in the coloured space of
appearance and his accentuation of the flat picture
surface in "pure" rhythmic and chromatic terms would
still be Fry's central theme (see 'Into the Twentieth
Century', pp. 24 ff). Matisse's work is held up alongside
Cézanne's as the paradigm of what Fry calls "the dual
nature of painting", by which he means painting's
capacity to force recognition, "at one and the same
moment, [of] a diversely coloured surface and a three-
dimensional world, analogous to that in which we live
and move".

And yet, having found Matisse's Cubist-related
experiments between 1915 and 1917 especially
impressive, Fry had his doubts about Matisse's embrace
of an explicitly naturalist approach in the Nice period.
Already in 1919 he expressed the hope that it would be
"a passing phase in Matisse's development", and
remarked: "Even Matisse cannot afford to rely so much
on ... the charm of his handwriting and the surprise of
his impromptu synthesis of appearance" ('Modern
French Painting at the Mansard Gallery II', *The
Athenaeum,* 15 August 1919, pp. 754–55). He accepts
"the infallible tact of his sense of colour", and in 1930

Fig. 122 (Cat. 184)

Fig. 123 (Cat. 183)

did not altogether reject the Nice pictures, but in the monograph he cannot disguise a note of Quaker disapproval when he remarks on their appeal to "the more cultured rich" in "the epicurean simplicity of the modern villa". He found in Matisse a duality: a "rococo" [*sic*] sensibility at odds with a love of "stark, structural architecture", which "aims at a more arduous kind of expression". Though it was the latter that most attracted him, for him even Matisse's "rococo" sensibility could impress.

Fry's acceptance that Matisse could be a "realistic" and a "pure" painter at the same time is underlined by his one purchase of a work by him, a small *Harbour Scene* of *c*. 1898 (fig. 123). Its free handling and tonal scale relate, for instance, to the little pictures Matisse painted at Etretat during the Nice period. "I've got a little Matisse for which I longed ever since I saw it years ago at the Eldar Gallery in London", he wrote to Vanessa Bell on 6 March 1924 (*Letters*, II, p. 550). He could afford nothing bigger or more recent, but he was content.

Omega

See also: Bell (Vanessa), Fry (Roger) and Grant (Duncan)

Works on paper

Cat. 188 Anon. (Henri Doucet ?), *Composition in yellow, green and mauve*, undated. Body-colour, with drawing with the point of the brush, 30.5 x 37.4 cm. Courtauld Gallery (PD.93).

Cat. 189 Anon. (Duncan Grant ?), *Design for a lampshade*, undated. Watercolour on shaped card, 17 x 41 cm. Marion Richardson Archive, School of Art & Design Education, University of Central England, Birmingham.

Cat. 190 Anon., *Design for an oval tray*, undated. Pencil and gouache on paper, 28.2 x 20.2 cm. Courtauld Gallery (PD 50).

Cat. 191 Anon., *Wallpaper design*, undated. Woodblock print on paper, 30 x 19.5 cm (block). Courtauld Gallery. (PD 39).

Cat. 192 Anon., *Wallpaper design*, undated. Courtauld Gallery (263/92).

Cat. 193 Frederick Etchells, *Design for a carpet*, undated. Watercolour on tracing paper, 25.8 x 15.2 cm. Courtauld Gallery (PD 64).

Cat. 194 Frederick Etchells, *Design for a carpet*, undated. Gouache on paper, 30.2 x 15.2 cm. Courtauld Gallery (PD 90).

Cat. 195 Frederick Etchells, *Design for a carpet*, undated. Gouache on paper, 40.5 x 50.8 cm. Courtauld Gallery (PD 22).

Cat. 196 Winifred Gill, *Military Man*, undated. Watercolour on paper, 26.8 x 21.2 cm. Courtauld Gallery (PD 78).

Cat. 197 Winifred Gill, *Toy Design – Casternet Dance*, undated. Pencil and gouache, 32 x 19.9 cm. Courtauld Gallery (PD 43a & 43b).

Cat. 198 Winifred Gill, *Toy Design – Dancing Master*, undated. Pencil and gouache, 32.1 x 19.9 cm. Courtauld Gallery (PD 75).

Cat. 199 Winifred Gill, *Toy Design – Jellicoe*, undated. Pencil and gouache, 27 x 21.3 cm. Courtauld Gallery (PD 74).

Cat. 200 Winifred Gill, *Toy Design –'Music'*, undated. Pencil and gouache, 32.1 x 19.8 cm. Courtauld Gallery (PD 77).

Cat. 201 Winifred Gill, *Toy Design –Shawl Dance*, undated. Pencil and gouache, 27 x 21.3 cm (dancer sheet), 19.8 x 24.5 cm (cut out shawl). Courtauld Gallery (PD 38a & 38b).

Cat. 202 Roald Kristian, *Designs for lampshades*, undated. Crayon and chalk on paper, 10.5 x 29.8 and 10.4 x 29.4 cm. Courtauld Gallery (PD 52, 53).

Cat. 203 Wyndham Lewis, *Nine designs for lampshades*, 1913. Ink on paper, approx. 17.6 x 31 cm each. By kind permission of the Provost and Fellows of King's College, Cambridge.

Fig. 124 (Cat. 195)

Cat. 204 Wyndham Lewis, *Three Figures* (design for a painted screen, in two parts) 1913. Pencil and watercolour on paper, 51 x 37.8 and 50.9 x 38.5 cm. Courtauld Gallery (PD 58a & b).

Books

Cat. 205 P.G. Jouve, *Men of Europe* (design by Roald Kristian), 1915. 5.2 x 16 cm (closed). Courtauld Gallery.

Cat. 206 Arthur Clutton-Brock, *Simpson's Choice* (woodcuts by Roald Kristian) 1915. 28.8 x 23 cm (closed). Courtauld Gallery.

Cat. 207 Lucretius, *On Death*, translated by Robert Calverley Trevelyan, 1917. 28.7 x 22.7 cm (closed). Courtauld Gallery.

Cat. 208 *Original Woodcuts by Various Artists* including Duncan Grant, *The Hat Shop* [p. 11], Roger Fry, *The Cup* [p. 13], Roald Kristian *Animals* [p. 19], and Vanessa Bell, *Nude* [p. 21], 1918. 26 x 18.8 cm (closed). Courtauld Gallery.

Textiles

Cat. 209 Jock Turnbull, *Silk scarf*, undated. Watercolour or dye, with drawing with the point of the brush, 40.5 x 92.5 cm. Courtauld Gallery (T.1959.XX.1). Presented by Miss Winifred Gill, 1959.

Three-dimensional objects

Cat. 210 Anon. (Wyndham Lewis?), *Paper Knife*, c. 1913–14. Maker, J.J. Kallenborn, marquetry, 29.7 cm. Private collection.

Cat. 211 *Bowl with cover* (handle in form of crouching figure), undated. Milky blue glaze, 10.8 x 14.7 cm (15.3 x 15.9 cm with lid). Courtauld Gallery (0.1935.RF 173).

Cat. 212 *Plate*, undated. Painted blue, diameter 19.4 cm. Courtauld Gallery (0.1935.RF 178).

Cat. 213 *Bowl*, undated. Painted black. 5.4 x 16.9 cm. Courtauld Gallery (0.1935.RF 171).

Cat. 214 *Soup Tureen* (handle in the form of a bear), undated. Painted with blue glaze, 22.5 x 29.8 cm (with lid). Courtauld Gallery (0.1935.RF 180).

Cat. 215 *Milk-jug*, undated. Painted white, height 18 cm. Courtauld Gallery (0.1935.RF 174).

Cat. 216 *Pot*, undated. Painted white, height 9.5 cm. Courtauld Gallery (0.1935.RF 172).

Furniture

Cat. 217 *Chair with embroidered back*, undated, height 98.5 cm. Courtauld Gallery (F.1960.XX.2). Presented by Mrs Marianne Rooker, 1960.

Cat. 218 *Pair of chairs*, undated. Cane seats and backs, painted red, height 101.5 cm. Courtauld Gallery (F.1958.PD 268 & F.1958.PD 269).

Cat. 219 *Table with painted lilypond pattern*, undated. 73.6 x 103.3 x 152.2 cm. Courtauld Gallery (F.1960.XX.1). Presented by Mrs Marianne Rodker, 1960.

Omega is discussed at length in this book by Judith Collins: see pp. 73–84.

TOP Fig. 125 (Cat. 215)

ABOVE Fig. 126 (Cat. 202)

FACING PAGE

TOP & CENTRE Figs. 127, 128 (Cat. 203)

BOTTOM Fig. 129 (Cat. 209)

Piero della Francesca

Cat. 126 Duncan Grant, *Copy of Piero della Francesca's 'Portrait of Federigo da Montefeltro', c.* 1904–05. Oil on canvas, 40.6 x 31.7 cm. The Charleston Trust.

The first evidence that Piero della Francesca (*c.* 1415/20–1492) occupied a special place in Fry's enthusiasms comes in May 1897, when, with Helen Fry, he saw the Arezzo frescos for the first time. By 1900–01 Piero is given a major role in his Cambridge Extension lecture course 'Florentines II', the fourth lecture of which dealt with the frescos, and the fifth with his other work alongside that of Baldovinetti (Fry Papers, 1/65; see 'Baldovinetti (Alesso)', p. 138). In the fifth Fry focuses especially on the *Baptism* and the *Nativity* in the National Gallery. A few years later, in 1904–05, the eighteen-year-old Duncan Grant would paint, unbeknown to Fry, superb copies in oil of Piero's *Portrait of Federigo da Montefeltro* (fig. 130) and of a two-figure group from the *Nativity*. Piero would become and would remain a special artist for Grant and Vanessa Bell as well as for Fry; the *Nativity* copy was included in an exhibition of "copies and translations" of old masters organized by Fry at Omega in 1917, and was bought by Maynard Keynes. When Fry revisited Arezzo in May 1913, he had written to Lowes Dickinson: "I've no doubt now that Piero della Francesca is the greatest artist of Italy after Giotto, incomparably beyond all the men of the High Renaissance" (*Letters*, II, pp. 367–70).

The essentials of Fry's enduring view of Piero are all there in the lectures of 1900–01 (Fry Papers, 1/65). In the fifth, he dwells on the appropriateness to "monumental design" of the "predominant mood" in the Arezzo frescos. That mood overwhelms anything "pathetic or sentimental", emotions considered transient by Fry, to "give us a feeling of noble indifference ...". And in all his work everything is presented "as the base unadorned fact placed straight before the spectator without any circumstance or apology". Piero's "noble indifference" made him Fry's model of the "disinterested" artist, it went with his artlessness, and, from 1926, consistently placed him alongside Seurat in his writings (see 'Seurat (Georges)', p. 208).

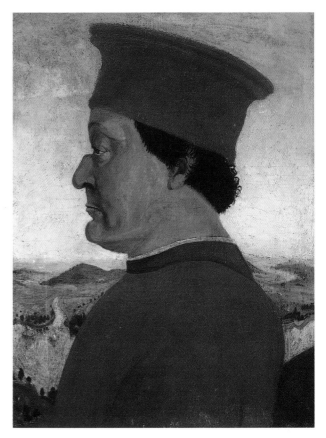

Fig. 130 (Cat. 126)

Piero di Cosimo

Cat. 69 Helen Fry, *Copy of Piero di Cosimo's 'Mythological Subject'* (*c.* 1495), *c.* 1902–03. Oil on canvas, 72 x 194 cm. Private collection.

It is not clear when Helen Fry made her full-scale copy of the National Gallery's mythological picture by Piero di Cosimo (died 1515) known at the turn of the century as *The Death of Procris* (fig. 131). Late in 1902, Fry became involved with Herbert Horne in a scheme to acquire Piero's *Fight between Lapiths and Centaurs* for the National Gallery. Probably then, and certainly before the work's purchase in 1905 by Charles Ricketts and C.H. Shannon, Fry wrote a lecture on Piero (Fry Papers, 1/75), which is among his most penetrating analyses of a single artist; the date is established by a reference to Horne's *Architectural Review* article on Piero of August 1902, and by the fact that Fry still places the *Fight* in the collection

Fig. 131 (Cat. 69)

of "Mr. Burke". Helen could have made her copy earlier, although its spacious atmospheric qualities, combined with its deep feeling for the lyricism of Piero's subject, closely echo the appreciation of the picture and of Piero's wider significance in Fry's lecture.

Here Fry dwells on what he calls Piero's "naïf imagination" and on his capacity to divide his compositions into subordinate parts, giving clarity to the telling of his fantastic stories, while at the same time pulling the parts together within a single space by the atmospheric unity of his treatment of light. For Fry, he is at once a throw-back to a "childlike" naïvety, associated with the "mediaeval imagination", and a technical innovator, prefiguring the development of chiaroscuro and atmospheric perspective alongside Leonardo. When he returned to Piero after 1912, he placed the stress on his "original contemplative vision" rather than his "peculiar charm as an illustrator" ('The Italian Exhibition – VIII', *The Nation and Athenaeum*, 22 February 1930, p. 702). Piero became most importantly a distant precursor of modern pictorial space construction, with what Fry described as his "vivid sense of the relative densities and resistances, so to speak, of coloured planes". By contrast, in his early lecture, his stress is at least as much on Piero's naïve, "poetical" qualities. It may be true that in the case of the *Death of Procris*, Fry observes how "the design is primarily conceived as pure outline – but [how] already here ... the whole form is enveloped in atmosphere". And yet he is much the most eloquent on Piero's "invention" in telling the story,

which he reads as a quirky variant on Ovid's story of Procris "unwittingly slain" by her lover Cephalus, where Piero has "one of the little satyrs who always hide in the woods" find her first. Fry's account focuses especially on the fallen Procris, surveyed "with wistful half human intelligence" by the satyr; he finds in the scene, not the tragedy that will come when Cephalus arrives, but something "idyllic" that allows one to reflect on "the varied beauties around her" as well as on how realistically she has been caught as she has fallen:

Again one has a shock of surprised delight at the felicity of the invention, which has enabled him [Piero] to realize just how she fell with the helpless arm crushed beneath her body. The lifeless fingers all relaxed or crumpled up by the fall of the fore arm on the ground, or still more the beautiful weak line of the pendant neck and the half open mouth all render our realization of the scene poignant to a degree. They are perfect instances of that closeness to fact that familiarity and intimacy which I have pointed to as the characteristics of the naive imagination.

Though Fry's view of Piero shifted at the expense of the naïvely imaginative qualities he dwelt on here, his respect for Helen's delicately poetic copy endured enough for him to include it in the exhibition of copies and "translations" from old masters put on in the Omega Workshops in May 1917, seven years after her final separation from him in an asylum in York.

Pre-Columbian Sculpture

Cat. 220 Copan (Honduras), *Maize Goddess*. Stone, height 2.74 m. Trustees of the British Museum, London (No. 321–1886).

The major reasons for Fry's reputation as an important writer for the post-Bloomsbury generation of sculptors led by Henry Moore and Barbara Hepworth are his essays 'Negro Sculpture' and 'Ancient American Art', which appeared together at the heart of the easily available anthology *Vision and Design* in 1920. The second of these texts dealt with Mayan and Aztec sculpture and was first published in 1918 as a review of three books by Thomas Joyce on ancient American civilizations (*The Burlington Magazine*, November 1918, pp. 155–57). He does not here supply a concept as useful to younger sculptors as his contribution in his essay on African sculpture, "plastic freedom", but he draws attention to "the magnificent collection of Mexican antiquities in the British Museum", remarks on the new interest taken by "some of our modern artists", and finds particularly in Mayan sculpture "designs" that combine the "sensitive and the reasoned" in a way comparable with "early Chinese sculpture". The piece is also a very clear instance of the total disjunction in Fry's thinking between form and symbolic function. It is an incomprehensible wonder to him that "such a civilization" as that of the Mayans, with its "hideous religiosity", could have produced sculpture with qualities so amenable to his aesthetic.

In 1933–34 Fry devoted one of his Cambridge Slade lectures to 'American Art' (*Last Lectures*, pp. 85–96). Near the beginning, he produced a revealing eulogy to a single Mayan sculpture in the British Museum (fig. 132), ignoring absolutely its symbolic function, and using almost exactly the aesthetic criteria – the balance between "geometric regularity" and "sensibility" – applied to Chou Dynasty 'yous' in his lecture on 'Early Chinese' (see 'Chinese Art', p. 150):

I do not know whether even in the greatest sculpture of Europe one could find anything exactly like this in its equilibrium between system and sensitivity, in its power at once to suggest all the complexity of nature and to keep every form within a common unifying principle, *i.e.* each form taking up and modifying the same theme. The oval is of extraordinary beauty in its subtle variations upon the main idea – you will note how a too exact symmetry is avoided partly by bringing the lock of hair on one side further over the cheek than on the other.

FACING PAGE Fig. 132 (Cat. 220)

Rembrandt (Harmensz.) van Rijn

Cat. 221 *Ecce Homo*, 1634 . Oil on paper, laid on canvas,
72.7 x 63 cm. The National Gallery, London.

If the Italian Primitives dominated Fry's first enthusiasms between the early 1890s and 1906, and Cézanne his next, between 1906 and 1920, it was Rembrandt who increasingly dominated his later enthusiasms from the early 1920s on. His very last publication was a broadcast on a Rembrandt ('*The Toilet* by Rembrandt', *The Listener*, 19 September 1934, pp. 466–68; Reed 1996, pp. 416–19). Tellingly, too, when he developed his complementary notions of "operatic" and "symphonic" painting in lectures of 1929 and 1931, Fry brought Rembrandt and Cézanne together as the two great paradigmatic examples ('Representation in Art', 1929, and 'The Literary Element in Art', 1931, Fry Papers 1/126 and 1/158). If by 1909 Cézanne had convinced Fry that form was self-sufficient, by 1929 Rembrandt had convinced him that psychological drama in painting (illustration) could be "art" and that it could combine with form to produce a pictorial equivalent of opera. Most tellingly perhaps of all, in 1933 when a newly discovered late Rembrandt self-portrait was exhibited in the National Gallery, Fry made two copies of it as sequel to the copy he had made of the little Cézanne self-portrait bought for the Tate Gallery in 1925 (fig. 2; the Rembrandt is now in the National Gallery of Victoria, Melbourne). By then he consistently thought of Cézanne and Rembrandt as a pair among those few artists he singled out for exacting and admiring attention.

Fry's first significant exposition of his view of Rembrandt came in the lectures on the 'Epic' and the 'Dramatic' from his series written to be delivered in New York in December 1907, especially the latter (Fry Papers, 1/76). Rembrandt is here "the great exemplar of the dramatic style", and already the issue that would make him the central test case for Fry in the 1920s is identified and addressed, even if, in pre-modernist terms, "the dramatic style is the one in which the claims of beauty and of expression come most into conflict – in which the contrast between ... sensual beauty and supersensual – is most apparent. And Rembrandt settles the dispute almost entirely in favour of the supersensual beauty."

Into this discussion, Fry brings the working of chiaroscuro, again in a way that anticipates his later writing:

[Chiaroscuro] is an altogether new organ of expression and a very potent one in that it appeals to very deep instinctive attractions and aversions of our nature. The fear of the dark is one of the most vivid recollections of our childhood. Rembrandt is almost the only artist who has really exploited this instinct and he uses it first to heighten immensely with its peculiarly poignant quality our imaginative feeling and also to remove his imagined world from the extreme particularization which his Dutch tradition imposed.

In general terms, this is what Fry found so impressive in the late self-portraits after 1920. By then, however, in an article of 1921, he could go further to suggest that forms generalized by the action of light not only produced "a coherent and systematic idea" from "the tangled complexities ... of [Rembrandt's] ... own battered countenance", but made of "Van Rhyn's head ... almost a mythological personification ... without losing anything of the sharp particularity of the individual" ('A Self-Portrait by Rembrandt', *The Burlington Magazine*, June 1921, pp. 262–63).

The issue of the sensual (form) and the supersensual (drama) raised in 1907 is addressed most influentially in *Transformations* in 1926. Rembrandt supplied here a key test-case, the grisaille *Ecce Homo* of 1634 (painted in preparation for an etching), the salience of which follows from the fact that in it, for him, neither the psychological drama nor the "plastic construction" predominates, and "the mutual accommodation of the two does not entail some sacrifice". It is, he asserts, "surely a masterpiece of illustration" in its portrayal of acutely observed individuals at a moment of high psychological tension; and "as a plastic invention it is also full of interest and strange unexpected inventions". At this stage he was unwilling to suggest that the two actually combined. Only with the lectures of 1929 and 1931 would he entertain the possibility of their meaningful combination in "operatic painting", but the question of their combination was one that he knew he would never resolve.

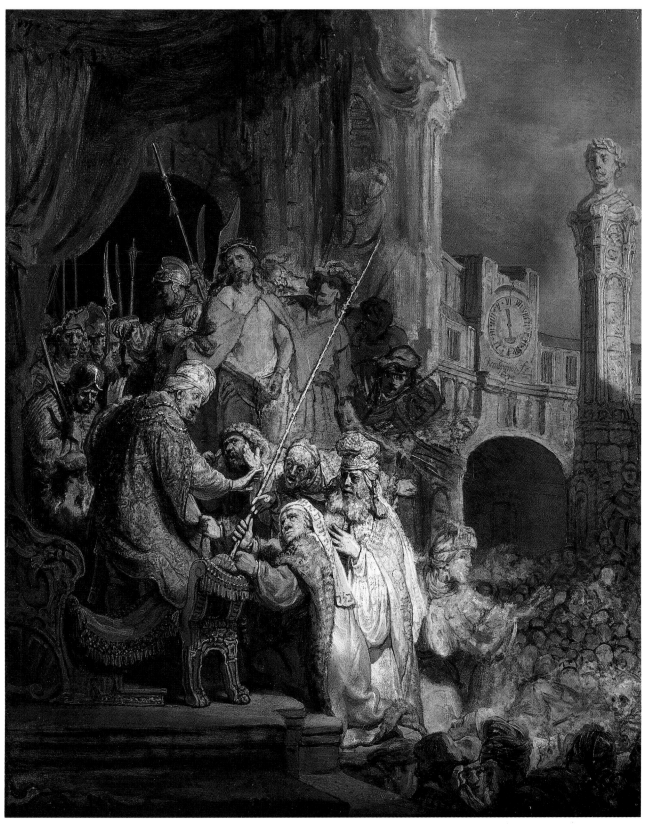

Fig. 133 (Cat. 221)

Reynolds (Sir Joshua)

Cat. 222 *Portrait of Dr John Ash*, 1788. Oil on canvas, 241.3 x 147.3 cm. The Special Trustees for the Former United Birmingham Hospitals Trust Funds.

Reynolds (1723–1792) figures in a paper written for the Cambridge Society of Apostles between 1887 and 1889 ('Are we compelled by the true Apostolic Faith to regard the standard of beauty as relative?', Fry Papers, 1/10). Fry invokes here Reynolds's relativist "idea of beauty as the thing which is not ugly", against which, therefore, all "deviation from the central type" is to be approximated. His central point in the paper is that there is a "standard of beauty", but that it will always be known only approximately because, like "the order of the universe", it can be known only "in our perceptions of phenomena ...".

Before Fry left Cambridge, then, he had already found in Reynolds's *Discourses* material fundamental to addressing what would be a major theoretical issue for him, the relationship between the ideal of order and phenomenal experience. It is significant, therefore, that the development of his formalist theory was preceded by the publication of his edition of *The Discourses of Sir Joshua Reynolds* (London 1905). In his Introduction, Fry presents Reynolds's aesthetics as above all "applied". Thus, when he deals with the principle of "unity", he dwells on Reynolds' practical application of it in his teaching. The student "is to look with a "dilated eye", to seize the general effect ...". Fry modernizes Reynolds, stressing his role in "the discovery of the art of the Middle Ages and early Renaissance", and updating his principle of unity so that it can apply both to Rubens and to Van Eyck. Reynolds becomes a key link in the whole of Fry's "great European tradition", not just the champion of "the grand style". The following year Fry found in a mixed old masters show at Burlington House a Reynolds to treat as a triumph of the principle of unity, his *Portrait of Dr John Ash* (fig. 134) ('The Old Masters at Burlington House', *The Athenaeum*, 20 January 1906, pp. 84–85). He writes:

It is one of those splendid compositions, at once simple and rich, which show Reynolds had acquired a greater command of artistic resource, and used it with a more unerring taste, than any other British painter. This is worthy of Titian or Rubens, and scarcely another portrait painter can lay claim to have given so much pictorial splendour to the subject. The building-up of the design upon a diagonal line is masterly in its art and in the subtle concealment thereof; and the colour-scheme is wrought out with such unity that one is conscious not so much of colours, rich though they are, as of colour.

Fig. 134 (Cat. 222)

Fig. 135 (Cat. 223)

Rossetti (Dante Gabriel)

Cat. 223 *The Tune of the Seven Towers*, 1857. Watercolour on paper, 31.4 x 36.5 cm. Tate Gallery, London.

When Fry wrote his lectures in response to the Burlington House exhibition in 1934 of British painting, he made a point of detaching himself from "patriotic feeling", and set about smashing several of the cornerstones of what he considered the patriotic British canon, including Hogarth, Turner and the Pre-Raphaelites. Though a youthful enthusiast for Pre-Raphaelite painting, he had shown little sympathy for it since beginning to publish criticism in the 1900s, but in 1916 he had made a single exception, Dante Gabriel Rossetti (1828–1882) ('Rossetti's Watercolours of 1857', *The Burlington Magazine*, June 1916, pp. 100–09).

Fry represents Rossetti here as a painter inspired by "passionate desire", which could only "rage in a curiosity shop, amid objects which had for him peculiarly exciting associations", a literary painter, therefore. He represented him also, however, as the artist "who came nearer than

any ... of the time to that close-knit unity of design which distinguishes all pure art". And so the watercolours of 1857 become test-cases in Fry's investigation of the relationship between "illustration" and "design". What he seeks to demonstrate is the disjunction between the two, and he picks out *The Tune of the Seven Towers* (fig. 135) as a key instance in which "the dramatic expression not only fails, but tends to injure the harmony" of a fine design. He is uninterested in the mysteriously enigmatic scene depicted, its illusion of a medieval world and its symbols (including the golden emblem of a seven-towered castle above the man):

Here there are delightful inventions of design, the boldest and most surprising motives like that of the staff of the banner and the bell-rope which cut across the figures, or the unexpected repetitions of forms in the belfries. The figures are ..., as usual, beautifully placed, but they annoy us by the over-emphasis on psychological expression.

Rouault (Georges)

Cat. 224 *St John the Baptist*. Gouache on paper, 30.5 x 19.6 cm.
Courtauld Gallery, Roger Fry Collection.

"Well", Fry wrote to Marie Mauron on 31 December
1919, "I found a young artist hitherto almost unknown
to me: Rouault, who is surely one of the great geniuses
of all times. I can only compare his drawings to the
T'ang art of the Chinese, of which only a few specimens
remain" (*Letters*, II, p. 476). He saw something of
Rouault (1871–1958) in 1920, and bought some of his
drawings, including *St John the Baptist* (fig. 136). By the
early 1920s, when he wrote 'Modern Art', the fifth
lecture in his Slade School series 'Some Principles of
Design', he was willing to place him alongside Matisse
and Picasso as a newcomer to his modern canon (Fry
Papers, 1/90). Here he set him "somewhat apart from
the whole contemporary movement", and called him a
"visionary, *i.e.* all his images appear to have been
transmuted by some inner process and then to be
externalized to the artist as hallucinations". As such, he
aligned him with William Blake (who had taken on a very
positive role for Fry in the Post-Impressionist controversy
of 1910), with the qualification that "the material out
which these images are formed is based on a far more
profound and clearer knowledge of visual fact".

 In 1926, with Daumier, Rembrandt and Poussin,
Rouault was chosen as one of the test-cases for Fry's lead
essay in *Transformations*. Here he picks out his own *St
John the Baptist* alongside a Rembrandt drawing as an
instance where "the two arts" of "illustration" and
"design" co-operate. Fry's general point is: "that co-
operation is most possible where neither of them are
pushed to the fullest possibilities of expression, where in
both a certain freedom is left to the imagination, where
we are moved rather by suggestion than statement".
Specifically in Rouault's case, he finds a high degree of
co-operation, but he remarks that "perhaps", as he has
found with El Greco, "in process of time the
psychological elements will, as it were, fade into the
second place, and his plastic quality will appear almost
alone".

Fig. 136 (Cat. 224)

Rousseau (Henri)

Cat. 225 *The Toll House, c.* 1890. Oil on canvas, 40.6 x 32.75 cm. Courtauld Gallery.

Fry made a point of including Henri Rousseau (1844–1910) in the second Post-Impressionist exhibition; it was the first time the "Douanier" was shown in England. Indeed it was Rousseau who came first in his preface to the French section, his opening point in the essay being that lack of skill or training is insignificant beside "the authentic quality" of inspiration and "certainty of ... imaginative conviction" ('The French Post-Impressionists', 1912; reprinted in *Vision and Design*). He sums up thus: "Here ... is one case where want of skill and knowledge do not completely obscure, though they may mar, expression. And this is true of all perfectly naïve and primitive art." One consequence of his formalist resistance to accuracy of representation was resistance to skill as a critical criterion. Since he was among the credulous taken in by the myth of Rousseau's totally unselfconscious naïvety, which was being built by Guillaume Apollinaire and others in Paris, the "Douanier" became for him a convincing demonstration of the irrelevance of skill in art.

During the 1920s, in Fry's lectures on modern art, slides of works by Rousseau were regularly used to re-make the point, but in ways that could both link him to the "primitives" Fry liked to find in other periods and cultures and to situate him as a bridge between those "Others" and modern Europe. In his lecture 'The Development of Modern Art', delivered at University College, Bangor, on 18 January 1927, he writes thus of a Rousseau landscape: "Here is another picture, as primitive, as innocent of all the complexities of art since the fifteenth century as you could wish. It takes us indeed straight back to the Italians of 1450 without the skill and refinement of the best of them but with their instinctive feeling for space construction and for composition" (Fry Papers, 1/117). While in 'Modern Art', the fifth of his Slade School series of the early twenties, he claims Rousseau as a "self taught heaven born Primitive, an artist of complete ignorance and extraordinary gifts for design and arrangement", and finds a simple equivalence between his "distorted conceptual vision" and that of "children and neolithic men". But he adds: "this man tho [*sic*] far more primitive than Botticelli *was* a modern ... One might learn from him more readily than from an early Italian for that reason" (Fry Papers, 1/90).

Fig. 137 (Cat. 225)

Seurat (Georges)

Cat. 226 *White Horse and Black Horse in the Water*, c. 1883. Oil on panel, 15.2 x 24.8 cm. Private collection, on extended loan to the Courtauld Gallery.

Cat. 227 *The Angler*, c. 1884. Oil on panel, 24.1 x 15.2 cm. Private collection, on extended loan to the Courtauld Gallery.

Cat. 228 *La Luzerne, Saint-Denis*, 1885. Oil on canvas, 64 x 81 cm. The National Gallery of Scotland, Edinburgh.

Cat. 229 *The Bridge at Courbevoie*, 1886–87. Oil on canvas, 46.4 x 55.3 cm. Courtauld Gallery.

Cat. 230 *La Poudreuse*, c. 1888–90. Oil on canvas, 95.5 x 79.5 cm. Courtauld Gallery.

Cat. 231 *Study for Le Chahut*, c. 1889. Oil on panel, 21.8 x 15.8 cm. Courtauld Gallery.

Cat. 232 *At Gravelines*, 1890. Oil on panel, 16 x 24.5 cm. Courtauld Gallery.

On 3 July 1916 Fry wrote to Vanessa Bell: "It's odd how everyone takes the same step at the same moment". The step he had in mind was towards a positive re-evaluation of Seurat (1859–1891). He was just back from Paris, having begun buying reproductions for study before going, and in Paris "all the conversations ... ended in discussing Seurat". Seurat was included only marginally in the first Post-Impressionist exhibition, but now Fry had "come to think that he was the great man [we] ... overlooked". One of those he saw in Paris that year was Picasso; in 1917 Picasso made his translation of Le Nain's *The Return from Christening* in the manner of Seurat. By the early 1920s, Seurat had replaced Gauguin and van Gogh in Fry's canon, alongside and almost on the same level as Cézanne. During the 1920s he was to buy his own Seurat, *La Luzerne, Saint-Denis* of 1885 (fig. 16).

Fry's earlier reluctance to accept Seurat clearly came of his reservations *vis-à-vis* Neo-Impressionism, which for him was Impressionism taken to its scientific extreme. In 'Modern Art', the fifth lecture in his Slade School series 'Principles of Design', written in the early 1920s, the reaction *against* Impressionism is seen by Fry to come from "Cézanne and Seurat independently" (Fry Papers, 1/90). "Seurat also accepting & even pushing further the Impressionist study of atmospheric colour reasserts the unity of the surface by a very deliberate choice of

interval and proportion of forms within the rectangle of vision." There is an echo here of Fry's view of Paolo Uccello's hyper-scientific development of linear perspective, first stated in the opening lecture of his Cambridge Extension series 'Florentines II' of 1900–01 (Fry Papers, 1/66). Like Uccello, Seurat for Fry is a scientific painter dedicated to representational accuracy who is, in fact, diverted from his representational goal by the need to abstract and simplify in pursuit of his method, and ends up producing "pure" design.

Fry's most extensive piece on Seurat was written in 1926 and was included in the anthology *Transformations* ('Seurat', *The Dial*, November 1926, pp. 224–32). Earlier that year he had welcomed the Tate Gallery's purchase of Seurat's *Baignade* ('The Courtauld Fund', *The Nation and Athenaeum*, 30 January 1926, pp. 613–14). That painting is his starting-point here, and he aligns it explicitly with Quattrocento art, invoking, however, Piero della Francesca, not Uccello. He would return to the Seurat/Piero parallel when he wrote on Piero's *Flagellation* at the Burlington House exhibition of Italian art four years later ('The Italian Exhibition – III', *The Nation and Athenaeum*, 18 January 1930, pp. 539–40). On both occasions Fry uses the parallel to highlight what, in 1926, he describes as their "common mood of utter withdrawal from all the ordinary as well as all the poetic implications of things into a region of pure and almost abstract harmony". They become model instances of "disinterestedness": that detachment from things in life which Fry came to believe the prerequisite for aesthetic experience, whether in life or in art (see 'Piero della Francesca', p. 196). In Seurat's case the perceptual aspect gives his work a "quality of immediacy" all the same, which is not, says Fry in 1926, undermined by his "scientific method" until the last paintings.

Fry's aim in 1926 is to separate Seurat's painting altogether from the problem of representation (science) and especially from the things it represents (life in society). Perhaps his most striking attempt to separate a particular Seurat picture from its subject is his analysis of *La Poudreuse* (fig. 138). Here, too, his writing is revealed at its most alien to the social art history currently dominant in analyses of Seurat:

Fig. 138 (Cat. 230)

Fig. 139 (Cat. 229)

This is, indeed, one of the strangest pictures I know, so utterly remote is the point of departure from the place Seurat carries us. It is as though he had made a bet that he would take the most intractable material possible and yet mould it to his ends. This impossible woman, in the grotesque *déshabille* of the 'eighties, surrounded by every horror of gimcrack finery of the period, might have inspired Daumier to a grim satire, or Guys to an almost lyrical delight in its exuberance, or Degas to a bitter and merciless epigrammatic exposure, or Lautrec to an indulgently ironical scherzo; but Seurat passes over all such implications with an Olympian indifference, he treats the subject with religious solemnity and carries it into a region of abstract beauty. No Byzantine mosaic, however solemnly hieratic, could be more remote than this from all suggestion of *"La vie Parisienne"*.

Sickert (Walter)

Cat. 233 *Queen's Road Station, Bayswater, c.* 1916. Oil on canvas, 62.3 x 73 cm. Courtauld Gallery, Fry Collection.

Works on paper

Cat. 234 *Roger Fry Lecturing, c.* 1911. Pen and ink on paper, 17.2 x 9.5 cm. London Borough of Islington.

Fry's relationship with Sickert and his views on his work are discussed at length in this book by Anna Greutzner Robins; see pp. 45–56.

Fig. 140 (Cat. 233)

Vlaminck (Maurice de)

Cat. 235 *A Village on the Route Napoléon,* 1912. Oil on canvas, 72 x 92.1 cm. Leicester City Museums.

Vlaminck was included in the second Post–Impressionist exhibition in 1912. Although Fry never published his views on his work, he seems to have preferred overtly Cézannist works by Vlaminck, such as *A Village on the Route Napoléon,* helping to stimulate a strong taste for such landscapes among English collectors.

Fig. 141 (Cat. 235)

Documents in the exhibition

Lectures

Cat. 236 Roger Fry, AMS papers delivered to the 'Apostles': 'Do we exist?' and 'Are we compelled by the true Apostolic Faith to regard the standard of beauty as relative?',1887–89. 2.5 x 20.5 cm and 28.5 x 22.5 cm. By kind permission of the Provost and Fellows of King's College, Cambridge.

Cat. 237 Roger Fry, 'Some Problems in Phenomenology and its Application to Greek Painting' (dissertation submitted in application for a Fellowship at King's College, Cambridge). Approx. 33.5 x 21 cm. By kind permission of the Provost and Fellows of King's College, Cambridge.

Cat. 238 Roger Fry, 'Notes from Leonardo'. Approx. 33.5 x 21.5 cm. By kind permission of the Provost and Fellows of King's College, Cambridge.

Cat. 239 Roger Fry, 'Florentines II. Lecture V: "Piero della Francesca, Alessio Baldovinetti"', Cambridge Extension Lectures II. Approx. 26 x 20.8 cm. By kind permission of the Provost and Fellows of King's College, Cambridge.

Cat. 240 Roger Fry, 'Some Principles of Design, referring to children's drawings and the art of Giotto', lecture given at the Slade School, c. 1905. Approx. 26 x 20.75 cm. By kind permission of the Provost and Fellows of King's College, Cambridge.

Cat. 241 Roger Fry, 'Syllabus for six lectures at the Slade School', pre-1914. Approx. 25.5 x 20.5 cm. By kind permission of the Provost and Fellows of King's College, Cambridge.

Cat. 242 Roger Fry, 'On the selflessness of the best painter: Cézanne'. Approx. 32 x 20.5 cm. By kind permission of the Provost and Fellows of King's College, Cambridge.

Letters

Cat. 243 Bernard Berenson to Roger Fry, 17 October 1901, and 30 December 1901. Both on I Tatti stamped paper and both approx. 10 x 8.5 cm. By kind permission of the Provost and Fellows of King's College, Cambridge.

Cat. 244 Roger Fry to Duncan Grant (with drawing for the Second Post-Impressionist Exhibition poster), autumn 1912. By kind permission of the Provost and Fellows of King's College, Cambridge.

Cat. 245 J.E. McTaggart to Lowes Dickinson and Roger Fry, 1 July 1888 and 19 June 1889. Both approx. 17.8 x 22.5 cm. By kind permission of the Provost and Fellows of King's College, Cambridge.

Cat. 246 Roger Fry to Virginia Woolf (including a drawing by Fry), 13 October 1921 and 3 August 1934. 27 x 21.5 and 25.5 x 20.3 cm. By kind permission of the Provost and Fellows of King's College, Cambridge.

Notebooks

Cat. 247 Roger Fry, Notebook. Approx. 16 x 22 cm. By kind permission of the Provost and Fellows of King's College, Cambridge (No. 4/1.6).

Cat. 248 Roger Fry, Notebook. Approx. 13.5 x 22 cm. By kind permission of the Provost and Fellows of King's College, Cambridge (No. 4/1.12).

Cat. 249 Roger Fry, Notebook. Approx. 22.5 x 28 cm. By kind permission of the Provost and Fellows of King's College, Cambridge (No. 4/1.23).

Cat. 250 Roger Fry, Notebook. Approx. 16.5 x 10 cm. By kind permission of the Provost and Fellows of King's College, Cambridge (No. 4/3).

Book Plates

Cat. 251 Roger Fry, Designs for Ex Libris plates for Bernard Berenson and Bertrand Russell, (i) Ex Libris Berenson, approx. 7.5 x 12 cm; (ii) Ex Libris Berenson, approx. 9 x 11.5 cm; (iii) Ex Libris Russell, approx. 21 x 12.75 cm. By kind permission of the Provost and Fellows of King's College, Cambridge.

Personal Papers

Cat. 252 Mr. Francis Galton's Anthropometric Laboratory: Roger Fry's physical measurements in 1890. Approx. 13.5 x 24.8 cm. By kind permission of the Provost and Fellows of King's College, Cambridge.

Cat. 253 Roger Fry's application for the Slade Professorship at Oxford, 1910, and supporting testimonials, (i) Fry's application; (ii) Letter from Saloman Reinach; (iii) Letter from Bernard Berenson. Approx. 26.5 x 21.1 cm. By kind permission of the Provost and Fellows of King's College, Cambridge.

Photographs

Cat. 254 Sir Edward Fry, mounted photograph. Approx. 29.5 x 21.5 cm. By kind permission of the Provost and Fellows of King's College, Cambridge.

Cat. 255 Roger Fry seated in an Omega chair, Durbins. Approx. 30.5 x 24.8 cm. By kind permission of the Provost and Fellows of King's College, Cambridge.

Cat. 256 Roger Fry sketching in the country. By kind permission of the Provost and Fellows of King's College, Cambridge.

Cat. 257 Pamela Fry and Nina Hamnett at Durbins, 1917. By kind permission of the Provost and Fellows of King's College, Cambridge.

A LECTURE BY ROGER FRY

'Principles of Design.

I. General Ideas, Palaeolithic and Neolithic, Early Art to Giotto'

Fig. 142 (Cat. 36) Anon., *Portrait of Marion Richardson*, Dudley Girls' High School, *c.* 1916–20. Watercolour on paper, 38 x 39.8 cm. Marion Richardson Archive, School of Art & Design Education, University of Central England, Birmingham.

Introduction

The hitherto unpublished text of this lecture survives in a handwritten manuscript in the Fry Papers (1/90). It is the first of a series of five, although the lecture itself is headed "Four lectures on Principles of Pictorial Design./Lecture I". A separate sheet has been attached as title sheet, announcing "Principles of Design/5 Lectures/I. General ideas/Palaeolithic & Neolithic/Early art to Giotto", and there are indeed texts for five. A note in Fry's hand has been added on the other side of the cover sheet (it is included below), asserting that the date is "not ascertainable, but post 1920 [a reference to the war]." The fifth lecture, 'Modern Art', was clearly written after March 1921, because it contains a reference to Picasso's "fat women", which Fry reports seeing for the first time in a letter to Vanessa Bell dated 15 March 1921 (*Letters*, II, pp.504–06). One cannot establish, however, how soon after the first lecture it was written – it may have been a late addition, given the fact that the series was to have been four. Fry's cover-sheet note indicates that he considered the first lecture publishable "without the other lectures", but suggests that the opening should not be included, and neither should the "part about Giotto (which is not very illuminating)." Both, however, have been included here, the former conveying something of Fry's engaging opportunistic style as a lecturer, the latter giving a necessary idea of how his picture of the origins of art and its European beginnings would have been completed (despite the end of the text is missing).

The lecture is a good demonstration of Fry's commitment to the elucidation of general principles as the starting-point for any art-historical or art-critical

project. It's topic, the origins of art, had bearing for him on all aspects of art.

The text is presented with only light editing. Fry's orthography is retained, including his abbreviations, except 'Xt', which stands for Christ (in this case, 'Christ' is added in square brackets). Also unchanged is the relative lack of punctuation. Question marks in square brackets follow any words about which there is uncertainty. These are few, since Fry's handwriting is easily legible, even when he writes fast, as he often does here.

A Note in Fry's Hand Appended to the Manuscript

Five lectures, beginning from earliest times down to the present day. date: not ascertainable but post 1920

Lecture 1. On General ideas on design, Palaeolithic and Neolithic man, and early art until Giotto. This is extremely good and suitable as the first lecture published. It can stand without the other lectures, so long as the part about Giotto (which is not very illuminating) is omitted. In any case the first pages will have to be taken out as they deal with lecturing in general. There are very few short hand notes and the lecture could be read easily in a book. One drawing would I think be necessary.

Lecture 2. On the 15th. century. This is far less interesting, being a too detailed account of Italian art at the period. I should not wish to republish.

A Lecture by Roger Fry

Preface on remission of entertainment tax. During the last course of lectures there were occasional evidences of amusement on the part of the audience. I know that some serious people like my friend Mr. Walter Sickert deplored this as unseemly. I confess I am impenitent. But in that course of lectures we paid a considerable sum to the government in the entertainment tax. I consider therefore that we were within our rights in enjoying ourselves in any way we thought fit. But for the present course the government has been kind enough to remit the entertainment tax and that of course alters the situation. It is now officially recognized that these lectures are not entertaining. They may be instructive

and edifying but entertaining they must not be. If in this course of lectures anyone should laugh it will be the duty of the rest of the audience to regard them as victims of those unfortunate nervous attacks to which we are liable even on the most solemn occasions. It will not be because their nerves are rather overwrought.

Now since when we study the works of any particular artist we can hardly avoid a sidelong glance at the artist's personality and since all human personalities have a ridiculous aspect I think I shall best conform to the legal restrictions by which we are bound and shall most completely avoid entertaining you by treating in this course of some abstract principles.

This course therefore will be devoted to considering certain general principles of pictorial design and seeing how these principles have effected pictorial composition at different periods. What I want to find out is the way in which different artists at different periods have arrived at their various pictorial visions.

It would be rash to say that painting was the oldest of all man's arts but it is the one for which we have by far the longest series of records.

If Palaeolithic man sang songs he neglected to leave us phonographic records of them whereas he did fortunately leave us a great many of his pictures and a few of his sculptures. But if painting is the oldest of the arts it is also one of the most inconvenient.

Man has painted pictures more or less ever since he did those Palaeolithic cave frescoes i.e. for let us say between 20 & 30 thousand years. But he is frequently in great perplexity as to what to do with his pictures when he has once painted them, and that difficulty as we shall see in the last lecture, which will treat of pictorial design to-day, still persists. Poetry and music man carries in his heart or conveniently printed and stacked away in shelves ready to be brought out when he feels the need for them. Architecture takes no more space than building which is a necessity. Even sculpture at first sight more cumbrous than painting can generally be put out of doors or can even be incorporated in buildings. But painting especially the painted cloth or panel which can be moved from place to place. What particular place are we to find for it? Is it to decorate our walls – well it's by no means certain that it does, even though it may be a very good picture.

Of course painting so long as it remained upon the surface of the wall was physically as commodious as sculpture in fact it took up no room at all. But the fact that it was upon the wall imposed certain conditions from which painting was bound sooner or later to endeavour to free itself. The fact that it is upon the wall sets up certain questions of the relations between the ideal space of the picture and the actual space of the building which the artist is bound to take into consideration and when in order to express himself fully he wishes to have complete freedom he is bound to take his picture off the wall and paint it upon a board or a piece of cloth. And when he has once done that he leaves the others the terrible problem of where to put it.

All this may appear very trivial and external to the art of painting but I think we shall see that they are not without a profound influence on the manner in which artists have at different periods set about constructing their pictorial designs.

I suspect that two distinct instincts or rather impulses come into play in the action of painting pictures. One is the impulse to externalize any vivid mental image – the other the instinct of adornment – the decorative instinct.

A mental image of any object or scene that has a strong emotional effect tends to haunt our minds. Any strong emotional tension tends to project the appropriate image upon the inward eye. The lover sees his absent mistress the exile his home the starving a splendid feast the man who is dying of thirst has visions of water & so on. And almost all of us have memory images of the scenes of our childhood so near the surface that they tend to thrust themselves between us & the printed page when we read a novel. As we go on in life the number of objects which are capable of arousing this emotional tension gets less and less – when we were children almost every object presented itself to our untired spirit with that rich intensity, every chair and table had its individuality friendly or forbidding as the case might be – and above all animals boats and carriages were charged with romantic feeling. But even with the child in spite of the vehemence of his desire these memory images are vague fleeting and elusive things. And from this vague elusiveness comes the desire to possess them in more definite & precise form and so if

he can get a chalk or a pencil the child begins to make pictures. And you will see that almost all children's drawings are the effect of this impulse to realize those mental images which his passionate response to life has provoked.

Now I believe this desire to externalize the haunting memory image so as to fix it & therefore possess it more completely has nothing to do with the desire to please the eye. It takes no account of beauty in the ordinary sense. I do not think that when a child draws the particular scrawl which he has come to regard as his symbol for a horse on a piece of paper he has any idea that that paper is made agreeable to his eye. His pleasure is not sensual but ideal. It expresses the idea of a horse & therefore puts him into closer contact with that object towards which his romantic interest reaches out. A piece of paper is not to a child a surface to be made interesting to the eye although children all have a strong feeling for the sensual pleasures of the eye – but it is a means to the firmer possession of the memory images of desirable or interesting things which fill his mind.

But since that other motive, the love of whatever is sensually pleasing to the eye already exists in him wherever for whatever reason the first impulse slackens or leaves a gap, this impulse to decoration comes in and modifies very profoundly his design.

(Slide) Fox hole tree

(Slide) Frieze. This strip of paper the cover of a newspaper was not a carte blanche for the imagination to realize its memory image on. It became owing to its odd shape a surface to decorate & so we get a new factor: order. Here the orderly repetition becomes rhythm.

Now we have to consider another exceedingly curious and important factor in all early design. The factor of language or rather of conceptual language.

I hope everyone knows what a concept is. I think I do but it's just the kind of thing that I don't like to explain or define. However for our purposes & that'll do well enough a concept is the result of classifying our sensations in certain groups. We tie up certain groups of sensations into bundles and we recognize similar groups under all sorts of different conditions as having a peculiar relation to each other. Thus the [?] eye nose mouth

cheek etc. are means of grouping into subsections the various sensations which we have when we look at a face. And we generalize from one face to another, or from one aspect of a face to another – so that although the sensations which we group under the symbol eye are always different as for instance an eye seen full face or in profile or a blue eye and a brown eye – still we always recognize the analogy between one such group and another & regard them as different examples of the same class which we call a thing.

Now you will see that in some cases the sensations are grouped into far more clearly isolated bundles than in others. Thus eye and cheek. If we hadn't a quite absorbing interest in our own and other people's faces we should never have taken the trouble to give a word to so ill defined a group as the cheek. Our classification is not really necessary & different people adopt different groups. We have a word for the inner aspect of the hand without the fingers we call it a a (sic) palm. I believe the Germans have no word for that. We have no corresponding word for the outer aspect of the hand without the fingers which in consequence has nothing like so definite an individuality to the imagination as the palm.

Now you'll see that this habit of tying up particular groups of sensations into bundles for which we have a word symbol is likely to distort very seriously our sensations. That group of sensations which in regard to my face we call an eye tend to hold together with a stronger unity than perhaps the actual sensations would explain. We notice more clearly wherein they are marked off from the surrounding surfaces more clearly than the distinctions between one nameless part of a surface and another. And this grouping of sensations together gives to the groups a special significance for the imagination which other nameless groups which may be quite as important in terms of pure visual sensation lack.

In fact it is hardly possible to exaggerate the distorting influence which our habits of conceptualizing sensations has had upon our vision. So that the whole history of art is from one point of view little else but our struggles to correct in one way or another this distorting influence. To learn to see with an unbiased eye is an almost superhuman feat. We shall see throughout our study how the conceptual habit has dominated not only the way of looking at objects but of envisaging their relations in space. In fact it has not only altered drawing but even composition.

It will give you an idea of how firmly the habit has impressed itself upon our imaginations even in their most inaccessible depths to know that in nervous diseases of sensation – where people have either excessive sensitivities or absence of sensation in certain parts of the body these diseased patches always correspond to some part that has a name. It is a wrist or elbow the chest or whatever it may be but it's never a nameless surface.

Now consider what happens when the child obsessed by some interesting image wishes to externalize it on paper. The memory image is excessively vague & elusive. He tries in vain to fix it and since he has already learned to talk he falls back on the concepts into which he resolves the object. If it is a face he thinks of it as a roundish surface – so far he follows a visual image – in which occur the concepts eyes nose mouth. And these he indicates by the most summary symbols (Slide) & we get the typical drawing of a man wh. is nothing but a short hand symbolism for the most striking concepts.

Here there are almost none of the fundamental visual properties of objects – the body & limbs have no volume tho' there is a sense of it in the head simply because he has to make a space in which to inscribe the facial concepts. When he gets on to think of buttons which are usually the only concepts referring to the body he has to make a certain surface on which to write these symbols. He has you see short-circuited as it were all his visual sensations, gone behind them to the conceptual ideas for which he has found symbols.

The strange thing is that he accepts these perfectly empty symbols as quite satisfactorily replacing the actual sensations – he takes these worthless counters for real sensations as greedily as the French peasant who hoards those pretty yellow metal counters which the French Government supplies, as tho' they were solid gold coin.

I say he accepts them greedily but only for a time – presently a vague dissatisfaction with these empty symbols invades him and he begins either to pester his parents as to how to draw a horse – how to draw a dog

& so on. If as usual they supply him with a slightly better formula he goes happily on for a time but if they wisely pretend total ignorance he has to begin to work consciously at the forms of his favourite animals & he very soon makes surprising discoveries. Anyhow he is launched now on the long & difficult business of gradually filling out the abstract symbols with something of the fullness and relief of actual visual sensation.

But now what would happen to a human being obsessed by memory images of intensely interesting objects if he lacked conceptual handles to his sensations, if in fact he had scarcely any conceptual language but only as one may imagine very primitive man to have had an interjectional one.

When he sought to seize the floating memory image he would have no classifying machinery ready to hand. He could not go behind his sensations to symbols, he would have to wrestle unaided with the total complex of unclassified sensations.

At first no doubt he would be helpless but as nothing wld. come to his aid and the obsessing images continued he would be forced to pay more & more attention to his sensations until at last images would be imprinted in his visual memory as clearly as if they were on a photographic plate. He would then externalize them in all their completeness as a single unity. The memory image would be perfectly accurate in all its relation proportions because it would have been grasped as a whole – having never been analysed into constituent parts.

(Slide) This I believe is the explanation of the drawings of Palaeolithic man. When these were first discovered and it was noticed that regarded as representations of nature they surpassed in some ways all that man has ever accomplished since – when it was noticed for instance that the poses of animals in movement were in accord with the results of instantaneous photography, a result to which no other unaided human eye had ever attained – it was supposed that so perfect an art of representation could only be the result of agelong [?] practice & tradition. It was almost believed that Palaeolithic man had had a high civilization & culture. But this view seems to me altogether impossible. Pal. man's only implements were flints & these he wrought with far less skill than his neolithic successors. He made no pottery even.

But from the point of view of exact photographic reading of those animals about which he had strong interests he had the immense advantage of having no full conceptual language. One may imagine that likely enough he had made some symbol for each kind of animal – since its individuality wld. be too striking to miss but that he had not yet fully grasped or found means to express such concepts as eye mouth head neck or to recognise the analogy between these organs in different animals.

I do not believe that had he grasped such ideas he could ever have drawn an eye with such exactly right proportions with so little emphasis & exaggeration as you see here.

Certain it is that neolithic man when he came had these conceptual ideas & that he & his successor modern man have never succeeded quite so completely as this in spite of their many thousand years of practice.

We must return once more to the child's conceptual hieroglyphic, that absurdly imperfect symbol which he accepted for a man. As the child grows older, he learns to compare this with his memory images and gradually its utter unlikeness to them forces itself upon his attention. He realizes that the body & limbs have extension as well as the head and he starts on a slow & lengthy process of filling out the bare symbol until it resembles more & more the memory image. In the end no doubt at least after thousands of years of practice concept making man has learned how to fill them out so as to approach very nearly to the unanalyzed photographic image of his Palaeolithic predecessor. But through all that long history Neolithic & modern man's images bear traces of their origin in conceptual symbolism. However closely they get to resemble that immediately grasped totality they never quite coincide with it. We will consider now some of the most obvious characteristics of the conceptually formed image.

Will you all think what simple visual symbol you wld. use to represent the appearance of a coin.

(Slide) Clear that | or O are equally correct symbols of the visual appearance of a coin but they are somehow less satisfactory to the mind.

It is evident that there are certain aspects of any object which we have come to regard as more representative of the essential character of the object than others that we should say were odd, unfamiliar, or accidental. But of course in all this we are again importing purely human values into our visual experience and still further distorting it from its pristine simplicity.

However the moment man had begun to break up the complex vision by conceptualizing nature he was impelled to go on and regard certain aspects of objects as most fully representing those concepts.

The main rule which follows is that the object is most characterized when it has its greatest extension in the field of vision.

If you take up any object to look at it you are almost certain to turn it unconsciously so as to see its largest aspect. Then likely enough you turn it at right angles. You look at it in full face, then in profile & it will only be later that you are likely to see what it looks like at some intermediate angle. Indeed unless you are an artist it is unlikely you will ever care for more than one of the direct aspects. So long as we are curious about the object qua object we are almost sure to prefer a right-angled aspect of one kind or another, it is only when we are curious about appearances in the abstract which is the main business of the modern artist that we experiment with other angles of vision.

Now primitive man was like the child preoccupied with objects, he wanted to represent interesting objects and he therefore used to the full these methods of conceptual symbolism.

(Slide) I need hardly go into detail to prove this familiar fact about all early art of concept-making man.

(Slide) Egyptian

We are in presence of a highly civilized & sophisticated art with a continuous tradition of 2000 yrs. longer than the tradition behind our own art of to-day & these artists follow strictly the rules of conceptual symbolism.

Head profile – as the most interesting aspect for the eye owing to contour

Shoulders full

twisted so as that legs shd. be full profile

Hands to show all fingers

LionOr here again. The symbol has here been filled out by repeated reference to nature until the actual forms may seem not so very much less naturalistic than those of Palaeolithic man but how entirely the aspect is chosen on conceptual grounds.

This Babylonian artist is infinitely removed from the possibility of conceiving such a pose as this for instance

(Slide) Palaeo

Child's drawing. Sea shore.

Children of course behave exactly as early artists of the concept-making kind.

Boat in full extension

Shore

The map is really an extension of conceptual symbolism & you see here how nearly the drawing when an extent of earth is in question approaches to a map. You can also guess how valuable our power of making such concept symbols is for all the practical affairs of life and how much pressure there is on us from the earliest infancy to translate purely visual sensations into convenient concept symbols.

I go back now to my first thesis – viz. that there are two main impulses in pictorial art

(1) the externalization of the haunting memory image or the conceptual symbol into which it has been converted.

(2) the decoration impulse.

I cannot doubt that of these two motives the first is much the more pressing & powerful. We have seen that Palaeolithic man unhandicapped as he was by concepts was able to externalize his memory images with astonishing completeness & this seems to have satisfied him entirely. There is no sign in his cave paintings of any rhythmic disposition, any pattern or symmetrical arrangement. In this respect he behaves exactly as does the child with a large sheet of paper.

Neolithic man & all savage peoples of to-day have a strong propensity towards decoration, they appear often to be entirely dominated by this & to have either never accomplished the externalization of memory images or to have abandoned it completely. In truth they have abandoned it for all their patterns have been traced back

to some naturalistic object or another. How does the decoration impulse come in then. There is first of all the desire to please the eye to interest & engage it by mere diversity of surface. Of two surfaces one plain and the other variegated the eye will be drawn insensibly to the variegated tho' it may afterwards become bored by it & seek relief in the plain surface. But there is more than this there is a psychic and quasi intellectual pleasure in rhythm.

The repeat of a pattern gives it a kind of logical consistency. It gives evidence of conscious purpose of its not being haphazard or accidental & in that way becomes a kind of abstract language between the creator & spectator.

There is indeed in all human activity a desire for order. This desire for order expresses itself in all our intellectual constructions & explanations and also it expresses itself in our arts.

Now & here I come to the important point. When neolithic man was prevented by his concept-making habit from externalizing a photographic memory image of the objects of his interest and was forced to make more or less adequate conceptual symbols he left room as it were for the decoration impulse to make itself felt.

Palaeolithic man discovered his image as a whole & the arrangement of its parts was given in the total image but when the image is made up of separate concept symbols the artist has no precise direction as to how these are to be arranged.

(Slide) Boat.

Here the child wants to express men rowing in a boat. He begins with the boat seen in its greatest extension. He arranges the men in it. Then he thinks of the oars. He has his concept symbol for an oar and since he wishes the boat to be in motion he has a vague sense that the oars are not perpendicular to the boat but of the relations of the oars to one another he has no fixed idea and at once the rhythmic harmonizing impulse comes in & he arranges them in symmetrical rhythm about the centre making a perfectly balanced and totally incorrect image.

(Slide) Greek vase.

This Greek vase painter of the 6th. cent. B.C. did, as you see, exactly the same.

There is yet another gap in the image recording business which lets in the decoration instinct. I have said that the child after making his first excessively abstract concept symbol of a man gets dissatisfied & gradually begins to fill it in by repeated reference to his memory images & by conscious observation but this is not an invariable process. Sometimes when he has found a new symbol which satisfies him as a representation of the beloved object he feels such satisfaction in it that he goes on repeating it almost mechanically to multiply as it were his means of possession.

In doing this the symbol gets very quickly distorted, as it were rubbed down and degraded until no one but the child himself could tell what it was meant for.

The same happens with primitive peoples & then obliterated images become the material of rhythmic arrangement they end by making patterns.

(Slide) Axoloth.

It happens particularly among what we call savages that this process goes on for so long that all attempt to go back to memory images is abandoned & their whole art becomes decoration – they forget altogether the naturalistic origin of the forms they use and become purely decorative.

Mahomedan [*sic*] art is a curious instance of this process in a highly civilized & self-conscious community. No doubt religious motives are alleged in this case but is it one wonders more than an a posteriori explanation.

On the other hand what one may call the natural man of to-day has almost entirely lost any sensibility to rhythmic order. Under the influence of the storytelling picture, the photograph & most of all the cinema he has no interest in anything but the completely naturalistic image.

No doubt one day psychology will explain why under particular conditions one or other of these impulses gets atrophied. In all great art we find both these motives working more or less harmoniously though as we shall see both of them may become so much modified as to be scarcely recognizable.

We have seen how Palaeolithic man throws the externalized memory images of the animals which excited his passionate interest helter skelter on the walls of his cave, & how the child for the most part puts one

image down after another without conceiving that the relative position of two objects has any meaning. Even in so highly sophisticated an art as the Assyrian there is little idea of any relationship between objects in space, all the different objects of interest are added one to another on the walls

(Slide)

or else the relation between one and another becomes directly symbolic of some important dramatic or social relationship.

Just as the artist has discovered a symbol to represent his concepts of sensation so he tries to find as it were a symbolic relationship. The relative position is a visual symbol of not of [*sic*] any actual spatial relation but of moral relations of King to subject, of conqueror to conquered of God to Man and this symbolism persists for a very long time in all Christian art as late on as the 14th. century.

(Slide) Simone Martini. St.Louis.

In early art then the objects alone are of importance. Their relationship in space is either totally neglected or is changed into a direct symbol of some moral relationship and it is only gradually that the idea of the importance of space relations – the idea of creating a definite ideated picture space grows clear. We shall see what an extremely important role in the artist's methods of pictorial design this question of the pictorial space plays.

We have seen that the image of an object may be arrived at by two methods – one the pure memory reproduction of a total visual impression the way of Palaeolithic man. The image is here accepted from nature (a posteriori). In the other the way of neolithic & primitive man & the child of to-day in which a conceptual symbolism is filled out until it resembles more or less exactly the visual impression of nature.

Here the image is constructed (a priori) built up gradually by successive corrections from the sum of concept symbols.

Now a similar distinction holds as to the way of arriving at the ideated picture space.

(Slide)

Here is a modern Dutch picture in which the whole space is accepted (a posteriori). But in all early art since space relations begin as symbols of moral relations or else subserve a purely decorative end – space is always constructed – like the particular images it starts as a visible symbol of certain concepts and gradually approximates to the space of actual experience.

And as you may suppose any such constructed space is likely to have some of the characteristics of the constructed image. As we saw the conceptual view of any object tended always to be at right angles to its greatest extension

(Slide) Dom [enico] Venez [iano]

so we find that the next normal way of constructing a picture space is to view it at right angles to its greatest extension – or by way of varying that we may look straight down the centre of its longest axis.

(Slide) [Perugino]

But in either case there is an inevitable tendency of the mind to conceive the picture space as disposed parallel to the picture plane.

(Slide) Return to Dom [enico] Venez [iano]

The picture space is of course made clear to the imagination by the objects disposed within it and unless for some positive reason there will be a tendency to dispose these objects symmetrically about a centre. That being the most obviously natural order which we can impose upon them & as we have seen in all conceptual (a priori) design the desire for order imposes itself in the relations of concept symbols one to the other – as I showed you in the child's drawing of the boat.

Such is the most natural & elementary composition then of an a priori picture in which we are dealing with an imagined space but an imagined real space. But a disturbing element comes in with the story telling motive in pictures. This the impulse to illustration as we say is really a further development of that primary motive to picture-making, the desire to externalize memory images of objects of intense feeling. By a natural & very early extension this becomes the desire to externalize the image of some action of absorbing interest.

Now this action is at first represented non-spatially as we saw in the Babylonian relief.

When once it is represented in an ideated actual space the problem arises how to arrange the figures or objects so as to express the action and here symmetry has soon

to be abandoned as too unlike real action.

The artist therefore replaces symmetry by balance.

(Slide)

The principle of pictorial balance is exceedingly simple & is exactly like that of the steelyard balance viz. that a weight of power at a distance of 1 unit from the centre will balance a weight of 1/2 at twice the distance from the centre & so on.

Giotto. Assisi. St. Francis & his father

The dramatic or strong picture thus very naturally arranges itself as a simple balance about the centre line the two protagonists forming as it were the two foci of the composition. Here in an early work of Giotto's the balance is so simply conceived that we have almost got exact symmetry – only the differences of gestures in the two groups modifying its too absolute & naive symmetry.

Raising of Lazarus.

Here in a late work there is nothing like symmetry but on the other hand the most subtle and expressive balance.

The 2 protagonists Xt [Christ] & Lazarus Xt [Christ] much more to left balances owing to greater leverage the much weightier group to rt. This enables his figure to be made very emphatic by its isolation & the sharp intricacy of the silhouette. Indeed so emphatic is the figure & the isolated hand of Xt [Christ] with its singularly authoritative gesture that G. has actually piled a great rock mass to the right with a strong diagonal line in order as it were to redress the balance otherwise overweighted to the left.

We get here a good instance of what is so remarkable in Giotto his clear perception of the dramatic idea is actually the starting point for his discovery of amazing new conceptions of formal design.

We can say if we like that Giotto used his astonishing genius as a composer to emphasize & illustrate the dramatic theme – but those who have once grasped the extraordinary significance of his formal designs will be likely perhaps to feel that the drama was the point of departure & the pretext for a profound and moving harmony.

Christ before Pilate.

Whatever way one takes him Giotto, every time one returns to him seems to be the most amazing phenomenon in the history of European art.

Nearly every one of the designs for the Arena chapel is a surprising revelation of some undreamt of & unforeseeable plastic organisation. In every one there is a perfect harmony between the volumes of the figures & the space in which they are placed. The nature of that space is presented with astonishing clearness to the imagination although Giotto disposed of much fewer means of creating the idea of space than a modern painter has - the space is always perfectly real and consistent with itself and with the volumes it encloses. Perhaps I can best express the peculiar

[The text ends here]

BIBLIOGRAPHY

Note

The essential reference work is Donald A. Laing, *Roger Fry: An Annotated Bibliography of the Published Writings*, London and New York 1979. Also invaluable in the formulation of this exhibition and catalogue have been the Fry papers in the Modern Archive, King's College Library, University of Cambridge

Primary Material: Fry's Published Writings, including Anthologies, and Writings by his Contemporaries

Clive Bell, *Art*, London (Chatto & Windus) 1914; or J.B. Bullen (ed.), Oxford 1987

J.B. Bullen (ed.), *The Post-Impressionists in England*, London and New York 1988

Roger Fry, *Cézanne: A Study of his Development*, London (Hogarth Press) 1927; or New York 1960

Roger Fry, *Henri Matisse*, London and Paris 1930

Roger Fry, *Last Lectures*, introduction by Kenneth Clark, Cambridge 1939

Roger Fry, *French, Flemish and British Art*, London (Chatto & Windus) 1951; originally published as: *Characteristics of French Art*, 1932; *Flemish Art*, 1927; *Reflections on British Painting*, 1934

Roger Fry, *Vision and Design*, London 1920; or London (Chatto & Windus) 1957; or Harmondsworth (Penguin) 1961

Roger Fry, *Transformations*, London (Chatto & Windus) 1932; or New York (Chatto & Windus) 1968

Roger Fry, 'Rembrandt: An Interpretation', *Apollo*, 75, March 1962, pp. 42–55

Roger Fry, 'The Double Nature of Painting', *Apollo*, 89, May 1969, pp. 362–71

Christopher Reed (ed.), *A Roger Fry Reader*, Chicago 1996

Denys Sutton (ed.), *Letters of Roger Fry*, 2 vols., London 1972

Denys Sutton (ed.), 'Letters from Herbert Horne to Roger Fry', *Apollo*, August 1985

Nigel Thorp (ed.), *Whistler on Art: Selected Letters and Writings*, Manchester (Carnacet) 1994

Oscar Wilde, *Intentions*, London (Methuen) 1909

Secondary Material: Writings on Fry and his Contemporaries

Isabelle Anscombe, *Omega and After: Bloomsbury and the Decorative Arts*, London (Thames and Hudson) 1981

Annie E. Coombes, *Reinventing Africa: Museums, Material Culture and Popular Imagination in Late Victorian and Edwardian England*, New Haven and London 1994

Judith Collins, *The Omega Workshops*, London 1983

David Peters Corbett, *The Modernity of English Art 1914–30*, Manchester (Manchester University Press) 1997

Richard Cork, *Vorticism and Abstract Art in the First Machine Age,* 2 vols., I: *Origins and Development*; II: *Synthesis and Decline*, London 1975–76

Richard Cork, *Art Beyond the Gallery in Early 20th Century England*, London (Yale) 1985

Denis Farr, *English Art 1870–1940*, Oxford 1979

Charles Harrison, *English Art and Modernism 1900–1939*, London 1981

Impressionism for England: Samuel Courtauld as Patron and Collector, exhib. cat. by John House, with William Bradford, Elizabeth Prettejohn and Andrew Stephenson, London, Courtauld Gallery,

Courtauld Institute of Art, 1994

Modern Art in Britain 1910–1914, exhib.cat. by Anna Gruetzner Robins, London, Barbican Art Gallery, 1997

Richard Morphet, 'Roger Fry: The Nature of his Painting', *The Burlington Magazine*, CXXII, July 1980, pp. 478–88

Benedict Nicholson, ' Post-Impressionism and Roger Fry', *The Burlington Magazine*, XCIII, January 1951, pp. 11–15

Elizabeth Prettejohn, 'Aesthetic Value and the Professionalization of Victorian Art Criticism 1837–78', *Journal of Victorian Culture*, 2:1, Spring 1997, pp. 71–94

Christopher Reed, 'The Fry Collection at the Courtauld Institute Galleries', *The Burlington Magazine*, CXXXII, November 1990, pp. 766–72

Christopher Reed, 'Making History: the Bloomsbury Group's Construction of Aesthetic and Sexual Identity', in Whitney Davis (ed.), *Gay and Lesbian Studies in Art History*, New York 1990

Christopher Reed, 'Through Formalism: Feminism and Virginia Woolf's Relation to Bloomsbury Aesthetics', in Diane F. Gillespie (ed.), *The Multiple Muses of Virginia Woolf*, London and Colombia, 1993

Christopher Reed, 'A Room of One's Own: The Bloomsbury Group's Creation of a Modernist Domesticity', *Not at Home. The Suppression of Domesticity in Modern Art and Architecture*, London (Thames and Hudson) 1996, pp. 147–160

Richard Shone, *Bloomsbury Portraits*, London 1996

Frances Spalding, *Roger Fry: Art and Life*, London, Toronto, Sydney and New York 1980

Frances Spalding, *Vanessa Bell*, London 1983

Frances Spalding, *The Art of Duncan Grant*, London 1990

Frances Spalding, *Duncan Grant: A Biography*, London (Pimlico) 1998

Marianna Torgovnik, *Gone Primitive: Savage Intellects, Modern Lives*, Chicago 1989

Simon Watney, *English Post-Impressionism*, London 1980

Simon Watney, 'The Connoisseur as Gourmet: The Aesthetics of Roger Fry and Clive Bell', in Tony Bennett *et al.* (eds.), *Formations of Pleasure*, London, Boston, Melbourne and Henley (Routledge, Kegan Paul) 1983, pp. 63–83

Virginia Woolf, *Roger Fry: A Biography*, London (Hogarth Press) 1940; or with an introduction by Frances Spalding, London 1991; or ed. Diane F. Gillespie, Oxford 1995

Secondary Material: The Metropolitan Museum of Art, New York

M. Ainsworth and K. Christiansen, *From Van Eyck to Brueghel: Early Netherlandish Painting in the Metropolitan Museum of Art*, New York 1998

C. Tompkins, *Merchants and Masterpieces: The Story of the Metropolitan Museum of Art*, New York 1970

F. Zeri and E. Gardner, *Italian Paintings: A Catalogue of the Collections of the Metropolitan Museum of Art, Florentine Schools*, New York 1971

F. Zeri and E. Gardner, *Italian Paintings: A Catalogue of the Collections of the Metropolitan Museum of Art, Venetian Schools*, New York 1973

F. Zeri and E. Gardner, *Italian Paintings: A Catalogue of the Collections of the Metropolitan Museum of Art, Northern Italian Schools*, New York 1986

INDEX